THE FATE OF A GESTURE

ALSO BY CARTER RATCLIFF

Fever Coast (poetry)

Botero

Andy Warhol

Red Grooms

John Singer Sargent

Give Me Tomorrow (poetry)

Robert Longo

Pat Steir: Paintings

Komar and Melamid

Gilbert & George: The Singing Sculptures

THE FATE

OF A GESTURE

JACKSON POLLOCK AND POSTWAR AMERICAN ART

CARTER RATCLIFF

FARRAR · STRAUS · GIROUX

NEW YORK

LIBRARY OF CONGRESS CATALOGING-IN-PUBLICATION DATA
Ratcliff, Carter.
 The fate of a gesture : Jackson Pollock and postwar American art /
Carter Ratcliff. — 1st ed.
 p. cm.
 Includes bibliographical references and index.
 1. Painting, American. 2. Painting, Modern—20th century—United
States. 3. Pollock, Jackson, 1912–1956—Themes, motives.
 I. Title.
ND212.R38 1995 759.13'09'045—dc20 95-12081
 CIP

TO PHYLLIS

ACKNOWLEDGMENTS

I am indebted first to Thomas B. Hess and James Fitzgerald, the editors of *Artnews* and *Art International*, who encouraged me to publish the essays and reviews that led, years later, to this book. I am equally grateful for the encouragement I have received from Elizabeth C. Baker, the editor of *Art in America*.

Writing could begin only after I had interviewed Rudy Burckhardt and Robert Goodnough. I have relied heavily on their recollections and insights, and on the help I received from many others in the art world. Annalee Newman, Grace Hartigan, Alex Katz, Michael Goldberg, and Irving Sandler were especially helpful in illuminating the forties and fifties. I should mention, too, how much I have benefited from Sandler's accounts of the entire postwar period.

Jasper Johns patiently answered my questions about his art and life. I am also indebted to Riva Castleman and Calvin Tomkins for their commentary on Johns, Robert Rauschenberg, and John Cage. Elizabeth C. Baker was an indispensable source of information about the sixties, as were Leo Castelli and Robert Rosenblum. The recent past is often the most elusive. For helping me bring the eighties into focus, I am particularly indebted to Robert Longo, Mary Boone, David Salle, and Julian Schnabel. I would also like to express my thanks for the help and encouragement given by Nobu Fukui and Kwi-soon Lee.

Art-world conversations seem endless, though of course they are not, and I am glad to have talked to Andy Warhol and Lee Krasner before their deaths.

Jonathan Galassi, my editor, provided crucial help in focusing my efforts. I am very grateful to him, and also to his assistant, Aoibheann Sweeney. I would like to thank Julie Garfield, Louise Weinberg, Sarah King, and Marisol Martinez for their help in gathering essential documents and photographs, and to express my appreciation for the sympathetic expertise with which Karla Reganold attended to the manuscript.

CARTER RATCLIFF

Contents

ILLUSTRATIONS xi

INTRODUCTION 3

PART 1 THE AMERICAN INFINITE 5

PART 2 THE ACTION PAINTER 97

PART 3 FRAGMENTS OF THE ORDINARY 129

PART 4 A DAZZLING CONTINUUM 173

PART 5 GLAMOUR AND DEATH 185

PART 6 THE QUEST FOR PURITY 217

PART 7 FROM DOLDRUMS TO BOOM 267

EPILOGUE 303

NOTES 309

ILLUSTRATION CREDITS 337

INDEX 343

ILLUSTRATIONS

COLOR PLATES following page 96:
I. Jackson Pollock, *Autumn Rhythm: Number 30, 1950*, 1950
II. Willem de Kooning, *Excavation*, 1950
III. Jasper Johns, *Flag*, 1954–55
IV. Andy Warhol, *Gold Marilyn Monroe*, 1962

BLACK-AND-WHITE ILLUSTRATIONS:
1. Jackson Pollock, *Cathedral*, 1947 2
2. Jackson Pollock and Lee Krasner, 1950. Photograph by Rudy Burck-hardt 6
3. Thomas Hart Benton, *Self-Portrait with Rita*, 1922 18
4. Thomas Hart Benton, *The Arts of Life in America: The Arts of the South*, 1932 20
5. Jackson Pollock, *Going West*, 1934–35 36
6. Jackson Pollock, *T.P.'s Boat in Menemsha Pond*, c. 1934 38
7. Jackson Pollock, *Flame*, c. 1934–38 41
8. Jackson Pollock, *Birth*, c. 1938–41 42
9. André Masson, *Meditation of the Painter*, 1943 45
10. Jackson Pollock, *Stenographic Figure*, 1942 47
11. Jackson Pollock, *The She-Wolf*, 1943 47
12. Jackson Pollock, *Mural*, 1943 54–55
13. Jackson Pollock, *Eyes in the Heat*, 1946 58
14. Jackson Pollock, *One, Number 31 (1950)*, 1950 60–61
15. Clyfford Still, 1958. Photograph by Hans Namuth 72
16. Clyfford Still, *1954*, 1954 75
17. Barnett Newman, 1951. Photograph by Hans Namuth 78
18. Barnett Newman, *Onement I*, 1948 83
19. Pollock painting *Autumn Rhythm*, 1950. Photograph by Hans Na-muth 86
20. Jackson Pollock, *The Water Bull*, c. 1946 90
21. Jackson Pollock, *Number 14, 1951*, 1951 91
22. Jackson Pollock, *Easter and the Totem*, 1953 92
23. Jackson Pollock, *Male and Female*, 1942 93
24. Jackson Pollock, *The Deep*, 1953 95

25. Willem de Kooning, New York, 1950. Photograph by Rudy Burck-hardt 98

26. Willem de Kooning, *Elaine de Kooning*, c. 1940–41 102

27. Willem de Kooning, *Queen of Hearts*, c. 1943 103

28. Willem de Kooning, *Painting*, 1948 104

29. Hans Hofmann, *Fantasia*, c. 1944 110

30. Willem de Kooning, *Woman I*, 1950–52 115

31. Willem de Kooning, *Suburb in Havana*, 1958 118

32. Franz Kline, *Mahoning*, 1956 119

33. Grace Hartigan, *New England, October*, 1957 124

34. Alfred Leslie, *Soldier's Medal*, 1959 125

35. Joan Mitchell, *Untitled*, 1958 126

36. Jasper Johns, *Target with Plaster Casts*, 1955 130

37. Jasper Johns in his New York studio with *Flag*, 1955. Photograph by Robert Rauschenberg 135

38. Robert Rauschenberg, *Bed*, 1955 138

39. Robert Rauschenberg, *Monogram*, 1955–59 141

40. Jasper Johns, *False Start II*, 1962 143

41. Jasper Johns, *According to What*, 1964 154–55

42. Jasper Johns, *Scent*, 1973–74 157

43. Jasper Johns, *Fool's House*, 1962 160

44. Jasper Johns, *Flag on an Orange Field*, 1957 166

45. Susan Rothenberg, *Cabin Fever*, 1976 171

46. Donald Judd, *Untitled*, 1964 174

47. Andy Warhol, *Brillo Box (Soap Pads)*, 1964 174

48. Frank Stella, *Conway I*, 1966 174

49. George Segal, *Man at Table*, 1961 174

50. Robert Rauschenberg, *Barge*, 1963 180–81

51. James Rosenquist, *F-111*, 1965 182

52. Claes Oldenburg, *Bedroom Ensemble*, 1963, 1996 183

53. Andy Warhol, *Yarn*, 1983 184

54. Andy Warhol at the Factory, 1966. Photograph by Billy Name 186

55. Andy Warhol, *Five Boys*, c. 1954 188

56. Andy Warhol, *Coca-Cola*, 1960 190

57. Andy Warhol, *Large Coca-Cola*, 1962 191

58. Andy Warhol, *Marilyn Monroe's Lips*, 1962 194

59. Andy Warhol, *Large Triple Elvis*, 1963 199

60. Andy Warhol, *Empire*, 1964 202

61. Andy Warhol at the Flowers show; Galerie Ileana Sonnabend, Paris, 1965. Photograph by Harry Shunk 205

62. Andy Warhol, *Leo Castelli*, 1975 210

63. Andy Warhol, *Orange Disaster*, 1963 213

64. Helen Frankenthaler, *Mountains and Sea*, 1952 218

65. Morris Louis, *Point of Tranquility*, 1958 221

66. Donald Judd, *Untitled*, 1969 224

67. Frank Stella, *Avicenna*, 1960 230

68. Frank Stella, *Flin Flon III*, 1969 232

69. Frank Stella, *Nasielsk II*, 1972 233

70. Frank Stella, *Nogaro*, 1981 234

71. Frank Stella, *Lo sciocco senza paura (#1, 4X)*, 1984 235

72. Richard Serra throwing molten lead, 1972. Photograph by Gianfranco Gorgoni 240

73. Robert Morris, *Observatory*, 1971–77 244

74. Robert Morris, *Untitled*, 1974. Poster for an exhibition entitled Voice 248

75. Lynda Benglis, advertisement in *Artforum*, November 1974 249

76. Lynda Benglis, *Totem*, 1971 250

77. Walter De Maria, *The Broken Kilometer*, 1979 256

78. Walter De Maria, *The Lightning Field*, 1977 257

79. Robert Smithson, *Spiral Jetty*, 1970 264

80. Miriam Schapiro, *Black Bolero*, 1981 268

81. Robert Longo, *Men Trapped in Ice*, 1980 278

82. Julian Schnabel, *Portrait of Mary Boone*, 1983 280

83. Julian Schnabel, *Exile*, 1980 285

84. Cindy Sherman, *Untitled Film Still #21*, 1978 286

85. Robert Longo, *Tongue to the Heart*, 1984 287

86. David Salle, *Cigarette Lady: Blue and Yellow*, 1979 290

87. David Salle, *Melancholy*, 1983 290

88. Andy Warhol and Jean-Michel Basquiat, *Untitled (Alert, GE)*, c. 1984–85 293

89. Mike Bidlo, *Jack the Dripper at Peg's Place*, 1982 296

90. Robert Longo, *Heads Will Roll*, 1984–85 299

91. Brice Marden painting, 1990. Photograph by Bill Jacobson 302

92. Brice Marden, *Presentation*, 1990–92 305

93. Robert Rahway Zakanitch, *Big Bungalow Suite IV*, 1992–93 306–7

THE FATE OF A GESTURE

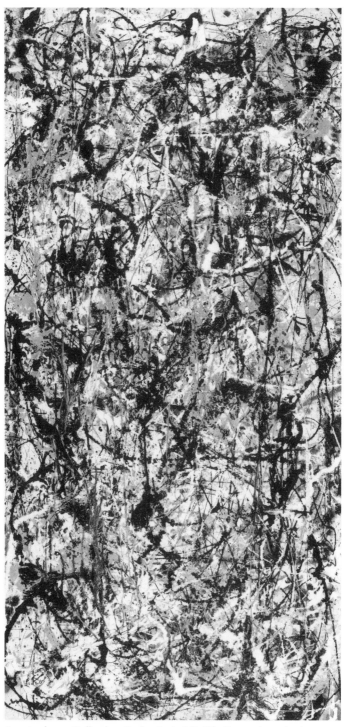

1. Jackson Pollock, *Cathedral*, 1947. Enamel and aluminum paint on canvas, 71 ½ × 35 in.

INTRODUCTION

With imperiously graceful gestures, Jackson Pollock flings pigments through the air. His technique is dramatic, it is astonishing, but it is not entirely original. Hoping to exploit the raw force of the unconscious, the Surrealists had poured and splashed their paints. There are dripped passages in certain canvases by Hans Hofmann, the European maestro who introduced a generation of New Yorkers to the traditions of the avant-garde. David Alfaro Siqueiros and Thomas Hart Benton are among those who dispensed with brushes before Pollock did. Their experiments are nearly forgotten. Pollock's paint-slinging is remembered because it generated a power that overwhelms understanding. Critics and historians describe him as a wrenchingly expressive artist, a major formal innovator, a brilliant stylist. Pollock was all that, as were others. What is unique about him has been elusive.

Surging to the edge of the canvas, sailing past it, Pollock's loops and swirls of color draw the imagination into a region of boundless space. Evoking a sense of limitless possibility, the best of his canvases gave us—for the first time—a pictorial equivalent to the American infinite that spreads through Walt Whitman's *Leaves of Grass*. Depicting neither landscape nor figure, Pollock pointed the way into a realm as vast as Whitman's, and his gesture made him one with it.

Pollock's friend Barnett Newman did something comparable by different means. So, on occasion, did Clyfford Still, another member of their generation. Yet these painters did not form a school. They founded no tradition. There can be no clear line of descent from artists who cultivated an ideal of absolute self-sufficiency. Often, it was the fate of Pollock's gesture to be remade by artists too independent to acknowledge any debt—Jasper Johns, for a preeminent example.

Frank Stella, color-field painters, Minimalists, earthworkers, Julian Schna-

bel—these and many other artists of the postwar era reinvented Pollock's gesture. Yet many did not. While Pollock played the hero at home in a zone with no boundaries, Willem de Kooning preserved the ideal of composition as harmonious enclosure. A hero of measure and balance, he was the counterforce to Pollock. This contrast resurfaced among the Pop artists.

From his obsession with glamour, Andy Warhol unfurled an image of America as boundless as Pollock's. Roy Lichtenstein does the opposite, arranging his bits and pieces of ordinary life in elegantly framed compositions. Thus he makes only a fleeting appearance in this book, as do other major figures, from Mark Rothko to Ellsworth Kelly and Alex Katz. For this is not a survey of postwar American art. *The Fate of a Gesture* concerns artists driven by the unreasonable belief that to be American is to inherit an infinite.

THE AMERICAN INFINITE

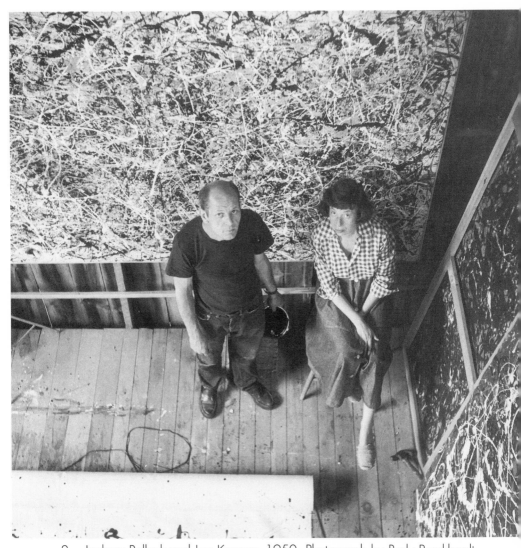

2. Jackson Pollock and Lee Krasner, 1950. Photograph by Rudy Burckhardt

1

One day early in June 1950, a photographer named Rudy Burckhardt rode in a car from Manhattan to Springs, a village at the eastern end of Long Island. There Jackson Pollock lived with his wife, Lee Krasner. The driver was Robert Goodnough, a young painter who wrote about his older colleagues for *Artnews*. At Springs, he would interview Pollock for an essay on his paint-slinging method; Burckhardt would take photographs of the painter in action. With the assignment came a ready-made title: "Pollock Paints a Picture." This was a variant on "Ben Shahn Paints a Picture," "Lipchitz Makes a Sculpture," and half a dozen others. The inventor of the formula was Thomas B. Hess, managing editor at *Artnews*.

"Tom wanted to show the progress of a painting," says Burckhardt. "So you'd go to the artist's studio and take a picture of a canvas at various stages. Hans Hofmann was delighted to paint in front of me and Elaine de Kooning." In "Hofmann Paints a Picture," she described a virtuoso performance by a seventy-year-old artist with a shock of thick white conductor's hair. Hofmann worked at "astonishing speed, never sitting down, constantly in motion between his palette and his easel, applying his paint with broad, lunging gestures." A teacher since 1915, he welcomed an audience and may have felt lonely without one. Onlookers made Pollock uneasy.

"He told me he couldn't paint in front of the camera," Burckhardt remembers. "But he was willing to pretend, so I took pictures of him making the gestures he would make when he actually painted." These are the large motions of a confident right arm. Burckhardt's photos register Pollock's muscularity and his knack for concentrating his attention. Crouching, stretching, thrusting, he never lets physical strength become mere force.

Burckhardt could record no gleam of pigment slithering from Pollock's brush, yet its absence isn't obvious. The artist's postures signal no falsity; though he's not painting, he is not acting. He is behaving and appears to be

at one with his behavior, like someone running not for form but to get somewhere quickly. Burckhardt also showed the artist squatting to stir a can of paint. The dome of his head is bald and his face is deeply creased. Its features have settled heavily, so you can't tell if he is frowning in thought or keeping his expression blank. Only thirty-eight years old, he looks as if a hard road has led him deep into middle age. Still, the arrangement of his limbs is lithe and nonchalant. He has preserved the physical vanity of youth.

Goodnough recalls that "Pollock's barn didn't make a very big studio. He had paintings tacked to the walls, and lying all over the floor. I went out to Springs a couple of times. Once there were three or four people around, and one of us stepped on a painting by mistake. Somebody said, 'Be careful.' Pollock said, 'What do you mean, be careful? So what if he steps on it?' It didn't bother him in the least." Pollock painted on heavy canvas duck. His works are not physically delicate, nor did he demand delicate behavior in their vicinity.

Some of his colors were traditional oils packaged in tubes. Others were commercial enamels sold by the gallon. Empty paint cans crowded the floor; some held his tools—sticks and hardened brushes. Mixed with this clutter were cardboard boxes, a few pieces of furniture, and a pair of old boots, all spattered with paint, like the patches of floor left uncovered when Pollock worked. Through the barn's slatted walls came wide beams of silvery light and, in winter, chilly drafts of ocean air. Pollock's property fronted on Fireplace Road. In back, the yard and a marshy verge led down to Accabonac Creek, which runs slowly for half a mile to Napeague Bay. On the harshest winter afternoons, he staved off the cold with a kerosene stove. This was a clumsy piece of equipment; paint fumes are flammable and the barn was made of tindery, weather-beaten wood. No mishap ever occurred, though Krasner, also a painter, fretted whenever he lit the stove.

Working with a brush in the usual way, Pollock had been clumsy. Now, as he flung his paints into the air, he became elegant. This is puzzling, though almost everyone remembers moments when a sudden cessation of doubt permits an utterly graceful gesture. Nonetheless, it's hard to imagine how Pollock could make gestures like that one after another, as the texture of a painting grew dense. In the best of the poured paintings, this density is airy and luminous, and the tangles of paint are splendidly legible. You can see how the texture weaves itself. Not every canvas was a success, yet Pollock wrote in 1947, "I have no fears about making changes, destroying the image, etc., because the painting has a life of its own. I try to let it come through. It is only when I lose contact with the painting that the result is a mess."

"Pollock said he liked to be in the painting when he worked," says Burck-

hardt. "He was submerged, in a way. To see everything he had done, he had to hang the canvas on the wall. Or if he wanted a quick look, he would leave it on the floor and get up on a ladder." By climbing Pollock's ladder, the photographer could see what the painter could not: artist and artwork entangled. In *Number 32, 1950*, the canvas Pollock pretended to paint for Burckhardt's camera, spidery strands of black enamel loop over a large field of white duck canvas. Shot from above in black and white, the poured pattern engulfs the arm that made it. Pollock's dark T-shirt is the largest of the blotches that gather filaments of paint into crossing points like synapses.

When Burckhardt was done taking pictures, Krasner invited him and Goodnough to stay the night. They accepted the offer. It was late in the afternoon; they were more than a hundred miles from Manhattan; and, anyway, Krasner's wish felt more like a command. Her charm resided in the force of her will. Pollock had let himself be seduced by it almost immediately. He doted on her strength, though he sometimes complained to friends, with childish cruelty, that she had a homely face. Mouth, chin, nose, eyes—each was large, and she could arrange them in an expression of iron hauteur. In command of art theory and art gossip, she knew how to survive and prevail in the impatient debates that had given the New York art world its ragged unity ever since the early days of the Depression. Acquainted with the scene's leading contenders, Krasner had counted as one of them.

Toward the end of 1941, a painter and occasional impresario named John Graham asked her to lend work to a show called American and French Paintings. The exhibition was to open the following January at the McMillen Gallery. Krasner was pleased. Her pictures would appear in the company of works by Old World masters: Pablo Picasso, Georges Braque, and Henri Matisse. Stuart Davis, Willem de Kooning, and the other American names on Graham's roster were less illustrious but just as familiar, save one: Jackson Pollock. Assuming that she "knew all the abstract artists in New York," she felt "simply furious because here was a name that I hadn't heard of." None of her close friends could tell her anything about him. Stubbornly digging, she learned that he lived on East Eighth Street, not far from her studio on Ninth. She found his building and, five flights up, knocked on his door. Hung over, Pollock let her in and showed her his work.

Then, in her repeated telling, came a moment of revelation: Krasner saw the light of Pollock's greatness. "To say that I flipped my lid would be an understatement," she said in one version of the tale. "I was totally bowled over." What she didn't say was that Pollock, not his pictures, impressed her. Only with the help of friends whose eyes she trusted did she learn to see promise in the rough, desperate pictures Pollock was painting. Later she convinced herself that her love for him and for his art had been identical

from the first dazzling instant. "I was terribly drawn to Jackson," she said in the late sixties. "I fell in love with him—physically, mentally—in every sense of the word. I had a conviction when I met Jackson that he had something important to say. When we began going together, my own work became irrelevant. *He* was the important thing. I couldn't do enough for him. He was not easy."

In truth, Pollock was nearly impossible, a brutal and infantile drunk. The point of moving from Eighth Street to Springs was to extract him from the swilling, brawling routines he had developed in downtown Manhattan. Of course he developed new ones in his new setting. Too poor to afford a car, he rode a secondhand bicycle to a restaurant called Jungle Pete's. After an excess of beer, he sometimes failed to find his way back to the house on Fireplace Road. Yet Pollock drank less in the country than in the city, and painted more. At the time of Burckhardt's visit, he had touched no alcohol for nearly two years.

"After dinner," the photographer recalls, "there was an evening to get through. Pollock was pleasant but he didn't talk much. He hardly said anything. Goodnough wasn't a big talker either, so things got a little boring. But Lee Krasner made it pleasant. In fact, she did all the talking and she was very gracious." It was more usual for her to be pugnacious, and Pollock's silences could have the sullen force of temper tantrums. That evening, Krasner behaved well and Pollock did the best he could. Their effort was strongly motivated; as Burckhardt says, "*Artnews* was a big deal in those days."

The art world had begun to honor Pollock. In return, he could muster only the most awkward civilities. The economy of his psyche encouraged no exchanges of any sort—courtesies, feelings, thoughts. Ordinary patterns of reciprocity baffled him, and the memory of his bafflement returns us to the small living room at Springs, where he and Krasner entertained the emissaries from *Artnews*. As the minutes inch by, Pollock tries to be pleasant and Krasner succeeds, her every word—her every lively inflection—driven by a sense of mission. They are an intense and dreary couple.

Though the aura of Pollock's importance was brightening in the summer of 1950, it still seemed patchy and thin. A year before, *Life* magazine had shown him standing before the eighteen-foot-long *Summertime: Number 9A, 1948* (1948). A headline asked: "Is He the Greatest Living Painter in the United States?" The article that followed left the question open. Illustrated by three color reproductions of poured paintings, *Life*'s report had the look —if not the tone—of an accolade. Pollock was delighted. True to the form of familiar, avant-garde legend, he had aroused the popular press. The time had come for the art magazines to announce his greatness. Over the past few seasons they had taken brief and sometimes respectful notice of his shows at

New York galleries, but there had been no prospect of a full-length essay, in *Artnews* least of all.

Now, with "Pollock Paints a Picture" in the works, he was being fitted to one of the art world's major formats. Krasner saw in Goodnough's article a necessity dictated by Pollock's importance. Yet editorial policy can be touched by caprice, sometimes at the last moment, as Krasner knew. She behaved nicely to Goodnough and Burckhardt in a chatty effort to prevent a cruel surprise. Writer and photographer counted only as the means to an end, yet we should hear no false notes in her cordiality. Because she truly believed that Pollock's career was a transcendently worthy cause, anything she did to serve it, no matter how calculated, blazed with a righteous sincerity.

2

Ashamed of his family background, Pollock glamorized it, mentioning often that he was born in Cody, Wyoming, in 1912. Maybe he liked the allusion to Buffalo Bill Cody, the founder of the town. At the Art Students League in Manhattan, he wore western boots and a cowboy hat, though he never rode herd on cattle. Few Westerners did. Most were farmers or laborers or pursued small-town lines of work. For a time, Jackson's father, Roy Pollock, hauled boulders in a horse-drawn wagon from riverbanks to a crushing plant.

Roy was born in 1877 to a couple named McCoy, who had migrated three years earlier from Ohio to a homestead in southwestern Iowa. When he was two, his mother died and his father gave him to James and Lizzie Pollock, the proprietors of a poor farm in the same corner of the state. Though they didn't adopt him formally until he was nineteen years old, Roy always went by his foster parents' name. Studious enough to graduate from high school at a time when most Iowans did not, he nonetheless lacked gumption. After a few haphazard attempts to escape the place of his birth, he drifted through half a decade of unambitious work, then married Stella McClure, the daughter of a mason in the nearby town of Tingley. Stella was a year older than Roy, and came from a more respectable family.

In those late Victorian times, pious and market-driven, the need to be good was indistinguishable from the hope of betterment. To become a proper sort of person—an upstanding American—you had to improve your lot in life, tangibly and otherwise. As much as money, you needed gentility. That Roy Pollock was incorrigibly countrified, a tobacco chewer who found dull contentment in slopping livestock, disappointed his wife more deeply than his failure to earn a good living.

Weakened by six years of hauling rocks, he took a job managing a sheep ranch. Four years later, the family doctor found he had rheumatic fever and recommended a warmer climate. He set out for California, with Stella and their five boys. Jackson, the youngest, was less than a year old. Not long after the family's arrival in San Diego, the unforeseeable—a freak blizzard—deflected Roy from his plan of raising citrus fruit. The Pollocks settled on a thirty-acre truck farm near Phoenix, Arizona. Jackson grew up as a farm boy, not a cowboy.

In photographs of the Arizona and California farmhouses where Pollock spent his childhood, you see at first a cluttered dreariness. Another look turns clutter into a Victorian plenitude of textures, patterns, and overwrought shapes. Stella Pollock plucked her notions of elegance from ladies' magazines and department-store catalogs. With her loud voice, abrupt manner, and strong hand with a team of horses went dreams of refinement. Entranced by a domestic ideal, she surrounded herself with furnishings as fancy as her husband's income would allow. No one now has her taste, though many still believe, as she did, that an ever more sophisticated sense of beauty must guide the acquisition of material things. When she was old and three of her five sons had become painters, Stella Pollock told a daughter-in-law that as a girl in Iowa she wanted to study art but never found the chance.

When Jackson was eight, his father bought a hotel in Janesville, a small town on the northern slopes of California's Sierra Nevada mountains. For half a year, Roy Pollock helped his wife run the establishment. Then, frustrated and restless, he joined a team of surveyors on its way through town. Though he never returned for good, his desertion was not complete. As Stella Pollock moved their five boys from town to farm to town, Roy occasionally visited or sent money. In 1928, after years of uncertain scrabbling in the Southwestern countryside, Stella Pollock settled the remnants of her household in Los Angeles. Two years earlier her eldest son, Charles, had gone to study with Thomas Hart Benton at the Art Students League in New York. Now sixteen years old, Jackson entered Manual Arts High School in Los Angeles as a sophomore.

There he found a substitute father of sorts in Frederick John de St. Vrain Schwankovsky, an art teacher with a mustache, a goatee, and flowing hair. His shoes were sandals and he wore a velvet jacket. Schwankovsky was a bohemian with a teacher's license who took seriously his mission of bringing aesthetic enlightenment to young men. Pollock learned from Schwankovsky an unfocused awe of art but no facility with a pencil. Writing to his brother

in New York, Pollock said his drawings were "rotten." They lacked "freedom and rhythem."

When Pollock was suspended from Manual Arts for distributing subversive broadsides, Schwankovsky arranged for him to keep attending art classes. The handouts had proclaimed that varsity letters should be awarded to artists and musicians, not football players. This theory drew Pollock into a scuffle with a gym teacher. He was suspended again, and again Schwankovsky intervened. His earliest drawings may indeed have been rotten. Still, some quality in them or their maker impressed Schwankovsky, who went far out of his way to encourage Pollock in the one hope for himself that he had ever expressed: to become "an Artist of some kind."

When Jackson came to Manhattan in September 1930, he moved in with his brother, who lived in a walk-up apartment on Union Square, just north of Fourteenth Street. At the Art Students League, he signed up for the course Charles had taken from Benton: Life Drawing, Painting, and Composition. Charles enjoyed that knack for likenesses which makes drawing instructors look better than they are. Because the flattery is unintentional, it is usually accepted, and Benton found it particularly gratifying. A pugnacious personality, constantly on the counterattack, he recruited allies when ever he could. Likable and talented Charles became a close friend of Benton and his wife, Rita, and a nearly always available baby-sitter for their young son, T.P.

After Charles left the Art Students League to scrape a living as a free-lance illustrator, Jackson took over his baby-sitting chores. He made a bit of money by posing for Benton's *America Today* (1930), a mural commissioned by the New School for Social Research on West Twelfth Street. Also, his teacher arranged for him to receive small grants from the Art Students League. In Benton, Jackson found a second substitute for his weak and absent father, this one wearing a jacket of sportsman's leather instead of bohemian velvet. Benton's wife saw in Jackson a fragile creature who needed mothering. Tending the four-year-old T.P., Pollock became an imaginary big brother. Helpful sometimes, he was more often underfoot. Yet the Bentons always welcomed him to their Hudson Street apartment, and he soon felt like an adopted member of the family.

Pollock was grateful, though the happiness of an invented kinship is always a carefully devised illusion. Rita's motherly warmth prompted in Pollock a violent and baffling infatuation. Benton was an unsatisfactory father figure. He didn't want a son so much as a sidekick, a young

and manipulable version of himself. The painter George McNeil, who attended the Art Students League in the early thirties, recalled the affinity between Pollock and Benton. "There was a rhythm, a flow, between them from the beginning to the end of their lives," he told Jeffrey Potter, whose biography of Pollock appeared in 1985. "It was a physical, gestural rhythm; teacher and student were *bonded*, you might say." In his western costume, Pollock played out a fantasy of youth and America. This was Benton's fantasy as much as his own.

Pollock stood two inches under six feet tall. Wide through the shoulders, with large hands and head, he was a hulking, uneasy presence. Often he could defeat his shyness only with belligerence, sneering at a bit of art jargon or echoing Benton's slurs against "wops," Jews, and homosexuals. Benton insisted on seeming tough. In boots and blue jeans, Pollock imitated him with ease. Struggling to draw in Benton's manner, he shamed himself. Faced with a task as simple as transferring an image to a sheet of tracing paper, Pollock could not make his pencil obey.

There is comfort in the belief that schooling is an orderly process of conveying knowledge from teacher to student. Historians have argued that Pollock must have learned something from Benton, maybe an idea about visual structure which guided him years later as he poured his colors onto canvas. This is not so. Beneath his eccentric surface, Benton was a thoroughly academic teacher. His students learned from him how to arrange their imagery in tight patterns of the kind Pollock flooded and swept away with his currents of paint. Nothing in Benton's pedagogy accounts for the billowing immensity of the poured paintings. Yet his reminiscences tell us much about his best-known student's eventual need to abandon traditional techniques.

Several years after Pollock's death in a car crash, Benton wrote that his student's talents had been "of a most minimal order." He displayed no grasp of the outlines, the volumes, the proportions of things; nonetheless, Benton added, Pollock "found their essential rhythms." Another time, he declared that "it was obvious from the very beginning that Pollock was a born artist. The only thing I taught him was how to drink a fifth a day." Pollock didn't learn even that from Benton. The biographies tell of him drinking heavily in his teenage years, out West. His brother Frank recalled that all the Pollock brothers were heavy drinkers; their straitlaced "mother had to know some of the time, but she didn't seem to have much influence on us, even if she had throttled my dad."

When Jackson arrived at the Art Students League, Prohibition was two years from repeal. In the school's cafeteria, he and a band of friends would pour drinks from bottles decorated with a bootlegger's gin label. In

the evenings, he visited a speakeasy on West Fifty-eighth Street, a block north of the school. A drink or two would numb his terrors and liberate his rage, turning him into a groper of women and an ineffective brawler. He could not resist the degrading fun of it, and from Benton he learned that his drunkenness was more than fun. It was a sign of manly strength.

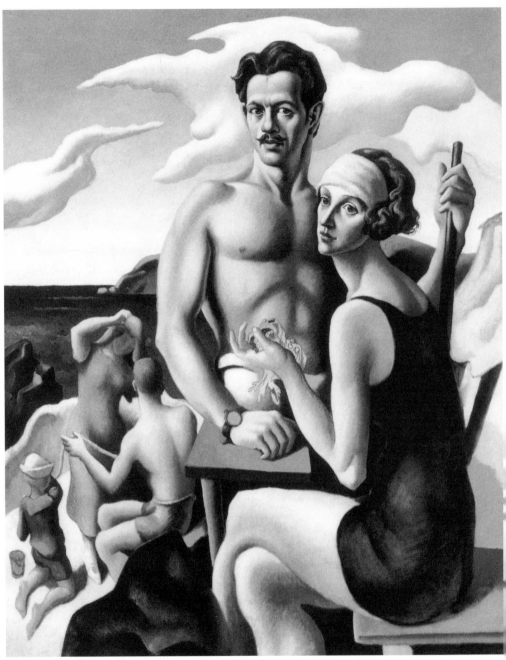

3. Thomas Hart Benton, *Self-Portrait with Rita*, 1922. Oil on canvas, 49½ ×
40 in.

3

Thomas Hart Benton was a short, slim man, with a weather-beaten face and a thick mustache. During waking hours he drank steadily but never enough to impair the performance of his self-appointed role: America's greatest painter. Benton's ability to hold his liquor was a metabolic quirk; he presented it as an admirable trait of character, a willed virtue. To drink like a manly man was to prove himself unfit for the world of art. Museums, he explained to interviewers, were sanctuaries for effeminate types too ready to dote on the fashionable obfuscations of avant-garde theory—especially the Parisian kind. Benton particularly needed to attack Paris. When he was nineteen, his well-to-do family sent him there to study art, and the city's avant-garde seduced him.

He was amazed and stirred by the paintings of Paul Cézanne. Neo-Impressionism, Expressionism, and Constructivism all insinuated themselves into his early work. Benton became sufficiently avant-garde to make a tentative alliance with the Synchromists, a splinter group of Cubists founded by two expatriate Americans, Morgan Russell and Stanton Macdonald-Wright. His Synchromist paintings showed promise, yet Benton chose not to be encouraged. Modernist freedom felt to him like a wallow in unwarranted license. After a short immersion in Parisian experiment, he fled, sputtering, convinced that the avant-garde was a decadent, alien force intent on ruining his American sense of the fitness of things. In 1924, six years after returning from his last trip abroad, he announced in a New York art magazine that it was time for "native painters to quit emulating our collectors by playing weathercock to European breezes."

Still, Benton never abandoned the ideas of form and structure he learned from the European avant-garde. This is an irony but not a subtle one. Benton tended to generate unsubtle ironies. He denounced effeminate curators so brutally, so repetitiously, and finally so hysterically that his sister told him he

was "protesting too much." Prodded by the fear that he might be homosexual, he played the militant homophobe; and as his attacks on museums and their personnel turned nastier, his reliance on museums and their contents grew more obvious. Benton's insistence on misunderstanding himself did little to cripple his output.

While working on *America Today* for the New School for Social Research, he launched and completed a smaller project, *The History of Water*. Commissioned by a drug company in Washington, D.C., this was a single large canvas on the theme of water's industrial uses over the centuries. Next came *The Arts of Life in America* (1932), a six-panel project for the library of the Whitney Museum of American Art, then lodged in four town houses on West Eighth Street. A month after finishing this cycle, he began *A Social History of Indiana* (1933) for the state's pavilion at the Chicago world's fair of 1933. It was to be fourteen feet high, 230 feet long, and finished in six months—a suitable project for an artist with a liking for the Midwest and a need to exhaust himself in marathon stints of hard work.

To prepare, Benton toured Indiana. Sketching as he went, he encouraged local people to tell him what they knew of the state's history and legends. The point of the routine was to give his art roots in American life. This, too, Pollock imitated. After his first year at the Art Students League, he and a

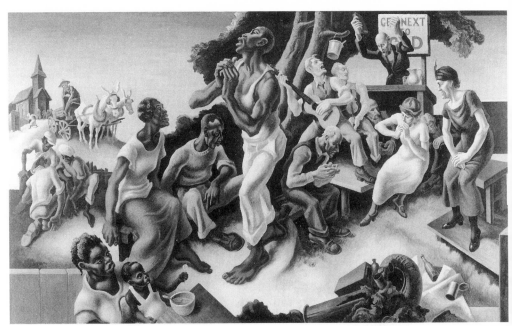

4. Thomas Hart Benton, *The Arts of Life in America: The Arts of the South*, 1932. Oil on canvas, 8 × 13 ft.

classmate, Michael Tolegian, hitchhiked from New York to Los Angeles. In a letter to Charles he reported that "the country began getting interesting in Kansas—the wheat was just beginning to turn and the farmers were making preparation for harvest. I saw the negroes playing poker, shooting craps and dancing along the Mississippi in St. Louis. The miners and prostitutes in Terre Haute gave swell color." He meant local color, a display of the picturesque. Pollock added that miners and prostitutes alike were "starving—working for a quarter—digging their graves." Pollock's background instructed him in racism and sentimentality; from Benton he learned how to convert them into a blustery patriotism.

Painting day in, day out, all day, with few breaks, often returning to work after dinner, Benton finished the twenty-six hundred square feet of *A Social History of Indiana* in sixty-three days. On average, he brought a four-by-ten-foot stretch of canvas to completion every day for over two months. This feat of stamina shows a fanatic certainty of purpose. Benton knew precisely what he wanted to paint; he knew even better his need for a hectic schedule. By keeping busy, he defeated introspection, and busyness triumphed in his murals too. With flashy juxtapositions of theme and fancy tricks of perspective, he just barely induces their overcrowded structures to cohere. The results look theatrical and rickety and, in their undeclared dependence on Europe, provincial.

Benton's murals borrowed structural ingenuity from Cubism and verve from El Greco's flamelike figures. Unable to deny that El Greco and his other master, Michelangelo, were European, he framed his theories to suggest that great art belongs to no time or place; it is transcendent, and the devices of greatness are at their best when they serve the militantly American themes of his murals. In Benton's compressed perspectives, each image is an element in a rebus spelling out a jingoistic speech about life in the United States. Elongated and twisted into extravagant poses, Benton's representative citizens make brittle gestures. Those who work are bent with toil and, having worked hard, they play hard—as cliché demands. When asked to expound on his devotion to America, he didn't so much praise this nation as sneer at all the others. This was a sour patriotism. The painter's father, Maecenas Eason Benton, was more generous.

Trained in the law, the elder Benton served four terms in Congress as a representative from southwestern Missouri. He was a Democrat, and small farmers were his constituency; his opponents were bankers and land speculators. This configuration of the political struggle was a legacy from his uncle, the first Thomas Hart Benton, a senator from Missouri. Sent to Washington in 1821, when his state joined the Union, he held that office until 1851, when his stand against slavery sent him to defeat.

Senator Benton was capable of extended ranting, on the Senate floor and in the newspapers. He was not above devious political maneuvers. Yet he had a large idea of America as a sanctuary of agrarian virtue, and he respected the American people—above all, the ones who returned him to Congress term after term. To praise them, even to flatter them, he needed only to call on feelings of genuine affection. Though his nephew, Maecenas E. Benton, felt a more remote concern for his constituents, he worked hard for them. Young Tom, the painter, saw himself as the inheritor of their responsibilities. His father and great-uncle had represented certain parties, certain regions, in Congress. He would represent the entire American people in paint.

To better their examples, Benton needed a national reputation. With dogged flair, he earned it. Each of his murals prompted an energetic response in the press. With his folksy mannerisms and evangelical devotion to the idea of an all-American aesthetic, he encouraged reporters to see him as a sort of Johnny Appleseed helping art to germinate throughout the country. Early in 1933 Pollock told his father, in a letter, that "Benton is beginning to be recognized as the foremost American painter today. He has lifted art from the stuffy studio into the world and happenings around him, which has a common meaning to the masses." In December 1934 *Time* magazine put a Benton self-portrait on its cover. Inside, it proclaimed him the leader of a small band of American painters whose plain styles and familiar themes had defeated the vogue for the "deliberately unintelligible" art of the modernists. In phrases echoing Benton's, *Time* announced the arrival of art made strong by American virtues. This was sheer boosterism. All that was generous in the earlier Bentons had shriveled in him.

He intended his murals to celebrate America as the nation's democratic ideals demanded, so it bewildered him to be called a right-winger. The best-aimed attack came from Stuart Davis, a leader of the New York avant-garde who tried, with his Americanized Cubism, to reconcile modernist aesthetics and leftist politics. "Any fascist or semi-fascist government" would have a use for Benton, wrote Davis in 1935. "His qualifications would be, in general, his social cynicism which allows him to depict social events without regard to their meaning." How, Benton wondered, could he be a fascist when for so long he had sympathized with Marxism? His illustrations appeared in a Marxist history of the United States, Leo Huberman's *We, the People* (1932); and he had borrowed the book's scheme of analysis in organizing *America Today*.

Benton did not claim to be a model Marxist. By the late twenties, the American Communist Party's habitual obedience to Moscow had begun to rub him the wrong way. Nothing in his temperament inclined him to accept the Stalinist dictate that artists depict workers as the happy, heroic citizens of a paradise in the making. Benton considered himself a realist of sorts; but

that, he indignantly argued, did not make him a fascist. What was he, then? Impressed by the cover story in *Time*, newspaper reporters gave Benton many opportunities to devise an answer to that question. For him, an interview was like a few rounds in the ring with a cooperative sparring partner.

His early moves always included an acknowledgment of the obvious: markets had collapsed in the Depression. Familiar institutions were helpless in solving the crisis, and American assumptions about rugged individualism were suspect. In the jargon of the times, there was the need for a collective solution. Collectivism in the Marxist mold was of course too rigid. Even Roosevelt's New Deal, admirably American as it was, had fostered ideological intransigence at the public art agencies. Hope, said Benton, thrives in the middle-western heart of the country. This region "has harbored the three important collective experiments in the United States (Rapp, Owen, Amana)." Moreover, its young, "radical" artists—Grant Wood, John Steuart Curry, Benton himself—have accepted "collectivist ideals" without sacrificing their independence. This is the Bentonite ideal: collectivism reconciled with the old-fashioned Jeffersonian democracy that encourages the autonomy of the individual. It is an impossible reconciliation.

The impossibility did not trouble Benton, for he had no genuine interest in politics. For him, communism, collectivism, and radicalism were hardly more than useful words: verbal counters in a game of polemics. When the occasion required, he would invoke the democratic ideals of his father and great-uncle, and of his great-uncle's presidential crony, Andrew Jackson. Never did he act on those ideals. Though not a fascist, Benton was far from a democrat. He was an America-Firster of the stubbornest sort. Fearing that he and everything American deserved the condescension of Europe, he often and loudly asserted that America was the best.

Benton protested too much about everything that troubled him, and his images of American superiority are unconvincing. With their Michelangelesque muscles, the white working men in his panoramas look like handsome dolts animated by habits of simple obedience; the women look blank and inconsequential, or sluttish if they're pretty. In Benton's America, intellectuals are New Yorkers with parodies of Semitic features and blacks play the roles of humble darkies who strum banjos when their cotton picking is done.

Signs of respect appear only in his pictures of men wearing suits and ties —corporate managers and political bosses—and here, too, cliché prevails. The bodies of these figures are heavy with authority. Their gestures are commanding, and the artist has stamped the face of each with one or two quickly read signs of character. Benton never paused over people's particularities. Even the figures he admired became pawns in his cranky game of dressing up his resentments and sending them into the world as a patriot's proud beliefs.

4

The jazz age brings to mind flappers and sporty roadsters. Then comes the Great Depression, with its breadlines and shantytowns crowded by men without jobs. These are newsreel images, grimly intelligible but weightless until we imagine the shock of sudden, massive economic disaster in a nation that understood its prosperity as a benefice ordained by history in concert with nature. Not every member of the middle class descended into poverty. Those who did carried with them a burden of fear and humiliation they never expected to bear. They found out what it was to be unwanted.

After standing on the margins for so long, avant-garde artists weren't shocked by the Depression, only further wounded. Some were disinclined to feel the pain of it fully. The sculptor David Smith told Thomas B. Hess that "parties were never as wonderful as in the 1930s, when everyone chipped in for whiskey and all the girls were beautiful." When the ordinary intruded— when it was time to pay rent or buy groceries or simply walk through streets filled with derelict people—the avant-gardists let their aesthetics arrange their points of view.

Their views were leftist, for in the thirties innovative art appeared to be the refined cousin of revolutionary politics. Members of the avant-garde attended union rallies; some marched in picket lines. The painter William Baziotes remembered strikers charged by mounted police on Eighth Avenue near the main post office, with no defense but marbles to roll beneath the horses' hooves. He was close enough to watch this expedient in action and to see precisely how it failed. Not so easily upended, the horses advanced as planned. In that reminiscence you feel the Depression's desperation turning into panic. Mostly, the artists of that time recall the art they made and how it led to later triumphs; or they talk of quiet stratagems that kept them housed and clothed and sometimes adequately fed.

"You learned to eat practically nothing so that you could buy a tube of

paint," said an artist named Burgoyne Diller. Always there was an eye out for the odd job or the opportunity to barter. "The artist," Diller added, "was probably the most self-reliant, self-sufficient individual in the city of New York. You had some of your top management people standing on a corner selling apples, but . . . the artist had so many accomplishments, craft accomplishments and related things, that he somehow or other survived." Diller had enrolled at the Art Students League before the 1929 crash; afterward, he earned his meals by painting restaurant placards.

Certified as an art teacher by City College, Lee Krasner decided to make art, not teach it. This was a courageous choice in 1933. To support herself, she decorated china and hats; in silk pajamas, she waited on tables at a Greenwich Village restaurant. The painter Mark Rothko taught art to children part-time at the Brooklyn Jewish Center, and his first wife, Edith Sachar Rothko, made costume jewelry. They had a small apartment on the Upper West Side of Manhattan. Downtown, artists lived in the cold-water flats of Greenwich Village; in neighborhoods to the east and north, they took up illegal residence in loft buildings zoned for light industry.

Some city inspectors were lackadaisical; others were bribable nuisances. When the thumping on the door began, pots, dishes, and whatever the artist used for a stove had to disappear. It helped if the bed could become a sofa. Jumpers—gadgets that bypassed electric meters—were disconnected. If the loft looked sufficiently unlived-in when the door was opened, the inspector would go away. If not, he would receive the handful of nickels and dimes set aside for the occasion. The usual sum was two dollars—roughly ten percent of a month's rent on an East Tenth Street loft.

Leading invisible lives, making works of art that went unseen, the artists channeled some of their fervor into loud public demands. They formed the Artists' Union and picketed City Hall, agitating for a gallery open to all applicants. They claimed to be unemployed, therefore deserving relief payments. Long afterward, the critic Harold Rosenberg remarked on the oddity of presenting oneself as an out-of-work artist. To paint or sculpt was not to hold down a job. Artists could not be dismissed like surplus factory hands. Pretending otherwise, they assumed the stances—and shouted the slogans—of an oppressed proletariat. "We want bread," cried John Graham, as he marched in a May Day parade, his gesticulating hands clad in chamois gloves. At another march, Rosenberg saw a writer carrying a sign that read "WE WANT BON-VIVANT JOBS."

These events were sometimes giddy at the edges, for artists and writers broke a taboo when they sacrificed their independence to a collective effort. Avant-gardists "can be as ruggedly individualistic as any creatures in the United States," said Diller. Awkwardly, they improvised allegiances, prompted by "one very simple, basic thing. They needed to eat." Union tactics

mustered a "power which each individual artist could not exercise. . . . It was something just building up, something that hadn't reached any kind of maturity in its demand, but still the demand was there, and it was vocal." To meet this demand, the Roosevelt administration jerry-built a series of art agencies. These departments of government appeared, evolved, split, and merged at high speed. The most important for painters was the Federal Arts Project, a branch of the Works Progress Administration—the Project, for short. It rested on the premise, sincerely believed by major figures in Washington, that art is a good thing.

When the Department of the Treasury became a patron of post-office murals, an assistant secretary told the press that "encouragement of the fine arts has always been recognized as one of the functions of the Federal Government." Traditionally, the federal government had been indifferent to the fine arts, and supported them now for reasons less aesthetic than therapeutic. "In times of depression," the assistant secretary went on to say, "the work of artists and craftsmen greatly aids everyone by preserving and increasing our capacity for enjoyment." Art is a good thing because it is good for morale; also, it provides an opportunity for proper politics. Franklin Roosevelt commended the Treasury Section of Fine Arts for drafting equitable regulations "in keeping with our highest democratic ideals." He and his advisers may have feared, also, that idle artists would turn radical sentiment into hard principles of revolutionary action.

When the Artists' Union had no point of its own to make, it sometimes joined forces with other unions. Joseph Solman, a social-realist painter, said later that "if the salesgirls went out on strike at Macy's department store in Brooklyn, a grouping from" the Artists' Union and the National Maritime Union "was bound to swell the picket line." When artists picketed, "a truckload of NMU workers would appear and jump out onto the sidewalk to join our procession. Cheers welled up from all sides. Those were spirited times indeed." Government stipends led the artists' high spirits back to the studio.

A clerk at Woolworth's lived on about thirty-two dollars a month in the mid-thirties. Receiving three times as much, artists on the Federal Arts Project had an income approaching the national median. With that, said Willem de Kooning, "one could live modestly and nicely." The Project allowed him to set aside carpentry, window trimming, and house painting to focus on painting as high art. Meeting "all kinds of other painters and sculptors and writers and poets and architects, all in the same boat," he learned a standard of seriousness. The FAP enrolled him in its mural division in 1935. A year later, an administrator discovered that de Kooning was not an American citizen and threw him off the Project.

Forced again to support himself with odd jobs, he accepted as few as possible. Rudy Burckhardt tells of a department store in Philadelphia offering

de Kooning a job as a full-time window dresser. "This was around 1936, maybe a little later," says Burckhardt. "The pay was $150 a week, which was very good then, but he turned it down because he didn't want to move to Philadelphia. He wanted to stay in New York and be a painter, which meant that he was very poor."

All the avant-gardists were poor, despite de Kooning's talk of living "modestly and nicely" on a stipend from the Project. During the war years, Baziotes sometimes indulged himself in the ambiguous luxury of recalling the hardships imposed by that meager and occasionally delayed sum. With skipped meals went a reluctance to flip electric light switches; in winter, artists often sacrificed heat. Baziotes's wife, Ethel, later recalled that his time on the WPA so damaged him physically that afterward he could paint only a few hours a day. Yet he refused to play the invalid's part. Jimmy Ernst, a painter and the son of the Surrealist Max Ernst, described Baziotes as a Bogart-like figure in a fedora and a dark overcoat.

Harold Rosenberg said the Depression forced New York artists to make a "personal code" of "ascetic discipline." From the rigor of their aesthetics they evolved an ethic of the hard life, and with this ethic they protected their art from their frailties. Burckhardt remembers a time in the thirties "when de Kooning was very upset about something. I suggested that he have a drink to calm down. He wouldn't. He refused to drink in those days. When he was upset, he would walk around all night." De Kooning was fidgety and stubborn. In a memoir of the thirties, the poet and dance critic Edwin Denby said, "I often heard him say that he was beating his brains out about connecting a figure and a background."

After a desperate stint in the studio, there would be another restless walk through the streets. Afterward, Denby recalled, de Kooning would talk with his friends "about scale in New York, and about the difference of instinctive scale in signs, painted color, clothes, gestures, everyday expressions between Europe and America. We were happy to be in a city the beauty of which was unknown, uncozy, and not small scale." Denby, de Kooning, and Burckhardt wanted to throw light on all that is thoughtlessly grand about Manhattan. Their art would give their reasons for loving a city that, despite its sophistication, had next to no idea of their struggles. Because their refined taste put them in danger of starving, it felt to them like personal courage.

In a poem called "The Climate," Denby notes the light flashing from a "worn-down cafeteria fork." In that instant, an ordinary object looks like an emblem of the way artists and poets lived then. Denby's cafeteria fork is a proud, even a prideful, emblem. Assuming heroic postures, these New Yorkers endowed themselves with resilient surfaces. As they endured and were overlooked, they would not complain, though they talked incessantly. It was

nearly all the entertainment they had. "Maybe the talking had something to do with coffee," says Burckhardt. "Everybody drank coffee then, at the cafeterias. The main one was the Waldorf, at the corner of Eighth Street and Sixth Avenue. You could eat there, fairly cheaply, or just get a cup of coffee and sit at a table for as long as you wanted."

During "the years of hanging around," as Rosenberg called them, the artists gossiped. They complained about the Project's regulations or sniped at each other's aesthetics. From aesthetics they drifted—or leapt—to politics. Social realists talked about painting pictures "of the people and for the people." They would sneer at avant-gardists in "ivory towers." Lee Krasner helped organize protests by the Artists' Union and sometimes she picketed with other unions. She accepted the idea, as pervasive as hunger in the days of the Depression, that misery is capitalism's leading product. To sympathize with that misery was to stand on the left; to be a serious painter, she stood apart. Looking back on the thirties, Krasner told the art historian Barbara Rose: "I, for one, didn't feel my art had to reflect my political point of view. I didn't feel like I was purifying the world at all. No, I was just going about my business and my business seemed to be in the direction of abstraction." The trouble was that only a few friends cared whether she succeeded.

Krasner and her colleagues read *Cahiers d'art*, the Parisian avant-garde's journal of record. They visited shows at the Museum of Modern Art, and whenever the work of a European avant-gardist appeared in the galleries of a Fifty-seventh Street dealer, they appeared on the premises, modestly dressed and obviously intending to buy nothing. They were looking for signs pointing to the high road of aesthetic advance. If none appeared, they would settle for cues to further conversation at the tables of cheap, overlit cafeterias. Refusing to let this talk subside, the avant-garde New Yorkers preserved the illusion that they were not thoroughly inconsequential. They were not, on the island of Manhattan, utterly insular.

5

The Museum of Modern Art opened in 1929. Seven years later, the museum's first director, Alfred H. Barr, Jr., put the institution's principles on display in an exhibition called Cubism and Abstract Art. The show was a gathering of work by more than one hundred artists, designers, architects, and photographers. There were paintings by modernist heavyweights—Paul Cézanne, Pablo Picasso, Piet Mondrian. There was a rug by a modernist lightweight named Jean Lurcat, a model of Le Corbusier's Savoye House, a poster by the commercial artist A. M. Cassandre, a lamp by the visionary architect Frederick Kiesler.

Barr complemented Picasso's Cubism with a small selection of "African Negro sculpture." The show also included an etching of a prison vault by the eighteenth-century Italian Giambattista Piranesi. With this image, said the director, Piranesi "anticipated Cubist-Constructivist esthetics." Amid the Old World plenitude was work by two Americans: Alexander Calder and Man Ray, expatriates who counted for Barr as honorary Europeans. New York was the site of the Museum of Modern Art, yet the city's artists did not appear in this exhibition.

A curator's choices cannot be right. They can only be coherent and, in their coherence, persuasive. The coherence of Cubism and Abstract Art was dazzling. Barr's associate Dorothy Miller said that he needed almost no time to select works for this exhibition: "Alfred had it all in his head." In the museum, the show occupied four floors of gallery space. Barr's concept of modern art and its major developments was monumental. On firm foundations, this quietly imperious scholar had raised a solid and only slightly fussy edifice of historical argument. Schematized, his thesis generated the diagram of avant-garde genealogy that spread across the cover of the exhibition's catalog. Though it is six decades old, this chart still guides the Modern's presentation of its holdings. Barr's chart had no room for New York artists.

Recalling the thirties, Krasner said, "There was little support and few rewards. I felt like I was climbing a mountain made of porcelain." All the artists she took seriously were scrambling on the same inhospitable slope. They looked at art, they read and talked about it. To relieve the solitude of the studio, they attended classes at the Art Students League or the Metropolitan Museum. In 1938 the painter Amédée Ozenfant, a veteran of the Parisian avant-garde, immigrated to New York and dispensed instruction in a midtown atelier. Preferring the Hans Hofmann School of Fine Arts in Greenwich Village, Lee Krasner studied there for three seasons.

Born in Germany in 1880, Hofmann had come to Paris at the age of twenty-three. Picasso was still in his Blue Period. When Hofmann returned to his native Munich in 1914, Fauvism had flourished and died, and Cubism was entering its maturity. Kept in Munich by the outbreak of war, he opened an art school and gave his students the benefit of his immersion in the conversations about style conducted by the Parisian avant-garde. Hofmann had met Picasso and Braque, and among his friends was the Cubist Robert Delaunay. He had attended drawing classes at the Ecole de la Grande Chaumière with Henri Matisse, who liked to explain to his fellow students the workings of color in the paintings of Cézanne. Hofmann felt that he had begun his career as a participant in history.

Invitations to teach brought him to California in 1931; within a year, the Nazis' increasing power persuaded him to abandon Germany for the New World. After stints of teaching in Los Angeles, Berkeley, and ·Gloucester, Massachusetts, Hofmann settled in New York and founded his school, which served as a platform for an immense apparatus of theory. The American art world has generated only one distinctive critical method, which goes by the name of Greenbergian formalism. Its inventor, Clement Greenberg, has acknowledged his debt to Hofmann's doctrine that a painted image should acknowledge the conditions of its existence: the flatness of the canvas, the straightness of its edges, the squareness of its corners. Hofmann gave New York painters a way to think coherently about their work.

To illustrate his principles, Hofmann would amend a student's drawing with his stick of charcoal, or he'd tear it up and rearrange its fragments to reveal the structure it should have had. His students were worthy of his efforts, but to outsiders he would offer "no explanations." An avant-gardist's task is to preserve the faith that "some day the Philistines will see!" For only habit and mild caution hide serious art from uninitiated eyes. These veils must fall of their own meager weight. When they do, serious art in all its integrity, its universality, will be there to meet the gaze. And no serious artist will be considered provincial.

At Hofmann's school, one faction blended his teachings with Wassily Kan-

dinsky's doctrines of transcendent symbol and spontaneous expression. They were the Romantic Hofmannites. The neoclassical faction favored the severe lucidity of Mondrian's straight lines and right angles. This was Krasner's group, a clique of geometers. By the end of the thirties, she considered herself a seasoned apprentice. Her pictures declared her allegiance to the principles Hofmann had distilled from his seasons in Paris. These principles are too general to produce an individual style. Krasner knew that. At the Hofmann school, she was fortifying the talent that, given free rein, would establish her singularity. When she met Pollock, the moment was near.

In him, she found something rare in the New York avant-garde: a painter who could talk only hesitatingly about art. Pollock read the art magazines now and then; he attended museum and gallery shows. He knew the modernist styles and had managed to vex his art with their complexities. Never, though, did he solve the small stylistic problems he set for himself, and he didn't know there was a large one; he had not faced the provinciality problem. Thomas Hart Benton taught that a proper style is what an artist's true nature prompts him to assert single-mindedly, the way a good American asserts his patriotism. Pollock left the Art Students League with nothing but a few Bentonite habits and no knack for developing his avant-garde reflexes. As innovations arrived from abroad, as they clashed and evolved and local styles emerged, he couldn't follow the action. During the thirties Pollock was lost, adrift in the present as others found ways into the future.

In the spring of 1933, he took his last class at the Art Students League and the school stopped its grants of money. Still feeling fatherly—or big-brotherly—Benton invited him to spend the summer with his family at their cottage on Martha's Vineyard. Jackson returned the next summer and the next. With his helplessness, he commandeered help. Late in 1934 Benton steered him to a janitor's job at a private elementary school in Greenwich Village. Pollock's brother Sanford arrived in town soon afterward. Finding no job for himself, he helped Jackson with his. Though the pay was laughable, their expenses were low. The brothers lived rent-free on the top floor of an abandoned, unheated building at 76 West Houston Street. Jackson earned bits of money doing household chores invented by Rita Benton. He helped her hang shows of young artists' work in the basement of the Feragil, her husband's gallery, and occasionally tended the shop. This was not a job so much as a way to keep busy at the edge of destitution.

Inevitably, Pollock and his brother went on relief. Still working as janitors, they now received two incomes, both minuscule. There was always enough to eat, though Pollock's myth has them stealing food and fuel from pushcarts in the killing winter of 1935. The Pollock boys made of the Depression a dreary and hectic carnival. If they stole in the streets, they were driven less

by hunger than by a mean sort of naughtiness. Sanford's worst tribulation was Jackson's alcoholism.

Silently, the Pollock family had allotted him the task of keeper. Without complaint, he accepted it, compelled by his brother's anguish and the chance to join in his staggering rampages. The painter Peter Busa remembers a party where Sanford climbed onto Jackson's shoulders and "started hitting people all over the room." This was horseplay only a few degrees more violent than usual on the rowdier fringes of New York bohemia. Sanford could stop himself at that point; Jackson could not. As his long, drunken nights ended, he became a stumbler down stairwells and a roller in gutters, literally.

Early in 1935 a city agency called the Emergency Relief Bureau assigned Pollock the task of cleaning the Firemen's Memorial, a bronze and marble leviathan at 100th Street and Riverside Drive. There was other statuary to scrub—George Washington on a horse in Union Square and, near Astor Place, a seated Peter Cooper. After a few months, the bureau demoted him and his pay fell from $1.75 to eighty-five cents an hour. No help came from the Bentons, who now considered themselves poor by the most forgiving art-world standard. Housed, fed, and miserable, Pollock endured until August, when he joined Sanford in the mural division of the Federal Arts Project.

A Benton protégé named Job Goodman chose Jackson as an assistant and kept him busy on a mural called *The Spirit of Western Civilization*. Goodman was determined to complete this large painting and he did, then he oversaw its installation in an outer-borough high school. Many FAP murals went uninstalled. More were never executed. The mural division was a sanctuary of elevated intentions and deflected energies. Yet there were enclaves of efficiency, and Pollock had been drafted into one of them. Feeling overworked for half a year, he switched to the easel division, which required painters to produce just one twenty-four-by-thirty-inch canvas every month for the approval of a local supervisor.

Now that federal bureaucrats formed the chief audience for contemporary art in America, the director of the Project, Holger Cahill, fretted about standards of taste. As he said, quality is "a very hard thing to pin down." Never confident enough to work up a set of critical criteria, the FAP defaulted, enrolling nearly everyone who claimed to be an artist. "It didn't matter," Harold Rosenberg recalled, "if you were a portrait painter or you painted bears in a shooting gallery on Coney Island." Supervisors were free to impose their own tastes—narrow or fickle or both. Even accomplished artists couldn't be sure, from month to month, that their offerings would be accepted. Like an underachieving child, Pollock was sometimes told to give a canvas a bit more work; now and then, his supervisors flatly rejected his submissions. The prospect of sparring with these functionaries drove him to blandness.

Few of his FAP pictures survive. One shows field hands bending over

cotton plants, their bodies strained in the manner taught by Benton. Alert for a transferred jolt of the teacher's energy, you feel nothing. *Cotton Pickers* (c. 1935) is a dismal picture, the product of dispirited compliance. Pollock resented the easel division for extracting efforts like this one, and he feared its power to turn away his livelier work. Stymied, defiant of deadlines, he would have been dismissed from the Project without the help of Burgoyne Diller, who had become a supervisor in the New York office.

A disciple of Mondrian, Diller was a utopian internationalist with no sympathy for Thomas Hart Benton's Americanism. Still, he refused to blame Benton's students for their teacher's unsavory attitudes. Now and then he had done what he could to shield Pollock from the Project's routines. Toward the end of the thirties, Diller was visited by the painter Philip Guston, who had been Pollock's classmate at Manual Arts High School in Los Angeles. When Pollock distributed pro-art, anti-football broadsides, Guston collaborated, and they were expelled together. Now Guston made himself as much a friend as the other's torment allowed. At the Project office, he told Diller that Pollock had "shut himself up" in his East Eighth Street studio and was "drinking too damn much," convinced he had strayed unforgivably far from the middle of the FAP road. Though a deadline had just passed, he refused to submit work. Maybe, Guston said, he would listen to reassurances from a Project official. Diller agreed to visit Pollock in his studio.

There he was astonished. Pollock's pictures showed that "he had been going through a terrific psychological thing. You could see it was just a turning upside-down of what he had been doing. He was attacking these canvases with a vehemence that freed him in a way. They had terrific impact." Singling out the least agitated ones, Diller told Pollock to bring them to the Project the next day. He did, and the pictures were approved. Rejection would have cost Pollock his stipend. This possibility gave him reason to be wary of the Project supervisors. It was not enough to plummet him into panic. What terrified Pollock was his evolution, as it took him step by uncertain step beyond the reach—and the support—of Benton's authority.

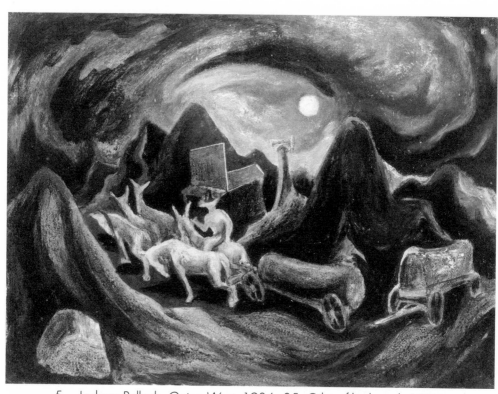

5. Jackson Pollock, *Going West*, 1934–35. Oil on fiberboard, 15⅛ × 20¾ in.

6

In his crackpot certainty about art and life, Benton thought he was fit to lead. Pollock wanted to follow, or believed he did. Yet he was unfit to be led, for he didn't know how to get the gist of another's example—not even Benton's—though his teacher did convince him that art could be a manly, not a sissified, pursuit. Paintings could be broad-shouldered and American; they could be Bentonesque. The workers and farmers in Benton's pictures are sinewy, like him, and their poses stretch their muscles taut. Built from intricate adjustments of form to space, his compositions feel clenched—an effect Pollock could never achieve.

Pollock's *Cotton Pickers* is merely slack. Stronger works like *Landscape with Rider* (1933) and *Going West* (1934–35) show traces of Benton's pedagogy— American themes, a brownish palette, shapes traceable to El Greco—and you sense Pollock's efforts to force these pictures to tighten up, to become trim Bentonesque bits of pictorial machinery. Failing, they swirl and pulse. They slip away from the eye. Also, they lack Benton's fussiness about detail. The people and beasts in *Going West* are smooth and tentative, as if their shapes could easily shift. The Bentonisms of Pollock's art are approximate. Those of his life were precise. The role of Benton's sidekick supplied him with attitudes and a costume, but gave no thrust—no torque—to his ambition. His first attempt to escape his teacher's influence was thoroughly studentlike. He mimicked Albert P. Ryder, an American painter famous at the turn of the century and the object of Benton's dogmatic praise.

Ryder was a visionary inclined toward themes like *The Temple of the Mind* and *Macbeth and the Witches*. In *The Race Track*, the figure of death rides a pale horse and clutches a scythe. Fraught with large and vague significance, Ryder's forms loom through a dusk that feels like melancholy made visible. In his pictures of moonlit nights at sea, waves and rushing clouds impose their shapes on solitary ships. These vessels persevere in their loneliness, and

sometimes lend their forms to the elements trying to engulf them. Each ship makes its distress the dramatic focus of unbounded immensities. When he turned from Benton to Ryder, Pollock chose to imitate the nocturnes, not the literary pictures.

Laboring to be original, he pictured a daytime setting in *T.P.'s Boat in Menemsha Pond*, a Ryderesque exercise from the mid-thirties. The colors are garish and the boat looks not lost but incidental. Though Pollock mismanaged each cue he took from Ryder, this picture is not just a botch. Every painting has what might be called muscle tone, a quality transferred to the image by the hand's idiosyncrasies. Benton's images look like the work of a hand made strong by hard, driven labor. The smooth density of Ryder's paint suggests that his strength was serene; no matter how eccentric, the shapes in his seascapes are elegant; they flow one from another. Pollock could not mimic that ease. In *T.P.'s Boat in Menemsha Pond*, the blunt curves of seashore and clouds gesture and grimace, straining for rhythm. They never find it, yet this image is not merely awkward. It has an odd force, as of baffled muscularity.

———

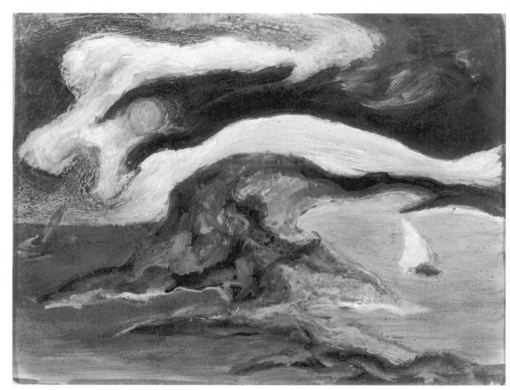

6. Jackson Pollock, *T.P.'s Boat in Menemsha Pond*, c. 1934. Oil on metal panel, 4⅝ × 6⅜ in.

Looking for a new model, Pollock turned from Ryder to the Mexican mu-
ralist David Alfaro Siqueiros. Appalled by the abysmal drift of European
politics, the New York avant-garde founded the American Artists Congress
as a platform for anti-fascist manifestos. At the first session of the congress,
held early in 1936, Siqueiros represented Mexico. With the proceedings ended,
he gathered a crew of young artists around him in a Union Square studio.
The mission was to execute in chicken wire and papier-mâché his design for
a May Day float—a confrontation between a Wall Street capitalist and a
towering hammer and sickle. Sanford Pollock had studied with Siqueiros in
Los Angeles. Now he joined this communal project and recruited Jackson,
who worked hard. Jackson was drawn to Siqueiros's aggressive energy, as he
had been drawn to Benton's. It gave him the illusion of a direction. Also, he
liked his new leader's devotion to new materials. In modern times you need
modern paints, said Siqueiros. His favorite was Duco, a lacquer designed for
automobiles. In solidarity with assembly-line workers, Siqueiros applied it
with a spray gun. He also dripped, poured, and splashed his colors. Pollock
took note, though he continued to work with pencil and brush.

Besides Siqueiros, the leading Mexican muralists were Diego Rivera and
José Clemente Orozco. These painters worked in the genre of history paint-
ing: the large, heavily populated composition with an elevated theme. Si-
queiros and the others joined their country's indigenous myths to Christian
images of crucifixion and resurrection. Adapting their mixtures of style and
theme to the needs of radical prophecy, these painters told of cruel landlords
and martyred peasants, greedy tycoons and the struggle between nature and
mechanization.

After staggering under the force of Siqueiros's grim bombast, Pollock no-
ticed the morbidity of Orozco. Responding with something like glee, he sub-
jected this muralist's skeletal motifs to hysterical repetitions. Though Orozco
talked chiefly of political revolution, he invented a new public style. Here
was his true success. Pollock didn't know what to make of it. From the bare
ribs and shinbones of Orozco's cruelest images, Pollock generated uneasy
patterns with only tenuous connections to any style, radical or conservative.

In 1935 Thomas Hart Benton had received two inducements to leave New
York: a commission to supply the Jefferson City, Missouri, state house with
a mural and the offer of a teaching job at the Kansas City Art Institute. He
accepted both. New York, he informed a reporter from *The Sun*, had "lost
its dynamic quality." As usual, Benton and his family spent their summers
on Martha's Vineyard. Pollock still joined them there, and he spent Christmas
1937 with the Bentons in Kansas City. On the way back to New York, he
stopped in Detroit to visit his brother Charles, who had found a job drawing
cartoons for a union newspaper.

Pollock lingered so long that he used up his leaves of absence from the Project. A sketching trip with Benton, planned for the following summer, would now be impossible. Enraged, he launched himself on a binge; two weeks later the Project dismissed him from its rolls. Helped by a psychiatrist named Helen Marot, Sanford Pollock arranged for Jackson to be admitted to the White Plains branch of New York Hospital. After three months, the hospital released him uncured. Pollock was an exemplar of incorrigibility. Early in 1939, he became a patient of a psychiatrist named Joseph L. Henderson, whose idea of therapy was to give detailed Jungian interpretations of the drawings Pollock brought to his sessions. Henderson did nothing about the artist's helpless drinking.

Re-enrolled on the Project, Pollock subsisted, suffering only his familiar grinding difficulties, until the war prompted his draft board to seek him out. In a panic, he persuaded Dr. Henderson's successor, Violet de Laszlo, to tell the board that he was unfit for military service. Pollock, she wrote, "finds it difficult to form or maintain any kind of relationship." Though Dr. de Laszlo was reluctant to call him a schizophrenic, she noted "a certain schizoid disposition" underlying his "emotional instability." Pollock's board classified him 4-F. He was less ashamed by the label than frightened by the army's promise of discipline. The mildest regimentation could unhinge him.

At the City and Country School in Greenwich Village, he had managed the routine of janitoring only with his brother's help. Sanford could ply Jackson's mop, but no one could lend him the competence he lacked. Pollock sought a state of swaddled suspension, an oblivion insulating him from even the gentlest, most oblique demands. Only sleep or a drunken coma gave him sufficient protection. Krasner remembered him staying in bed for "twelve, fourteen hours . . . around the clock. We'd always talk about his insane guilt about sleeping late." If no crisis erupted, he would get to work sometime in the afternoon.

Only by the usual measures was Pollock slothful. His labors of imagination were immense, though dazed by frustration. *The Flame*, painted toward the end of the thirties, is a pattern of red, black, and white. Desperately overworked, these colors spread across the canvas in a tarry crust. Here, flame does not gracefully flicker. It is awkward and dense and gives off a violent light. All the pictures he painted for himself—not for FAP supervisors— seethe with panicky energy. Whatever he saw in Pollock's studio, Burgoyne Diller was right to take it for a sign that its maker had been weathering a "terrific" storm of the psyche.

Pollock had a seismic hand, the kind that registers cataclysms of need and fear. That was not enough for him. He wanted the hand of a great artist. Impressed by an image, he would try to capture its power by impersonating its maker. This was not the calm mimicry that earns a young artist a place

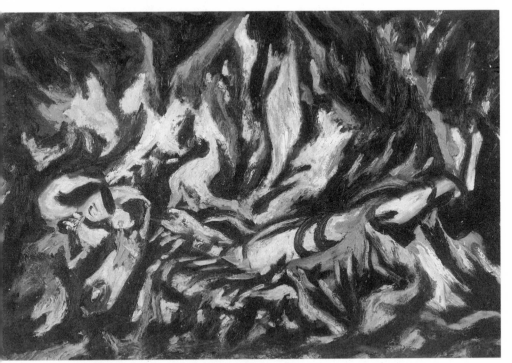

7. Jackson Pollock, *Flame*, c. 1934–38. Oil on canvas mounted on composition board, 20½ × 30 in.

in a master's following. It was an attempt to become the other artist. He failed because he felt no empathetic impulses. Pollock's way of being himself was so chaotic that he could not imagine what it was to be another person. Whatever his model, he lumbered around it with excruciating awkwardness. The failures of his early struggles are difficult to see; we lose them now in the glamour blazing from his major work.

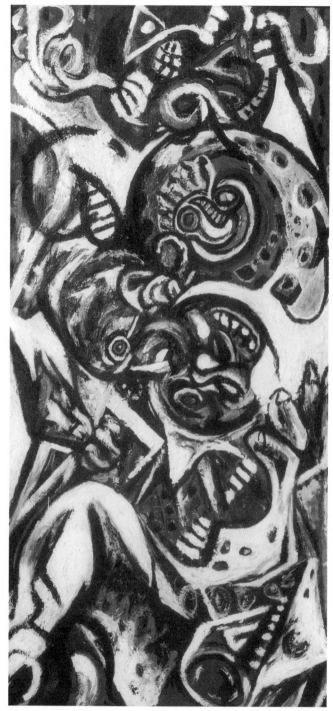

8. Jackson Pollock, *Birth*, c. 1938–41. Oil on canvas mounted on plywood, 46 × 21¾ in.

7

In April 1937 the *Magazine of Art* published John Graham's article "Primitive Art and Picasso." Pollock read it and wrote to the author, who sought him out, for that was his habit. Graham insisted on knowing what New York painters were doing, especially the younger ones. He wanted to be an art-historical Gabriel, announcing the future of painting in the New World. Born Ivan Dombrowsky, Graham was descended from minor Polish nobility. During the Russian Revolution, he fought as a cavalry officer on the czarist side. Imprisoned, he escaped and joined White Russian forces in the Crimea. Anyway, these are among the stories he told after the White Russian cause failed and he fled westward, settling eventually in New York. There he studied at the Art Students League and became enough of a painter—and enough of a Marxist—to claim a place in the avant-garde.

Dogmatic and fierce, he exercised strict control over every detail of his public presence: his military bark and theatrical gestures, his cravat and monocle, his cuff links and gloves. When Graham died, in 1961, Thomas B. Hess wrote of his talent for scavenging: "It was said that he could walk into any junk shop and find a beautiful object for 50 cents." During the thirties, Graham dealt in African sculpture, buying in Europe and selling in the United States. Among his Parisian acquaintances was Pablo Picasso. After visiting this colossus of modernism, Graham would report on their conversation to friends in New York.

From the Surrealists Graham learned to speak of "vision" as a "power procreative." "Work in art," he wrote, "is like making primitive fire." The will must abdicate, freeing the painter's hand to take dictation from the raw, anarchic energies of the unconscious. As color flows in "absolutely spontaneous" currents, painting becomes *écriture automatique*—automatic writing. With his talk of spontaneity, Graham only slightly jumbled a doctrine pro-

mulgated in 1924 by André Breton, the field marshal and chief theoretician of the Surrealists.

In long quasi-therapeutic conversations with Pollock, Graham tried to talk the young artist past his resentment of Europe. Pollock responded at first with Bentonoid sneers. He attacked Picasso, even. Though Graham would bristle, he stayed in the mentor's role—autocratic yet forgiving. After all, Pollock had come to him, drawn by the force of new ideas. And Graham felt in Pollock's violence the nearness of the unconscious and the promise of the new. With imperious patience, Graham encouraged him to keep looking at non-Western art and to think about Surrealist experiments in painterly freedom.

Sometime between 1938 and 1941, Pollock painted *Birth*. To finish the picture, he impersonated Orozco, Picasso, and the carver of the Eskimo mask pictured in John Graham's essay on primitive art. Though he failed to escape himself, Pollock did charge the image with the force of his desperation. The writhing figure of *Birth* may be several figures, male and female, or a solitary creature with the organs of both sexes. Graham chose *Birth* for American and French Paintings, the exhibition he presented at the McMillen Gallery. A reviewer for *Artnews* admired its "swirling figures." This was Pollock's first critical notice; the review didn't mention Krasner.

The McMillen show ended in February 1942; a few months later, Project administrators chose Krasner to lead a team of artists in the war-services division. Their task was to design window displays promoting military courses at New York city colleges. Krasner chose Pollock as an assistant and took care not to overburden him. During the summer, he ended his treatments with Dr. de Laszlo. Firmly, Krasner was assuming the management of his life. As 1942 ended, so did the Project. Pollock got a job decorating ties and lipstick cases in a silk-screen studio. Like Pollock, Robert Motherwell was saved from the draft by a 4-F rating. Barnett Newman and Mark Rothko were approaching forty when America entered the war. Neither summoned nor rejected by their draft boards, they waited out the conflict in a state that Newman later described as "horror."

Since the late thirties, war and the threat of war had been driving avant-gardists from Europe to New York. By 1942, the roster of émigrés included Fernand Léger, Marc Chagall, Yves Tanguy, André Masson, and Pavel Tchelitchew. These were personages already introduced by the art magazines. American artists could now meet them in the flesh, yet few took the opportunity. They didn't want to seem overly interested in émigrés so obviously unimpressed by them. Clustered around André Breton, the Surrealists were especially disinclined to fraternize with locals. Breton and several others refused to speak English. Except for Motherwell, the New Yorkers spoke no

French, and their manners didn't mesh with those of the zealously snobbish Surrealists.

Only Roberto Matta Echaurren, one of the younger Surrealists, made an effort to meet Americans. A native of Chile, Matta had studied architecture in Paris with Le Corbusier. After his exposure to the geometric rigor of Corbu, he switched his allegiance to Breton and became an advocate of spontaneity—an automatist. Automatism was a product of Breton's fear that education was bad for poets and painters. Burdened with too much knowledge and good taste, they were capable only of the most predictable proprieties. They needed to be liberated. Cribbing the Freudian method of free

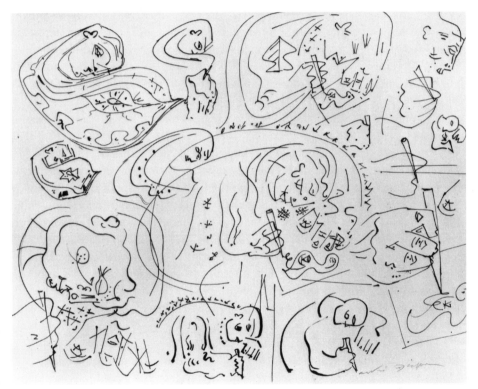

9. André Masson, *Meditation of the Painter*, 1943. Ink on paper, 20⅜ x 25⅞ in.

association, Breton proposed that writers set aside their literary intentions and record whatever currents of language flowed directly from the unconscious mind, where all was "subject to the principle of pleasure alone."

Automatism would allow a writer to receive messages from a paradise usually silent and, of course, invisible. To show us pictures of this hidden

Eden, an artist needed only to suspend his aesthetic standards and let the unconscious move his pencil over the paper. Many Surrealist painters played with the method. Masson, Joan Miró, and a few others became addicted, though they never inveigled the conscious will into a complete surrender. At most, they persuaded it to relax, to lighten the aesthetic effort with a carnival spirit. The will was on holiday but still in charge.

The automatist method made a good fit with Matta's brio. Motherwell called him "the most energetic, enthusiastic, poetic, charming, brilliant young artist I've ever met." Also, he was fluent in English and restless with ambition. In New York he saw a chance to declare his independence from the Surrealist veterans through whose hierarchy he feared he would never rise very far. With Motherwell's help, he would recruit the best American artists to a fresh avant-garde; with Matta guiding them, they would set off an aesthetic explosion. Motherwell was game; so was his friend William Baziotes. On their advice, Matta invited Arshile Gorky, Pollock, and a few other painters to his New York studio for a demonstration of automatist techniques. Putting Matta's lessons to proper use, Gorky impressed Breton as the only New Yorker worthy of induction into the Surrealist ranks. The breakaway cadre never formed.

In the forties and throughout his long career, Motherwell would launch an image with a burst of unpremeditated form; then, remembering its refinement, his hand would gather the wild blobs of color and tangles of line into an orderly composition. This was a reined-in automatism. Baziotes, Rothko, and Newman resisted the method still more rigorously. Art, they believed, is not a surrender to unconscious impulses. Nonetheless, the idea of that abandonment turned them toward the swampy and the primordial. Baziotes set amorphous creatures adrift in pools of dark color. Rothko's forms are wispier and swim in sunnier environments. Evoking egg and sperm and fertilization, Newman's drawings from the early forties illustrate his fixation on beginnings.

Not long after the session with Matta, Motherwell stopped by Pollock's studio and explained, again, the theory of automatism. "To my astonishment," Motherwell recalled, Pollock "listened intently; in fact, he invited me to come another afternoon, which I did. This would be the winter of 1942." That year, Pollock painted *Stenographic Figure* (1942). Color moves through this picture in quick flickers. Anatomy turns elastic. In *The She-Wolf* (1943), Pollock's brushwork grew denser and more violent, calling forth an image of bestial grotesquerie. Alfred Barr acquired this canvas for the Modern in 1944. *Stenographic Figure* entered the museum's collection later. These images can be made to testify to a Surrealist Pollock, an American painter with a secure place on Barr's chart of modernist progress. But there was no Surrealist Pol-

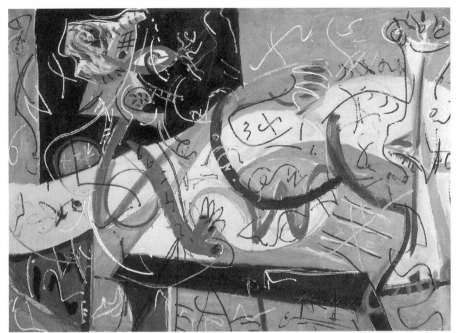

10. Jackson Pollock, *Stenographic Figure*, 1942. Oil on canvas, 40 × 56 in.

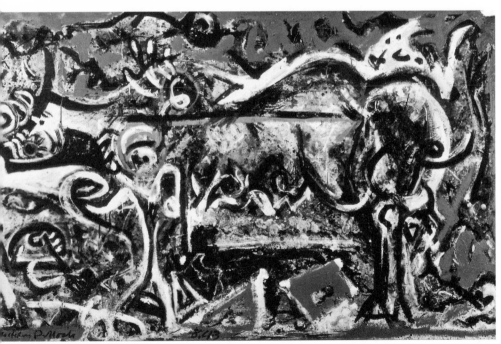

11. Jackson Pollock, *The She-Wolf*, 1943. Oil, gouache, and plaster on canvas, 41⅞ × 67 in.

lock; or, if this personage did appear for a season or two, he vanished in the painting of *The She-Wolf*.

As performed by Masson, Miró, and other Surrealists, automatic painting was a brilliant charade. With a lively hand and a willingness to shock, these artists generated the look of wild new freedom won through the sacrifice of old refinements. Yet their automatist images tend to be lushly textured and beautifully composed. Promising to unleash the primitive forces of the unconscious, these Surrealists revitalized our most sophisticated pictorial traditions. In this discrepancy between program and practice lies the wit of automatism. Pollock had no use for it.

Indifferent to Surrealist ironies about control and abandon, he wanted to force his medium to obey. With the splashed, smeared, scratchy brushwork of *The She-Wolf*, Pollock tried to register every surge, every flicker, of his deliberate will. Confined to an oblong habitat, the she-wolf fills it with her oblong shape. *The Guardians of the Secret* (1943) guard a cryptic image: a painting within the painting the guardians occupy. Edges reiterate edges, corners echo corners in these works from the early forties. Pollock's willfulness was producing blunt, brutal symmetries. He wanted more command over his medium, not less, and—this is the paradox of his art—he brought his colors under full control only when he began to fling them through the air.

Still, the Surrealists did convince Pollock that an unkempt painting can be legitimate. So historians continue to talk of a Surrealist Pollock, though he had no firm grasp of automatist theory or any other doctrine of the avant-garde. Many paths took him beyond Benton's dogma, and on all of them he was lost. Embracing a new style, a new method, he would bear down on it with obsessive fervor, hoping for immediate satisfaction. He never learned that avant-garde art was not intended to be satisfying now, in the moment. It was an assault on the future. Avant-gardists asked themselves: of all that is happening at present, what will turn out to have been of use to those who make history? Krasner attacked this question doggedly. Pollock ignored it. Immersed in his private quandary, painting as if there were no tomorrow, he looked to her like a primitive. He also looked to her like the most powerful painter in New York.

As artists come to know their ambitions, they invent ways to realize them. Pollock knew only that he needed to be great. He needed Krasner to tell him what that meant, and she needed him as the recipient of her lessons. She wanted to feel that parental dominion. She taught him that ambition requires enemies, and high ambition requires precisely the right one: the artist who blocks the single, narrow path from present oblivion to a place in history. This was Picasso, whose blithe and terrible egoism made him the one to supplant—not to emulate, as Pollock had tried to do in the late thirties and

early forties. Then, Picasso was one model among many. Krasner taught him to concentrate his gaze.

One evening, when they were still living on East Eighth Street, she heard "something fall" in his studio. Next came the sound of

> Jackson yelling, "God damn it, that guy missed nothing!" I went in to see what had happened. Jackson was sitting, staring; and on the floor, where he had thrown it, was a book of Picasso's work.

Artists had long looked for possibilities neglected by Picasso. Pollock was now poised to give the possible a redefinition that would make Picasso's mastery obsolete.

The nemesis of Picasso could not be too American, for he had to count as an internationalist, a fitting successor to the hero he had defeated; yet he needed to be thoroughly American, to show that modernist progress had led to the New World. Worse than being too European was being American in the wrong way, like the jingoistic Benton or the provincial adepts of Mondrian. The right way was to be an American pioneer whose explorations led deep into Parisian tradition and beyond to new territory.

8

The idea of avant-garde progress gives artists a proprietary attitude toward the future: when it arrives, they believe, it will be theirs. The New York painters had sustained that faith even when the cruelty of the Depression pushed them hard against their moment, and sometimes they took their difficulties for signs of a high destiny. Then the war began abroad, and historical pressures subsided in New York. The artists felt diminished, especially as their city filled with art stars from Europe. Most of these visitors intended to return to Paris the moment it became possible; for the duration, New York would be a way station—the avant-garde's capital-in-exile. To its original inhabitants, the city's art world felt increasingly tenuous. Then Peggy Guggenheim arrived on the scene and gave it a center.

Guggenheim was an expatriate New Yorker with an indifference to America, to the war, to nearly everything but her edgy need for pleasure. Upon turning twenty-one, in 1919, she had inherited a share of the family's mining fortune. Certain relatives had received more, so Peggy called herself a "very poor" Guggenheim. Still, her portion was more than sufficient to sustain her luxuriously in Europe. There she pursued distraction and no particular purpose until 1937, when her uncle Solomon announced that he would establish a foundation for the support of two modernist painters: Wassily Kandinsky and Rudolf Bauer. Suddenly rivalrous, Peggy launched Guggenheim Jeune, a London art gallery; a season later, she sketched plans for London's first museum of modern art. The blitz drove her to Paris, the original headquarters of her expatriation.

In her memoirs she tells of finding modern paintings for sale at panic prices. Making the rounds of studios and galleries, acquiring as she went, she soon found the effort unnecessary. Artists and dealers would visit her house "with pictures. They even brought them to me in bed, in the morning before I woke up. . . . My motto was 'Buy a picture a day' and I lived up to it."

She also sought a man a day but, as she once told the art historian John Richardson, "pictures were easier to obtain." As the German advance drove a stream of refugees through the city, she lingered. Only after the city fell, in June 1940, did she slip reluctantly into the current. Crates containing her pictures reached New York in the summer of 1941, a few days before she did.

Guggenheim brought along her newest lover, the handsome and conceited Max Ernst, who considered himself the only Surrealist painter of any consequence and a natural aristocrat with a license to behave as he pleased. An artist of judicious whims, he married Guggenheim after the United States entered the war and his German citizenship put him at risk of deportation. Upon meeting an attractive young Surrealist painter named Dorothea Tanning, Ernst began an affair with her. Guggenheim reciprocated by sleeping with Laurence Vail, her first husband and the father of her two children. Soon bored by this distraction, she opened Art of This Century at 30 West Fifty-seventh Street, to provide a showcase for her collection.

Guggenheim commissioned Frederick Kiesler to design the interior of her miniature museum. Barely five feet tall, this native of Vienna had an indomitable faith in his power to "break down the physical and mental barriers which separate people from the art they live with." He alone among the modernist architects knew how to establish "a unity of vision and fact," the harmony of self and world that had "prevailed in primitive times." Geometric abstractions were removed from their frames and mounted on lengths of string stretched taut between ceiling and floor.

In the Surrealist room, paintings hung from adjustable wooden beams cantilevered from concave panels of gumwood. Behind these tall, curving panels, the walls were black. Illumination was by spotlight. This, wrote the critic Rudi Blesh, "was uterine architecture as involute as the subconscious minds from which were born the paintings themselves." With more delight than shock, the New York press and Fifty-seventh Street habitués agreed that here was the look of the modern.

Marcel Duchamp—instigator of Dadaism and friend of the Surrealists— had encouraged Guggenheim with her plans for the London gallery. In 1942, he settled in New York, and Guggenheim again turned to him for guidance. Duchamp suggested that she present a selection of artworks by women. She offered a few solo exhibitions and, early in 1943, decided to assemble a "spring salon" of work by young artists. For this event, she recruited a jury. Among its members were Duchamp, Alfred Barr, and the partially forgiven Ernst. One morning, as she leaned pictures against the gallery wall, another member of the jury arrived. It was Piet Mondrian, a refugee from Paris by way of London. When he paused before a small batch of Pollocks, Guggenheim

rushed over and said, "Pretty awful, isn't it? That's not painting, is it?" Mondrian said nothing and she went away.

Later he was still in place, still absorbed. Guggenheim returned and spouted what she supposed were Mondrian's judgments: "disorganized . . . muddy . . . dreadful." He remained silent as Guggenheim went on: "There is absolutely no discipline at all. This young man has serious problems, and painting is one of them." Mondrian turned to her, unflustered, and said: "I have a feeling that this may be the most exciting painting I have seen in a long time, here or in Europe." Guggenheim was amazed. Style usually prompts a game of allegiances. Mondrian was the era's leading geometrician. With straight black lines and rectangles of primary color, he composed emblems of universal harmony. Pollock's colors were garish and murky; his lines swooped and skidded over the canvas. What could Mondrian find to like in painting like this?

He allowed that Pollock's art "points in the opposite direction of my painting, my writing." To his eye, it looked alien. Yet he saw "no reason to declare it invalid. . . . Where you see 'lack of discipline,' I see tremendous energy." Mondrian declared himself "very excited." Soon Guggenheim was calling Pollock an "exciting" new artist; in her memoirs she named him "the greatest painter since Picasso"—greater, presumably, than Mondrian. Half a year later, she gave Pollock his first solo show.

After three months of decorating neckties and lipstick cases, Pollock had found work at the Museum of Non-Objective Painting. Established by Solomon R. Guggenheim, this institution was later renamed for him, and now occupies Frank Lloyd Wright's spiral monument on upper Fifth Avenue. In 1943, the museum was housed in a smallish building on East Fifty-fourth Street. Pollock ran the elevator, helped with frame-making, and mocked the museum's collection—especially pictures by Mondrian, Paul Klee, and Jean Arp. He was rescued from this job by Peggy Guggenheim, who agreed to advance him one hundred fifty dollars a month against future sales. Their contract was for twelve months. If, at the end of a year, not enough had been sold to cover advances plus the gallery's commission, Guggenheim would be compensated in paintings. From 1943 "until I left America in 1947," Guggenheim later wrote, "I dedicated myself to Pollock." He "became the central point of Art of This Century."

Still poor, Pollock could now paint full time. During the war years, no other downtown artist was so little burdened by everyday constraints. None had been so oppressed by them. De Kooning gained much by rubbing against the grain of the ordinary. Pollock did not. The world's friction infuriated him. Guggenheim reduced it crucially and, of course, imposed new pressures, for she was a demanding patron. Having scheduled his solo exhibition, she

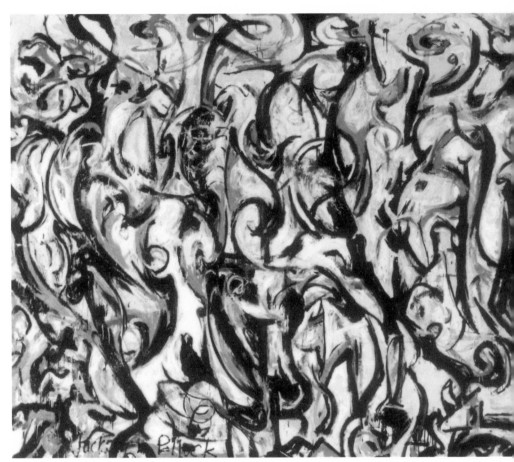

12. Jackson Pollock, *Mural*, 1943. Oil on canvas, 8 ft. 1¼ in. × 19 ft. 10 in.

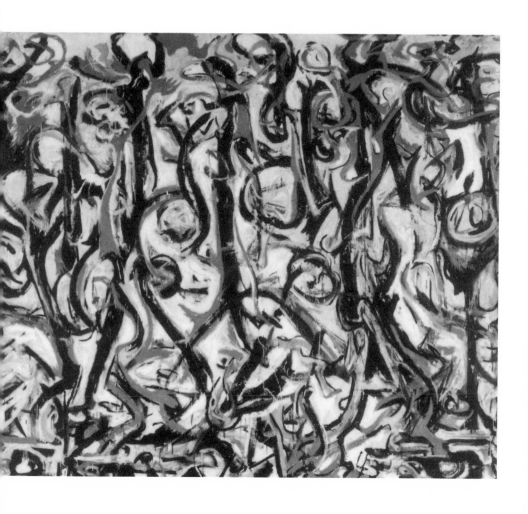

commissioned him to paint a mural for the vestibule of her Upper East Side town house.

To make room for a stretcher large enough—roughly nine by twenty feet—he tore down a partition in his Eighth Street studio. He stretched his canvas, hung it, and wrote to his brother Charles, in Detroit, that the empty field "looks pretty big, but as exciting as all hell." It was now midsummer. The picture was to be finished by November, so Guggenheim could include it in Pollock's debut exhibition. He completed many works during the next three months but not the mural. Then in a single night he covered his huge canvas with writhing tendrils of color and called it, simply, *Mural* (1943).

At his patron's house, Pollock discovered that his twenty-foot canvas was too long for its intended place. Guggenheim was at the gallery. Pollock telephoned her there for advice, but she could make no useful suggestions. Calling again and again in panic, he continued to receive no help. Nosing about, he found her hidden liquor, got drunk, and kept calling. The afternoon had slipped away unpleasantly before Guggenheim asked Marcel Duchamp and the sculptor David Hare to hang *Mural*. Hare later remembered asking Pollock whether it would be all right if they lopped off a short section of the work. He said he didn't mind, though he may not have focused sharply on the question.

As *Mural* was wedged into place, Pollock removed his clothes and wandered into Guggenheim's living room, where a party of her friends had gathered. Crossing the floor, he stood before the fireplace and urinated. This stunt is a matter of public record. We have only Guggenheim's word to support her story that Pollock also peed in her bed during her one attempt to seduce him. He was stupefied by alcohol, and the experiment failed. Krasner did not fear Guggenheim's allure. Pollock's anxieties about women made him nearly unseducible. What Krasner feared was his drinking. He needed to get away from Manhattan, with its familiar bars and ready supply of fellow drunks.

On a visit to East Hampton, Krasner glimpsed the possibility of resettling out of town. Pollock rejected it at first, then changed his mind, and in the summer of 1945 they found a house for sale on Fireplace Road in Springs. Of course they could not afford it. Aside from *Mural*, Pollock sold no other large work but *The She-Wolf*. Now Krasner came to Guggenheim to borrow two thousand dollars for a down payment on the house in the Hamptons. No, said Guggenheim, it was an expense she could not possibly justify.

As Guggenheim lay in bed, exhausted by an ailment diagnosed as mononucleosis, Krasner visited her every day and made the same pitch. The contract could be renegotiated; two thousand dollars was not such a terribly large sum; it was imperative for Jackson to be taken away from the city. Eventually, Guggenheim gave in. Under the new contract, to run for two years, Pollock

would receive three hundred dollars a month, minus fifty dollars for repay-
ment of the loan, interest-free; in return, Guggenheim would receive the
painter's entire output, except one painting a year. Pollock's works were so
hard to sell that Guggenheim had next to no reason to accept this deal.
Nonetheless, she did, explaining that "it was the only way to get rid of Lee."

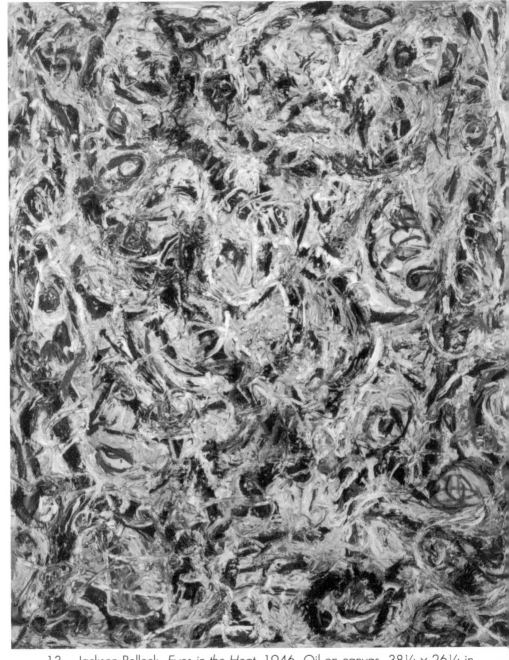

13. Jackson Pollock, *Eyes in the Heat*, 1946. Oil on canvas, 38¼ × 26¼ in.

9

Leaving Eighth Street late in November, Krasner and Pollock arrived at the house on Fireplace Road "during a northeaster." "What an entrance!" said Krasner, long after Pollock's death. "The house was stuffed with the belongings of the people who had lived there. It was a rough scene. The barn was packed solid with cast-iron farm tools. So it was a matter of cleaning everything out before either of us could work. In the meantime, Jackson took one of the bedrooms to try to paint in." The run-down house had never been comfortable. A water pump stood in the basement; there was no bathroom and no central heating. In winter, reliable warmth came only from the kitchen range. To open a view to Accabonac Bay, the barn was moved twenty yards to the north. Pollock painted there and Krasner set up her easel in the bedroom-studio he had vacated.

During his first year at Springs, Pollock painted *Eyes in the Heat* (1946). Though its colors look gluey, the artist's brush skittered in laying them on, and it moved with even greater speed to cover *Shimmering Substance* (1946) with its agitated crust of brilliant, sun-soaked white. To eliminate all friction of brush on canvas, Pollock taught himself to pour his colors through the air, and from these currents flowed the paradoxes of his mature art. To intensify his contact with the painting—the image—Pollock had to break contact with the canvas. Giving up the usual control of his medium, he gained control of a new kind. No longer bedeviled by the constraints of traditional technique, he found new and congenial ones in gravity. Unable to determine precisely how color would fall on the canvas, Pollock redefined precision. A streak of slung paint looks well formed if its vector is clear; if it merges with the immediate field, it looks well placed.

Alfred Barr had accepted *The She-Wolf* as the work of an American with Parisian affiliations. Pollock's poured imagery made him feel uneasy. Early

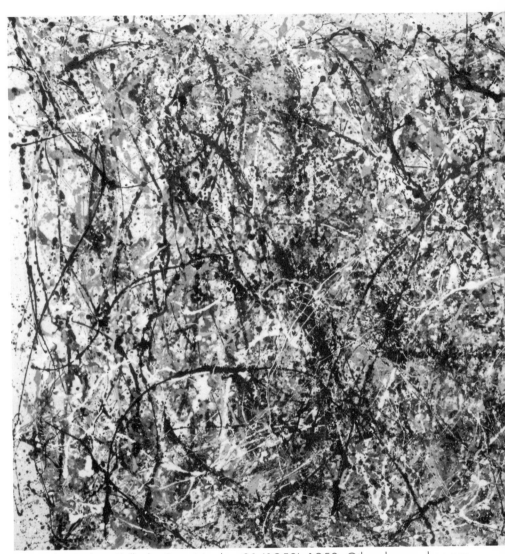

14. Jackson Pollock, *One, Number 31 (1950)*, 1950. Oil and enamel on canvas, 8 ft. 10 in. × 17 ft. 5⅝ in.

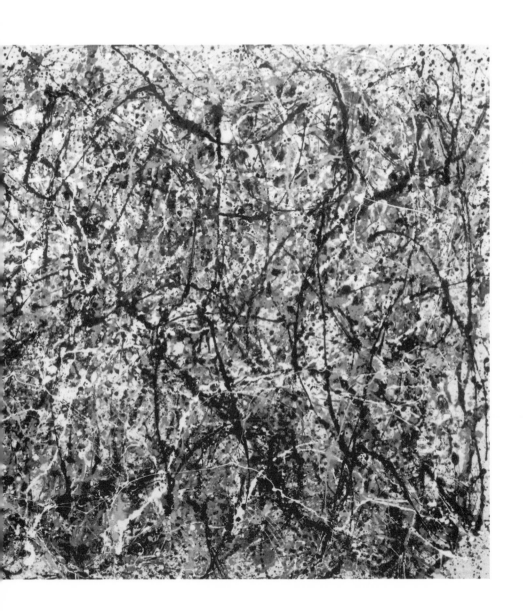

in 1950 Barr warned a young curator at the Modern: this was not work "that we would want to support." Soon afterward, he persuaded the Modern to buy a large drip painting called *Number 1A* (1948). When Betty Parsons showed this canvas in 1948, it had gone unsold. Her explanation of the shift in Barr's policy was simple: everyone was talking about the poured images and he could not ignore the buzz. One hears this explanation often, outside the art world and deep within it: taste is an exercise in conformity. An artist turns hot and art lovers flock around in unthinking admiration; favorable criticism spews forth automatically, collectors collect, curators acquire; like a totalitarian regime in perfect working order, the fad imposes complete unanimity. Yet fads never do that, even at their most powerful.

Much of the praise Pollock received in the late forties and early fifties had a forced and overheated quality. Nonetheless, the early furor included a note of intelligent zeal. Barr caught that note and replayed it in his writing. Asked to select three of six artists to represent the United States at the Venice Biennale of 1950, Barr settled on de Kooning, Gorky, and Pollock. Among the Pollock canvases he chose was the Modern's recent acquisition, *Number 1A*. In a note composed for the Biennale catalog, Barr said that Pollock's pouring "provides an energetic adventure for the eyes, a *luna park* full of fireworks, pitfalls, surprises and delights." Here were pleasures to be felt and high aesthetic significance to be glimpsed.

"Sometimes," said Barr, the painter's "whirling vortex of lines develops a mysterious depth and glow of light, without however destroying the sense of the picture surface which Pollock and all his companions seek to preserve as essential to their art." As intense as the delights of Pollock's art may be, they never violate "the sense of the picture surface." The integrity of that surface is preserved, as Clement Greenberg had been arguing for the past few seasons. His argument had a corollary, crucial to the claim for Pollock's importance: the "constructed, reconstructed flatness" of his imagery evolved from Parisian precedent. Thus Pollock is an "extreme disciple of Picasso's cubism and Miró's post-cubism, tinctured also with Kandinsky and Surrealism."

In the babble about Pollock, Barr heard this well-constructed argument and made it his own. For here was the link to Europe that gave the drip paintings their place in the Museum of Modern Art. Pollock's *One, Number 31 (1950)*, a drip painting more than seventeen feet wide, is a monumental feature of an itinerary that begins in a gallery devoted to Cézanne. Next come leading figures of the School of Paris: Monet, Van Gogh and Gauguin, the Neo-Impressionists, Matisse and the Fauvists, Picasso and the Cubists, Mondrian, Miró. Byways lead to minor episodes and back to the high road, the great boulevard of Parisian modernism. *One* appears as the boulevard veers toward New York. At this turning, we are to understand Pollock's greatness as an adhesive joining Old World and New.

This is an impressive claim. Ever since America's discovery, its relations with Europe have generated friction, and it would be gratifying to believe that Pollock overcame the conflict—in the realm of painting, anyway. If he did, his accomplishment is major, though there is something small about it, too. An elaboration of Cubist flatness is, after all, just a formal exercise, even if it does join the avant-garde painters of Paris and New York. The passion, the strange glory, of Pollock's best art must have some greater significance than that. Yet authoritative voices have been saying for nearly half a century that it doesn't—rather, Greenberg and Barr and William Rubin, Barr's successor at the Modern, have argued that, in painting, there is no greater significance, no greater glory, than a major innovation in form.

Others are not convinced. To account for the power of Pollock's drip paintings, critics invoke images of air and light. They look for figures in his tangles of color, and some have tried to see them as mirrors—images of the artist who made them. Pollock's most recent biographers, Steven Naifeh and Gregory White Smith, claim that he excreted the major paintings—not in fact, of course, but with a vividly literal sort of mimicry. By letting his paint run from a stick, write Naifeh and Smith, the artist enacted an early memory of his father urinating on a flat rock out West, somewhere in the mountains of Arizona or California. As Roy Pollock asserted his manhood by tracing patterns on rock, so his son became a man, or at least a mature painter, by tracing similar patterns on canvas. Thus a resemblance becomes an explanation.

Naifeh and Smith base their theory on a statement taken down by Jeffrey Potter, the third of Pollock's biographers. Among Lee and Jackson's friends in the country was a writer named Patsy Southgate, who told Potter of hearing the painter say that

> the reason he put his canvas on the floor . . . came out of his childhood. The thing he had really liked then was standing beside his father on a flat rock pissing. He was really tickled, you know, when he watched, and said to himself, "When I grow up, am I ever going to do that!" This theory says, *"Now* I'm going to show Dad!"

Whatever the explanatory power of this theory, the flow of pigment from Pollock's stick did resemble the arcing, spattering flow of male urine; and his alcoholism often reduced him to uncontrolled peeing.

Naifeh and Smith quote the Southgate anecdote, then present a dossier on Pollock the pisser. They retell the story of Pollock urinating in Guggenheim's fireplace. They report that he often wet the sheets while sleeping off a binge, at home or as a houseguest, and they call on witnesses willing to testify that Pollock liked to urinate in the street rather than use the men's room of a

bar. Pissing had more than ordinary significance for Pollock, as the evidence makes it pointless to deny. Though Naifeh and Smith can't say exactly what that significance is, they conclude that, whatever it may be, the artist's poured paintings share it.

To believe this, you have to believe that Pollock was deluded in supposing that he wanted to make images, that his true purpose was to mimic urination with the flow of paint. Unhappily, he spent nearly two decades muddling along with pencil and brush, trying to master those implements, before it occurred to him to let paint sail off the end of a stick. With that, painting's resemblance to peeing was complete. Pollock's work as an artist was finished, so far as Naifeh and Smith understand it.

This account prompts questions. What about other children who saw a man peeing outdoors? Why did none of them grow up to invent a drip method like Pollock's, and what are we to make of the paint dripped on canvas in the thirties by David Alfaro Siqueiros? Did he see his father peeing on a rock? Naifeh and Smith's explanation of Pollock's big gestures sounds like a parody of all the clichés about Jackson the frontiersman, the Westerner, the American hero letting loose in American immensities. Most commentators throw the Naifeh-Smith thesis out of court with shudders of indignation. "What nonsense!" Clement Greenberg said.

Still, before we dismiss the metaphor of drip painting as peeing, we ought to note how easily it turns into the metaphor of painting as ejaculation. When Pollock let his enamel get more viscous than piss, it spattered onto the canvas like gobs of sperm. He taught himself to "control the flow of paint" from the end of his stick, he said, yet nothing controls the mind's associative drift. To the critic Max Kozloff, Pollock's method suggested an "aerial sphincter." Where his paint flows over the surface stickily, it looks like venous blood. A frothier flow suggests the arterial kind. Instead of rejecting the Naifeh-Smith thesis, we should expand it until intimations of all the body's processes appear in Pollock's stained, smeared, encrusted canvases.

Sometimes vision sinks helplessly into a pool of color. The image congeals and the force of Pollock's gesture fades. Metaphor weakens. Emerging from a murky pool, the eye feels stymied by flurries of drips and drops and spatters—the effluvia of Pollock's method. At these moments, it's tempting to turn away, though the eye that lingers with patience always finds a path into the painting's dense tangle. It reopens, more grandly than before. Sailing on rapid currents, vision finds it impossible to separate the artist's presence, his bodily energy, from the surges of light and weather his gesture stirs up.

In "Pollock Paints a Picture," Goodnough wrote that a session of about half an hour produced the first stage of the large painting called *Number 4, 1950*. Afterward, Pollock

did not know yet when he would feel strongly enough about the picture to work on it again, with the intensity needed, nor when he would finally be finished with it. The paint was allowed to dry, and the next day it [the canvas] was nailed to a wall of the studio for a period of study and concentration.

The painter came back to *Number 4* several weeks later, having launched other works. Over the black of the first session he sent filaments of reddish brown. There were spurts of aluminum paint, then a halt and another interval of contemplation. "The final work on the painting was slow and deliberate," wrote Goodnough. "A few movements in white paint constituted the final act."

A picture usually comes to rest after a time, clicking into a harmonious stability; or the picture doesn't click and you say it is badly composed. Composed neither well nor badly, a poured painting is a zone of contingency with an atmosphere permanently roiled. Everything plays off against everything else locally, and overarching forms do not emerge. No compositional architecture subordinates small incidents to bigger ones; nothing establishes a principle of containment. Reaching for the edge of the canvas, arcs of Pollock's color often swerve away and return to the interior, or they zoom onto the studio floor. That a canvas has limits is an obvious fact. Pollock treated it as a mere fact, not as the indispensable premise it is for most painters.

A poured canvas has no stable premises, only the rush of its image, its bursts and swirls of pictorial incident, each making an equal claim on the attention and none willing to relinquish any part of it. Interviewed by *The New Yorker* in 1951, Pollock mentioned "a reviewer a while back who wrote that my pictures didn't have any beginning or any end. He didn't mean it as a compliment, but it was. It was a fine compliment."

10

Pollock died in 1956, when he drove his car off the road. Krasner had insisted on their marrying before moving to Springs, and for years the art world knew her best as Mrs. Jackson Pollock, the widow who tended the estate with a careful hand. Slowly, Krasner rewon her independence as an artist. At her death in 1984, she routinely appeared on historians' rosters of the heroic postwar generation of American artists. Though Krasner escaped Pollock's shadow, she always longed for him and for the time when she had been nearly alone in feeling the power of his art.

A year before she died, Krasner told Barbara Rose of a dream she remembered from her early days with Pollock: "Jackson and I were standing on top of the world. The earth was a sphere with a pole going through the center, I was holding the pole with my right hand, and I was holding Jackson's hand with my left hand. Suddenly I let go of the pole, but I kept holding onto Jackson, and we were both floating off into outer space. We were not earthbound."

Pollock, too, had dreams of limitless space. "I'm sort of way out there on my own," he told Jeffrey Potter. "Moving slowly to the edge, but not to a cliff, and it's not a void either. What it is, what it *feels* like, is just more me—on and on." There are no definite edges, no true voids, because self equals space equals self—an expansive equation the artist could sustain only in dreams or in the depths of a painting. He never tried to explain this equation. Language, he feared, could only cloud it.

The painter Grace Hartigan remembers Pollock dismissing all talk, especially his own, as "a betrayal." Betrayal is always tempting and sometimes he gave in. De Kooning testified that Pollock was good at art talk, especially when "he was half-loaded, that in-between period." These periods were

short. Fully loaded, he bellowed. Sober, he was habitually silent, and if he did venture a remark, he could never be counted on to sound like a proper avant-gardist. When Krasner met Pollock, she was appalled to learn that the few bits of jargon he commanded were tattered Bentonisms. To help him acquire jargon of a higher grade, she persuaded her teacher, Hans Hofmann, to visit Pollock's studio. Hofmann would be impressed by what he found, she hoped, and in his comments Pollock would hear the voice of the avant-garde.

The visit took place in 1942, soon after Pollock and Krasner showed their work at the McMillen Gallery. It was not a pleasant occasion. Pollock's clutter disgusted Hofmann. When he picked up a brush that sat in a can, the can came with it. The paint had hardened, capturing the brush. "You could kill a man with this," he said. "That's the idea," Pollock replied. Unfazed, the older painter turned to the younger one's canvases and delivered a critique, as if he had been presiding in his classroom. According to Hofmann's doctrine, the artist cannot be satisfied with ordinary vision. True art requires "spiritual projection." By exercising this faculty, "our emotional experiences can be gathered together as an inner perception by which we can comprehend the essence of things beyond mere, bare sensory experience."

Hofmann believed that the mechanical tone of scientific perception deprived modern life of meaning. The artist's mission was to make good the loss. With the airy flood of his pedagogy, Hofmann exhorted his students to find in themselves the organic vitality of spirit that feels its way past the world's familiar surfaces to the depths of the real. His teaching blended a dog-eared version of German Romanticism with the style of formal analysis he learned during his Paris years. Comporting himself as a missionary from the Old World to the New, Hofmann had announced upon his arrival in Manhattan that "the problem of civilizing this enormous country is not finished." Yearning to improve themselves, Americans like Krasner saw Hofmann as European high culture made flesh. Pollock found him intimidating and finally insufferable.

During his studio visit, Hofmann recommended that the younger artist attend his classes. Pollock replied that he wasn't interested in Hofmann's theories, adding that he ought to "put up or shut up." This was a nicely placed jab. For years, Hofmann had been reluctant to exhibit his work. None of his students knew how he painted. Deciding to put up, he allowed Krasner to persuade Peggy Guggenheim that his work deserved a show at Art of This Century. Pollock helped win Guggenheim over, though he was indifferent to Hofmann's painting and resisted his teachings with reflexive vehemence.

Their best-known skirmish occurred on that first visit or later, at the artists' colony in Provincetown, Massachusetts. Accounts vary. Hofmann told Pollock he should work from nature. All accounts agree on Pollock's reply: "I am nature." This comeback has the flat clang of cliché. Pollock asserted what a few Surrealists, many Expressionists, and nearly all Romantics had asserted before him: authentic art is the work of those who embody natural forces. Hofmann, too, promoted this doctrine, though he couldn't accept Pollock's brusque equation of artist and nature.

Like the German Romantics whose subtleties he sloganized, Hofmann talked of empathy. Harold Rosenberg recalled that, in the summer, Hofmann "ritualistically attended the setting of the sun from a high point among the dunes of Provincetown." The painter would say, "I bring the sunset home with me." This was not a blending of artist and nature. Intuiting the essential being of other things, other people, the artist feels a heightened individuality. And whatever is embraced by intuition becomes more fully, more self-evidently itself. Everything that has withered in a disconnected state is renewed and returned to natural harmony: perception and fact, self and world, the particular and the universal.

When Pollock said, "I am nature," he argued in shorthand that empathy was unnecessary. He and the world were one, so he had no reason to look at sunsets or at anything outside himself. "But if you work from inside," Hofmann said in reply to Pollock's famous outburst, "you will repeat yourself." With this warning, Hofmann prophesied the sameness that would afflict Pollock's art when it became great. The best of his poured paintings are all the same painting. On canvases of various sizes colors change, gesture modulates, density shifts, yet nothing new appears—and rightly so, for Pollock's pouring succeeded only when he held fast to the premise that all is present, all is reconciled.

That is why the poured images have no use for compositional devices, those means of reconciliation. No emblem of the self stands apart, needing to be harmonized with all that it is not. The poured paintings show an ego construing its isolation as its triumphant unity with the universe—not the commonplace universe overrun by others but a universe made bearable, made glorious, by the absence of every ego but one's own. When Pollock painted, he transcended ordinary life. Then he felt sufficient. Away from the studio, his being grew thin and turbulent; he felt himself begin to tatter. The studio always tugged at him and terrified him, too. He could never be certain that his gesture would create the needed unity of body and space, painter and painting, figure and ground.

Occasionally, Pollock let a definite shape emerge from his webs of slung paint. Or he cut a crudely human outline from an old canvas and pasted it on a new one. In 1948 he attached the flat wooden profile of a rocking horse to a poured image. The usual distinctions between figure and ground seemed natural to Pollock, and he never abandoned them completely. At most, he could hold them in abeyance with skeins of color that induce the ground to permeate the figure and the figure to permeate the ground. No boundary is firm, all edges look arbitrary. Contained only in the most contingent manner, the image implies an infinite.

An infinite can only be implied because it cannot, of course, be pictured. The poured images do not picture anything. That is why members of the New York art world usually call them paintings or canvases. They are objects bearing traces of a self-absorbed drama: not merely a journey to the infinite but a transformation. Pollock becomes the infinite; his feeling of helpless exposure vanishes as his presence expands to fill the space that in less exalted moments would bear in on him unendurably.

Even a small poured painting is ungraspably large in scale; and even the largest has a human scale, because it is the residue of the artist's gestures. Currents of paint lead us past the visible to an obscure sense of the body's interior, pulsing and wet. Glistening allusions to blood and guts refer as well to substances the body expels, sometimes explosively. From metaphors violently mixed come evocations of the body that imply boundless space, as if the infinite were bodily and the body were infinite. In Pollock's words, "It all ties together."

This oneness made Pollock feel optimistic so long as he kept it vague— an intimation of his allover image, as it is known. Nothing else permitted him much hope, though he had gravitated toward leftist politics during his high-school years. At the age of sixteen, he was a fan of Jeddu Krishnamurti, the Indian mystic who became a cult figure in southern California during the twenties. Pollock liked Krishnamurti's intimations of something beyond the reach of the mundane, a saving force that individuals can draw from themselves.

Baffled by the leader's cloudiness, he clung more urgently to the idea of art, having gathered that artists were somehow estranged, different from others, and extreme in their individuality. Their power raised them above the common world and its miseries. Year after year, from early adolescence well into middle age, Pollock had not known what to do with his singularity, which left him feeling as raw and shapeless as a clam without a shell. Then, pouring his paints, he ushered himself into a state of oneness with all that is. Because this was no ordinary unity, it was not visible to ordinary eyes. Among the few who seemed to see was a fellow painter named

Clyfford Still. Pollock accepted with gratitude Still's grandiose praise. Quizzed in the year of his death about the point of his art, Pollock could say only that he had "changed the nature of painting." So, he said, had his friend Clyfford Still.

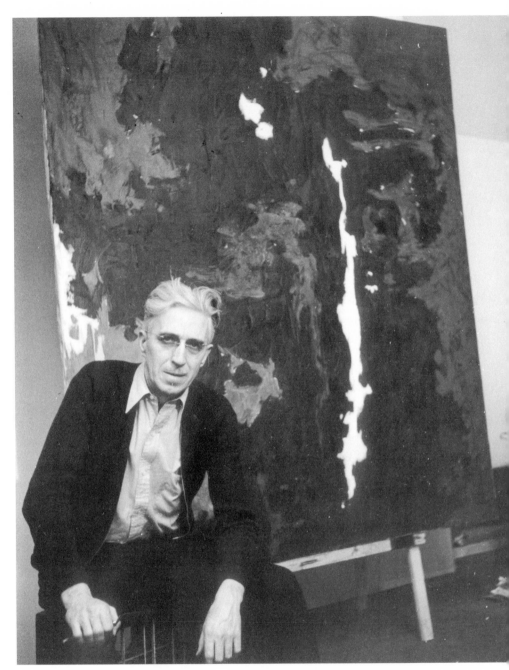
15. Clyfford Still, 1958. Photograph by Hans Namuth

11

The son of an accountant, Clyfford Still grew up in Spokane, Washington, and Bow Island, a small town in Alberta, Canada. Encouraged to draw as a small boy, he taught himself to paint as he grew older. His parents introduced him to music and literature and gave him the means to accumulate a sizable array of art books and magazines. Still made his first visit to New York in 1925. Twenty-one years old, a native of the Far West, he expected to find the city a place of happy fulfillments.

From reproductions, Still had gathered grand ideas about certain old-master paintings, including some in the collection of the Metropolitan. When he saw them in the flesh, these images seemed weak and uncompelling. He had come to New York to complete his education at the Art Students League. After forty-five minutes of his first class he quit, convinced that he knew all the lessons being taught—and knew them, furthermore, to be worthless. New York, the capital of his country's high culture, had nothing to give him. Returning to Spokane, Still enrolled at the local university. After graduation, he taught fine arts at Washington State College, in the town of Pullman.

In 1934 Still painted a picture of a naked, brutally awkward figure striding through an empty landscape. The figure nearly fills the surface of the canvas, as the cloud-laden sky presses outward toward us. He is a monument immersed in nature's glory. Still arrived at his mature style by letting the figure be overwhelmed, drawn into the background, which became the foreground—the dense surface of his oil paints. Heavily but delicately laid on, his patches of dark color are craggy and mountainous. Tall, jagged voids allude to canyon openings or fissures in cloud banks covering western skies. Sometimes a jagged streak of bright color snakes over the surface like a bolt of lightning.

Still's forms are versatile. His clouds flicker like flames; they loom up like bat wings, ready to enfold you. Melodramatic by temperament, Still had a

knack for gothic effects. Before a particularly dark painting, you half expect a sudden clap of thunder. Yet the eye feels at home in even the spookiest of his paintings—at home and at ease, for his imagery evolved from familiar pictures of the unspoiled American West. In the nineteenth century, Albert Bierstadt and Frederick E. Church became famous by celebrating this country's bigness with big, swaggeringly sublime paintings. Still was their direct descendant. Nonetheless, he stated in 1961 that "I paint only myself, not nature."

This statement makes sense only if we return to the thirties, when Still was merging human anatomy with the forms of mountains and clouds. The figure vanished, yet it survived. It became the surrounding territory—flesh of the earth, breath of the sky. In the expansive light of Still's paintings, nature was at one with him, with the self that supplied the artist with the only subject he considered worthy. Through his art, he had achieved "total psychic unity." His "feeling of freedom," he added, "was now absolute and infinitely exhilarating." Still conceived his canvases—these emblems of his being—as portions of a single, ever-expanding work so powerfully cohesive that it swept aside all boundaries. "To be stopped by a frame's edge was intolerable," he declared in 1963. And it was intolerable that the European avant-garde had filled the world with paintings that merely reiterated the frame—paintings like Piet Mondrian's, though Still rarely did Mondrian the honor of indicting him by name.

Looking past all geometric painters to geometry's origins, Still saw an ancient tyranny of straight edge and right angle. There is "a Euclidean prison . . . to be annihilated," he said. To be free, the painter must challenge the "authoritarian" frame with forms indifferent to boundaries. Painters unwilling to make this challenge were weaklings "hopelessly trapped in the grids and geometries laid down by the saint of all masochists, Euclid." In undeniable fact, the frame does stop the spread of Still's painted forms. Yet they move over the canvas as if it had no limits; they show no respect for the edges of the frame or the traditions of painting that give the edges the authority to enclose an image and detach it from ordinary space.

During the early years of the war, Still worked in the defense plants of Oakland and San Francisco. In the spring of 1943 the San Francisco Museum of Modern Art gave him his first one-man show. The following autumn, he returned to teaching, at the Richmond Professional Institute in Virginia. A year and a half later, he moved to New York and looked up Mark Rothko. The two had met in Berkeley. Rothko now introduced Still to Peggy Guggenheim. She showed a few of his works in an autumn salon at Art of This Century and, early in 1946, gave him a solo show. In Still's art Guggenheim detected "a melancholy, almost a tragic sense." This sounds like language

16. Clyfford Still, *1954*, 1954. Oil on canvas, 9 ft. 5½ in. × 13 ft.

learned from Rothko, whose catalog essay claims that "Still expresses the tragic-religious drama which is generic to all Myths at all times." Thus Still transcends the limits imposed on the mind by any particular culture. Further, he comes close to transcending the mind itself, with its mundane clutter. The shapes in Still's pictures, said Rothko, "form a theogony of the most elementary consciousness, hardly aware of itself beyond its will to live."

Guggenheim remembered that all day, every day, during the run of his show, Still sat in the gallery, saying little. "A strange man," she decided. Maybe, as Guggenheim assumed, he wanted to keep track of sales. Maybe he wanted to know how visitors managed their confrontation with his tragic, uncommunicative art. Would it exalt them? Would they flinch at an intuition of the disenchantment that had led him into isolation? Maybe they would join him on "the high and limitless plain" where there is no eluding the tragic sense of art and of life. Still was not hopeful. Nor was Rothko, though he persisted in talking of the audience that awaited him—all "the people who are looking for a spiritual basis for communion."

These viewers would feel in his darkly glowing colors "the states of mind

of the total man." Unhappily, they did not appear save at long intervals, in small groups or alone, and Rothko could never feel sure of their responses. The picture that "lives by companionship . . . dies by the same token," he said. So "it is a risky and unfeeling act to send it out into the world." Rothko feared painting's audience. Still despised it, and felt he could do no less.

In 1950 Betty Parsons showed a roomful of Still's new paintings. With these works, the artist said, he "made it clear that a single stroke of paint, backed by work and a mind that understood its potency and implications, could restore to man the freedom lost in twenty centuries of apology and devices for subjugation." Still believed that his paintings had redemptive powers: See them clearly, feel their power fully, and you will be free. You will be new and strong.

Evidently, though, the audience did not want to be redeemed. It wanted to be amused or soothed; at its most serious, the audience wanted to be told truths about itself or the world. Still would not oblige. "To memorialize in the instruments of art the banal attritions of daily experience that are common to nearly every individual, appears to me to be of small virtue," he wrote in 1972. There was sizable virtue only in creating images of one's liberated self. If others had the courage for that task, there might have been a community of creator-heroes in America, this immense nation with no use for the "sterile conclusions of Western European decadence." Americans might have remade themselves and the world. Their refusal to do so drove Still into a state of unrelenting bitterness.

Hans Namuth's photographs of Still show a tall, slim, dignified man with stiff posture. A taut half-smile hovers on his lips. This is the Clyfford Still, prim and restrained, who sent a thin, persistent stream of bile through the American art world from the early forties until just before his death in 1980. It was not enough for him to declare his contempt for artists who give in to the temptations of the marketplace. He must tell us that he hears them "whimpering from their morbid cribs," hoping to justify their offense. Why did they compromise themselves? "For the price of a flunky's handout," says Still, and for the sake of showing their art in "dead rooms . . . prepared for self-contempt, for clowns, for the obscenity that degrades the discipline of true freedom and perverts the idea that marks the moment of elevation."

Still admired only Rothko, Pollock, and Newman, for they stood apart, as he did, uncompromising and unentangled. A year after his show at Parsons, Still wrote:

When I expose a painting I would have it say: "Here am I; this is my feeling, my presence, myself. Here I stand implacable, proud, alive, naked, unafraid. If one does not like it he should turn away because I

am looking at him. I am asking for nothing. I am simply asserting that the totality of my being can stand stripped of its camouflage and look out on the fractional people who pass before me and see them without rancor, desire, or fear."

He is whole, others are "fractional." Sublimely self-sufficient, he would be diminished by contact with us. So we are to expect no messages from Still. "Demands for communication are both presumptuous and irrelevant," he said. Nothing is relevant but the display of a will untouched by all debilitating counterforces: others' wills, society's expectations, the authority of historical tradition. Still's destiny is solitude. Our part is to marvel and to avoid impertinent thoughts about the bitterness that sustains him.

Still gave up the last of his New York studios in 1961. Settling with his wife, Patricia Still, on a farm northwest of Baltimore, in Carroll County, Maryland, he became the irascible hermit he had long impersonated. Still exhibited his work in later years, if he felt sufficiently flattered by the opportunity. He accepted medals and honorary degrees and donated paintings to favored institutions—the Albright-Knox Art Gallery in Buffalo and the San Francisco Museum of Modern Art. To the end of his life, he filled his letters with denouncements of "the parasitical forces . . . who would appropriate and pervert" the work of "creator-man"—the lonely, liberating hero that Still believed he embodied for his time.

17. Barnett Newman, 1951. Photograph by Hans Namuth

12

Alone and adrift, permeating the fullness of space with one's unshackled vitality—this is the state of being evoked by the paintings of Clyfford Still and Jackson Pollock. Their grandiosity has a peculiarly American tone, as Willem de Kooning noted in 1960. A native of Rotterdam and trained at the local academy, de Kooning cast a skeptical, European eye on his friends' efforts to elude the clutches of tradition. Painters like Pollock and Still "stand all alone in the wilderness—breast bared," said de Kooning. "This is an American idea."

It is an idea of losing one's tiresome, ordinary self in the unbounded promise of the New World; liberated from history, one is reborn with primordial strength and integrity. When Pollock and a few others infused their paintings with the hope of redemption American-style, de Kooning said they were making art "out of John Brown's body"—a reference to the abolitionist who tried, in his raid on Harpers Ferry, to resolve the quandaries of American life with a single violent gesture. After Brown's execution in 1859, Henry David Thoreau praised him as "the most American of us all." As de Kooning saw, Pollock and Still had some of his fanaticism.

At first glance, Mark Rothko seems to belong in their company. The three painters admired one another, and Rothko espoused a notion of art no less heroic, no less exalted, than Pollock's or Still's. Toward the end of the fifties, he declared his devotion to the "basic human emotions—tragedy, ecstasy, doom." A dark splendor blazes from the blocks of color that Rothko balanced, one above the other, to form the signature image of his mature work. Each luminous red or purple floats in a state of absolute quietude. All is cloudy, yet all has been resolved with exquisite precision. Rothko's forms are at peace with one another and with their places within the boundaries of the canvas. Though a hazy strip of bright color may draw the eye into infinite

depths, none of Rothko's hues crowds the frame. His colors accept their confinement, and in that acceptance is Rothko's difference from Pollock and Still.

Rothko treated the frame with something more than respect. His oblongs of color echo the edges and right angles of the frame in a homage that continued for more than two decades, the entire span of Rothko's maturity as a painter. It may be that the enclosing frame was his emblem of doom and its inevitability. To honor the frame was to honor our fate, which Rothko understood as tragic. Pollock and Still had no patience for tragedy's insights. In their paintings, form pushes restlessly at the frame, as if any enclosure were arbitrary and therefore dubious—a mere fact not worthy of full respect. Refusing to resolve their imagery, they filled it with expansive forces to be felt with equal power in the work of only one other painter: Barnett Newman.

Born in Brooklyn and educated at City College in upper Manhattan, Newman borrowed from the French the habit of wearing a beret—an emblem of his artistic vocation. His monocle, suspended from a length of black ribbon, announced an Old World formality of manner. Well-tailored, he made a point of not resembling Clyfford Still, with his air of small-town irascibility, or Jackson Pollock, in his T-shirt and blue jeans. Yet he considered them friends. Newman felt exaltations like theirs and—beret and monocle to the contrary—he shared their distrust of the European past. Like Still, Newman believed he had glimpsed an irony both subtle and shocking: Piet Mondrian, progressive leader, guide to a perfected future, wielded the authority of the past with particularly oppressive skill.

Mondrian made paintings from straight lines, right angles, black, white, and the primaries—red, yellow, and blue. These, he argued, are the distillates of pictorial tradition. To paint well is to place them in the "equilibrated relationships" that "in society signify what is just." In due time, art like his would show the way from proper composition to the architecture of utopia. Room, house, street, city, and society would be remade and gathered into the "cosmic" unity. "And man?" asked Mondrian. "Nothing in himself, he will be part of the whole; and losing his petty and pathetic individual pride, he will be happy in the Eden he will have *created*!"

Mondrian wanted us to see his exquisitely adjusted pictures as promises of an all-embracing harmony. Newman saw in them "an empty world of geometric formalisms." Mondrian's arrangements of line and color left Newman feeling beleaguered, imprisoned, reduced to a cipher capable only of correct but reflexive responses to the composition's domineering cues. In the place defined by a Mondrian canvas, Newman sensed a deadening, a loss of himself.

So "it is precisely this death image, the grip of geometry, that has to be confronted." He confronted it with Mondrian's own means: straight lines, right angles, flat expanses of bright color.

Almost eight feet high and nearly eighteen long, Newman's *Vir Heroicus Sublimis* (1950–51) is a field of warm red punctuated by five thin vertical lines—or "zips," as the artist called them. At first, these zips look like familiar compositional devices: echoes of the frame that measure off the field into nicely balanced, comfortably contained units of color. But that is not how they work. With astonishing delicacy, Newman has arranged the zips in a pattern that does not mesh with the proportions of the red field. The zips float free, indifferent to the edges of the canvases. Their authority denied, these edges do not contain the field of red with any force. This color seems endlessly expansive, potentially infinite, and imbued with the will of the artist who generated this openness with his placement of the zips. Having exercised the power of his gesture, Newman claimed to have "busted geometry." "I've licked Mondrian," he boasted. "I've killed the diagram."

In the early fifties, Thomas B. Hess had not yet become Newman's leading advocate and most ingenious explicator. With embarrassment, Hess later recalled having seen Newman at a Kootz Gallery opening a week before his second one-man show was to open at Parsons: "He came over, beaming with pleasure, and gave me the announcement card, which he had designed himself. It was printed in white ink on white paper. 'White on white,' I thought, 'poor Malevich.' But Newman had 'confronted' the mystical Constructivist, wiped him out, and made something else. 'It is,' he said, 'sort of a combination of the *tabula rasa* and Huck Finn.' I thought, 'More lessons from the learned sage.'" Take away the flip tone, and Hess's thought was correct. Newman was in fact highly learned, and his description of his white-on-white announcement contains, in condensed form, a helpful lesson about John Locke, Mark Twain, and America.

The tabula rasa—blank slate—is Locke's image of the mind at birth: innocent of all but its potential. Sensory perceptions deliver simple ideas, said Locke, and from these the mind builds its complex ideas. To Newman, Locke's tabula rasa was a guarantee of the individual's independence. Recognizing no authority but one's experience and the will to make something of it, one creates oneself. Newman understood this labor as immense and possible only in conditions of uncompromised freedom—only in America, if one sees the true America as the blank slate it was for Huck Finn in the last chapter of his story.

Aunt Sally plans to "sivilize" Huck and he "can't stand it." So

he decides to "light out for the Territory," the empty, unbounded region to the west, where civilization has not yet begun to erect its confining, regulating structures. Out West, it is always the present, and the individual is eternally renewed—or that is the fantasy Newman elaborated by conflating so brilliantly the Lockean model of the mind and Huck Finn's idea of geography. His greater brilliance was to paint images that evoke the habitat of the solitary, primordial American. But what use is that to others?

In 1962 Newman told an interviewer that "almost fifteen years ago Harold Rosenberg challenged me to explain what one of my paintings could possibly mean to the world. My answer was that if he and others could read it properly it would mean the end of all state capitalism and totalitarianism. The answer still goes." Properly read, Newman's art would lead each of us beyond tradition, beyond inhibition, to self-renewal in a world of perpetually renewed individualists. His art did not have this effect, any more than Still's gave us back "the freedom lost in twenty centuries of apology and devices for subjugation." Newman was disappointed, perhaps more than Still, for he had begun more optimistically. In 1933 Newman ran for mayor of New York on a Writers-Artists Ticket, with himself at its head. In a pamphlet addressed to "all the members of New York's cultural community," he stated it as axiomatic "that culture is the foundation of not only our present society, but of all our hopes of all future societies to come." He meant high culture, the work of educated creators: "artists, musicians, writers." Fiorello La Guardia won the election, as expected, and Newman looked for ways to define society as beside any exalted point a serious artist might want to pursue.

Making the gallery rounds, Newman presented himself as "Barney"— affable, attentive, always game for a drink and chat about art and artists. In the studio, he cultivated a sublime isolation. "The aesthetic act always precedes the social one," Newman proclaimed in 1947. "Man's first expression . . . was a poetic outcry rather than a demand for communication. Original man, shouting his consonants, did so in yells of awe and anger at his tragic state, at his own self-awareness and at his own helplessness before the void." Self and void: the bitterness of defeated hope permitted the most ambitious New York painters to see genuine significance in nothing else. Their paintings are monuments to an ideal of isolation perfected.

Newman talked for three decades of the true artist as a figure "outside society" who can't "build on anything" external to himself. He has no social or cultural inheritance of any worth. To begin "from scratch," as he must, the artist forces himself "to give up the whole notion of an external

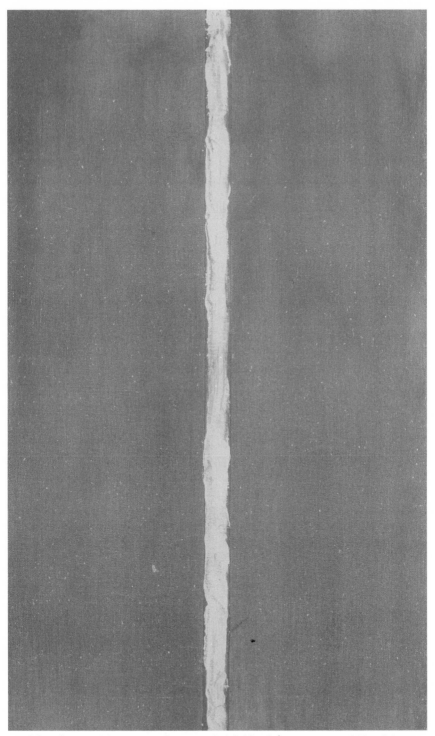

18. Barnett Newman, *Onement I*, 1948. Oil on canvas, 27 × 16 in.

world." Then he is free to realize his one legitimate hope: to say "something that would be important to himself." In 1947 the avant-garde magazine *Tiger's Eye* asked artists for comments on art and its prospects. Newman stated, in full: "An artist paints so that he will have something to look at; at times, he must write so that he will also have something to read." Indifferent to the work of others, the true artist doesn't much care if others attend to his work. Why, then, did Newman exhibit his paintings?

No doubt his hope of being useful—of improving society, of ending "state totalitarianism," and the rest of it—never entirely faded. Yet his experience persuaded him to repudiate the hope that his art might ever be of use—or even intelligible—to anyone but himself. Art, he believed, can succeed only by making that repudiation. He exhibited his grandly uningratiating paintings to let us know that his independence was uncompromised. He would concede nothing to weakness, nothing to sentimentality, his own or ours. The presence pervading the somber blaze of *Vir Heroicus Sublimis* is not a familiar sort of person with communicable feelings. He sends us no messages. Newman is present in his art as a force of will. If you are able, you may impersonate him. You may come to know what it is to be the outsize self filling a place that lacks most of a place's usual features, for here are next to no forms, no dependable scale, nor any sharp distinction between surface and depth. In Newman's version of an American place, everything feels sublimely provisional, including oneself.

These images encourage the sensibility to drift beyond its own purview. The effect can be joyful and grand. In the absence of reliable cues, so many responses are possible that one begins to seem vast to oneself—vast and powerful and yet unable to prevent the failure of joy. Newman said that his subject is "the terror of the Self," and an exhilarated confrontation with his art drifts easily into a desolate understanding that one is alone in one's experience.

After Newman's second show at the Betty Parsons Gallery in 1951, Pollock visited his studio, looked hard at paintings others had mocked, and accepted Newman as an equal. Barney's birthday was the twenty-ninth of January, Jackson's the twenty-eighth; for a few years the Newmans and the Pollocks made a custom of celebrating the occasion together. Seven years Jackson's senior, Barney sometimes played the elder brother. He would lecture Jackson about his drinking and, at Lee's request, try to retrieve him from benders. Newman made the effort out of friendship and deep admiration for Pollock's art. Yet he said that his own art "had meaning only in

relation to Pollock's work and *against* it." Newman turned his art against everyone and everything. His images are utterly unwelcoming. We feel the full force of their splendor only when we see how adamantly they exclude us, how unfit they are for anyone but Newman in his most sublimely heroic conception of himself.

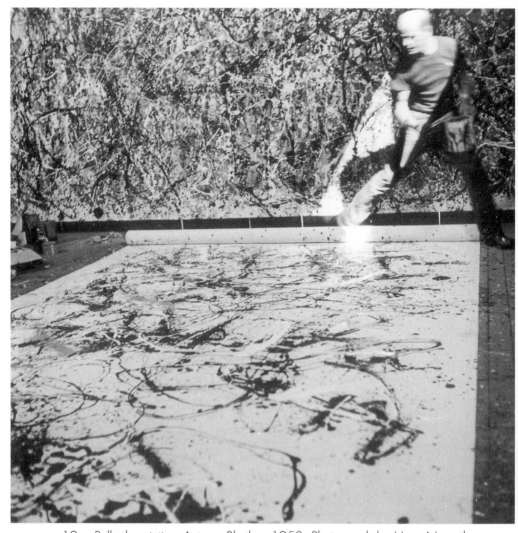

19. Pollock painting *Autumn Rhythm*, 1950. Photograph by Hans Namuth

13

We like to think that even the most wildly peculiar art is somehow useful. At the very least, it stimulates memory and feeling. It provokes the association of ideas. In 1949 a poured painting in a Pollock exhibition reminded the critic Henry McBride of "a flat, war-shattered city, possibly Hiroshima, as seen from a great height in moonlight." This is a recurring notion: Pollock's snarls of line were his means of "expressing the city"—in the words of Selden Rodman, who interviewed Pollock two months before the painter's death. "What a ridiculous idea," said Pollock. "Never did it in my life!" Musing, he allowed that he might somehow express "my times and my relation to them." Then he added, "Maybe not even that." Or certainly not that. Art like Pollock's is a means of withdrawing from one's times, of having only a reproachful relation with them. A poured painting offers us the spectacle of a will manifesting its isolation, first to itself and then to the audience.

Struggling to be helpful, Pollock told Rodman that "painting is self-discovery. Every good artist paints what he is." These are clichés, yet they are given an anguished vitality by Pollock's doubts about who or what he was. He once told another interviewer that "the modern artist is working with space and time." What artist doesn't do that? Pollock's words come alive only when we see that, for him, to work with space and time was to paint what he became in his wildest imaginings: the artist as Nature, coincident with the universe. In Pollock's aesthetics, creative self and created world are one. Making that unity visible, gesturing it into being, he felt redeemed. Idle, he felt damned. Krasner remembered him saying in the late forties, "Painting is no problem; the problem is what to do when you're not painting."

Away from the studio, he would putter around the property at Springs. He would drive up and down the roads of rural Long Island, sometimes cutting across lawns and open fields. He'd pore over his reviews or the article in *Life*—signs that the world was taking notice of all that he had suffered,

all that he was accomplishing now, as his strength increased, from one season to the next. Yet he suspected that attention was coming to him tinged by falsity. No one could know him truly, for he didn't know himself. Unable to state his painterly intentions, he could only enact them, and he always feared that one day he would fail. To know the inward source of his gesture would have been a comfort. At the very least, Pollock needed a definition of the art his gesture produced. By 1950, the critic Clement Greenberg had supplied one.

During studio visits, Greenberg coached Pollock on matters of surface, abstractness, and the need for historical continuity—with Cubism, in particular. Pollock was coachable because Krasner had for long seasons been teaching him similar lessons learned from Hans Hofmann, the source she shared with Greenberg. By the time Alfred Barr acquired Pollock's *One* for the Museum of Modern Art, the painter was adept at impersonating the American modernist who is intrinsically European—or not too American. Or, anyway, not an American of the wrong sort, a provincial midwesterner like Thomas Hart Benton or a New York provincial devoted too slavishly to the example of Mondrian.

In 1950 Pollock told a radio interviewer that "modern art didn't drop out of the blue; it's part of a long tradition dating back with Cézanne, up through the cubists, the post-cubists, to the painting done today." By giving this already official account of his history—Cézanne to Picasso to me, Jackson Pollock—he showed he could speak in the voice of a respectable avant-gardist. He showed that Krasner's sacrifice, herself for him, was in truth her triumph, for Pollock the successor to Picasso was her creation. And he showed that Alfred Barr's chart could be extended to provide a salient place for this post-Picassoid Pollock. In doing all this, Pollock hid himself and his art.

Speaking as the next great painter after Picasso, Pollock became the conscious medium of Krasner's ventriloquism, for he had intuited a truth: his poured paintings did not evolve from late Cubism or any other avant-garde style. They belong nowhere in the updated versions of Alfred Barr's modernist genealogy. These images are off the chart. De Kooning could see their strangeness, and he sensed Pollock's distaste for the part Krasner had taught him to play. Inclined to be mischievous, de Kooning liked to tell Pollock that the drip paintings are "beautiful." This was a needling sort of compliment, for it meant: these works are not at all strange; they are well composed, well executed, and thus admirable by the familiar standards of the Old World. When he accused Pollock of producing beauty, de Kooning was saying: Don't feel so uneasy about parroting the avant-garde line you learned from Krasner and Greenberg; in fact, you are an avant-gardist, a New York painter dedicated to School of Paris traditions.

This needling hurt. Pollock returned it by calling de Kooning "a god-

damned European." This meant: You're the one who composes beautiful
pictures; you lay on your paints in the traditional manner; you're the
descendant of the Cubists; you are the captive of avant-garde history. I am
none of these things, I do none of those things. I am my own painter, my
own man, free of the past and its oppressive directives.

A month or so after his session with Rudy Burckhardt, Pollock let Hans
Namuth photograph him at work. There was no miming this time, and
Namuth's pictures turned out so well that he proposed a further intrusion: a
film of the painter slinging his pigments. Shooting outdoors in the cold North
Atlantic light, Namuth worked slowly. Pollock was cooperative until it came
time to assemble a sound track. Namuth's collaborator, Paul Falkenberg,
suggested Indonesian gamelan music. As he later wrote, "The seemingly
amorphous elements swirling in Pollock's canvases suggested to me the loose-
structured sound sequences of a gamelan orchestra." Pollock objected, saying,
"Paul, this is exotic music. I am an American painter!" The music that even-
tually accompanied Pollock's performance in the film is the work of Morton
Feldman, an American composer.

"I am an American painter." This was true, though Pollock's worldly
success depended on his stressing the point precisely as instructed. He was to
present himself as the conduit through which the most powerful impulses of
modernist painting passed on their way from the Old World to the New. If
he played along with this scenario, the poured paintings would be seen as
crucial links between Paris and New York. But if he played along, he would
play himself false. Pollock felt trapped in a nightmarish scheme. Namuth's
movie seemed part of it, though he couldn't say exactly why.

As the camera rolled, Pollock was free to behave precisely as he did in the
isolation of his studio. From the filming came a painting, an addition to his
oeuvre. Pollock could formulate no objection to the project, to Namuth's
intentions, or to his own, yet he feared that he was lost—that the machinery
of his success had already snared him. Pollock's panics made him melodra-
matic, and the weather on the last day of filming encouraged dire imaginings.
It was late in the year and late in the afternoon. Thanksgiving had just passed.
The breeze had turned to a sharp wind, as you can tell from the painter's
numbed face in the last sequences of the film. Namuth remembered an
exchange of congratulations while equipment was being stowed. The project
had been difficult at every step. Money was scarce, and there was no assurance
of an audience or even of a theater willing to show the work. Nonetheless,
Namuth persuaded himself to be optimistic.

In the house were a dozen guests, assembled for a post-Thanksgiving din-
ner. Pollock entered, went to the cabinet beneath the kitchen sink, and
brought out a bottle of whiskey. He poured one glassful for himself and

another for Namuth. Krasner saw and was horrified. He had not drunk liquor for two years. During that time, he made his best paintings, the ones that make him memorable now. Pollock drank off his first glass and then another. Krasner called the party to the table. On his way, Pollock snatched from the wall a leather strap decorated with sleigh bells. Pretending to be playful, he swung it at Namuth, who told him to put it down. Krasner suggested that everyone be seated. Pollock dropped the bells and lurched to the head of the table. Unfortunately, the shuffle of guests left Namuth seated at Pollock's right. Soon the others heard voices, held low in anger. The word *phony* kept recurring nastily. Namuth, it seemed, was being charged with the sin his accuser most feared to commit.

Suddenly Pollock stood, his hands under the edge of the table, poised to tip it over. "Now?" he asked, glaring at Namuth, who said, "Jackson—no!" "Now?" he bellowed. He waited, as everyone watched him, then bellowed it again, still louder. Then he tipped the table on its side, sending the meal and several guests to the floor. As Pollock stalked out, Krasner announced that coffee would be served in the living room.

Three days later, Betty Parsons opened a show of Pollock's new drip paintings; among them were the Modern's *One* and *Autumn Rhythm* (1950), now in the Metropolitan. Even the artist's detractors were impressed. These canvases had an air of unassailable triumph. Also, Rudy Burckhardt remembers, they inspired "something a little odd. One of the fashion magazines used them as backdrops for their models." The photographer was Cecil Beaton, on assignment for *Vogue*.

At Parsons, Beaton wanted Pollock's latest images to oxygenate the slightly stale air swirling around the "new soft look" that *Vogue* had decreed for

20. Jackson Pollock, *The Water Bull*, c. 1946. Oil on canvas, 30⅛ in. × 6 ft. 11⅞ in.

21. Jackson Pollock, *Number 14, 1951*, 1951. Enamel on canvas, 57⅝ in. × 8 ft. 11 in.

spring. It was 1950 and the magazine's arbiters were pretending that it was 1934, when gowns wreathed the body in clouds of taffeta, silk, and ostrich feathers. Beaton's lens drew an equation between puffs of see-through fabric and Pollock's airy loops of pigment. The painter's reaction is not on record. No one on the downtown scene wanted to admit that a fashion photographer could discredit a serious painter. Undeniably, though, Beaton had gathered the poured paintings into the media's store of exploitable images. Maybe *Autumn Rhythm*'s appearance in *Vogue* was a sign that Pollock had become an old master, great but no longer in contention. Burckhardt says, "There was a feeling that Pollock had reached a dead end with his drip method. You could imitate him but you'd never be able to do it the way he did." Pollock, too, felt the need for a new way.

In 1950 he laid aside his sticks, took up an oven baster, and sent streaks of black enamel looping and curling over unprimed canvas. When he worked fast, his line turned wispy. Slowed down, the current of paint spread into velvety pools. With his first method of pouring, Pollock had banished the creatures that inhabited his art. With this second method, he induced them to return, somewhat evolved. *Water Bull*, of around 1946, became the hulking beast of *Number 14, 1951* (1951). The tall, dense figures of *Totem Lesson II* (1945) reappeared as the tall, airy figures of *Echo: Number 25, 1951* (1951).

22. Jackson Pollock, *Easter and the Totem*, 1953. Oil on canvas, 7 ft. ¼ in. × 58 in.

The black-on-white paintings of 1951 have the cool yet burnt-in feel of persistent afterimages. At their best, they are like glamorous nightmares, imprints of obsessions that a personality blander than Pollock's might envy. After basting his canvases with black enamel, he went back for a moment to sticks

23. Jackson Pollock, *Male and Female*, 1942. Oil on canvas, 6 ft. 1¼ in. × 49 in.

and dripping. Tangled and shimmering, *Convergence: Number 10, 1952* (1952) belongs among the poured canvases of 1947 to 1950. He would move forward, he hoped, if he could persuade his past to haunt him.

Easter and the Totem (1953) is a tribute to Matisse and a reprise of *Male*

and Female (1942), which honored Picasso. Pink and green and willfully rough, *Easter and the Totem* pays marvelously involuted homage to Parisian modernism. In *The Deep* (1953), a field of white solidifies and then opens onto a dark and eerie void. This is abstraction in the gothic mode. During 1954 and 1955, Pollock let his paint become as thick as it had been in 1946, just before he began to pour his colors; the next year, the last of his life, he painted nothing.

In 1955 Pollock met a young writer named B. H. Friedman. "I'm not working much anymore," the painter said, unprompted. "I go to my studio, but nothing happens." After a pause, he added, "I don't want to repeat myself." By then, he had spent half a decade redoing with unsteady flair all that he had done in the forties. For help with his drinking and his bafflement in the studio, Pollock turned to the last of his psychiatrists, Dr. Ralph Klein.

Pollock's weekly appointment was on Monday. Sometimes his friend Patsy Southgate sat with him during the train ride from the Hamptons to Manhattan. Her task was to steer Jackson past a dingy, favorite bar in Grand Central Station and on to Klein's office. After his session, he was left to his own self-punishing devices. Nearly always, he appeared at the Cedar Street Tavern. Despite its name, the Cedar stood on University Place just north of Eighth Street. It was a neighborhood bar with fluorescent lighting and walls painted a dreary color no one has bothered to remember with much precision. Office workers ate lunch there. At night, painters and sculptors filled the place and alcohol set the tone. "In the forties," said Elaine de Kooning, a painter and the wife of Willem de Kooning, "we all drank coffee." Then, as the fifties began, "there was a booze explosion in the art world." Downtown, liquor became conversation's fuel, a necessity taken for granted. The artists did not make a topic of it, nor wonder at length why coffee was now obsolete. They let booze suspend all tedious inquiries.

Downtown, bad manners were mannered. Toughness had its proprieties, even toward the end of an evening at the Cedar. No matter how drunk, the artists did not discuss politics. They did not complain about the perfidy of dealers or the indifference of the public. They drew near the subject of art and talked around it, preferably with self-assured wit. From the clash of attitudes, the artists wove a delicate and fragmentary web of beliefs about the meaning of their efforts. Pollock's appearance disrupted the weaving.

The bar was in Pollock's old Manhattan neighborhood, and there he played his old part: the two-fisted desperado from out West. No longer a flat-broke art student dependent on the friendship of Thomas Hart Benton, Pollock was a painter more fascinating to the popular media than Benton had ever been. The painter Franz Kline remembered how carefully Pollock directed his appearances at the Cedar. Before coming in, he would look through the

24. Jackson Pollock, *The Deep*, 1953. Oil and enamel on canvas, 7 ft. 2¾ in. × 59⅛ in.

front window to see if the crowd of hangers-on was big enough to justify an entrance. Then, or later, he would walk in and exhibit his version of the drunken demented artist.

Pollock's staggering antics once prompted de Kooning to aim a punch at his face. It landed, and spectators egged him on to a counterattack. "What?" said Pollock. "Me hit an artist?" Writers offer this story and a few others as proof that Pollock felt solidarity with his colleagues. Possibly he did, though his refusal to hit de Kooning has a tone of false indignation. When drunk, Pollock felt no scruples about hitting anyone, nor about impersonating the aggrieved victim—especially in the company of de Kooning, who was gaining strength as Pollock lurched through the sad routines of alcoholism. He too felt the force of de Kooning's glamour, and when he was drunk he resented it. He resented Kline, he resented Philip Guston, he resented anyone of his generation who had not slipped and fallen, and he found it impossible to bring the younger artists into focus. They should be content, he felt, to serve as the blurs, the woozy presences, that formed the audience for his performances at the Cedar.

If Pollock was not drunk on arrival, his friends could see traces of his old radiance, the allure that outreaches every sexual label. Then his first few drinks would take effect and he'd become what another painter, John Ferren, called an "ugh artist"—boorish and inarticulate, a stumbling dervish who whined and blubbered and snarled and sank into obscenity. According to legend, Pollock tore the door of the men's room at the Cedar off its hinges; he may actually have done it. There is no doubt that he liked to clear tables of glasses and ashtrays with a lunging sweep of his forearm. Raging, flailing, weeping, proclaiming his helpless, hopeless despair, Pollock displayed his torment with melodramatic élan. Nonetheless, it was real and deepened yearly.

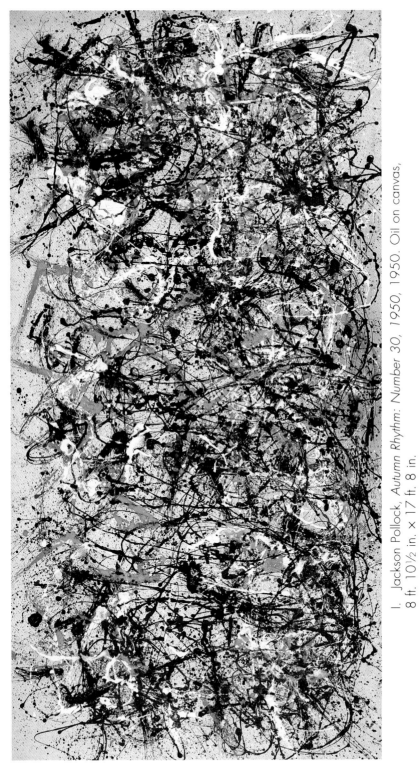

1. Jackson Pollock, *Autumn Rhythm: Number 30, 1950*, 1950. Oil on canvas, 8 ft. 10½ in. × 17 ft. 8 in.

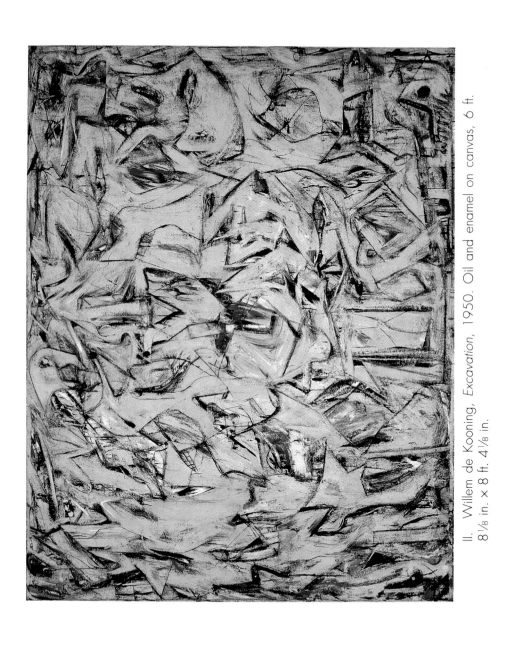

11. Willem de Kooning, *Excavation*, 1950. Oil and enamel on canvas, 6 ft. 8⅛ in. × 8 ft. 4⅛ in.

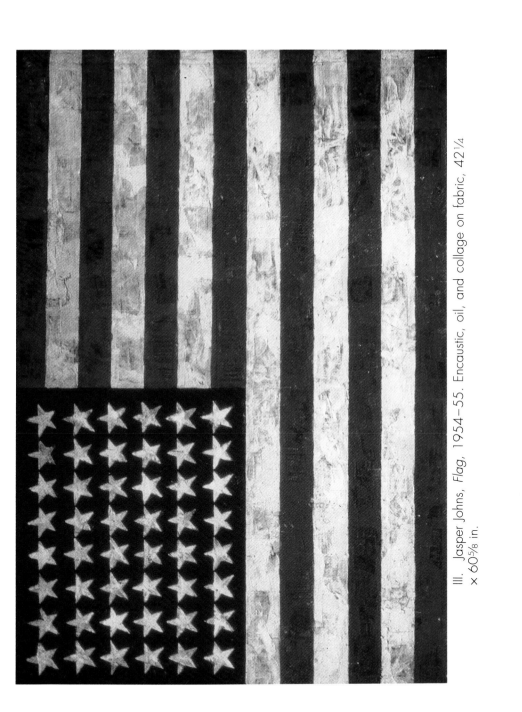

Ill. Jasper Johns, *Flag*, 1954–55. Encaustic, oil, and collage on fabric, 42¼ × 60⅝ in.

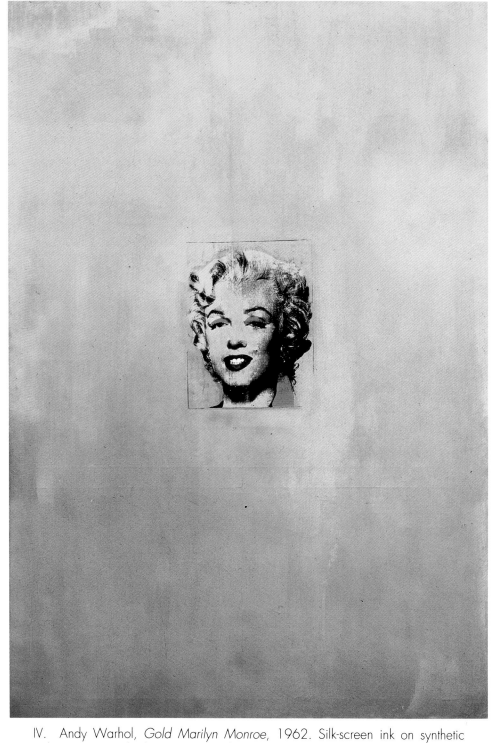

IV. Andy Warhol, *Gold Marilyn Monroe*, 1962. Silk-screen ink on synthetic polymer paint and oil on canvas, 6 ft. 11¼ in. × 57 in.

THE ACTION PAINTER

DE KOONING: That's what fascinates me—to make something I can never be sure of, and no one else can either. I will never know, and no one else will ever know.

ROSENBERG: You believe that's the way art is?

DE KOONING: That's the way art is.

25. Willem de Kooning, New York, 1950. Photograph by Rudy Burckhardt

14

As Pollock sank, the currents of his infinite reached into paintings by Grace Hartigan, Harry Jackson, Al Held, Norman Bluhm, Alex Katz, and other recent arrivals on the scene. Plying brushes and palette knives, never pouring their colors, these artists felt safe from the charge of mimicking Pollock's gesture. He had dismantled standard structural devices. Now Hartigan and the others did the same. For a few seasons, downtown studios filled with approximations of Pollock's dripped and spattered fields. These paintings look inadvertent, almost entranced. Pollock's art worked on newcomers like a daydream of the abyss. After sinking into it for a while, they'd pull away and return to the solid realm of well-built compositions. Only the veteran Willem de Kooning made a thoroughly conscious effort to redesign Pollock's intimations of infinity. The result was a canvas called *Excavation* (1950).

Its structure looks elastic. Angles are springy; lines stretch and become curves that feel to the eye like muscles flexed or voluptuously relaxing. Certain slits in the painting's fleshy surface are evidently mouths; others may be female genitalia. This is a big painting, over eight feet wide. Across its surface, allusions to the body proliferate and turn topographical; supple flesh becomes fluid, like watery clay, and spreads in currents churned by remnants of anatomy. De Kooning's challenge to Pollock was unmistakable. He, too, could make a field painting.

Unlike Pollock, he felt no need to abandon traditional technique. *Excavation* flaunts the virtuosity of the maker's hand; and never, not even in this hectic, slippery image, did de Kooning entirely dismantle the scaffolding of composition. With little complaint, the roiling forms of *Excavation* allow themselves to be contained by the edges of the canvas. You could say that *Excavation* is nothing like a drip painting and therefore no challenge to Pollock. That is not what the downtown painters concluded in the fifties. They saw in this canvas proof that aesthetic options need not exclude one another;

in art, you can have it both ways. You can undermine pictorial architecture and persuade it to stand. You can evoke the infinite without abandoning proper composition. You can make a painting that looks, in its moment, as audaciously new as *Excavation* and give it roots deep in European tradition.

At the start of the fifties, de Kooning was ending his forties. Short and sinewy, he had a high forehead and a strong chin. His fine, wavy hair was already gray and would soon be white. The force of de Kooning's intelligence kept him from looking merely handsome. Grainy snapshots from those days show that, when excited, he would mug a bit; sometimes his features turned rubbery and coarse, though his nose preserved its delicate shape. On documentary sound tracks, his voice sounds a little flat. He is avoiding the pomposity of the maestro, the whimsicality of the bohemian. Occasionally, he lets himself be wry.

De Kooning's English is so supple that after a while his quirks of grammar begin to sound like legitimate variations. The ear ignores his Dutch accent, though it was strong enough to affect his spelling. In a letter to friends about the Hamptons, he wrote, "The vegetation here is really nothing to rave about." Therefore, it is "yust right. It fits my condition. For a painter like me it is much better to be surrounded by a *small* nature. Places like the Grand Canion would frighten me to dead." *J* becomes *y, th* becomes *d*. When American-born painters borrowed the look of his brushwork, some adopted his accent, too. A few became assiduous mimics. Others were more casual, and didn't always notice their de Kooningisms. To talk like Bill, as he was known, was simply to sound like a downtown painter.

Born in 1904 to a working-class family, de Kooning entered the Rotterdam Academy of Fine Arts and Techniques at the age of thirteen. There he learned lettering and commercial design; he drew from statuary casts and made properly academic paintings. His earliest surviving canvases are still lifes—pictures of dishes rendered with a precise and unassuming realism. Rooted in the seventeenth century, this familiar Dutch manner was pretty well exhausted by the middle of the nineteenth. De Kooning gave it fresh strength. In his teens, he was a grown-up painter.

After a four-year apprenticeship to a decorating firm in Rotterdam, de Kooning found a job with an art director at a local department store. He thought of himself as a workman, the practitioner of useful trades. Much later he told an interviewer that young artists at the Rotterdam Academy

were not interested in painting *per se*. We used to call that "good for men with beards." And the idea of a palette, with colors on it, was rather silly. At that time we were influenced by the de Stijl group. . . .

The idea of being a modern person wasn't really being an artist in the sense of being a painter.

When he was twenty, de Kooning and a few friends made a long visit to Antwerp and Brussels. They wanted a change of scenery and a chance to visit some unfamiliar museums. De Kooning supported himself by painting signs, trimming windows, and drawing cartoons—"all sorts of jobs," he later said, "and after three months of crazy work I couldn't even buy one pair of socks."

Europe depressed de Kooning. It felt small and unpromising, a place which taught ordinary citizens to accept modest lives. Yearning to live expansively, de Kooning stowed away on a ship bound for America. He came ashore at Newport Beach, Virginia, in August 1926. Soon he had settled in Hoboken, New Jersey, and found a job as a housepainter. "What the hell," he has said. "If you can paint you can paint houses." De Kooning remembered getting "nine dollars a day, a nice salary for that time. In one week I could buy a new suit, black, for Sundays . . . nice workman's clothes. In three weeks I could pay off my rent and had new underwear and socks."

The following year, he found an apartment in Manhattan's West Forties and worked at his trades. He was still poor, but American poverty permitted his ambitions a measure of elbow room. Toward the end of the twenties, he found paths leading to the bohemian margins of New York. He met Stuart Davis, John Graham, David Smith, and Arshile Gorky. De Kooning listened to their shoptalk, he painted, yet he stopped calling himself a commercial artist only after finishing his stint on the Federal Arts Project of the WPA —his year of living "modestly and nicely" in the depths of the Depression. At the end of that year, 1935, he went back to living desperately, all the more so because he was reluctant to paint houses or take on commercial art assignments.

Like Gorky, de Kooning played variations on the Picassoid still life. Those of his friend are earnest, sometimes labored. De Kooning's are cool and airy and filled with evidence that he has looked past Picasso to the geometries of Mondrian and the lush, anti-gravitational fantasies of Miró. Toward the end of the thirties, de Kooning began a series of minutely realistic portraits, first of men and then of women. For these, he borrowed a delicate line from Picasso, who had borrowed it, more than two decades earlier, from the neo-classical portraiture of Ingres. Gathering precedents at the highest level of pictorial endeavor, modifying them to his taste, de Kooning had become a fine artist—serious but not solemn.

In a memoir of the thirties, Edwin Denby recalled walking at night with de Kooning through the streets of Chelsea, "and his pointing out to me on the pavement the dispersed compositions—spots and cracks and bits of wrap-

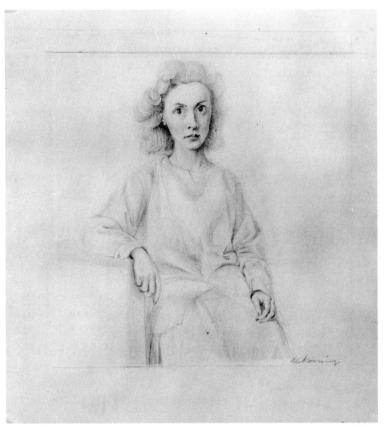

26. Willem de Kooning, *Elaine de Kooning*, c. 1940–41. Pencil on paper, 12¼ × 11⅞ in.

pers and reflections of neon-light—and I remember the scale of the composition was too big for me to see it. Luckily I could imagine it." Even de Kooning's smallish early canvases tremble with the restless immensity of New York. All is ramshackle and exalted, and all coheres, though the artist makes it easy to overlook his stratagems of order. So much else engages the eye. De Kooning knew how to get dry, delicately weathered textures from a half-loaded brush; he understood the way thick paint skids on a tight curve, and what to expect from an overload of thin paint, how its splashes become rivulets.

During the war years, de Kooning let his realistic portraiture merge with his abstract imagery. From this process, which the artist did not intend to be smooth, came a series of increasingly agitated pictures of women. As the forties ended, he dismissed his identifiable subjects, though some were reluctant to leave. In white-on-black abstractions like *Orestes* (1947) and *Painting* (1948), voluptuous contours bring to mind the warmth and sliding weight of

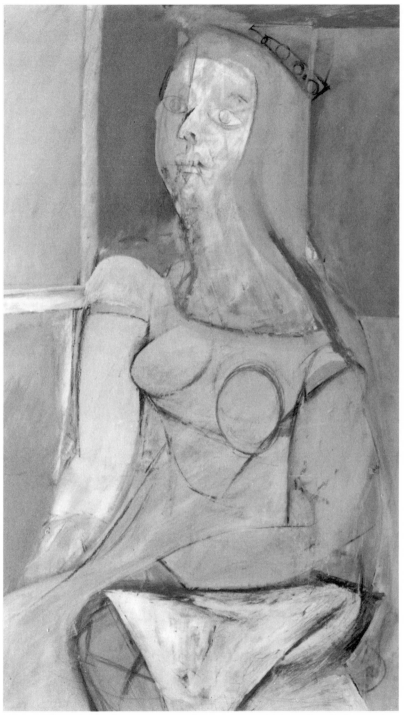

27. Willem de Kooning, *Queen of Hearts*, c. 1943. Oil and charcoal on fiberboard, 46⅛ × 27⅝ in.

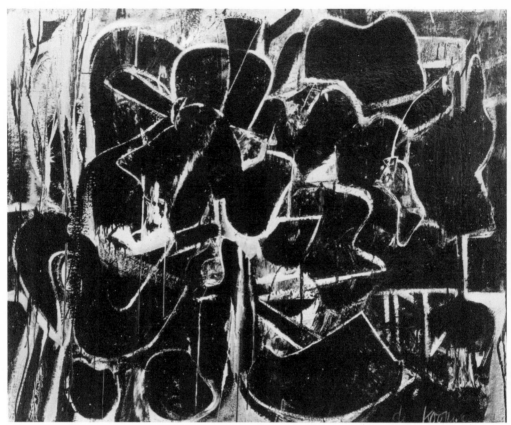

28. Willem de Kooning, *Painting*, 1948. Enamel and oil on canvas, 42⅝ × 56⅛ in.

buttocks, breasts, and thighs: in murky light, a damp grinding. Straight lines and right angles suggest woodwork and window frames. Sometimes a shape looks like a coupling of organic and carpentered form. In de Kooning's theater, nothing, not even the stage set, goes unembraced.

Always, he confines the formal drama of his art to the shallow space in which Georges Braque and Picasso elaborated the compacted subtleties of Cubist form. Cubism is so obviously de Kooning's master style that he once felt obliged to state: "I never made a Cubistic painting." This is a disclaimer of the sort that leads to one counterexample after another; and there are many, for he required none of his mature paintings to do without the amenities of Cubist architecture. Yet even as he learned from Braque and Picasso, de Kooning was tearing Cubism down to the ground; by the end of the forties he had rebuilt it to his own specifications. The Parisian Cubists adjusted images of the body to the inanimate structures of Euclid and the city.

In *Excavation* de Kooning offers an astonishing variation: Cubist structure with the body's heat and pliancy.

According to Clement Greenberg, Pollock was pointing the way past the landmarks of Parisian Cubism. Nearly everyone else gave de Kooning credit for doing that. Laden with valuable baggage, de Kooning was entering new terrain. History and its possibilities seemed to be gathering around him, not Pollock. As de Kooning advanced, the most ambitious younger painters would not follow him; they would find destinies of their own in his vicinity. This is what they told themselves. In truth, they followed him more closely than they ever admitted then or later, and so did many of de Kooning's contemporaries. Early in the fifties, the New York art world tacitly recognized him as America's exemplary modern artist, and in the pages of *Artnews* Harold Rosenberg presented de Kooning as the embodiment of a myth: the "action painter."

15

Though history has labeled him an art critic, Harold Rosenberg was no specialist. He believed he could write about any topic big enough to interest him. Born in Brooklyn in 1906, he made his Manhattan debut as a poet devoted to revolution, aesthetic and political. Attracting little notice, he reappeared in prose. His fast-moving essays won him a place at *Partisan Review*, *Dissent*, and other left-wing journals of the Depression years. In these circles, Marxist sympathies were obligatory. Rosenberg met the obligation but it chafed against his large idea of himself. After the war, he denounced communist dogma for imposing a rigidity on the mind that relieves it of the need to think.

Rosenberg was tall—well over six feet—with a barrel chest and a large, angular face sectioned off by thick eyebrows and a mustache. He delivered quips in a voice at once querulous and imperious; falling silent for a moment, he would glower. Quickly the quips would resume, with their impatient edge. His conversation was always a kind of chiding. He demanded agreement or a challenge or a sudden swerve to a new subject—anything that would charge mere talk with the urgency of dramatic dialogue. Wanting the excitement of theater but not the confinement of a tightly scripted role, Rosenberg became an advocate of improvisation.

Marxists, Freudians, utopians, and tastemakers must be resisted, he argued, because their common purpose is to trap us in thoroughly predictable scenarios. To behave as they demand, one must wear a mask and let the will go numb. Actions no longer belong to the actor. Existence feels fake and weightless, a sensation that cannot be relieved by devoting oneself to a fresh cause, tinkering with the personality, or learning to love a new style of art. One must remove one's mask and stop playing an alien part; one must become oneself. Rosenberg never explained how to do this. Instead, he praised certain artists who had done it, despite the "depersonalizing" vulgarity of Western

society. In "The American Action Painters," published by *Artnews* in 1952, Rosenberg argued that the artist must fight his way to the integrity of isolation: to be worthy of an audience, he must seek none. Uninhibited by anyone's expectations, including his own, the artist will become spontaneous. Rosenberg believed that spontaneity was the solution to every problem and the action painter was its one true practitioner.

In Rosenberg's telling of the exemplary tale, this hero anguished for years over the pleasures and the morality of art. He—the action painter is always ostentatiously "he"—grew weary of his doubts. Then, in the mid-forties, he suffered "a grand crisis" of belief. Baffled, he somehow understood that the way out of this impasse was through sheer doing, pure action. "The canvas," declared Rosenberg,

> began to appear to one American painter after another as an arena in which to act—rather than as a space in which to reproduce, re-design, analyze or "express" an object, actual or imagined. What was to go on the canvas was not a picture but an event.

Dismissing all systems, methodologies, and scenarios, the action painter arrived at "the big moment" when "it was decided to paint . . . just to PAINT. The gesture on canvas was a gesture of liberation, from Value—political, esthetic, moral. . . . The refusal of values did not take the form of condemnation or defiance of society, as it did after World War I. It was diffident. The lone artist did not want the world to be different, he wanted his canvas to be a world." In this blank and unencumbered realm, the painter took dictation from no doctrine. Acting by and for himself, he "gesticulated upon the canvas and watched for what each novelty would declare him and his art to be."

"He is not a young painter," said the critic, "but a re-born one. The man may be over forty, the painter around seven." Having removed the disguises of his long apprenticeship, he is becoming himself, Rosenberg tells us. He is emerging in his art. But how are we to know that the painted image has any bearing on the painter's being? How are artist and artwork to be joined so that the truth of one entails the truth of the other? They don't need to be joined, says Rosenberg; they were never separate: "the act-painting is of the same metaphysical substance as the artist's existence. The new painting has broken down every distinction between art and life."

To common sense, this breakdown is a nonevent; distinctions between art and life remain. And this "metaphysical substance" looms up like a large wisp of fog, a scenic effect designed to obscure slapdash methods of construction. Having fashioned no convincing links between the action painter's art and life, Rosenberg carried on as if they simply were identical. His polemic

requires this unity, and his tone suggests that if readers don't believe in it they should try harder. They should have more faith, for the action painter is what the moment needs; furthermore, he has arrived and everyone ought to be glad. In a time falsified by politicians, therapists, and every manner of manipulator, the action painter enjoys the strenuous pleasure of being real, of being spontaneous; and in the world of his canvas he creates new realities with the slightest impulse of his hand.

This man of action was the product of Rosenberg's chronic exasperation with the life of the mind. Our intellectual traditions, he believed, are the half-conscious accomplices of commerce and politics; instead of clarifying the world, they hide it in a haze of delusions. This is the existentialist case against the routines of rationality, as set forth by Rosenberg's acquaintance Jean-Paul Sartre. Few of the American writer's grander flourishes lack Sartrean authorization. When he talked of de Kooning's willingness to doubt all art, including his own, Rosenberg was reporting accurately on the American painter's state of mind. He was also recycling Sartre on Alberto Giacometti's devotion to transience, ambiguity, and risk. The angst of Sartre's Giacometti essay settles like dust into every corner of the action painter's studio.

Yet Rosenberg never enlisted in the philosopher's band of followers. He was too vain—and too itchy a satirist—to accept a leader. In any case, his impatience kept him from devising respectably philosophical arguments. He intended his polemic on action painting to make a fast, sharp impression on the New York art world, and it did. Michael Goldberg remembers "reading Harold's action-painting piece out loud. We were in East Hampton—Patsy Southgate, who was my wife then, and Frank O'Hara, Norman Bluhm, a few others. The essay made no sense but we knew the jargon. We filled in the blanks."

"The American Action Painters" was a stylish performance. Nimbly evading academic issues, Rosenberg claimed for New World artists the glamour of the moment's most fashionable Old World writers—not only Sartre and his friend Albert Camus but Simone de Beauvoir, Jean Genet, and Samuel Beckett. Those who kept track of style in the late forties and the early fifties felt the affinities between Sartre's idea of the absurd and the droll horror of Beckett's plays and the grim but delicate beauty of Juliette Greco, the Parisian chanteuse who wore an astonishing amount of mascara and sang in wearily bell-like tones.

For all its disapproval of conventions, existentialism became popular not as a philosophy but as an attitude, a manner, a clichéd look. Toward the end of the fifties, Willem de Kooning told Irving Sandler that "we weren't influenced directly by Existentialism, but it was in the air, and we felt it without knowing too much about it. We were in touch with the mood." "It was a

29. Hans Hofmann, *Fantasia*, c. 1944. Oil, Duco paint, and casein on panel, 51½ × 36⅝ in.

mood, all right," says Alex Katz. "All the painters kept Sartre's *Nausea* on their night tables. At the Cedar you'd hear the existentialist phrases—*alienation, man alone*, stuff like that. Guston would talk about squeezing his life through tubes of paint. Marxism and primitivism were out, all of a sudden. No more proletariat, no more myth. Existentialism was the hot new thing— cigarettes and black turtleneck sweaters and lots of brooding."

In Namuth's film of Pollock painting, you see the artist concentrating his gaze. Suddenly he makes a gesture, a series of gestures. He acts. For decades, the art world has assumed that Rosenberg must have had Pollock in mind when he devised the figure of the action painter. Krasner knew better.

To paint, said Rosenberg, is to launch a dramatic exchange; the painter makes a gesture, the painting gestures back, and its replies may of course be empty. Naming no names, Rosenberg suggested that certain painters were smothering their canvases with billowing clouds of pretense. Working his way to a joke about "apocalyptic wallpaper," Rosenberg made it obvious to Krasner that he had aimed his charge of vacuity at the sprawl of Pollock's biggest, most ambitious canvases. She was enraged.

Krasner and Rosenberg had been friends since their days on the Project. His example had taught her that a disputatious temperament could be witty, not merely aggressive. She taught him that a woman could be his equal in aggression and in wit. Rosenberg respected Krasner but condescended to Pollock, who commanded no bright repartee. One evening, the painter drank too much at the critic's house on East Tenth Street. Conversation became theoretical, as always, and Pollock dismissed every flight of abstract disquisition as "a lot of shit." Eventually, Rosenberg directed him to go upstairs and take a nap. Pollock obeyed, with the docility of a child who agrees that he has been naughty. After he left, Krasner turned on Rosenberg and informed him, in her most fervently nasty tone, that Pollock was a famous painter and no critic had the right to condescend to an artist of such consequence. Rosenberg's wife, May Tabak, remembered him saying, "Don't tell me who's famous. But if there's going to be anyone famous here, it's me and not that drunk upstairs."

Rosenberg's action-painting essay appeared soon afterward, bristling with cleverly unfair jibes at Pollock's best work. Determined to form an anti-Rosenberg front, Krasner turned to Clement Greenberg and found him in retreat. Action painting is a way of life, an all-consuming effort to stave off moral and psychological death. Busy disentangling art from these messy concerns, Greenberg had nothing to gain from a feud with Rosenberg. Anyway, his support for Pollock's recent work had begun to weaken by the end of 1952. Careful steps were leading him to the conclusion that the best interests of pure painting were now being served by Clyfford Still. Clem, as the critic

was known, had abandoned Jackson, and Krasner found it difficult to deny that Pollock was abandoning himself. Her campaign against Rosenberg failed.

For a season or two, Pollock had feared, vaguely, that younger painters were finding de Kooning's paintings more pertinent than his. They were ignoring his gesture. Now Rosenberg had mocked it. Willfully, Pollock chose to be flattered by "The American Action Painters." His name for the essay was "Rosenberg's piece on me." This annoyed the critic, who had trimmed the image of his painter-hero to fit artists he liked far more—Hans Hofmann, Arshile Gorky, Willem de Kooning. In their paintings, not Pollock's, Rosenberg saw identities taking shape. "Painting for de Kooning . . . is a real action, comparable to crossing an ocean or fighting a battle," Rosenberg declared. "His sole concern has been to maintain touch with himself as he is—an enterprise which in this epoch so disturbed by the fear of anonymity has demanded the deepest insight as well as genuine moral independence."

Rosenberg applauded de Kooning's canvases as episodes in a lifelong work of existential theater. He never sensed the pleasure the painter felt as he taught his doubts to knock down the scaffolding of Parisian Cubism. Nor did he feel de Kooning's joy in converting doubt to bravado, as he rebuilt this Old World style to accommodate a grandiose idea of life in the New World. For de Kooning, to paint was to dote obsessively on his responses to American space and architecture, light and flesh. Rosenberg's action painter displayed a more puritanical self-involvement. Born in difficult times, overcoming them through sheer authenticity of being, he was blazing a path through moral thickets.

Though he never objected to being taken for the epitome of an action painter, de Kooning didn't much resemble this imaginary artist so intently focused on himself that he displayed no eye for painting. In Rosenberg's scenario, to paint was no longer to make a permanent and therefore ponderable image. Working with a brush had become a species of performing art, as evanescent as dance or theater, and so the action painter needed no eye for painting. Gazing into his canvas, he looked only for signs that his hand had moved spontaneously enough to leave traces of his true being.

16

For the act to be spontaneous, said Rosenberg, the will must be pure. The downtown painters liked the impatient sweep of Rosenberg's rhetoric. They liked his assumption that New York painting was now crucial to its moment. But they couldn't work up much interest in the idea of purity. De Kooning detested it, or so he told Thomas B. Hess one afternoon late in the fifties, on a walk through the galleries of the Metropolitan. Hess had invited the painter to visit the museum and say whatever came to mind; afterward, he published some of his friend's remarks in *Artnews*.

De Kooning began by praising the accuracy of Courbet's eye. He called Pollock's *Autumn Rhythm* "lyrical and calm," and questioned Marcel Duchamp's devotion to art. He said that "being anti-traditional is just as corny as being traditional." De Kooning called Velázquez "great," and then Søren Kierkegaard loomed up in the conversation, as he often did in the fifties. Claimed as an ancestor by the existentialists, this nineteenth-century Dane had become a stylish ghost. The last time he read Kierkegaard, said de Kooning, "I came across the phrase, 'To be purified is to will one thing.' It made me sick." De Kooning took pleasure in willing several things at once—success and failure, for example.

"I took the attitude that I was going to succeed," the painter said in 1960, "and I also knew that this was just an illusion." Failure was inevitable—or success was indefinable—so there was no point in setting out with "an idea of perfection." He would work and rework an image just "to see how far one could go . . . with anxiousness and dedication to fright maybe, or ecstasy." De Kooning found it nearly impossible to bring a canvas to completion. Once, he said that the end arrives when "I paint myself out of the picture." The painting becomes itself; it has its own "countenance." Another time he said that he is "always in the picture somewhere." With contradictions like these, de Kooning kept his art alive and on edge.

De Kooning found uses for the chaste, neoclassical line of Ingres. He also loved the passionately sloppy art of Chaim Soutine. To paint like Soutine and Ingres at once—that, Rudy Burckhardt remembered, was de Kooning's wish. It can't be done, though de Kooning sometimes sends a contour of Ingresque clarity slicing through a swamp of color as frantic and sweaty as any in Soutine's overloaded canvases. While Rosenberg argued that the moment's best painters were becoming more truly themselves, de Kooning looked for new ways to be at odds with himself. In his pictures, a flourish of drafts-manship reminiscent of the aristocratic Peter Paul Rubens can become, with a second look, a bohemian affront to good taste.

De Kooning never tried to justify his inconsistencies. Instead, he flaunted them, with a bravado that often collapsed into its underlying anxiety. Paint-ing, said de Kooning, "never seems to make me peaceful or pure." Nothing in art is ever settled. Nothing reassures or redeems. Rosenberg could not agree. From his account of the action painter emerged a crucial article of faith: at certain moments, "painter and painting are one." The authenticity of the painter's act unites art and artist in a bond untouched by the demands of history or criticism or the marketplace. Rosenberg found this unity in the careers of de Kooning, Gorky, Hofmann, Kline, and a few others. In the act of painting, said Rosenberg, these painters become themselves, truly and purely; prolonging the act from one painting to the next, they reveal the flux of their identities.

The painters' states of being were not of much interest to Clement Green-berg. He was more concerned that paintings become more truly themselves: less illusionistic, more purely "optical." To achieve this purity, a painting needed to acknowledge its physical traits: flat surface, straight edges, square corners. An object itself, a painting was under no obligation to represent other objects. A depicted thing appeared in a depicted place; to look into that place was to enter it imaginatively. Such looking engaged the body and that was bad, said Greenberg. A painting attained its true nature by appealing to the eye and the eye alone. The flatter, the more abstract the image, the stronger the appeal to vision, so a ban on pictures of people and other three-dimensional objects was a logical imperative. For a decade, de Kooning ap-peared to be following the path Greenberg had marked.

In the late thirties, de Kooning's precise Ingresque portraits were realistic in a manner that could fairly be called old-fashioned. Year by year, his touch became more frantic, his forms less easily recognizable. By the end of the forties he had become an abstract painter, and yet no stage of de Kooning's evolution was simple. Though the black-and-white pictures he exhibited in 1948 and 1951 are not realistic, the sexual insinuations of their heated, surging contours are difficult to miss. From the insomniac shallows of these canvases

30. Willem de Kooning, *Woman I*, 1950–52. Oil on canvas, 6 ft. 3⅞ in. × 58 in.

emerged the Women he showed in 1953—massive figures with imperious poses and rapacious smiles.

Concentrate on the behavior of paint—the way it splashes and drips and smears—and you can see these pictures, too, as abstractions; but the Women will not be denied. You feel their wild gazes on you. Greenberg was appalled. "It is impossible today to paint a face," he told de Kooning. "That's right," said the painter, "and it's impossible not to." Eventually, there were five more Women, each a variant of the first. Her smile persists. Unnerved, the artist tried to reduce her to a pretext for his brilliance. He failed, of course, knowing at every moment that he would. The dazzle of his brushwork could not fend off this nightmarish Woman, only make her more seductive.

Female anatomy disappeared from de Kooning's pictures in 1955. It also remained, its massively voluptuous shapes entangled with drifts of cloud and water and terrain. "The landscape is in the Woman," he said, "and there is Woman in the landscapes." Thus he "could sustain this thing all the time because it could change all the time; she . . . could not be there, or come back again, she could be any size." She could be either sex. "You can't always tell a man from a woman in my painting," he noted, adding that "those women are perhaps the feminine side of me—but with big shoulders. I'm not so big, but I'm very masculine and this masculinity mixed up with femininity comes out on the canvas."

De Kooning's first show of black-and-white paintings had introduced a virtuoso fully formed. His second was such a strong encore that even *Time* was impressed. The magazine's anonymous reviewer said that de Kooning's works "are always original and often elegant in composition." To no one's surprise, sales were negligible. Like Betty Parsons, Charles Egan had become a dealer when clients for contemporary American art were an unevolved species. Sales were not expected, so Egan never bothered to cultivate patrons who responded to good notices, to cues from the Museum of Modern Art, to the sense that an artist was becoming a contender. Other dealers did.

The quickest on his feet was Sidney Janis, who showed de Kooning's Women in 1953. Though the Modern bought *Woman I*, collectors held back. A while later, the artist told Harold Rosenberg, "Janis wants me to paint some abstractions and says he can sell any number of black and whites, but he can't move the Women. I need the money. So if I were an *honest* man, I'd paint abstractions. But I have no integrity! So I keep painting the Women." Before he stopped, there were fifteen of them.

Remaking the meanings of ordinary words, de Kooning left their usual meanings in play. We are to understand that his supposed lack of integrity was in fact integrity of the highest kind, braced by irony. Because he could not have a purpose that was not a cross-purpose, a flicker of shifting intention

fills his art. Willing many things at once, he outwitted his equilibrium. Thus he kept it. He prevented nausea.

Toward the end of the fifties, a number of New York painters looked closely at Franz Kline's wide swathes of black paint. The force of his example shows in pictures by Elaine de Kooning, Al Held, Michael Goldberg, Alfred Leslie, and Joan Mitchell. Usually considered followers of de Kooning, these artists were finding uses for Kline's boldness—as de Kooning himself did when he painted *Montauk Highway* (1958), *Door to the River* (1960), and other "parkway landscapes," as Thomas B. Hess called them. Joining in a move made by certain of his younger admirers, de Kooning became his own acolyte, a de Kooningesque painter. Or he played that role, though his mix of delicacy and brusque urgency is always recognizable. *Door to the River* doesn't really look like a Kline. It looks like a de Kooning masquerading as a Kline.

Being poor in the fifties was not the ordeal it had been during the Depression. Artists scrambled from week to week, month to month, without deep fears of complete ruin, and now they can't recall precisely how they managed. Even memories of first sales are dim. Most of the hard facts about artists' incomes in the fifties float on the currents of Jackson Pollock's legend. According to Tony Smith, Pollock's art earned him about $2,600 in 1950. *One* sold for $6,000 in 1954; soon afterward, *Blue Poles* (1952) fetched $8,000. In the last year of his life, 1956, Pollock's work sold steadily. Within a season, de Kooning began to do nearly as well in the marketplace.

De Kooning had used cheap commercial enamels to paint his black-and-white abstractions. Now he moved his studio from East Tenth Street to 831 Broadway, just south of Union Square, and overstocked it with oil paints and canvas of the highest quality. De Kooning's new top-floor space was what Hess called the first of the " 'luxury lofts'—wood floors sanded and waxed, sparkling like crystal; chairs by Eames instead of homemade carpentry; a refrigerator capable of producing ice with real suburban efficiency."

In 1963 de Kooning fled the city for Springs. The following year he began to work in a studio built—and endlessly rebuilt—to his shifting specifications. Early in the seventies, Rosenberg asked him if working out of town had affected his art. "Enormously!" said de Kooning. "I wanted to get back to a feeling of light in painting . . . I wanted to get in touch with nature. Not painting scenes from nature, but to get a feeling of that light that was very appealing to me, here particularly. I was always very much interested in water." The landscape shimmers, as if in a reflection, and female anatomy has the fluidity of ocean currents. All is lush and sprawling, an overflow of hot pinks and yellows.

During the seventies, de Kooning smeared and scraped his overloaded

31. Willem de Kooning, *Suburb in Havana*, 1958. Oil on canvas, 6 ft. 8 in. × 70 in.

canvases, sometimes pushing them to the edge of chaos and beyond. With their soggy greens and muddy reds, these pictures seem waterlogged, yet you wade through their tangled expanses in the company of familiar landmarks. Unmistakably de Kooningesque forms float by in slow motion, blurry and half-submerged and charged with the familiar sensuous force. After this jumbled density came a clarification. De Kooning would send a few flat, twisted ribbons of red and blue meandering elegantly over the surface. Curving planes are implied and occasionally filled with yellow.

In 1984 de Kooning turned eighty. For several years, his memory of recent events had been erratic. Usually, but not always, the distant past remained vivid. The present engaged him only when he turned to a painting in progress. His last works look empty until you see how succinctly they summarize the repertory of taut, luscious forms he had begun to develop nearly half a century earlier. De Kooning did not go unhonored in old age. A steady

succession of awards and international exhibitions began in the mid-seventies. In 1979, an especially busy year, he was elected to the American Academy and Institute of Arts and Letters; he received the Andrew W. Mellon Prize from the Carnegie Institute in Pittsburgh; and the Dutch government made him an Officer of the Order of Orange-Nassau.

This recognition appeared to please him, though it may have seemed no more than the aftermath of that moment, in 1959 or 1960, when he looked up from his work and sensed that he was "the center of things." The center he occupied for the rest of his career is the one reserved for America's leading modernist master. Pollock may be our greatest artist. Some have nominated Jasper Johns or Andy Warhol for that position. Undoubtedly, though, our greatest painter is de Kooning.

32. Franz Kline, *Mahoning*, 1956. Oil on canvas, 6 ft. 8 in. × 8 ft. 4 in.

17

One night at the Cedar, in March 1956, Pollock met Ruth Kligman, a twenty-five-year-old brunette who provoked comparisons with Elizabeth Taylor. Enrolled in a painting class at the New School, she had a job at a small downtown gallery and an apartment on East Sixteenth Street. According to a memoir Kligman published years afterward, she and Pollock began a love affair a week after they met. Other accounts suggest that their affair didn't start for several months, that she had to pester him into it. Pollock was afraid of Krasner, who had developed a loathing of his behavior but refused to consider divorce. It is certain that, by late spring, he had fallen into the routine of spending Monday nights at Kligman's apartment, then taking the train back to the Hamptons the following morning. Before meeting again, they would talk by telephone, Kligman in Manhattan, Pollock at Springs, with Krasner nearby. She refused to acknowledge the affair.

Pollock took Kligman drinking in midtown nightclubs. They attended the theater. At *Waiting for Godot*, he found the spectacle of Beckett's tramps insupportable. He began to cry, then to moan. Kligman led him away, into the street. As summer started, she took a job at the Abraham Rattner School of Art in Sag Harbor, not far from the Pollocks' house on Fireplace Road. She lived in an apartment near the school. Pollock and Kligman would meet at the beach. They'd have dinner together. Krasner still said nothing.

Early one morning, she saw Kligman and Pollock emerging from his studio. With the full force of her outrage, Krasner ordered Pollock to "get that woman off my property before I call the police." Pollock drove Kligman to Sag Harbor. When he came back to Fireplace Road, Krasner said that she'd leave him if he continued the affair. Usually, this threat would cue Pollock's apologies, then his well-worn promises to stay sober, to try to paint. Her grief and anger assuaged, Krasner would pretend to be convinced, and the couple would continue as before. Now Pollock refused to go through the routine.

Krasner threatened to sail for Europe. Pollock suggested that she go ahead. She did, and three days later Kligman moved into the house at Springs.

Their life was bearable at first, though Pollock tended to pass out, drunk, early in the evening. Or he would weep endlessly. Kligman has written that "he was wonderful as far as being able to cry and let out his emotions." Inevitably, his anguish turned aggressive, and he would rage at her as he had raged at Krasner. Once, without letting Kligman know, he arranged for a dozen roses to be sent to his wife's hotel in Paris. In front of friends, Pollock would insult Kligman or ignore her. After three weeks at Springs, she returned to New York.

Toward the end of the following week, Kligman called Pollock to say that, on Saturday, August 11, she and a friend would arrive at East Hampton on an early train. Pollock met them with his car, an Oldsmobile convertible. He was sullen, barely saying hello to Kligman's friend, Edith Metzger. On the way to the house, he stopped at a bar for a drink. Squabbling filled the day, as Pollock drank and wept. That evening, he was expected at Alfonso Ossorio's house for a piano concert. Driving there with the two women, he felt sick and stopped his car at the side of the road. He wanted to return to Springs. Kligman convinced him not to turn back, though she thought that perhaps he ought to have something to eat before he went on.

They found a restaurant, where Pollock telephoned Ossorio to tell him of the delay. He had several drinks. Afterward, Metzger refused to get into the car, infuriating Pollock as he staggered across the parking lot. Kligman persuaded her to climb into the backseat of the Oldsmobile, and Pollock sped out of the lot, along Fireplace Road. Metzger screamed, demanding that he stop, that he let her out. She tried to jump from the convertible, but the wind forced her back into her seat. A hump in the pavement sent the car to the right.

Veering left, Pollock kept the car on the road for a long moment, until it lurched across the shoulder, snagged a patch of dense vegetation, and sailed end over end. Metzger was crushed to death when the car fell to earth. Flying free, Kligman sustained several injuries. Pollock was thrown fifty feet through the air and died when his head struck a tree.

In May a subordinate of Alfred Barr had written to Pollock with good news. The Modern was launching a series of shows that would survey the achievements of artists who had arrived at middle age. The first would be dedicated to Pollock. Four months after his death, the show opened in an atmosphere of solemn remembrance. No one was certain when Pollock had slipped into the past. It may have happened six years before, when he finished the last of the great poured paintings. Now that he was dead, the question was settled. New York artists paid their respects to the thirty-five canvases on view at

the Modern, then turned back to the increasingly exciting present. De Kooning, Kline, and Guston were painting at the height of their powers and showing regularly on Fifty-seventh Street. In vigor and sheer numbers, the next generation was beyond the capacity of the uptown dealers. To meet the demand for exhibition space, a dense cluster of cooperative galleries appeared on East Tenth Street, between Third and Fourth Avenues.

Treated ever more respectfully by the popular press, New York painting had found an audience beyond the boundaries of the art world, in the nation at large. Almost more important to the painters was the interest they had piqued in Europe. Traditionally, the Old World had ignored New World art. After the war, a series of traveling exhibitions brought American painters to the attention of audiences in Western Europe's capital cities. Pollock, de Kooning, and their colleagues became the objects of controversy. Dismissal was common and sometimes violent. Puzzlement sometimes gave way to praise. These reactions were never more intense than during the European tour of The New American Painting, an exhibition organized by Dorothy Miller, the most powerful of Alfred Barr's lieutenants.

As he built the Modern's collection of European modernists, Barr had delegated American art to Miller. Fourteen Americans, the first of her surveys, opened in 1946. The last, Americans 1963, ranged from the veteran abstractionist Ad Reinhardt to a trio of Pop artists—Claes Oldenburg, Robert Indiana, and James Rosenquist. Presented every three to five years, these shows were masterworks of curatorial diplomacy. The assortment of styles was always lively, with competing tendencies subtly balanced. Mixing newcomers with veterans, Miller usually offset the preponderance of East Coasters with a few artists from other regions.

Over the years, her shows included Jackson Pollock, Mark Rothko, William Baziotes, and Clyfford Still. Grace Hartigan's career was solidified by her appearance in Twelve Americans, of 1956. Among the other eleven were Franz Kline and Larry Rivers. In 1959, Fifteen Americans introduced Robert Rauschenberg and Frank Stella. The art historian Robert Rosenblum says that being tapped for a Miller show at the Modern was the art world's equivalent of an Oscar.

Early in 1958, The New American Painting opened its eight-city tour at the Basel Kunsthalle. The exhibition included Pollock, de Kooning, Newman, Still, Guston, Motherwell, Kline, and Rothko. Gorky and Baziotes recalled New York painting's Surrealist past. Bradley Walker Tomlin preserved the scale and delicacy of prewar abstraction. Miller chose only two younger artists—Hartigan and Sam Francis, a painter with light-flooded affinities to Pollock. European critics were astonished first, and possibly last, by the sheer size of the American canvases. Reporting for a Barcelona newspaper, Mercedes Molleda noted that a painting by Pollock and another by Hartigan

could enter Madrid's Museo Nacional de Arte Contemporaneo only after workmen had enlarged its main doorway. In the exhibition, wrote Molleda, "a strange sensation like that of a magnetic tension surrounds you." This art, she concluded, is animated by "myths, gods, and ideas different from those prevailing in Europe at present."

Other critics agreed that the Americans had set Europe aside, and some were indignant. "Why do they think they are painters?" asked a Parisian critic, Claude Roger Marx, in *Le Figaro Littéraire*. André Chastel, of *Le Monde*, was more willing to be impressed. The New American Painting displays a lively originality, he granted, adding that "the roots of this art are European, and are called fauvism, German Expressionism, Klee, Picasso, sometimes Matisse or André Masson's inspired surrealism." This was a gratifyingly French echo of Barr's line on the postwar American painting he approved: new as it might look, it extended the logic of his genealogical chart.

The tour of The New American Painting came to a close at the Tate Gallery in London toward the end of March 1959. Members of the Modern's International Committee felt extremely pleased. The exhibition had gone abroad with a point to make, and the point had been taken. American art was no longer dismissible. To celebrate this success, the Modern gave a party in its sculpture garden. And so, on an evening early in the spring of 1959,

33. Grace Hartigan, *New England, October*, 1957. Oil on canvas, 7 ft. 4½ in. × 6 ft. 11 in.

34. Alfred Leslie, *Soldier's Medal*, 1959. Oil on canvas, 7 ft. 8 in.
× 9 ft. 11 in.

the New York art world's best-connected inhabitants gathered in the company of Rodin's immense, brooding figure of Balzac and Picasso's mother baboon, with her head made of a toy Citroën sedan.

The art dealer Irving Blum remembers it as "an extraordinary occasion. Just extraordinary. Everyone was there, in the garden, and really there were only about one hundred and twenty of us. The art world was just a village then. Yet there was a feeling that something momentous had happened. There had been a breakthrough. It wasn't a matter of the market. There was still hardly any. People weren't competitive yet. One had total access to the entire scene, which seemed, just then, to have entered a fresh stage of its history."

What Paris had begun, New York was continuing. The overseas tour of Dorothy Miller's show had been a triumph for de Kooning, Pollock, and their generation—deservedly so, thought Alfred Barr, though he felt doubts about the next generation. More than a year before the celebration in the garden of the Modern, Barr had visited the Club, on Eighth Street, and informed the younger painters that their art was, by and large, worthless. Their success was a kind of failure. Proper avant-gardists reject the past, said Barr. Alfred Leslie, Joan Mitchell, and their friends were embracing it. They

35. Joan Mitchell, *Untitled*, 1958. Oil on canvas, 6 ft. 5¾ in. × 68 in.

had formed a new academy. Barr could not have made a more insulting charge. Rebuttals were furious, driven by the suspicion that he was not entirely wrong. No one denied that Leslie, Mitchell, and a milling crowd of others were performing variations on themes established by their elders. What these younger painters denied was Barr's understanding of the results.

"I don't know how I responded to Barr that night," says Grace Hartigan. "I know I was furious, screaming at him." Michael Goldberg remembers Barr impressing him as

an eloquent guy who had no idea about the mechanics of painting, no interest in uncertainty. He was a programmatic man with this preconceived idea of painting's progress—the Freudian idea that you had to kill your father. What he could not understand is that, downtown, one never considered the Oedipal pattern. That's a product of hostile feelings about authority, which we weren't especially interested in feeling.

As Alex Katz puts it, "We liked our father figures."

A year later, Hess posed a question to *Artnews* writers: Is there a new academy? "Of course," wrote Elaine de Kooning. "In the 'old' academies, originality was not a value: they knew that it cannot be borrowed. In the New Academy, originality is the *only* value. And the only question is, Who's who—to which our New Academicians have been answering: 'It's me who's him.'" Confronting Hess's question with a head-on evasion, de Kooning epitomized the downtown style.

In 1955 she had written that, "unless they are singing themselves to sleep," artists feel "engulfed in an overwhelming sense of the second-hand. Shocks today are mock-shocks. The opponents are all straw men. Parody is king." If one acknowledged with enough subtlety the problem of being original, a sort of originality might appear. Barr did not respond to ironies like these. The downtown painters' passion for their convoluted present looked to him like complacency. He felt that no matter how vehemently a young painter might attack his canvas—or her canvas, for Joan Mitchell had the most cruelly slashing touch—the older painters remained unchallenged. Convinced that progress emerges only from the clash of generations, Barr wanted to find a young New Yorker willing to rebel against the authority of de Kooning and Pollock, an authentic avant-gardist. Before the fifties were over, Barr found what he sought in a painter named Jasper Johns.

FRAGMENTS OF THE ORDINARY

Beware the body and the mind. Avoid a polar situation. Think of the edge of the city and the traffic there.

Jasper Johns
"SKETCHBOOK NOTES"
(1965)

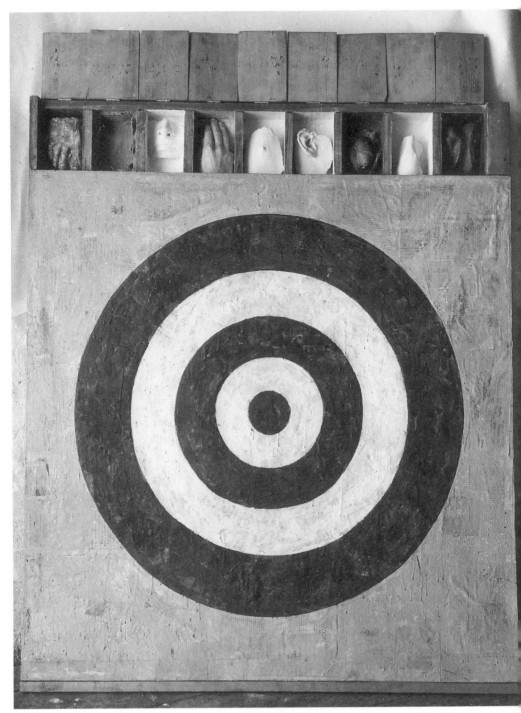

36. Jasper Johns, *Target with Plaster Casts*, 1955. Encaustic and collage on canvas with objects, 51 × 44 in.

18

Late in January 1958, the Leo Castelli Gallery, at 4 East Seventy-seventh Street, presented Jasper Johns's first solo exhibition. His *Flag* (1954–55), a canvas just over five feet long, displays the Stars and Stripes with deadpan accuracy. Another painting sets the flag afloat on a field of orange. *White Flag* (1955) is, of course, all white. On square canvases called Targets, concentric circles appear in sets of five. Along the upper edge of *Target with Four Faces* (1955) runs a row of four compartments, each containing a plaster cast of a face. The faces are identical, expressionless, cut off at the cheekbones. The compartments of *Target with Plaster Casts* (1955) contain plaster body parts—ear, toes, penis, nose, hand, a nipple with a section of breast, the lower half of a face. On other canvases, grids are filled by the alphabet, one letter to an opening, or the numbers—zero to nine. Smallish canvases contain a single biggish number or letter.

Johns made the grids, Targets, and Flags with encaustic, a mixture of wax and pigment not in wide use after the Middle Ages. Praising his medium, Johns said: "What it did was immediately record what you did. I liked that quality. It drips so far and stops. Each discrete moment remains discrete." The effect is cool, lucid, and rubbery. Working with demonic patience, brushstroke by careful brushstroke, Johns seemed to have calmed the turmoil of painterly painting in New York.

As his show was being hung, Thomas B. Hess wandered into the Castelli gallery and recognized *Green Target* (1955), which he had seen recently in a group show at the Jewish Museum. Scanning the other works lined up along the gallery walls, Hess pointed to *Target with Four Faces* and asked if he could take it to *Artnews*. His quick eye made him abrupt. Smoothly, Castelli said that of course he was welcome to borrow the picture for a while. These days, artworks are assiduously documented. Galleries supply editors not with paintings but with color transparencies; in 1958 *Target with Four Faces* was

casually wrapped by an assistant, then borne away in a taxi. Not long afterward, the painting appeared on the cover of *Artnews*. Hess had obeyed a sure reflex and an odd one, for his inclination was to bask in the Abstract Expressionist heat that Johns had cooled off with the calm surfaces of his Flags and Targets.

Drawn by the magazine cover, Alfred Barr spent three hours at Johns's show. Castelli was amazed. In those days, he has said, "I thought Alfred Barr was God." Returning to the gallery a few days later, Dorothy Miller at his side, Barr found the artist on the premises. He asked Johns if it would be permissible to exhibit *Target with Plaster Casts* with the doors of its compartments shut. His acquisitions committee, he feared, would balk at the anatomical fragments, especially the green penis. Johns said that it would be all right to close the compartments some of the time but not always.

Barr and Miller settled on three other works: *White Numbers* (1958), *Green Target*, and *Target with Four Faces*. They wanted *Flag* but hesitated because the McCarthyite panic about alien subversion had faded only a few seasons earlier. Superpatriots might flare up, in anger or perplexity, at the sight of the Stars and Stripes in a museum so unapologetically sympathetic to the communist Pablo Picasso. Determined to have the painting, Barr persuaded the architect Philip Johnson to buy it as a future gift to the museum. With no enthusiasm, Johnson complied. *Flag* changed his feelings gradually and so completely that he refused to let the museum have it until 1973.

Of the remaining pieces in Johns's show, the Burton Tremaines, Ben Heller, and other leading collectors took all but two: *Target with Plaster Casts*, which Castelli added to his own collection, and *White Flag*, which looks like the not-quite-finished model—the fetus—of the other Flags. Or it is the ghost they will become when authority has faded from the icons of the New York art world. Embryo unborn or ghost persisting after death: the precision of the symmetry is typical of Johns's art. He kept this painting for himself.

Some visitors to Johns's first show felt like passersby drawn to the site of an immense erosion, as if he were undermining everything passionate and witty in New York painting. Others saw fresh wit in his use of ready-made images. In his restraint they glimpsed hints of deep, difficult feeling. Pleased or not, nearly everyone suspected that Johns would become major. When his show came down, the New York art world had two new luminaries: Johns, who was twenty-seven, and Castelli, who had suddenly become decisive at the age of fifty-one. Until then, he had been a vivid presence but never quite in focus.

Leo Castelli says that Trieste, where he was born in 1907, is "a strange and very interesting city. It is Italian, of course, and yet it was deeply influenced by Viennese culture." Once the chief seaport of the Austro-Hungarian

empire, Trieste had an international tone. During the First World War, Castelli's father took a post at the upper levels of a Viennese bank. When the family returned home three years later, Castelli had added German to his Italian. At the University of Milan, he studied law. Though bored, he earned a degree, then took a job in an insurance company. Bored even more thoroughly now, he imagined himself a professor of comparative literature.

The senior Castelli was not pleased, the dealer says. "He made a bargain with me: if after working in a branch office of the insurance company in Rumania for a year I still wanted a career in literature, he would be happy to support my studies." Castelli was then twenty-five years old. He found insurance to be just as dreary in Bucharest, the Rumanian capital, as in Trieste. Happily, he met Ileana Schapira, the daughter of a Rumanian industrialist. Less than a year later they were married.

Castelli's family was well-to-do. Schapira's was rich. Her upbringing had endowed her with fine taste in expensive things, particularly new pictures and old furniture. The young couple had a splendid apartment in Bucharest; they traveled; they accumulated objects of the highest quality. With his father-in-law's help, Castelli got a job in the Paris branch of the Banca d'Italia. He and Ileana met Parisian designers, artists, dealers in art and antiques. Having found that banking interested him no more than the insurance business, Castelli persuaded his father-in-law to back a gallery. Opened on the place Vendôme, it was to establish an outpost of the Surrealist revolution. The first show featured one work: Pavel Tchelitchew's *Phenomena* (1938), a panoramic landscape filled with foreshortened bodies and melodramatic symbols of sexuality and fate.

"*Le tout Paris* showed up for the opening," Castelli has recalled. "We really seemed to be on our way. That was the spring of 1939." The war began the following September. Castelli's partner, an architect and designer named René Drouin, joined the French army. The Castellis moved to the Schapira family's villa at Cannes. By 1941, they had arrived in New York. Not yet a citizen of the United States, Castelli was nonetheless drafted into the American army and sent to Rumania as an interpreter. Back in New York after the war, he began making a place for himself among the downtown artists.

At Southampton, he opened his summer house to painters. Elaine and Bill de Kooning spent two seasons there; Pollock was in the habit of dropping by and behaving badly. Castelli's respect for artists was obvious. Now and then, he'd defray their expenses; sometimes he bought small works. He didn't count as a patron nor was he a colleague exactly, though he could hold his own in the artists' conversations at the Cedar Tavern. His manner was friendly, his praise generous, and he carried himself with a slight excess of Old World elegance. The artists suspected him of a seigneurial attitude. Because Castelli

was as short as de Kooning, they called him Mighty Mouse, but not to his face. Their jibe was not entirely cruel. Mighty Mouse is a formidable figure, and so, it seemed, was Castelli. The art world expected much from him.

In need of work, Castelli agreed to manage a New Jersey sweater factory partly owned by his father-in-law. To amuse himself, he arranged small projects with the dealer Sidney Janis. The sweater business had failed by 1955, and Castelli was tired of inveigling Janis into peripheral schemes. In February 1957 he and his wife opened a gallery in their Seventy-seventh Street town house. Their first show compared American and European artists. De Kooning, Pollock, and David Smith led one side; major figures on the other side were Alberto Giacometti, Piet Mondrian, and Jean Dubuffet. Next came solo exhibitions of paintings by young New Yorkers—Paul Brach, Friedel Dzubas, Norman Bluhm, a few others. Offering portions of their collection for sale but finding few clients, the Castellis were playing at dealing.

A few months after launching their gallery, they visited a building on Pearl Street, at the southern tip of Manhattan. Condemned then, vanished now, it housed the studio of an artist named Robert Rauschenberg. Young and extravagantly talented, he showed the Castellis the rarest quality of all: independence. While others of his generation took up residence near the local monuments—de Kooning, Kline, Guston—Rauschenberg seemed to be wandering with admirable impatience into territory as yet unsettled.

A native of Port Arthur, Texas, Rauschenberg was at once innocent and, if not sophisticated, disinclined to be surprised by anything. The Castellis had never met an artist quite so unabashedly American. Brash yet courteous, he attracted them with the glitter of the exotic. And they had admired his one-man shows uptown. Now, as peculiar as it was to be climbing the stairs of a derelict building on Pearl Street, they felt they were on the right track.

Before she married, Dora Rauschenberg was a telephone operator; her husband, Ernest, worked as a lineman for Gulf States Utilities. Their only child was born in 1925; they named him Milton Ernest Rauschenberg. Reborn as an artist, Milton Ernest called himself Bob, which the solemnities of the art world expanded to Robert. As a boy, he was good at drawing, but no one much cared. In Port Arthur, he has said, "there was no such thing as thinking that you were an artist. There was no possibility." The possibility occurred to him when he was eighteen years old and newly drafted into the navy.

On leave from his post in San Diego, Rauschenberg visited the Huntington Library, just northeast of Los Angeles. There he happened upon *Pinkie* (c. 1795), Thomas Lawrence's portrait of the very young Sarah Moulton-Barrett in pink and white, and Thomas Gainsborough's *Blue Boy* (c. 1769–70), which shows the adolescent Jonathan Buttall in a suit of shimmering blue satin. In Rauschenberg's childhood, these figures had decorated the backs of

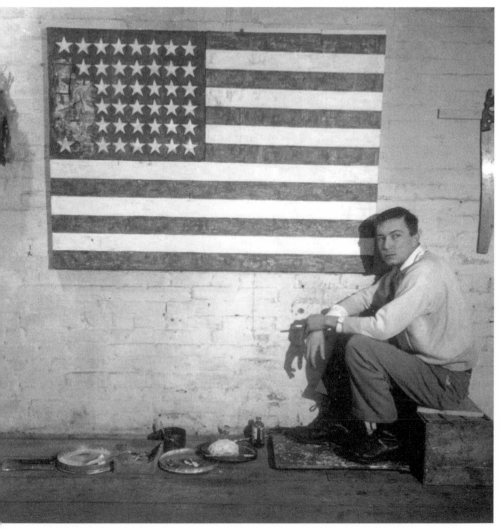

37. Jasper Johns in his New York studio with *Flag*, 1955. Photograph by Robert Rauschenberg

playing cards. Then, the girl in pink and the boy in blue had looked to him like sheer facts, present but in no need of being accounted for. The originals startled him into seeing what had always been obvious: such things do not simply appear; somebody thinks them up. You start with a blank and end with an image. Rauschenberg bought art supplies and tried to paint.

Discharged from the navy in 1945, he settled in Los Angeles and found work as an illustrator. Untrained, he was a bit hapless; he wanted to do better. Encouraged by his best friend, a woman named Pat Pearman, Rausch-

enberg enrolled at the Kansas City Art Institute. Because Kansas City was her hometown, he listened when she told him how good the school at the Institute must be: Thomas Hart Benton had taught there not so long ago. Milton Ernest became Bob when he registered for courses. A year of freshman classwork left him greedy for studio technique and nagged by a new conviction: Paris was the place to study. With Pearman's help, he enrolled at the Académie Julian under the G.I. Bill.

Bored by the Académie, Rauschenberg skipped classes with a young New Yorker named Susan Weil. Together, they followed their inclinations through the museums of Paris; they sketched in the streets, then wandered back to their pension and painted. These pleasures continued for half a year. Then Weil received a letter from a former teacher advising her to enroll at Black Mountain College, a pedagogically adventurous institution in Asheville, North Carolina. She did and Rauschenberg followed. He loved her; moreover, he had formulated another bright idea about his educational requirements. Rauschenberg knew he was energetic; he suspected he had talent. What he manifestly lacked was discipline. Black Mountain would solve this problem, he believed, for he had read in *Time* magazine that the school's drawing master was a notoriously strict veteran of the Bauhaus: Josef Albers.

Rauschenberg was infatuated with the slippery, running, skidding substance of paint; sometimes he dispensed with brushes and laid on color with his hands. Albers insisted on a more sober method: first you find, through experiment, a cogently related set of colors; then you apply them, carefully, in a lucid geometric pattern. Rauschenberg felt "intimidated by Albers. But somehow it was all so exciting because . . . his nature, and what he was trying to make me do, was so foreign to my nature." When Albers left Black Mountain for the Yale art school in 1949, Rauschenberg and Susan Weil moved to New York.

Two years later, Betty Parsons showed a selection of the white paintings Rauschenberg made early in the fifties—roughly brushed scratch pads for a frantic pencil. Next, Rauschenberg made white paintings bereft of any mark, and black ones just as empty but not as smooth. Over strips of newspaper pasted to the canvas, he laid on thick black pigment; as it dried, the paper buckled and curled off the surface in tatters. The Stable Gallery presented paintings from both series, the black and the white, in 1953. The exhibition was Rauschenberg's reward for laboring, with his friend Cy Twombly, to make the Stable fit for art. "We spent a summer raking out the horseshit and pissed straw," said Rauschenberg. Then they rebuilt the interior. Twombly was given a show, too.

At ease with paint, Rauschenberg felt at home among New York's veteran painters. During his short season with Betty Parsons, he liked to spend evenings at the Cedar, two miles uptown from his ten-dollar-a-month loft on

Fulton Street. He has said that he walked there to save the expense of a subway ride. But the subway cost only a nickel then. Rauschenberg enjoys an embarrassment of energy. He may have gone on foot because he felt the need to burn off a bit of this surplus. At the Cedar, he said,

I always paid for my beer. One beer would last six different artists' fantasies: Rothko, Barney Newman, Franz Kline, Bill de Kooning, Reinhardt, and Pollock occasionally. Pollock always opened every conversation with me by asking, "Who are you? What do you do?"

He could never remember that they were both on the Parsons roster, nor that Rauschenberg was making himself what Pollock never had the finesse to be: an enfant terrible.

38. Robert Rauschenberg, *Bed*, 1955. Oil and pencil on pillow, quilt, and sheet on wood supports, 6 ft. 3½ in. × 31⅛ in. × 8 in.

19

In 1953 Rauschenberg asked Willem de Kooning for a drawing to erase. For reasons he never made public, de Kooning supplied one. Rauschenberg remembered him saying that "he wasn't going to make it easy for me—and he didn't! I spent four weeks erasing that drawing." Though it used up forty erasers, this ceremony of rejection was not effective. Rauschenberg's greatest strength remained his version of the older artist's brushwork. Despite himself, he was the most brilliant of de Kooning's heirs. Few noticed the relationship then. On the downtown scene, Rauschenberg had the reputation of a joker. He was "just fooling around," said de Kooning. "Not really serious."

Late in 1954 the Charles Egan Gallery showed Rauschenberg's red paintings: large canvases where crimson, scarlet, and orange pigments wage territorial struggles with patches of striped silk, spotted gingham, and white lace. Surging color pleases the eye; ferocities of touch suggest violence, too. Every garish shift of hue, every dramatic wrinkle of fabric, every parade of rivulets attracts the sort of attention we pay to the gestures of an actor going over the top.

When Leo and Ileana Castelli visited Rauschenberg's studio that day in 1957, they found a painter whose art had moved off the canvas into three dimensions. Yet he hadn't become a sculptor of any recognizable kind. Large, gawky presences crowded his studio. Made of salvaged objects, lowly but not always common, these new pieces were like props for a theater of exhilarated panic. Rauschenberg called them combines. The first works to bear that title were wall pieces built from scrap wood and bearing bits of hardware and fabric. The Castellis had seen them at the Egan Gallery, amid the red paintings. Those combines had been easy enough to place in familiar categories: Dada collage, Surrealist assemblage. The new ones were more troublesome.

Bed (1955) is a tall canvas wrapped in a quilt and caked with violent color. Later, the officials of a festival in Spoleto, Italy, refused to display this object.

With the nonchalance of an artist adept at gazing past the obvious, Rauschenberg claimed to "think of *Bed* as one of the friendliest pictures I've ever painted." Compelled, as always, to overstate his case, he added, "My fear has always been that someone would want to crawl into it." That is an unlikely impulse. However the colors of *Bed* might interest the eye, this combine looks like the scene of a slashing or an unspeakably violent coupling.

Rauschenberg's big-gestured American verve, which had seemed so charming, was displaying its grisly side. Castelli felt uneasy. The new combines were too aggressive, too derelict, too insistently sexual. *Monogram* (1955–59) is a stuffed, long-haired Angora goat standing on a squarish canvas stained with dark pigments. He wears a smattering of mock Abstract Expressionist paint on his snout and an automobile tire around his middle. This is a frankly phallic goat, and the tire he penetrates is not lush and vaginal but snugly anal.

Castelli felt hemmed in by unpleasantness. His thoughts kept careening away to a strange green painting he had seen several nights before at the Jewish Museum. This object fascinated the dealer; the artist's name bemused him. Had Rauschenberg ever heard it? "Jasper Johns?" said Rauschenberg. "His studio is just below mine." In some tellings of the story, Johns's name comes up when Rauschenberg says he has to go downstairs to get ice from a friend's refrigerator. Or it is Johns who appears from below, with ice or empty-handed, ready to help his friend move his big new awkward combines. In every version, Castelli insists on an immediate visit to Johns's studio.

The dealer has said that when he saw the Flags and Targets and grids in Johns's studio he was "amazed." He was "bowled over" by "evidence of the most incredible genius." "It was an extraordinary experience," for Johns's work was "obviously something entirely new." It was "astonishing . . . the most incredible thing I've ever seen in my life." Decades afterward, Castelli is still trying to find words for his feeling that, the moment he saw Johns's paintings, his life intersected with history. Sometimes the dealer notes how shy Johns seemed, how little he said. Sometimes he recalls that Betty Parsons promised to visit Johns but never did, and then he mentions the persistence of her regret. Castelli asked Johns to join the gallery and he said that he would. Less than a year later, he made his debut with paintings that still loom over the New York art world with the authority of landmarks.

In 1960 a visionary entrepreneur named Tatyana Grosman invited Johns to make a lithograph at her studio in West Islip, Long Island. Johns was reluctant. "I'd never made a print," he said in 1973, adding, "I still don't know how to do it." Larry Rivers told him that printmaking is practical; it brings in money. Johns still wasn't interested. If an artist balked at her offer, Grosman would send lithographic stones to the studio. Franz Kline ignored his. When Johns found a stack of these weighty objects sitting just inside the

39. Robert Rauschenberg, *Monogram*, 1955–59. Oil and collage on canvas with objects, 42 × 63¼ × 64½ in.

door of his Pearl Street building, he recruited Rauschenberg and a vagrant to help him haul them up to his studio. On the first stone Johns drew a zero, possibly a sign of his interest in lithography. On the second he drew five concentric circles. Flurries of his jittery shading turned this pattern into a gray-on-gray Target. Next came lithographs of Flags, Numbers, Alphabets. Johns spent three seasons transferring these trademark images from canvas to paper.

The grids, stripes, and circles of his first show had enclosed and restrained the currents of New York painting. Nothing confined the color that burst across the canvases of his second show, which opened at Castelli's early in 1960. Yet there was mockery in this new freedom. In geometry's absence, Johns's touch was just as deliberate, just as cold, as before. An atmosphere of regulation lingered. Advancing over the surface of *Out the Window* (1959), the blocky letters of RED, YELLOW, and BLUE wade through patches of red, yellow, and blue paint. Johns's *Flag* is an image of an object and the thing itself. Now he showed that a color is itself and its name, though the colors of *False Start* (1959) often bear names not their own. Red is tagged ORANGE and elsewhere BLUE. Though the word BLUE is spelled out in blue, the letters

of ORANGE are white. Johns likes to introduce slippage into the systems of reference that give us the impression of having a grip on things.

A year after finishing *False Start* the painting, he redid it as a color lithograph, mimicking on stone the brush marks he had made on canvas. Then he reprinted this lithograph in shades of gray, displacing its image to a ghostly realm. It's as if Johns has drained away the life of color, its prismatic blood, leaving only the concept of color and the dreariness we expect from a conceptual residue. Though the gray version of *False Start* is grim, it is also delicate. It is lively. Sudden shifts from dark to light gray fill the print with austerely sparkling weather.

Johns has said that, in his eyes, painting and lithography are "separate and equal." Though he makes endless distinctions, he builds no hierarchies. His latest works are as important to him as the early iconic ones. His account of his art and himself features no swooping dramatics, no privileged moments. He has devised no myth of origins. Tatyana Grosman never thought of him as having arrived in New York from anywhere in particular. "I knew him so well through his work," she once said, "it never occurred to me to think about his background, where he came from. It was just his work, and what he represented in working."

Johns once walked with a woman through the garden of the Museum of Modern Art. Impressed by his gentility and reserve, she said, "Jasper, you must be from the Southern aristocracy." "No," he said, "I'm just trash." The label doesn't fit. Johns's father studied the law. His aunt, Gladys Johns Shealy, taught school and inculcated in him a respect for the American flag. When he called himself trash, Johns was dissembling, not out of modesty but on principle. Over the years, he has provided only the most perfunctory sketch of his background.

He was born in 1930 and grew up in Allendale, a small town in South Carolina. As a child, he lived with his paternal grandparents, then with an aunt and uncle. Johns has never said why he didn't spend his early years with his parents, though it is known that they were divorced when he was very young. His father, William Jasper Johns, "had no real profession and was something of a ne'er-do-well," says the artist, and until now that is all he has ever said on the subject.

He remembers drawing when he was three years old. At the age of five he knew that he wanted to be an artist. The source of this ambition is a mystery to him. His paternal grandmother painted in oils, yet Johns feels that no inspiration came from her pictures—"swans on a stream or cows in a meadow—things like that." Once, an itinerant painter arrived in Allendale to paint birds and flowers on the mirrors of the local Greek restaurant. During his stay, he boarded with Jasper's grandparents. The child found the

40. Jasper Johns, *False Start II*, 1962. Color lithograph, 18 × 13¾ in.

visitor's supplies and stole some. "It didn't occur to me," Johns said, "that he could miss the things I took—he had so much! But he did. Not knowing that oil paint wouldn't mix with water, I made a mess before his materials were returned to him by our cook."

After finishing third grade in Allendale, Johns stayed for a year with his mother and stepfather in Columbia, the state capital. For the next six years he lived with his aunt Gladys in a town called The Corner, where she taught every grade at the local one-room schoolhouse. He finished high school in Sumter during another stay with his mother and stepfather. His subjects included art and mechanical drawing.

For three decades, critics and curators, historians and journalists have given Johns countless opportunities to talk about his youth. Asked why he avoids the subject, he said, "It wasn't especially cheerful." This is to be understood as an understatement, and we are to understand, too, that persistent questions will not be welcomed. Occasionally Johns volunteers a recollection. For example, the only glamorous thing he saw as a child was a performance by Silas Green's dance troupe, a black ensemble that visited Allendale every year.

After high school, Johns spent three semesters at the University of South Carolina, in Columbia. His art teachers

were not highly accomplished but they did interesting things. In the summer, one studied with Ben Shahn in New York. Another attended Hans Hofmann's school in Provincetown. So I learned about fairly sophisticated things, though they were presented to me in diluted form. Or, I suppose, I didn't learn those things. So much of what I did was just a rejection. It's something in my character. For someone who wanted to be an artist, I did very little about it. I had no sense that control and accomplishment could have been useful to me. I found no model for my own development. But I did get the idea from my teachers at the university that, to be an artist, you would have to be somewhere else.

In 1949 Johns moved to New York. He was nineteen. After attending a commercial art school for half a year, he applied for a scholarship. It would be granted, he was told, for two reasons: he was destitute, and a teacher from South Carolina had put in a word for him. The award would not be based on merit. This announcement so angered Johns that he still refuses to give the school's name. Quitting his classes, he got a job as a messenger. In 1950 the army drafted him for a two-year tour of duty. He spent the last six months of it on a base in Japan; there he "made posters that advertised movies and . . . told soldiers how not to get VD. And I painted a Jewish chapel." Released from the army, Johns returned to New York and enrolled at Hunter

College under the G.I. Bill. Most New Yorkers knew that Hunter's Park Avenue campus was for women only. Johns was surprised to learn that he had signed up for coeducational instruction in the far-off Bronx. On his first day, he went to French class and understood nothing. A course in *Beowulf* seems to have meant almost as little. In art class a teacher he remembers as "a handsome, red-haired lady" told him he "drew a 'marvelous line.'" Making his way back to his apartment, on East Eighty-third Street, he passed out from hunger and exhaustion. After a week in bed, he found a job as a clerk on the night shift at the Marboro bookstore on West Fifty-seventh Street. His formal education was over.

Though Johns's wish to be an artist was persistent, he wasn't sure what he was wishing for. Though he visited museums and galleries, he didn't feel that he was becoming familiar with art. "It seemed to me to exist on a different plane from the one I lived on," he later said. "I remember seeing things like Pollock's paintings on glass and an incredible Noguchi sculpture of balsa wood and string, but then it was hard to give what I saw a value." On weekends he would draw and make watercolors. He was producing art but not, he suspected, living like an artist.

As he worked, Johns would drink a bottle of wine. He preferred the German vintage called liebfraumilch—anyway, that is what Rauschenberg recalled nearly three decades later. In 1954 an artist named Suzi Gablik introduced him to Johns at the corner of Madison Avenue and Fifty-seventh Street. She and Rauschenberg had met at Black Mountain College. Johns had met her at a friend's apartment. She thought they'd like each other; over the next few months, it turned out that she was right. Slowly, they became the equivalent of unidentical twins.

20

Johns and Rauschenberg are tall. When they met, both were slim. With his wide forehead and wide, finely-formed lips, Rauschenberg was reassuringly handsome. Johns's high and delicate cheekbones gave his face a closed-off look. "I have photos of him then that would break your heart," Rauschenberg once told Calvin Tomkins. "Jasper was soft, beautiful, lean, and poetic. He looked almost ill—I guess that's what I mean by poetic." Rauschenberg was prosaic, if one limits the word to self-assured prose about enterprising heroes. In the fifties Rauschenberg could have played the part of a charming young man, poor but magnetic, in the sunniest of F. Scott Fitzgerald's early stories.

To Johns, Rauschenberg looked like a marvel: "the first person I knew who was a devoted painter, whose whole life was geared to painting." Johns had been subsisting with breath held, an artist so ignorant of the art world that the sight of Rauschenberg's loft delivered a fascinating bit of news: artists live in spaces congenial to their work. Johns acted on this knowledge with the help of a young woman named Rachel Rosenthal. She was a friend of Rauschenberg and, for a short while, Johns's lover. Having studied dance and painting, she now wanted to make sculpture. A search of Rauschenberg's neighborhood brought her to an abandoned building on Pearl Street, just north of Fulton. On the top floor, she set up a studio and proposed that Johns move into the floor below.

Years later, Rosenthal told of wishing wildly—and in vain—to continue her affair with Johns; also, she felt "very attracted to Bob." When Rosenthal took a job teaching theater in California, Rauschenberg and Johns turned to each other. In the fifties, Rauschenberg has said, "it was sort of new to the art world that the two most well-known, up-and-coming studs were affectionately involved." The phenomenon was so new that some missed it. Johns and Rauschenberg did not fit the era's stereotypes of homosexuals. They acted

like "studs"—one brash, the other detached, neither less than manly in the style of that dark-suited, narrow-lapeled time.

When Rachel Rosenthal left New York in 1955, Rauschenberg shifted his studio to her Pearl Street loft. By then, he had taught Johns another lesson: artists do not have steady jobs; artists make art, stopping only to scramble for money. When Rauschenberg found work designing window displays for Tiffany's on Fifth Avenue, he persuaded Johns to quit clerking at Marboro and collaborate with him. They signed their windows with a single name: Matson Jones. Though commercial art required an alias, it was worth doing well. Their windows had austere pizzazz, and they found enough work to maintain their drab households on Pearl Street. Reaching upward, Johns could touch the metal-lined ceiling of his loft. Lacking a bathtub, he used a tub Rosenthal had installed on her floor.

On forays to Fifty-seventh Street, Johns and Rauschenberg kept track of shows at Parsons, Egan, and a few other galleries. They noted shifts in de Kooning's manner and in the attendant mannerisms of the de Kooningesque painters. Years later Rauschenberg stated flatly that "there wasn't any resistance to the Abstract Expressionists." Only he and Johns had resisted, he said, and they felt isolated by the effort. "Basically," Johns remembered, "we were just living and working on Pearl Street, and our world was very limited." The composer John Cage expanded it considerably.

Rauschenberg says that he met Cage at Black Mountain College. Another account has Cage introducing himself to Rauschenberg at the Betty Parsons Gallery. In this version of the story, Rauschenberg removed a white painting from the gallery wall and gave it to Cage. However they met—and the uncertainty suits the aesthetics of both men—Cage welcomed the younger Rauschenberg into his small coterie. The group's other distinguished member was Cage's lover, the choreographer Merce Cunningham. They lived in a tenement on Monroe Street, deep in the Lower East Side. After tearing down all the interior walls of their apartment, said Rauschenberg, they "had a really incredible view of the river. John had only two pieces of furniture—a slab of marble on a couple of bricks, which is still in the best of taste, and his piano. Actually, he was beyond using his piano by that time. It was a great piece for decor, however."

Before he abandoned pianos, Cage would "prepare" them for concerts by weaving spoons and other bits of hardware into their strings. A Cagean piano is a machine for dismantling standard assumptions about music. Cage gave concerts of electronically generated sound and confronted audiences with long passages of silence. To transcribe his musical compositions, he used systems calculated to produce works of graphic art. Cage painted, wrote, lectured, and gave interviews. He gathered and cooked wild mushrooms. All his ac-

tivities were equal, he believed. To those who questioned his intentions he said that intentions are best avoided.

Art, said Cage, is a way to make "an affirmation of life—not an attempt to bring order out of chaos nor to suggest improvements in creation, but simply to wake up to the very life we're living." To wake up we must be free, especially from the will's endless prodding. Seeking freedom, Cage wandered far from Western tradition to the *I Ching*, the Chinese book that shows us how to take direction from the workings of chance. He attended to Zen masters, present and past, who taught of a path beyond the self. Recognizing no authority, his own or anyone else's, he came to believe that he had escaped the limits of his personality. In fact, he had arrived at a sense of self so grand, so nearly infinite, that he took only passing notice of the difference between his actions and the universe where he acted. His art formed a portion of what happened, and some of what happened was his art. This grandiosity looked indiscriminate to most New York artists of the fifties.

Sitting at a restaurant table with Willem de Kooning, Cage heard the painter say, "If I put a frame around these bread crumbs, that isn't art." But it is art, insisted the composer; to say otherwise is to invoke the authority of definitions, which are worse than useless because they try to impose fixity on flux. "I would want art to slip out of us into the world in which we live," Cage declared. Unenclosed by categories, art belongs to life's flow. In 1959 Rauschenberg made a statement that still resounds in the art world's ear: "Painting relates to both art and life. . . . I try to work in the gap between the two." This ambition is not quite Cagean, because it preserves the suspicion of a difference between art and life. Nonetheless, Rauschenberg and Cage had affinities of perception.

Cage considered all sounds and excluded none from his music. Rauschenberg has said, "I have a peculiar kind of focus. I tend to see everything in sight." Johns tends to see only the detail at the end of his visual tunnel. Hans Namuth's photographs of him at work show a body frozen in the anxious hope of leaving the eye undisturbed. Of course his eye perpetually slides from one detail to the next, bringing into focus new fragments of the ordinary and giving Johns his own affinities with Cage. During the late fifties, Cage looked on like a friendly elder brother as Rauschenberg widened his focus and Johns narrowed his.

Their differences established a balance and brought them close. Rauschenberg once persuaded Johns to let him paint a red stripe on a Flag. Overawed by the honor, he got the jitters and placed a dab of red encaustic on a white stripe. Johns made a mock-Rauschenberg or two, then quit when he saw how thin they looked. Afterward, whenever a Rauschenbergian idea occurred to him, he would offer it to his friend, who would then come up with a Johnsian idea in return.

Rauschenberg has often drifted—or dashed—from the studio to the theater, as if he could find onstage the gap between art and life. In 1953 he designed costumes for the Merce Cunningham Dance Company and the next year supplied it with a set for a work called *Minutiae*. Cunningham made Rauschenberg his stage manager in 1961. He has choreographed dance pieces; in some, he has performed. And since 1984 his Rauschenberg Overseas Culture Interchange has improvised a collaborative drama from the struggle to make prints with local artists in Venezuela, China, Berlin, and other far-flung places.

In 1967 Rauschenberg persuaded Johns to become an artistic adviser to the Cunningham company. Though he invited Robert Morris, Andy Warhol, Frank Stella, and others to design sets, Johns usually limited himself to costumes. "I don't see the necessity for objects on the stage during a dance," he has said. For a series of paintings called *Dancers on a Plane* (1979–81), he transposed dance patterns from the three dimensions of space to the two dimensions of canvas. Johns does not feel at home in the theater. Asked why not, he replied:

I don't like the deadlines, the putting up and taking down, the success and failure, the moving about from place to place, the wear and tear and repair, the community of personalities with its and their aches and pains and religions and diets, etc.

Rauschenberg skids headfirst into the currents of the mundane; Johns draws back fastidiously. The nephew of a schoolteacher, Johns corrected Rauschenberg's grammar now and then. Rauschenberg chose not to be miffed. He had found in Johns a critic worth heeding and an artist worth criticizing. Johns had found the same in him. As they clarified their differences, each invented a more vivid idea of himself. These ideas, it turned out, were not compatible. Their breakup was painful.

21

The debut of Jasper Johns had prompted Alfred Barr to apply a label: neo-Dada. His logic was clear. Johns's ready-made images recalled the ready-made objects the Dadaists had presented as art four decades earlier. Man Ray's *Gift* (1921) is an iron with a row of tacks affixed to its flat surface, points outward. Dada offered puzzles and, on occasion, an affront. In 1920 Francis Picabia nailed a toy monkey to a slab of wood and called it *Portrait of Cézanne*. Johns annoyed some and baffled others with his Flags and Targets, yet the neo-Dada label did not stick firmly to these paintings.

With the violence of their wit, the Dadaists tried to inflict therapy: shock treatment for bourgeois stuffiness. Turning prickly, Dada became an exercise in moral exasperation. Johns's art is never that. In his self-absorption, he feels no need to judge or improve his audience. He feels disconnected. In 1964 the critic Gene Swenson asked him about the ale cans he had cast in bronze. Doesn't subject matter like that imply "a social attitude"? Johns deflected the question. Swenson asked it again, and again Johns deflected it. With some asperity, Swenson suggested that Johns transformed ale cans into sculpture because he was too impressionable and took the environment's most obvious hints too easily. "Accept or reject, where's the ease or the difficulty?" said Johns, finally defeating the critic's effort to elicit a comment on art and society.

Dada was contentious, sometimes clamorous. Johns's *Flag* has the calm of an object encountered inadvertently—not that it looks like a secret revealed. The painting isn't shamefaced, nor does it flaunt itself. Ordinarily, the Stars and Stripes are the emblem of the nation's public life. Johns turned the emblem inward, made it private. Expecting only a few gallery-goers to take note, he was amazed when his debut at Castelli's became the not-to-be-missed show of the season. "I liked the attention," he has said. "And I thought it was interesting that other people had a reaction to my work, because prior

to that time I had assumed that it was mostly of interest to myself." Dada is art in the public interest. Behind the barricade of his private concerns, Johns dismissed the neo-Dada label.

Though the label came loose, it didn't immediately fall away, for there appeared to be shatterproof links between Johns and the proto-Dadaist Marcel Duchamp. Never officially one of the group, Duchamp now and then professed his "sympathy" for the Dada spirit, which he had been the first to display. In 1913 he mounted a bicycle wheel on a wooden stool and declared it a sculpture. By similar fiat, he conferred aesthetic status on a urinal, a snow shovel, and other manufactured, ready-made objects. Duchamp had been impatient with the avant-garde styles of his time, especially Impressionism and Cubism. Johns's Flag signaled his impatience with Abstract Expressionism. Both artists enjoyed the intellectual play that calls definitions into doubt. Made famous by his first show, Johns was introduced to Duchamp. They liked each other but never spent much time together.

After meeting Duchamp, Johns read Robert Lebel's recently published book on the artist. Soon he was filling his work with Duchampian devices —color charts, painted shadows, real objects in place of representations. A note in Duchamp's Green Box (1934) describes a hinged painting. Johns used hinges to attach a small canvas to the surface of a big painting called According to What (1964). Swing the small canvas outward and a Johnsian version of Duchamp's Self Portrait in Profile (1958) appears. This homage invites us to see Johns as the son of the older artist. Johns himself revokes the invitation. In 1977 he said that "when my work was first compared to Duchamp and termed neo-Dada I didn't know who Duchamp was." There are two reasons to believe him. First, Johns has a reputation for honesty; second, he displays no deep affinity for Duchamp's aesthetic.

With his ready-mades, Duchamp gave dramatic force to a large question: What is art? Entangled in minutiae, Johns does not grapple with this issue. Art is whatever artists make, he believes, and it does not trouble him that Duchamp intended his Dadaist gestures to "destroy art." "My interest in his work is not from the point of view of killing art," Johns has said. "I know one's not supposed to say this, it's not quite proper, but I regard his work as art of a positive nature. I see it as art." With this mild impropriety, he denied the point of Duchamp's career.

Not long after Duchamp died, in 1968, Johns wrote in Art in America that "it may be a great work of his to have brought doubt into the air that surrounds art." Duchamp's doubts had grandeur, and he brought them to bear on the large themes of Western thought. His oeuvre forms an involuted system—or anti-system—of intellectual speculation. Duchamp was an architect of labyrinthine subtlety. Johns is more a carpenter, an improviser of localized solutions—or mock solutions—to immediate problems. Duchamp-

ian motifs appear in his rambling oeuvre, take on a Johnsian tinge, then fade, but never completely. The shadow of Duchamp's wit accompanied Johns as he advanced, slowly, into the seventies and eighties. Yet Johns is no disciple.

He produces new works by subjecting his old ones to the faint but persistent pressures of rumination. *According to What*'s waxen cast of a leg evolved from the plaster body parts in his early Targets. The coat hanger jutting from the surface of this painting is a cousin to all the cups and brooms and other domestic objects Johns attached to his canvases in the sixties. Bent nearly in half, this coat hanger casts a shadow almost as sturdy as itself. In the opposite corner, the upside-down leg on its slim fragment of a chair mixes its shadow with veils of stained-in gray paint.

Between leg and coat hanger, two vertical rows of aluminum letters jut out from the surface. In a reprise of the inscriptions that had been appearing on Johns's canvases since 1959, the year of *False Start*, these three-dimensional letters spell RED, BLUE, and YELLOW. Their shadows tangle with the same letters rendered in paint on canvas. Sometimes the shadow-words coincide with the painted words, sometimes not. It depends on the lighting. From this uncertainty came the painting's title. In 1971 Johns told an interviewer that "the shadows change according to what happens around the painting. Everything changes according to that."

The artist once said, "I don't think there is any particular right and wrong when you're viewing a painting." There is, though, a mood to attain, a state of attentiveness to slip into. One comes alive to the nuances of Johns's paint and the textures of feeling that run through his images, preserving them as if they were childhood memories, and changing them, giving them at least a tentative place in the present.

Sixteen feet wide, *According to What* was one of just four paintings in the show that opened at Castelli's early in 1966. Each is large enough to suggest a wall. Together, they converted the gallery into something like a stage set, an elliptical replica of the studio where they were painted. The canvas called *Studio* (1964) is almost as big as *According to What* and far emptier. Along its right edge, nine beer cans are strung on a length of wire; the pendant is a paint-encrusted brush. Gray and murky white fill much of the canvas, recalling the neatly modulated gray scale of *According to What*. To the left of *Studio* appears the tilted image of a door. Along the bottom edge sit three sooty squares of primary color—red, yellow, blue. In *According to What*, these patches of color are bright.

In the third of the studio paintings, *Untitled* (1964–65), the color samples of the other two expand to fill the surface with squared-away expanses of red, yellow, blue, and purple. This spectrum reappears in small swathes of paint that arc over the canvas like rainbows. At one end of each arc, Johns

41. Jasper Johns, *According to What*, 1964. Oil on canvas with objects, 7 ft. 4 in. × 16 ft.

placed a twelve-inch ruler—an emblem of line, to answer the sheer, enveloping fact of color. In *Eddingsville* (1965), the fourth painting in the 1966 show, *According to What*'s upside-down leg is rendered in paint, not wax. *Eddingsville*'s gray scale is merged with the color scale, and primaries are again high-keyed.

Toward the right, a wax cast of forearm and hand reaches over the surface. To this object Johns bolted a yardstick. His point may be that humanity is the measure of all things, though it is the fragment of anatomy that submits to measurement. Between ruler and arm he wedged more objects—a fork, a beer can, a shell, a sponge, an ice-cube tray. Johns once told the art historian Roberta Bernstein a story that goes some way toward explicating this enigmatic array.

In 1961 the artist bought a house in Edisto Beach, a small town on the coast of South Carolina. Offshore lies an island named Eddingsville, where the Marquis de Lafayette and his friends are reputed to have had a champagne picnic. Johns reenacted the event with friends, though the beer can and ice-cube tray of *Eddingsville* suggest that he was not overly concerned with fidelity to legend. With this painted memorial to a pleasant afternoon, Johns opened his art to the world beyond the studio. Another interpretation—and there is always at least one other—is that he lured fragments of the ordinary world into the hermetic zone he mapped in his elliptical way with the four studio paintings of his 1966 show at Castelli's.

In *Studio II* (1966), the door of *Studio* has become a wall of windows. These paths of vision's escape lead to the blankness of sheer paint. Johns's big paintings of the sixties picture his ideal studio as a place of comfortable—and comforting—isolation. Here he feels free to indulge, uninterrupted, his fascination with the workings of his mind—not large gestures of thought but small, incidental acts of scanning, noticing, remembering, matching. Willed just barely or not at all, unremarked by most of us, acts like these are the raw materials of Johns's art. His studio pictures convert the idling of the mind into images of the place where that conversion occurs.

Johns's mind idles with compelling force and imperious reach. He says that once, while riding in a car through Spanish Harlem, he saw flagstones painted on the side of a building. Later, this pattern of flat, irregular ovals migrated to the left panel of a painting called *Harlem Light* (1967), where it has the look of decoration that would be noticed only if the eye could find no way around it. On the right panel of *Harlem Light*, a tilted window drifts beneath smears of blue paint.

In *Untitled* (1972), flagstones occupy the central panels. On the right, an irregular scaffolding of planks supports an array of waxen body parts: toes, fingers, a knee, a torso. To the left, a new pattern appears: short parallel lines

of color laid on in small clusters and separated by intervals of white. Oriented this way and that, the clusters fit together like flagstones. Johns's name for this pattern is *hatching*. Usually, there are five lines to a set, each a different length. The outer lines are often the shortest, the middle line the longest. The suggestion is of fingers, skeletal and wet with paint, pressed to the canvas repeatedly, until the blankness is transformed.

Johns varied this pattern for more than a decade, darkening it, lightening it, blurring it to an afterimage of itself, then bringing it back into focus. Red hatch marks interspersed with white call to mind the stripes of his Flag. The Flag itself returned in paintings and prints of the seventies. An image of a human skull, which had looked out from the lower right corner of *Arrive/ Depart* (1963–64), resurfaced in a set of paintings called *Tantric Detail* (1980– 81). Centered now, the skull hovers near the bottom of the canvas. Above it, a pair of testicles echoes the skull's empty eye sockets and reverses their meaning. Life rises above death, and from the testicles rises an erect penis, most of its length hidden by hatch marks in black, white, and gray.

Near the upper edge of a canvas called *In the Studio* (1982), a nail supports a cast of a child's arm. Over its surface, hatching spreads like a tattoo. This anatomical fragment reappears to the left, reversed, drawn with colored pencil

42. Jasper Johns, *Scent*, 1973–74. Oil and encaustic on canvas, 6 ft. × 10 ft. 6½ in.

on a sheet of paper. Pasted to the canvas in fact, the paper is also attached to a make-believe wall with painted nails. In Johns's art, a fact is and is not equivalent to an image of that fact. Similarly hedged equivalencies liken flesh to canvas, the human body to works of art. The painter is and is not his painting. For years, both were stubbornly reticent. "In my early works," said Johns in 1978, "I tried to hide my personality, the psychological state, my emotions. This was partly due to feelings about myself and partly due to my feelings about painting at the time. I sort of stuck to my guns for a while but finally it seemed like a losing battle. Finally one must simply drop the reserve." Johns was becoming autobiographical.

Racing Thoughts (1983) places a silk-screened image of the young Leo Castelli against a background where Johns's hatching blends with his flagstone pattern. Nearby is the Mona Lisa. She recalls Duchamp, who supplied her with a mustache in 1919, and Leonardo himself, Johns's favorite Renaissance painter. A skull lurks, this one borrowed from an Alpine sign warning skiers of avalanches. Johns let it be known that he collected pots by a turn-of-the-century American named George Ohr, two of whose odd designs are pictured in *Racing Thoughts*. Still the sphinx, Johns was putting his memorabilia on display.

The image of a whale looms up in *Ventriloquist* (1983). Prodded, the artist revealed that he had found it in an edition of *Moby Dick* illustrated by Barry Moser. A dark rectangle split by a thin white stripe alludes to a Barnett Newman print, as few in the art world needed to be told. Suddenly, critics had their hands full of keys to Johns's art. Fresh images crowded the four canvases of *The Seasons* (1985–86), and Johns was willing to talk about them all: the geometric shapes he had taken from a painting by a nineteenth-century Zen master; the allusions to Picasso's Minotaur; the snowman who recalls a wintry—indeed, a deathly—poem by Wallace Stevens.

Depicting his studio in upheaval, slowly jumbled by the passage of time, *The Seasons* address life and death, the past that is remembered and the future that is feared. Earlier, Johns had only hinted at themes of this magnitude. The sphinx, it seemed, was becoming confessional. Never, though, did he reveal anything more than the source of an image. He explained, for example, that he had traced certain nebulous forms in *Perilous Night* (1982) from the outlines of fallen soldiers in Matthias Grünewald's *Isenheim Altarpiece* (c. 1510–15). Before he got bored with giving explanations like these, Johns noted that the faucets and laundry hamper in *Racing Thoughts* and *Ventriloquist* are what he sees when he lies in his tub.

To reveal sources is not to explain meanings. Commentators eventually understood that Johns had left his new images as securely veiled as the old ones—the Flags and flagstones and waxen arms that returned from the past

to hover in his later paintings. Johns neither illuminates life and death nor tells us how he feels about these massive and murky topics. At most, he tinges them with his sensibility. The nature of that tinge is obscure, a matter one cannot even begin to address before withdrawing to an inwardness as private as Johns's own. His art induces us to be like him: entranced by the elusive but somehow always dependable hum of solitude.

43. Jasper Johns, *Fool's House*, 1962. Oil on canvas with objects, 6 × 3 ft.

22

In *Perilous Night*, a companion piece to *Racing Thoughts*, the familiar Johnsian melancholy darkens until velvety black absorbs all painted form. Nothing is sharply visible but the three casts of an arm that hang from the canvas side by side. In an untitled painting from 1988, the wall becomes a dark blue sky filled with stars and nebulae. Night seems less perilous now, yet the hermetic atmosphere of the studio persists. This dark immensity of sky is an enclosure, a flat surface inscribed with patterns borrowed from Grünewald. In the first of the studio paintings, *Fool's House* (1962), shifting tones of gray suggest sunlight finding its way through a bank of clouds. A tall canvas becomes a high, narrow window—but only for a moment. The austere vigor of Johns's brushwork flattens the sky's depths to a wall where a broom is suspended from a hook. From the picture's lower edge hangs a cup. A small towel, neatly folded, occupies the corner to its left.

Next to each object the artist wrote its name. When a friend saw the word *broom* beside the broom, he said, "Any fool can see that it's a broom!" The name of the painting followed. Johns builds the house of his art from what any fool can see: a broom is a *broom* is a broom. Along the bottom of the canvas, the artist affixed a small stretcher and painted it gray. Soaked with the same color, the towel has the look of a paint rag. Paints were mixed in the cup, it seems, and the broom bears signs of having served as an outsize brush. In *Fool's House*, all is known three times over—by its look, by its name, by its use, which is to make art. Nothing here has any other use. No house could be cozier, more perfectly fitted to its sole inhabitant. Its plenitude sustains his isolation.

Tinged by the bitterness of his early life, Johns wanted no genealogical connections. He wanted to be born of himself, of his private sense of order, with no debts to anyone. That was impossible, of course. Though he stood apart from the furor of downtown painting in the fifties, Johns accepted its

sooty New York atmosphere as a sign of aesthetic seriousness. From Rausch-enberg he learned bits of painting lore, and his visits to museums surely taught him something. Yet Johns's art is not a continuation of anything. He is no one's heir. Painting the American flag, he has said, "was something that I could do that would be mine." He did it with encaustic, a medium so long neglected that he could find no one to teach him how to use it. He had to teach himself from a book. Rendered in this curious mixture of wax and pigment, the flag became his emblem. And Johns became an emblem of independence, that favorite American virtue.

In the archives of the Castelli Gallery is a card with a single fold. The outside bears a color reproduction of Johns's *Three Flags* (1958). Inside, the card reads, "MERRY CHRISTMAS, HAPPY NEW YEAR, EMILY AND BURTON TRE-MAINE." There is no date. The image of *Three Flags* signaled the Tremaines' success as collectors. Also, it stood in for Jesus, Joseph, Mary, the three Wise Men, the shepherds, Santa Claus, his reindeer, and everything else you might see on a Christmas card. In 1980 the Tremaines decided the time had come for *Three Flags* to have a public life. A painting so frankly American belonged in the Whitney Museum of American Art, they felt.

The Tremaines chose Arnold Glimcher, of Pace Gallery, to oversee the transaction. He suggested a price of one million dollars. Never had that much been paid for a work by a living artist. In the phrase "one million dollars," Tom Armstrong, then the director of the Whitney, heard the sound of a magic charm. Launching a fund drive, he found the charm effective. Do-nations were quick, and *Three Flags* made a smooth entry into the public realm.

With ease, the painting migrated from the Tremaines' Christmas card to the cover of the Whitney's introductory brochure. It appears on the dust jackets of American history books, American poetry anthologies, and books about painting in America. For the show American Art in the 20th Century at the Royal Academy in London in 1993, all official communications bore a reproduction of Johns's first Flag. He has given aesthetic weight to the na-tional banner and to many other images and objects that we usually don't bother to notice—maps of the lower forty-eight states, twelve-inch rulers, the letters of the alphabet, coat hangers, spoons, the cardinal numbers, paint-brushes, beer cans, flashlights, and enough else to swamp the memory. Any fragment extracted from the Johnsian repertory could stand for American culture in the anthropologist's sense: the sum of our artifacts and institutions. Refined by Johns's touch, his images and objects stand as well for high culture in America.

Johns once said, "Whatever I do seems artificial and false, to me." This sounds like the confession of a fault. In fact, it is an assertion of a virtue: superiority to the dictates of the merely natural, the instinctive. Calling his

actions "artificial and false," Johns notes that his civilized way of being puts him in harmony with a world of invented things, products of artifice. Much in his oeuvre, from hinges to gunmetal grays to the stencil style of his lettering, recalls old-fashioned manufacturing, and on occasion he has played the part of a quirky manufacturer.

In 1960 Johns produced a solid bronze light bulb. Four years later came the aluminum letters of *According to What*. And from the mid-fifties until the early eighties, he cast any number of human body parts. These anatomical fragments do not represent the sensuous impulses of the flesh. They are signs of a life regulated by decorum. The body inhabits the art of Pollock as a surging force, gesturing into being an unbounded habitat. In Johns's art, the body is one object among others in a world where everything is subject to the same strict—and elusive—rules of propriety. Pollock said, "I am nature." To this boast, Johns makes the tactfully unstated reply, "I am culture."

Ordinary or high, culture begins where nature leaves off, and develops by turning in on itself. Culture is an enclosure offering the comforts of well-guarded borders, which Johns marks with the walls of the imaginary studio invoked by *Fool's House* and its variants. Nothing appears on these walls except emblems of the American culture Johns embodies. It is difficult to imagine a house more snug than *Fool's House*, yet its comforts are entangled, as in a troubled family, with causes for deep uneasiness.

At the left edge of *Fool's House*, the artist wrote USE. The rest of the title appears at the opposite edge. To get from USE to FOOL'S HO, the eye need only cross the width of the canvas. But say that reading begins at the beginning of the phrase. From FOOL'S HO, the eye would sail off the right edge of the canvas. Afloat, you could traverse the fullness of space—the infinite—before arriving at the left edge of the canvas and USE, the completion of the phrase. The architecture of *Fool's House* opens onto other gulfs—the one separating the word *broom* from a broom, for example, and the gulf between an ordinary broom and a broom of the Johnsian kind, which is an implement of high art. Both drafty and shipshape, *Fool's House* provides a suitable home for all the uncertainties that its sole inhabitant likes to foster.

Johns permits nothing to be simple, not even the direction of time. "I think art criticizes art," he said in 1973. "I don't know if it's in terms of new and old. It seems to me old art offers just as good a criticism of new art as new art offers of old." Going forward to a new image, he may reach back for an old one—a Flag or a body part. His past is perennially present. Also, it is absent, empty, lost beyond recall. When asked what he thought of the works assembled for his retrospective exhibitions in Venice, London, and New York—all in 1964—Johns said, "They just looked like a lot of old paintings." Did he really feel so indifferent to works he had already begun to recycle?

And how are we to take his Flags? Are they pictures of the Stars and Stripes or actual flags, rendered in paint on canvas? This question occurred before the doors closed on his first show at Castelli, and critics still mull it over. Unresolvable conundrums loom up in every stretch of Johnsian terrain.

Having covered a panel with hatching, Johns would sometimes mirror its pattern in a second panel. This doubling holds the image within the frame, but only until you see that the doubling could be doubled and redoubled endlessly. Though the hatching seems nestled into itself, its clustering lines never settle into a composition—a balance of form against form that sets its own boundaries. Nothing in the hatching calls for a halt to its spread. The halt is imposed from without, by the edges of the canvas. If it were not for those merely physical constraints, the hatching could go on forever. Like Pollock's skeins of paint, this Johnsian pattern implies an infinite.

A hatched painting called *Scent* (1973–74) shares its title with a Pollock drip painting from 1955. When the critic David Bourdon asked Johns if he had intended a reference to Pollock, the artist said, "No. The title *Scent* occurred to me as the proper title for the picture, and I started *not* to name it that because I thought it would make associations with the Pollock picture." It would draw a misleading line of genealogical descent. Johns's hatching did not evolve from Pollock's pouring. Each worked from a parallel impulse, an American bias for the unbounded.

In 1960 Johns filled a small outline map of the forty-eight states with cold white encaustic that deepens to black along interior borders. A year later, he transferred the map to a canvas over ten feet wide and colored in the states with the reds, yellows, and blues of *False Start*. Here and there, a secondary color emerges. Red turns orange; there are passages of green in Florida, Kansas, Colorado. In *False Start*, a patch of blue can be labeled RED, a red YELLOW. In the Maps, the states keep their names, though much else is arbitrary in these images of America. Johns's brush respects one state line and blurs another. Here, a state's name pops out of the welter of paint; nearby, a name almost vanishes.

A Map could have any dimensions whatsoever; the circles of a Target are subject to infinite multiplication; and nothing about the look of a grid locks it to the surface where it appears. No matter how big it may be, a grid is always a swatch, never the whole bolt of cloth. Not long after his first show, Johns said, "I don't put any value on a kind of thinking that puts limits on things." He went on to a career of drawing lines, charting differences, setting limits—but always tentatively. In his art, no edge is firm, no boundary is final. Every premise is an occasion for amendment, extension, extrapolation. Slippage is constant, and sometimes the eye feels it in the very grain of the paint. Shaping and obscuring other forms, a brush mark may become a form in itself. Subtleties like these do not make high pictorial drama. An inter-

viewer once confronted Johns with the notion that art is a latter-day alchemy, a means of revelation through wondrous transformations of the mundane. Johns gave a deflationary response: "If you have one thing and make another thing, there is no transformation, but there are two things."

Though the Johnsian Flag occasionally becomes two or even three Flags, it always seems content with whatever size it happens to be. For convenience, one assumes that a Flag 42¼ inches high by 60⅝ inches wide simply is a flag of those dimensions. Read as a picture, it seems to represent a flag precisely that big. Yet the Flag belongs to no landscape, waves in no atmosphere, open or constricted. Nothing gives it a location or a scale. Very small American flags appear on lapels; very large ones cover the exterior walls of massive buildings. Floating free of all particular places, a Flag by Johns refers to flags of every size, real and imaginary. Among the make-believe flags the artist pictures is one of unlimited extent, a national banner infinitely large and thus commensurate with certain fantasies about America's power and importance. Charged with that immensity, a Flag has the scale of a drip painting by Pollock.

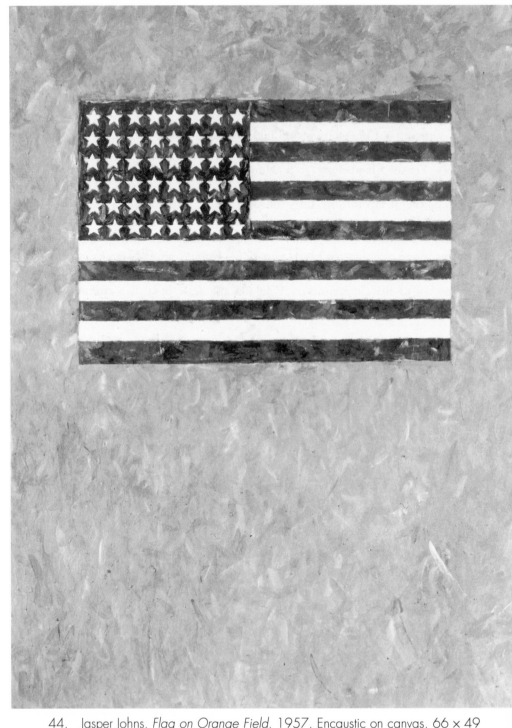

44. Jasper Johns, *Flag on Orange Field*, 1957. Encaustic on canvas, 66 × 49 in.

23

"One thing is not another thing," said Jasper Johns in 1965. His art celebrates this self-evident truth. Thus a Flag, a broom, a word makes a declaration of independence simply by being what it is. Johns doesn't permit these declarations to become overly assertive; sometimes he undermines them. Asked why he marked with an *X* an image in a print called *Bent "Blue"* (1971), Johns said he wanted to show that "it's not too important what's there." Also, he added, "It's of great importance what's there, because that is what is there"—a scrap of the funny papers, as it happens, and for the artist an instance of unimpeachable isness. Instances of isness serve him as emblems of the unentangled autonomy a person might have. One might be a discrete presence, truly and inalienably oneself.

In truth, said Johns, the scrap of the funny papers "could be anything else." An emblem of autonomy is replaceable, if only in principle. Though Johns does not revise finished works, his motifs have a doubtful air. For all their permanence, they look unstable. A whole becomes a part, a unity starts to look like a fragment. One moment an image displays integrity, the next it is an allegory of disintegration. Your reading depends on the focus of your eye, and that, as Johns remarks, is always changing. Shifts in focus generate the slow flood of nuance that fills the Johnsian infinite over which the Johnsian Flag presides.

His Flag returns the gaze as if the viewer were nobody in particular, a generic member of the audience—the citizen who recognizes the Stars and Stripes, the literate person who can read the alphabet, the biological presence whose vision hits the Target with reflexive accuracy. Performing these functions, we stand outside the realm of Johns's art. Our role is to see how successfully he has isolated himself in that boundless zone, and how thoroughly he occupies it. The grain of his imagery is the grain of his presence. He pervades his infinite as minutely as Pollock pervades his.

I once asked Johns where he had first seen a drip painting by Pollock. At the Whitney Annual of 1949, he said. When I asked him what he thought of it, he said, "My immediate impression was that it wasn't ordered enough." In Pollock's pouring he found

> nothing that I could use. It seemed a dead end. De Kooning was more useful. His paintings had something you could grasp and vary, but at first I didn't have the knowledge to do that. By the time that I had some sense of what was what, I didn't want to do it. Younger artists were doing things easy to relate to de Kooning. I was anxious to avoid doing what everyone was doing. I was anxious to clarify for myself and others what I was.

Americans from Henry David Thoreau to Jasper Johns have felt this anxiety. They have cultivated it, strengthened it, taught it to serve as the leading principle of their lives. Arranged chronologically, these militantly independent spirits form no line of succession, only an array of "Isolatoes," as Herman Melville called them—none "acknowledging the common continent of men, but each *Isolato* living on a separate continent of his own." The "separate continent" of Pollock's art is America in a pure state of nature. For Johns, it is American culture in a thoroughly personal state. His oeuvre is the residue of a quiet drama, the constantly varied performance of acts that imprint the things of high art and ordinary life with the texture of his sensibility. Assembling, arranging, labeling, merging, dividing, rearranging, he constructs a world and merges with it.

Johns's isolation in his art is his oneness with America—not the America overrun by others but an imaginary place made bearable by the absence of every ego but his own. Appearing at the outer extremes of American individualism, the Johnsian self communicates a disinclination to communicate. Proclaiming the artist's absolute solitude, the Flag takes on melancholy glamour. And there is something alluring about the nation for which it stands— an America liberated from all social difficulties, from the very idea of society, and endowed with the boundlessness of nature.

Pollock invaded the canvas with intimations of the raw American infinite. The open-ended subtleties of Johns's canvases suggest that the American infinite need not be raw. It can be refined, and its refinements need observe no limits. Though culture draws boundaries, Johns is forever moving them outward, claiming more terrain for his sovereign sensibility. Because he would accept no legacy from Pollock, their succession couldn't launch a tradition, only a rivalry in which Johns has always been dominant. Pollock started to turn hazy even before he died. Appearing suddenly, two years after Pollock's

death, Johns presented an enigma in sharp focus. With his opaque gaze and immobile face, he was an oddly unflappable figure of the artist.

This figure has not evolved; it has only become more confident and institutional. Johns's bursts of public laughter have a controlled, declarative quality. They are sudden and never occur at precisely the moment dictated by the tempo of conversation. It's as if he knows reflexively how to keep patterns of talk from catching him. Robert Rosenblum has vivid memories of conversational difficulties with Johns. "Even the simplest thing could go completely off track," Rosenblum says. "Once, when Jasper was present, I happened to ask what time it was. He said something like, 'Time? I didn't realize you were so interested in time.' He wasn't being hostile or rude. Just impossible."

With affectionate exasperation, art-world veterans talk of Johns's "scary" laughter and "spooky" silences. They recall his stiletto wit and then, more often than not, remark on how rarely they see him. Johns is the absent monument, the invisible sphinx at the heart of the New York art world. The target of cultish respect, he may well have done more than Pollock to convince viewers that the unfolding of an oeuvre can be the mapping of an infinite.

With Rauschenberg, Johns blazed a path into the realm of the American mundane. Those who followed were called Pop artists—Andy Warhol, Roy Lichtenstein, Claes Oldenburg, Tom Wesselmann, Robert Indiana. Warhol, in particular, found useful cues in Johns's devices—his grids and his solitary images, centered on the canvas and flattened against its surface. As the sixties ended, a young artist named Bruce Nauman looked for ways of being Johnsian without becoming a Pop artist. Johns had made casts of anonymous bodies. Nauman made casts of his knees, his arm and shoulder, his back. Johns's Flag became his oblique self-portrait. Nauman turned his signature into a zigzagging, purple neon wall piece. Cold green emanates from *Neon Templates of the Left Half of My Body Taken at Ten-Inch Intervals* (1967). Usually, Nauman worked in grayed-out colors. Deforming familiar forms, devising insoluble puzzles, he generated a variant of the Johnsian mood—inward, melancholy, sustained by shadowy refinements.

That mood was widespread. Keith Sonnier mixed Johns-like grays and beiges into batches of latex, which he spread on gallery walls in rectangles the size of big New York paintings. Peeling away part of the latex, he produced a look of picturesque decrepitude. Neon tubing brightened the effect, and lengths of see-through silk softened it to a reminiscence of the atmosphere of Johns's cluttered studio paintings. This homage earned Sonnier a place on Castelli's roster in the late sixties. Further homages appeared in the works of Dorothea Rockburne, Paul Mogenson, David Novros, and Robert Mangold.

All showed at the Bykert Gallery, an outpost of Johnsian elegance on East Eighty-first Street.

The most refined of the Bykert artists was Brice Marden. Like Johns, he used encaustic. His earliest works are canvases covered with a single, cautious variant of a Johnsian green or gray. Marden proceeded with deliberation, taking a day to mix a hue, and weeks to smooth it on with a palette knife, layer after waxy layer. Eventually, his patience brought him to colors that shift as the eye tries to pin them down. In his monochromes of the late sixties and early seventies, a dense gray may seem haunted by a green, then by some elusive shade of blue.

From the uncertainties of a Marden color came insinuations of light. Recalling times of day, subtleties of weather, the obdurate monochrome opened onto airy distances. Always, the eye returned to the surface and a smoothness like that of butter or skin or polished stone. In Marden's paintings from this time, sensuality was perpetually shadowed. Gloomy undertones lurked in the loveliest of his grays, and his ochres sometimes had an exhausted look. Johns generated moods from enigmatic words and images. Marden was more economical. He distilled Johns's clutter to a blankness laden with all that it denies.

During the mid-sixties, Robert Moskowitz inflected Johnsian monochrome with shifts in tone. These are neatly patterned and so faint that it is not always obvious that the artist has formed the image of a room's empty corner. As the next decade began, Moskowitz's paintings became walls of color bearing shrunken, isolated images—a chair, the outline of a duck's head, the profile of a Cadillac's tail fins. Lois Lane, Nicholas Africano, Donald Sultan, and others displayed variations on this device, which uses monochrome painting as a backdrop for private fetishes in picture form. Dubbed "new image" painters, these artists updated the by-then old format of Johns's *Flag on an Orange Field* (1957).

The group's most widely admired member, Susan Rothenberg, arrived with a single subject: horses. Standing or running, they are always in profile, always in silhouette. Rothenberg's brushwork is as deliberate as Johns's but not as refined. Under pressure from her hand, equine shapes take on the baggy bulk called shapeless. The ungainly head and clumsy hooves of a Rothenberg horse give it the companionable presence of a stuffed animal. Her paint is thick, yet it's easy to imagine that the coats of her horses are thin, worn down to the nap by her repetitive touch. Toward the end of the seventies, she pictured a big teddy bear. Revamped by Rothenberg, Johns's austerities turned cuddly. Rothenberg won a place at the center of the art world as a Johnsian waif.

As Rothenberg's horses evolved, childlike variations on Johns's example surfaced in the works of another young painter, Donald Baechler. A desperate

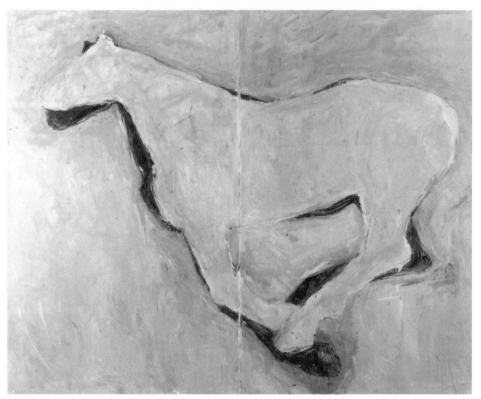

45. Susan Rothenberg, *Cabin Fever*, 1976. Acrylic and tempera on canvas, 67 in. × 7 ft.

sweetness, as of battered innocence, shapes Rothenberg's images. Whether they grin or frown, Baechler's deliberately primitive figures look dazed by their discontents. With a bitter, even surly economy of line, he can make a piece of garden furniture or a toy boat look utterly bereft of any earthly use. Amid the exuberance of the eighties, Baechler impersonated the Johnsian painter as dysfunctional child. Transposing Johns's tonalities from gray to brown, Terry Winters found new subject matter—organic forms, reminiscent of spores. Winters brought a touch of nature to Johns's realm of ready-made signs and symbols. James Brown gave Johnsian textures to the fetishes and pictographs of tribal culture, motifs borrowed from the Parisian modernists —Picasso, especially.

The elaborators of Johns's devices form a large and tangled lineage. This genealogical pattern is a suitable emblem of his importance but not its full measure, for his influence reaches far beyond the works of those who have used devices traceable to his oeuvre. The paradoxical tone of his art—its

austere sensuality, its exhilarated gloom—reverberates mutely through much of the painting and sculpture made in New York since the late fifties. He has become the city's exemplary artist, though he would be the first to question the existence of such a figure. Johns is exemplary precisely because he cultivates his doubts with the calm persistence of a monument.

A Dazzling Continuum

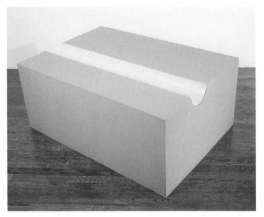

46. Donald Judd, *Untitled*, 1964. Oil on wood and enamel on iron, 19½ in. × 48 in. × 34 in.

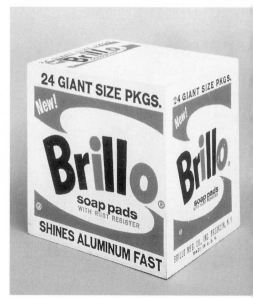

47. Andy Warhol, *Brillo Box (Soap Pads)*, 1964. Synthetic polymer paint and silk-screen ink on wood, 17 × 17 × 14 in.

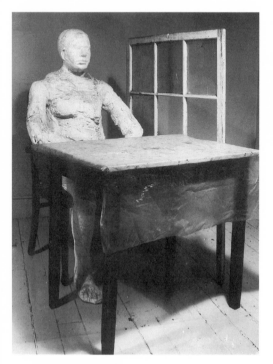

48. Frank Stella, *Conway I*, 1966. Fluorescent alkyd and epoxy paint on canvas, 6 ft. 8½ in. × 10 ft. 2¼ in.

49. George Segal, *Man at Table*, 1961. Plaster with mixed media, 28 ft. 2 in. × 25 ft. 5 in. × 25 ft. 5 in.

24

Jasper Johns showed in detail how a set of well-chosen premises can sustain a career. This was a lesson Jackson Pollock did not teach. Brushing aside his predecessors, Pollock opened the way to an infinite and filled it with a lingering, expansive present. The sweep of his arm denied the need for a future, for descendants, and in the fifties he seemed to have none. For two successive months in 1958, *Artnews* published memoirs of Pollock. The prevailing tone was elegiac, as if a glory that had departed from the world were fading from memory, too, and needed to be recalled. Only a young artist named Allan Kaprow looked from Pollock to the future.

Kaprow began by arguing that Pollock had made painting into a "ritual," which the edges of the canvas interrupted for no good reason. To Kaprow's eye, the drip paintings looked truncated. Even so, he said, they feel like "environments." We are "confronted, assaulted, sucked in" by the swirl of Pollock's imagery, though Kaprow didn't mean that a drip painting draws us into imaginary depths. Instead, "the entire painting comes out at us . . . right into the room." The impulse to make art is stranded in real space, and members of the audience are "participants rather than observers." According to Kaprow, Pollock "left us at the point where we must become preoccupied with and even dazzled by the space and objects of our everyday life, either our bodies, clothes, rooms, or, if need be, the vastness of Forty-second Street."

This argument had precedents. "Art should not be different from life but an act within life," John Cage had declared at Black Mountain College. He continued to declare it at the New School for Social Research, in Manhattan, where Kaprow studied with him in 1957. Student and teacher were in close but not perfect sympathy. Cage believed that if art is estranged from life, one musn't fuss about the situation. It is best simply to proceed with the alert detachment he considered proper under all circumstances. This attitude didn't suit Kaprow, who believed that art would soon be pointless if it could not

reestablish its archaic unity with life. Cagean insouciance was not sufficient. Art faced a crisis, and modernist history showed how to solve it.

Earlier in the century, Cubist collage had brought bits of the ordinary world into the realm of high art. Now collage was becoming assemblage, as Richard Stankiewicz, John Chamberlain, and Mark di Suvero found the raw materials of sculpture in rusted boilers, junked fenders, and the beams of demolished buildings. Rauschenberg—another disciple of Cage—was busily converting urban detritus into "combine" sculptures. Galleries were beginning to feel overstuffed with chunks of the mundane.

In 1958 Kaprow hung strips of plastic and cloth from the ceiling of the Hansa Gallery, dividing the space into a labyrinth of aisles. He offered no discrete works of art for contemplation, only an environment to enter and navigate by the glow of Christmas tree lights. Of course, a gallery installation could be seen as a work in itself—autonomous and self-contained. It seemed that whatever qualified as "art" was removed by its label to a realm apart from ordinary life. Art needed to break through the boundary of its own definition, and the "environmental" feel of Pollock's drip paintings convinced Kaprow that it could. Yet it was an imaginary artist—Harold Rosenberg's action painter—who showed the way.

Rosenberg had said that the action painter "wanted his canvas to be a world," "an arena" where acts have more than aesthetic consequences. Though he approved of the action painter's high purpose, Kaprow felt it was too circumscribed. Painters needed to leave the little world of the canvas, and move forward on the path that leads "not to more paintings, but to more action" in the larger world. Instead of artworks, there would be Happenings, which Kaprow described as

> events that, put simply, happen. Though the best of them have a decided impact . . . they appear to go nowhere and do not make any particular literary point. . . . They have no structured beginning, middle, or end. Their form is open-ended and fluid; nothing obvious is sought and therefore nothing is won, except the certainty of a number of occurrences to which we are more than normally attentive. They exist for a single performance, or only a few, and are gone forever, as new ones take their place.

Kaprow presented his first Happening at the Reuben Gallery in 1959. The setting was sparse—three clear-walled spaces distinguished chiefly by differences in the quality of light. Members of the audience were divided between the spaces, trooping from one to the next at the direction of numbered cards. As they moved, slides flashed from projectors, tape recorders broadcast electronic sounds, words were spoken. The work, wrote Kaprow, "is to be intimate, austere, and somewhat brief in duration."

Happenings presented by the painter Jim Dine were quick flurries of desperate, strangled emotion. For *The Smiling Workman* (1960), he donned a clownish version of a studio outfit, drank what seemed to be paint, poured the liquid on his head, then plunged through his canvas. Kaprow intended Happenings to unsettle expectations and release aesthetic energies from their usual places of confinement. Dine was skeptical. After his fourth Happening, he offered no more. "It was becoming so chic," he said in 1965. That year, John Cage objected that Kaprow and other impresarios of the Happening were relying too heavily on scripts and rehearsals. They might as well be producing Broadway plays. By then, Kaprow had acknowledged the obvious: Happenings would never be mistaken for ordinary life. No less than paintings and sculptures, they bore the "art" label. Though Kaprow made it reluctantly, this was not a damaging admission.

In the early sixties, fresh arrivals were crowding into the art scene. Restless and impatient, these newcomers had no very rigid ideas about the relations between art and life. It was enough to feel embroiled as those relations shifted. Elizabeth Baker, now the editor of *Art in America*, remembers the uncertainties and excitements of that long, hectic moment. "Pop Art, Minimalism, kinetic art, environments—it was all new and puzzled me greatly at first sight," she says. "And I was fascinated. Having come to New York in 1961, with an art-history background, I got a job at the Martha Jackson Gallery. The gallery director, John Weber, sent me to Oldenburg's Store on East Second Street, this scruffy space filled with spattered plaster versions of everything from sneakers to pieces of pie to American flags. I went to Happenings all over the city, uptown and down."

As she made the rounds, Baker noticed affinities. Andy Warhol made plywood boxes and imprinted them with supermarket logos—Brillo, Del Monte, Heinz. Donald Judd painted his boxes solid orange. "You wouldn't confuse a Warhol box with a Judd box," says Baker, "yet a sensibility was being shared. By the end of the decade, the styles of the sixties were strictly differentiated. Pop Art, Minimalism, and color-field painting all became quite separate. Earlier, there was lots of overlap. Abstract Expressionism had opened up a wide field. The younger artists were roaming around at will, jostling one another quite a bit. Art was spread across a wide continuum."

Strictly abstract, Frank Stella's Irregular Polygons had Pop flair, and the Mylar panels in Pop paintings by James Rosenquist had a blank, Minimalist shimmer. Before they attained the austerities of their signature styles, Minimalists like Judd and Dan Flavin were sometimes as playful as the kinetic sculptors who flourished in the sixties—Robert Breer, Len Lye, Takis, and others. At certain points, the continuum stretched into the recent past. Crumpling fenders and other automotive body parts, John Chamberlain found three-dimensional equivalents to Willem de Kooning's pictorial complexities.

The cantilevered beams of Mark di Suvero's sculptures sent Kline-like forms angling into real space.

The bustle of Happenings filled one end of the sixties continuum. At the other sat the catatonic Minimalist object. Somewhere near the midpoint lingered the plaster figures of George Segal, cast from life and frozen in action. Or you could place Roy Lichtenstein's hard-edged Pop Art at one extreme and Jules Olitski's color-field mist at the other. Between them would hang the shimmering stripes of a canvas from Frank Stella's copper series, or an orange and a blue maneuvered into blunt confrontation by Ellsworth Kelly. There are any number of ways to construe the sixties continuum. Styles formed a web of affinities and allegiances rewoven every season, sometimes erratically and always in an overload of bright gallery light.

The atmosphere of the time is preserved in Op Art, so called because it generates optical effects—afterimages, color reversals, dark flickering along the border between two aggressively luminous hues. Ascending as quickly as Pop, Op prompted the Museum of Modern Art to celebrate it in 1965 with an exhibition called The Responsive Eye. A year later, having satiated even the most sensation-hungry eyes in New York, Op abruptly vanished. Touted by mainstream journalists as the successor to Pop Art, Op Art became the insider's standard example of a silly sixties art trend. Elizabeth Baker demurs: "The style produced some marvelous painters—Bridget Riley, for example. Also, Op was not confined to the work of artists who bore the Op label," Baker says, noting the shimmer that Lichtenstein generated, on occasion, with his benday dots. Abutting red and green, Warhol caused visual vibrations, and Stella's Day-Glo colors sometimes warp under optical pressure. "Many artists created these effects in the sixties," Baker adds. "And that made perfect sense. It was a flashy, glitzy time."

Quickly, the art world's turf spread from Fifty-seventh Street, up Madison Avenue as far north as the Eighties. Openings were on Tuesday, starting at five in the afternoon. Every gallery served wine, many offered hard liquor. Invitations were not required, which meant, says Baker, that "a giant floating party ensued every week—crowds of people drifting from show to show, walking up and down the street with glasses in their hands." Most men wore standard jackets and ties. Some male artists dressed down, in studio blue jeans. Women dressed up, assertively.

Baker recalls certain items of wardrobe—a white fishnet dress, a silver slip-dress, extremely short, with thin straps. "Of course we all wore bouffant hairdos," she says, "and that pale, pearlescent lipstick, which was fitting considering that you might hear records by the Supremes blasting at you during an opening." In 1965 Bob Stanley filled the Bianchini Gallery with a suite of big canvases bearing quasi-abstract, photomechanical images in Op colors. At his opening, the Supremes themselves performed.

Far from losing itself in ordinary life, art had ascended to a state of high visibility and learned to rub elbows with the livelier elements of pop culture and high fashion. Frank Stella, Richard Anuskiewicz, and other painters saw no reason to deny themselves the fun of designing coats for a collector and furrier named Jacques Kaplan. *Vogue* and *Harper's Bazaar* kept a close watch on gallery trends. In the gossip columns of *Women's Wear Daily* and *The New York Post*, art stars mingled with the stars of Hollywood and politics.

During the early sixties, Robert Rauschenberg stayed at ground level, immersed in the American sprawl, trying to emulate it. Between 1960 and 1965, he oversaw a retrospective of his career at the Jewish Museum; he cofounded an organization called Experiments in Art and Technology with Robert Whitman and Billy Kluver; and he collaborated with three dance companies—Judson Church, Merce Cunningham, and Paul Taylor. Continuing, throughout this half decade, to make prints, sculptures, and mixed-media pieces, Rauschenberg moved his studio twice. Painting was the endeavor most easily misplaced in the shuffle, so he was delighted to learn from Andy Warhol how to automate the process with a method called photo-silk-screening.

First, the artist selects an image and sends it to a shop for conversion to a photographic transparency. The transparency is projected onto a screen—a piece of silk stretched on a frame and treated with a light-sensitive emulsion. The screen is then dipped in hot water. Areas touched by light remain, the rest wash away. In the studio, the artist lays the screen on a canvas and forces ink through the mesh of the silk with a rubber bar known as a squeegee. With one gesture, an image in all its photographic detail is spread across the surface. Warhol first used this method in the summer of 1962. Toward the end of the year, Henry Geldzahler took Rauschenberg to Warhol's studio for a demonstration.

Soon Rauschenberg had filled almost one hundred screens with pictures torn from newspapers, from *Time* and *Life* magazines, from *Newsweek* and *The National Geographic*. His camera produced pictures of a New York street sign, an anonymous pedestrian, Merce Cunningham and members of his troupe. From the storehouse of museum reproductions came Rubens's *Toilet of Venus* and the *Rokeby Venus* of Velázquez. George Washington stands in marble effigy, John F. Kennedy gestures at a news photographer, an American eagle rests. Into this melee songbirds fly, a yacht sails, a parade bears flags.

Rauschenberg would print an image, overlay it with another, and place another alongside it, often at an angle. Transitions are abrupt. Sometimes a burst of brushwork intervenes, giving a tenuous stability to the painting's swirl of raw documentary evidence. Once he had adapted the process to his

50. Robert Rauschenberg, *Barge*, 1963. Oil and silk-screen ink on canvas, 6 ft. 7⅞ in. × 32 ft. 5 in.

quick tempo, Rauschenberg worked on several canvases at once, sometimes a half dozen or more. He has said that, with a batch of new paintings in progress, he was "not so likely to get hung up, or to work *schemingly.* . . . Which isn't saying you don't sometimes get hung up on all of them at once." To get hung up on all of them, on everything, at once: Rauschenberg flirted knowingly with this dilemma, which felt like a triumph in an art world impatient with distinctions and inclined toward a promiscuity of taste. Skittish, garish, overloaded, his seventy-nine silk-screen paintings are mirrors of their aesthetic moment.

They also reflect the hectic optimism that filled the American sixties until President Kennedy was assassinated in November 1963. Rauschenberg's series continued into the following year with no change of mood. Reassembled at the Whitney Museum in 1990, the silk-screen paintings looked like pages of a diary filled on the run by an artist drawn into the world by his curiosity and into himself by a fascination with his patterns of attention. Rauschenberg likes to leave a record of the way an allusion or visual pun occurs, sets off a flurry of images, then fades so that the mind can notice its next swift motion.

The extended high point of the series is *Barge* (1963). Roughly six and a half feet high and over thirty-two feet wide, it is a dense jumble of military hardware, sports events, house keys, trucks, astronauts, architecture, and more, all rendered in the black and gray and off-white of a tabloid newspaper page—or a black-and-white abstraction by Willem de Kooning. In the struggle to be seen, these silk-screened images must compete with one another and

with the artist's brilliantly offhand slatherings, splashings, and drippings of paint. Occasionally Rauschenberg's brush turns calm. On this vast surface, there is ample room for quiet passages of monochrome painting, and some regions are completely vacant, like marginal real estate not yet ready for development.

Barge merges the rush of city streets with the flow of the highway, the magazine layout, the nightly news on television. Blended, these currents establish a state of equality between images of every kind—the glamorous and the banal, the grubby and the dignified. Displaying no sign of deference, the curves of a cloverleaf interchange mimic those of the *Rokeby Venus*. A headlight pops up repeatedly, an emblem of the artist's illuminating eye. As a form, it echoes the shape of truck tires, an open umbrella, a dish-shaped antenna, and the circle that directs the attention to the football in a photograph lifted from the sports page. Nothing in the visual echoes and rhapsodic drift of *Barge* implies a boundary. To stir up this cloudy mix of brushwork and photomechanical litter, Rauschenberg cast himself as Pollock's audacious son, able to invoke the infinite and willing to taint it with the mundane.

Barge's equal appeared two years later in *F-111* (1965), by James Rosenquist. Named after the fighter plane that floats, in fragments, across much of its surface, *F-111* cannot be hung on a wall. Eighty-six feet long and ten feet high, this canvas is itself a wall—or four walls, which form a gallery-sized environment of hot colors and sleek forms. Interspersed with chunks of the F-111's anatomy are monumental images of a snow tire, a light bulb, a mush-

51. James Rosenquist, *F-111*, 1965. Oil on canvas with aluminum panels, 10 × 86 ft.

room cloud. An angel food cake repeats the shape of the tire, and a smiling infant sits beneath a shiny chromium hair dryer that bears an uneasy resemblance to the jet fighter's nose cone.

Rauschenberg's *Barge* has a smudged and spattered elegance. In *F-111*, Rosenquist's hand mocks the bland impersonality of a four-color spread in a popular magazine. Lethal or innocuous, all the objects in this painting have a bright, dead shimmer. The artist said that he painted *F-111* to alert us to our dependence on advanced technologies, some of which "seemingly can't be dealt with, they're so sophisticated." In the mid-sixties, it was becoming clear that the Pentagon had planned the Vietnam war as a triumph of new hardware. With his allover imagery, military and civilian, Rosenquist argued that war production in league with consumerism had set loose a seething jumble of infinitely destructive forces.

Looming in close-up, his tires and cakes and fuselages are easy to read as abstractions—which is to say, viewers tended to look past the political point of *F-111* to its Pop finesse. It was admired as one of many big, formally ambitious New York paintings that appeared in the sixties. Ellsworth Kelly's *Spectrums* of mid-decade—sequences of vertical panels, each a different color—are frankly abstract and endlessly extendable, as are the grids that proliferated in the work of Agnes Martin, Carl Andre, Sol LeWitt, Patrick Ireland, Larry Poons, and others. Like the all-white paintings of Robert Ryman, grids open onto the infinite, allowing artists to make use of Pollock's

example without mimicking his method. Of course mimicry tempted many.

Allan Kaprow had written in his memorial essay that "the great scale" of Pollock's paintings, "the endless tangle" of his splashes and loops "are by now the clichés of college art departments." In *F-111*, Rosenquist parodied those clichés with a wide, writhing expanse of orange spaghetti. And with an always-shifting degree of irony, Claes Oldenburg inflicted the splashy, smeary look of downtown painting on his early sculptures of hamburgers, desserts, and pieces of clothing. In 1962, the rough became smooth; suddenly, the Oldenburgian object was as shiny and immaculate as a box by Donald Judd.

In Oldenburg's *Bedroom Ensemble* (1963), the bed is a vinyl-covered object with the distortions of perspective built in. A zebra-striped slab forms the headboard. A coat made of leopard-spotted vinyl lies on an ottoman of rigidly geometric form. On the walls hang "pictures"—pieces of fabric found in Los Angeles shops and mounted on stretchers of modest size. Each bears a designer's neat and irredeemably banal version of Pollock's web. With *Bedroom Ensemble*, Oldenburg devised a proper environment for all the clichés that,

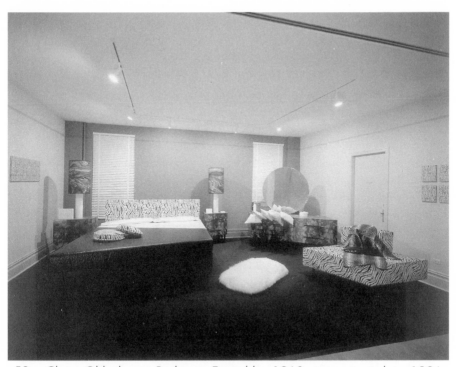

52. Claes Oldenburg, *Bedroom Ensemble*, 1963, reconstructed in 1996. Wood, vinyl, metal, fake fur, and other materials; overall dimensions: 10 × 17 × 21 ft.

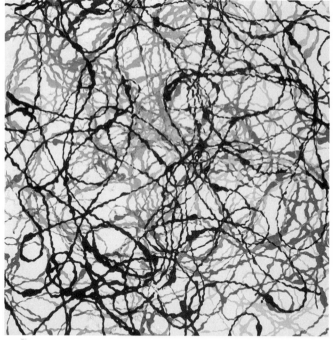

53. Andy Warhol, *Yarn*, 1983. Silk-screen ink on canvas, 40 × 40 in.

by 1963, had evolved from Pollock's drip paintings. Andy Warhol didn't get around to his Pollock jokes until much later.

Pollock himself compared his paint-slinging method to pissing. Literalizing the metaphor, Warhol pissed on canvases primed with copper sulfate. Reacting to his urine, the copper turned green and gold and black. Warhol made the first of these *Oxidation* paintings in 1977, the last in 1982. The following year, a textile company in Florence commissioned him to produce a series of canvases. To honor his patron's interests, he produced images of yarn in airy tangles. Designed to recall the swirls of *Autumn Rhythm* and *One*, the Yarn paintings do the job with blithe simplicity. From the moment they appeared, some called Pollock's drip paintings decorative. Now Warhol had produced a variant on Pollock that could be called nothing else.

Like the ready-made "Pollocks" in Oldenburg's *Bedroom Ensemble*, Warhol's Yarn paintings are works of commercial art—more attractive, more sophisticated, but thoroughly commercial. During the last two decades of his life, critics often dismissed Warhol as the merest of imagemongers. The charge is true enough to have obscured a larger truth: in his way, Warhol was as authentic an artist as Jackson Pollock, that titan of authenticity, and their many differences hide a few resemblances. Like Jasper Johns, Warhol devised a variant on Pollock's infinite. To Pollock's "nature," Johns had replied with "culture." In place of culture, Warhol put society.

GLAMOUR AND DEATH

We all loved him but were a bit mystified. He never seemed to have much to say or do, although he always sniffed out tomorrow's news.

Diana Vreeland on Andy Warhol
(1989)

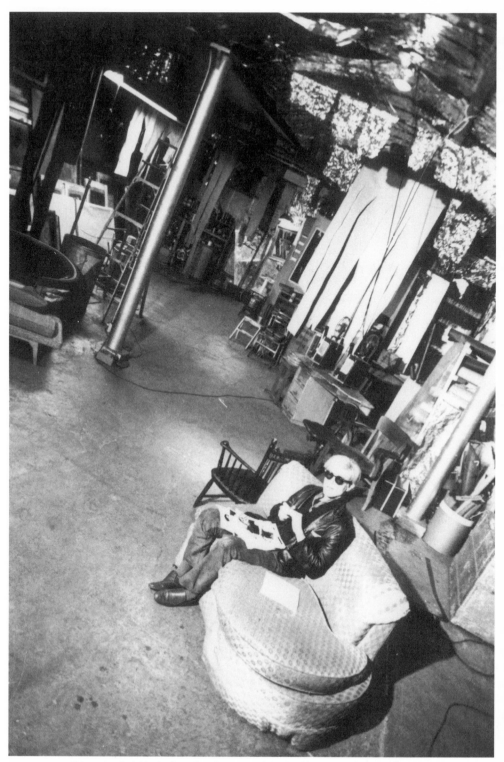

54. Andy Warhol at the Factory, 1966. Photograph by Billy Name

25

Andy Warhol liked to fudge the date of his birth. It was 1929, he would say, or 1931, or 1933. Sometimes he'd give his hometown as Providence, Rhode Island, or Cleveland, Ohio. He died after routine gall-bladder surgery, for reasons that are still not entirely known. The date of his death—February 22, 1987—was instantly memorialized by the media here and abroad. As reporters pieced together their obituaries of the artist, the puzzle of his age reappeared. Soon afterward, his headstone declared that he was born on August 6, 1928. This was Warhol's true birth date, say his two older brothers; they add that he was born and grew up in Pittsburgh.

Of his early years, Warhol once said:

> My father was away a lot on business trips to the coal mines, so I never saw him very much. My mother would read to me in her thick Czech-oslovakian accent as best she could and I would always say "Thanks, Mom," after she finished with Dick Tracy, even if I hadn't understood a word.

A conspicuous detail of this account makes no sense. Czechoslovakians were citizens of a nation but not members of an ethnic group. By saying that his mother spoke in "a thick Czechoslovakian accent," Warhol invites us to guess if she was Czech or Slovak. In fact, she was neither. Born Julia Zavacky, she and her husband, Andrej Warhola, were from Ruthenia, a land that stretches through the Carpathian Mountains of northeastern Czechoslovakia to the border provinces of Hungary and Poland.

The Warhols' first son, Paul, was born in 1922; next came John, in 1925. Andrew arrived three years later. When he was eight, he suffered the first of his "nervous breakdowns"—attacks of St. Vitus' dance, a neural disorder that enfeebles the limbs and leaves the skin splotchy. Warhol remembered

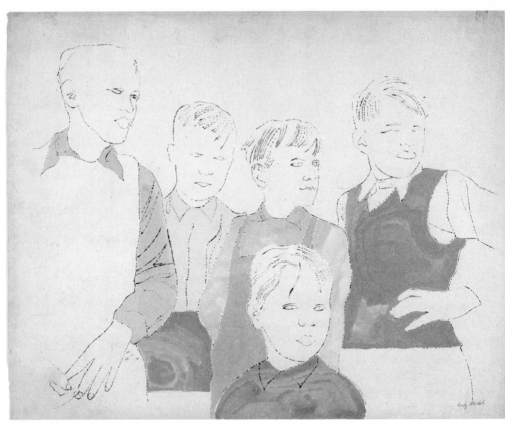

55. Andy Warhol, *Five Boys*, c. 1954. Ink and colored gouache on paper, 23 × 29 in.

three of these episodes. Each "started on the first day of summer vacation. I don't know what this meant. I would spend all summer listening to the radio and lying in bed with my Charlie McCarthy doll and my un-cut-out cut-out paper dolls all over the spread and under the pillow."

He had comic books and coloring books, a camera and a cap gun. With a toy movie projector, he ran cartoon reels over and over. His brother Paul helped him write fan letters to movie stars. In reply, he received glossy eight-by-ten portraits from the publicity departments of the Hollywood studios. Mrs. Warhola encouraged all three sons to draw—it kept them amused—though Andy was the only one with a knack for it. A grade school teacher recommended him for free Saturday classes at the Carnegie Museum, where he was exposed to the rituals of "art appreciation" and learned rudimentary studio techniques. When he was seventeen, Warhol entered the pictorial design program at Carnegie Institute of Technology. Money for tuition came from a savings bond purchased by his father, who had died three years earlier.

For extra money, Warhol worked part-time as a soda jerk and a children's

art teacher. During the summer, he trimmed windows at a Pittsburgh department store, where his boss—"a wonderful man named Mr. Vollmer"—gave him the task of flipping through old copies of *Vogue* and *Harper's Bazaar*. "I got something like fifty cents an hour," Warhol wrote, "and my job was to look for 'ideas.' I don't remember ever finding one or getting one. Mr. Vollmer was an idol to me because he came from New York and that seemed so exciting. I wasn't ever thinking about ever going there myself, though."

A classmate, Philip Pearlstein, recalled that "Andy's first idea was to be an art teacher in the public school system. . . . I talked him into going to New York that summer of 1949. He said he wouldn't go unless I went, he just didn't feel secure enough. We each had a couple of hundred dollars." Settled in an apartment on St. Mark's Place near Avenue A, Warhol and Pearlstein took their portfolios around to the offices of uptown art directors.

Warhol won his first freelance assignment in August 1949, when Tina S. Fredericks, of *Glamour* magazine, commissioned him to illustrate a cluster of short articles—"Success Is a Career at Home," "Success Is a Job in New York," and so on. In the credit for these pictures, the last *a* was dropped from Warhola. The artist didn't object; he had proposed this amendment in 1941, when signing a portrait of a friend. Soon he was turning out illustrations for *Mademoiselle*, *Vogue*, *Harper's Bazaar*, *Charm*, and *Seventeen*, for album covers and dust jackets, for Bonwit Teller's advertisements and Tiffany's Christmas cards. He had as much work as he could manage. Designed to be quickly seen, his images were quickly made. Tina Fredericks particularly loved the wiry, blotted lines he reeled out at high speed. They were "electrifying," she said. "They grabbed at you."

When Andy fell ill as a child, his mother had insisted that he stay with her at night. Her husband and two older sons slept in an attic bedroom. In 1950, she came to live with her youngest son in his apartment on East Seventy-fifth Street. She would stay with him until 1971, when her declining health persuaded her to return to Pittsburgh. Warhol's mother mended his clothes, fixed him breakfast, and labored to keep order amid the clutter of her son's work and his quickly growing collections of phonograph records, picture books, antiques, and objets d'art.

Some evenings, the apartment was crowded with friends and friends of friends, young people mobilized by the will that hid behind Warhol's diffident facade. He would organize them into an assembly line of sorts, with each person applying a patch of pink, green, or yellow to the pages of his privately published books. It reassured Mrs. Warhola to know that Andy had so many friends, and she gloated over his success, though she fretted when his career took him away at night. Obsessively, Warhol went to parties where he might

56. Andy Warhol, *Coca-Cola*, 1960. Oil and wax crayon on canvas, 6 ft. × 54 in.

meet people who could give him work. He also liked to attend the Broadway theater, but only if tickets could be had at the last moment.

Art directors understood that Warhol's blotted line was a Ben Shahn knock-off, and they were familiar with other illustrators who used the same device—David Stone Martin, for instance, who did a much-noticed series of album covers for Verve Records. Warhol worked the high end of the look, giving an airy plausibility to promises of glamour. In 1955 Geraldine Stutz, the head of retailing at I. Miller, hired him to picture the company's wares in the Sunday editions of New York's major newspapers. This was steady, lucrative employment.

 I. Miller shoes were elegant and a touch too staid, or so some shoppers felt. Warhol had the job of convincing these restless consumers that the com-

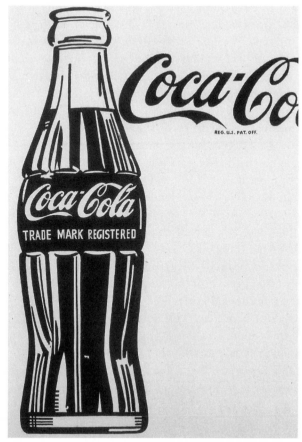

57. Andy Warhol, *Large Coca-Cola*, 1962. Synthetic polymer paint on canvas, 6 ft. 10 in. × 57 in.

pany's latest designs were fresh and bright and therefore worth the traditionally elevated I. Miller price. For years, its advertising had relied on matter-of-fact illustrations. As Warhol's blotted line unfurled, high heels grew higher and slimmer; toes became more imperiously pointed. Warhol's imagery "made an enormous difference in how the name 'I. Miller' was perceived by women," said Stutz.

The I. Miller campaign continued for more than two years, a long time in the fashion business, and Warhol continued to ascend. In 1952 he had received an Art Directors Club Medal. With more commissions and larger fees came further prizes. The Art Directors Club gave Warhol its Award for Distinctive Merit in 1956; three years later he received his third Certificate of Excellence from the American Institute of Graphic Arts. He and his mother now lived in a large apartment on Lexington Avenue near Thirty-fourth Street.

However tight the deadline, Warhol appeared on time with fresh, unlabored images; when asked to revise, he'd come up with a new idea and execute it on the spot. Warhol displayed an unusually reliable brilliance. No matter how often he had to redo a drawing, its sparkle or buzz or silky whisper never went dead. He didn't put on airs or indulge in spats with art directors; he never burned out. Tina Fredericks felt that he was "almost nonexistent. I mean, he was so willing to go with *you*, like he was willing to do anything, and that's very different from most people."

Warhol seemed so boyish, so fragile. He liked to give the impression of being too dazzled or baffled or weary to talk in entirely grown-up sentences. To call a play or a restaurant "fun" was to bestow his highest accolade. "Gee" and "gosh" were his favorite ejaculations. To keep a conversation going, he would ask fake-naive questions or present an anecdote about his hapless, mock-heroic innocence. In one of these stories, he is fresh from Carnegie Tech. Arriving at the office of Carmel Snow, the editor of *Harper's Bazaar*, he unzips his portfolio and a cockroach crawls out. Feeling sorry for this unfortunate waif, she gives him an assignment and he is on his way to fame and fortune as a commercial artist. This was actually an episode from Philip Pearlstein's early career in New York, and it ended differently. Disgusted by the cockroach, Mrs. Snow sent the young applicant away without a job. This is the truth, though it is also true that the story belongs to Andy Warhol. The image of the downtown cockroach on the uptown editor's desk is among the many he borrowed, in making his art and remaking himself.

As money accumulated, the artist formed a corporation: Andy Warhol Enterprises. His name appeared in a book called *1000 Names and Where to Drop Them*. In 1959 he moved to a town house at the corner of Eighty-ninth Street and Lexington Avenue, a substantial building in a posh neighborhood. Warhol bought it outright. He felt prosperous but unsatisfied. The world where people dropped his name was stylish. It was fun, to use his word, but far too narrow. A star on the margin where preciosity met commercialism, Warhol wanted to be a star in the world of high art, like Jasper Johns or Robert Rauschenberg.

Emile de Antonio, a filmmaker who sometimes found window-dressing jobs for Warhol, introduced him to Castelli's newest star, Frank Stella. Warhol bought six small Stella canvases. Learning the right names, getting to know the cooled-down severity of Stella and Johns, he began to make cooled-down paintings of his own. Warhol had spent the fifties refurbishing the look of high glamour. For his paintings on canvas, he gathered images from the seedy peripheries of commercial art—comic books, matchbook covers, the yellow pages.

Often he made two versions of the same subject. He would soften the first with drips, splashes, and scruffy imitations of Abstract Expressionist brush-

work. The second he would render in hard focus. Warhol liked to display them side by side, like samples in a showroom. Confronted by a pair of Coke-bottle paintings, de Antonio said the painterly image was "a piece of shit, a little bit of everything. The other is remarkable—it's our society, it's who we are, it's absolutely beautiful and naked, and you ought to destroy the first one and show the other."

Warhol agreed uneasily and kept making the gallery rounds. Sidling into Castelli's one afternoon, he let his assistant, Ted Carey, indicate an interest in a drawing by Jasper Johns: *Light Bulb* (1958). The price was $475. With his implacable diffidence, Warhol bargained it down to $350. Next he asked the gallery director, Ivan Karp, if he had anything else of interest on the premises. Happily, Karp showed him Roy Lichtenstein's *Girl with Ball* (1961), a painting derived from an advertisement for a resort hotel. In the usual rendering of this scene, Warhol gives a plaintive sigh—"Ohhh"—and whispers, "I'm doing work just like that myself." Then he asks Karp to visit his studio.

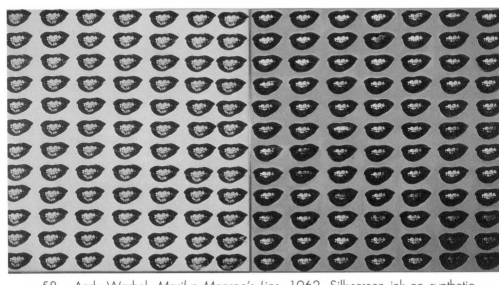

58. Andy Warhol, *Marilyn Monroe's Lips*, 1962. Silk-screen ink on synthetic polymer paint and pencil on canvas; two panels, 6 ft. 10¾ in. × 6 ft. 8¾ in., 6 ft. 11⅜ in. × 6 ft. 11 in.

26

Youngish and portly in a dark suit and dark glasses, Ivan Karp flourished a cigar and paced or, at a minimum, jiggled on his heels, while spouting a filigreed commentary on form, style, trends, and the sociopolitical import of it all. With a passing and not entirely ironic reference to his "acute perception," he would talk of the United States as "a world-cultural power," of "the establishment," of "force and conviction," and the "alienation" responsible for everything from the hysteria at rock concerts to the "gothic behavior" of the fifties painters. Karp's conversation worked like an updraft; it lofted listeners into a stratosphere where all was cloudy but shot through with light.

In 1961 he was broadcasting hints that, in its triumph, Abstract Expressionism was no longer "a liberating force." Further liberation would be the work of a new style, and Ivan believed he had glimpsed it in the paintings of Roy Lichtenstein. Now he suspected that Andy Warhol, this "very shy, strange-looking, gray-haired man," might show him a bit more of the future. When Warhol invited Ivan to his studio, the director did not ask to see slides of his work, did not assure him that the gallery would respond in due time. He made an appointment for an immediate visit.

Karp remembered the Lexington Avenue studio as "a rather scrumptiously bizarre Victorian setting." The light was low. Some rooms were empty. Others were overcrowded with shadows and jumbled Americana—gum-ball machines, merry-go-round horses, wedge-heeled shoes from the forties. Warhol had hidden his commercial work. Karp saw only Pop paintings, some messy and some neat. His judgment was de Antonio's: the splashy, Abstract Expressionist ones were weak, the neat ones strong. Karp promised to bring Castelli to the studio, then cautioned Warhol that the dealer wouldn't take him on. He would say Warhol's work was too much like Lichtenstein's. Castelli didn't take him on, and that was precisely the reason he gave.

Unofficially, Karp became Warhol's agent. He brought collectors to the

studio, showed slides of Warhol's paintings to dealers, and introduced him to salient personages. Among these was Henry Geldzahler, an art historian just out of Harvard who had recently joined the staff of the Metropolitan Museum. Geldzahler's title was assistant curator in the department of American paintings; his job, he later said, was "to be the eyes of the Met." In Warhol he saw the present personified. Like Karp, he talked up Warhol's art, and both managed to place his work in lively collections.

Warhol had transferred Dick Tracy and Superman to canvas. Now he ran Popeye and Nancy through the same process. He painted a refrigerator, an old-fashioned telephone, and a diagram of dance steps. Once, during lunch, Warhol asked Geldzahler what he should paint next. Geldzahler showed him that day's headline in the *New York Mirror*—"129 DIE IN JET!" Warhol reproduced the full front page on a canvas over eight feet high, and Karp sold it to the Burton Tremaines.

Warhol had admirers but still no dealer. After a visit to the Green Gallery early in 1962, Ted Carey called Warhol to report that a painter named James Rosenquist had covered the walls with big canvases roiled by fragments of billboard imagery—7UP bottles, models' smiles, automotive chrome. "I think they're really wonderful," said Carey. "I think I'd like to buy one." "If you buy one of those paintings," said Warhol, "I'll never speak to you again." Warhol had begun to panic. "I mean," said Carey, years afterward, "it was *all* happening and he was not getting any recognition. . . . He was thinking of showing at the Bodley . . . not a gallery that would really have helped Andy prestige-wise, but he was so desperate. . . . I think he would have even *paid* the gallery to have shown him."

Too cautious to ignore Warhol completely, the major dealers gave him second-class treatment, accepting his pictures on consignment and making next to no effort to sell them. "They were stacked away, all up and down Madison Avenue," said Eleanor Ward, director of the Stable Gallery. In the spring of 1962, Irving Blum saw Warhol at the opening of the Guggenheim Museum's Philip Guston retrospective. Warhol invited the dealer to his studio, which was only a few crosstown blocks away. Upon arrival, Blum was amazed to find images of Campbell's soup cans by the dozens. Half a year earlier, he had seen Warhol's cartoon pictures and thought them "too strange, somehow, and simple-minded." Now Blum asked why that imagery had disappeared. It was too much like Lichtenstein's, said Warhol, adding that he had dropped his advertising imagery because it brought him too close to Rosenquist. Now he feared that dealers would see his Soup Cans as lagging indicators of yet another trend. Just the month before, Allan Stone had presented a show of Wayne Thiebaud's luscious oil paintings of hot dogs and

cakes. Claes Oldenburg had exhibited plaster-of-paris ice cream sundaes and slices of pie à la mode.

Untroubled by Warhol's trendiness, Blum offered him a show at the Ferus Gallery in Los Angeles the following July; the artist accepted. In those days, Campbell's produced thirty-two varieties of soup. At Ferus each was represented on a canvas twenty inches high and sixteen inches wide. Hung in neat rows, they formed a wall-sized grid. Blum recalled that artists in Los Angeles were curious about the show but not impressed. "They tended to shrug," he has said. Local newspapers hooted loudly.

In 1962 all the Pop artists were coming under vigorous attack from the press and many gallery goers. If any echoes of West Coast laughter reached Warhol, he must have been pleased. He had made his debut. He had been noticed. Now he needed a solo show on the East Coast. He needed to be laughed at in Manhattan—laughed at by the wrong people, admired by the right ones. Finally, it happened. A slot opened in the Stable Gallery's schedule, and Eleanor Ward filled it with a Warhol exhibition.

As the November opening approached, Warhol would appear at the Stable, a rolled canvas under his arm, murmuring, "Look what the cat dragged in." Ward was enchanted. She liked Warhol and she was coming to believe he was important. Then, the night of his opening, she discovered her doubts. Fearing she had made an immense mistake, she hid in her office. In the gallery, a crowd was gathering and taking its restless shape around that season's notables—Emile de Antonio, Ivan Karp, Henry Geldzahler, the Pop artist Robert Indiana, the architect Philip Johnson, and Marisol, a sculptor who had been induced by *Vogue* to moonlight as a model. The writers David Bourdon and Gene Swenson were in attendance. Warhol's former assistant, Nathan Gluck, and other colleagues from the fifties came by.

Ward emerged, at last, to find a triumph in progress. Standing alone in a corner, Warhol felt quietly thrilled. He had entered the front ranks of New York artists. Philip Johnson bought *Gold Marilyn Monroe* (1962) that night, though he later said that what he liked best about the event was the artist's presence. Relentlessly attentive, greedily there, Warhol was also absent and unreachable, like an image of himself.

Warhol had laid on his first Pop images—airmail stamps, S&H Green Stamps—with stamps of his own, which he cut from rubber erasers. With a balsa-wood block, he imprinted his canvases with rows upon rows of Coca-Cola bottles. For the Dollar Bill and Campbell's Soup Can paintings, he used silk-screens cut by hand. His next technological step took him to photo-silk-screening. Now he could make a painting of anything the camera could convert to halftones. "It was all so simple," Warhol wrote. Pictures of Warren

Beatty and Troy Donahue and Marilyn Monroe accumulated quickly. Warhol liked the "assembly-line effect."

In 1957 Jasper Johns placed the Stars and Stripes on a large expanse of orange. Warhol's *Gold Marilyn Monroe* substitutes the star's face for the Flag. In place of Johns's orange encaustic he put synthetic polymer paint of a metallic hue that is less golden than a wistful reminiscence of gold. The canvas is nearly five feet wide and just under seven feet high. Floating at its center, Marilyn's face is a bright pink oval of silk-screen ink. Her eyeshadow has expanded to a pair of curving aquamarine blotches. A red blotch with an opening is her mouth, which Warhol isolated and repeated 168 times—twelve neat rows of fourteen—in a painting called *Marilyn Monroe's Lips* (1962). Another painting from 1962 bears one hundred imprints of her entire face, with its crown of lemony-yellow hair.

Warhol's method required one screen for each color. With the last screen, he would overlay the black photographic detail which converts a play of bright colors into a familiar image—a secular icon. Yet the conversion from abstract pattern to legible picture is never complete. If the black screen was too heavily inked, Marilyn's features sank into a dark smear. If too many impressions were taken from a single inking, the details of her face turned ghostly. Distracted by these flaws, which Warhol welcomed, you cannot bring the star's face to life. From the eyes of a Warhol Marilyn comes a stare so blank you can hardly call it dismissive.

Two blocks north of Warhol's Lexington Avenue town house stood an empty fire station. At the start of 1963 he rented it and set up his silk-screening apparatus on the second floor. There he made pictures of Elvis, Marlon Brando, and Elizabeth Taylor, of Electric Chairs, Car Crashes, Race Riots, Suicides, and Atom Bombs. To maintain a high rate of production, he hired a young poet named Gerard Malanga as an assistant. Malanga's pay was $1.25 an hour, then the minimum wage.

Notified toward the end of 1963 that the firehouse had been condemned, Warhol moved his studio to a building on East Forty-seventh Street near Third Avenue. "The neighborhood," he said, "wasn't one that most artists would want to have a studio in—right in midtown, not far from Grand Central Station, down the street from the United Nations." His loft was on the sixth floor. The next floor up was occupied by a large antiques shop. Nearby was a YMCA, a modeling agency, "and lots of photography labs." Warhol shrouded the windows, installed his assembly line, and works poured out: pictures of Jackie Kennedy, self-portraits, more Campbell's Soup Cans —these in garish colors—more Electric Chairs. The new studio was known as the Factory.

In a back room, a thin young man named Billy Linich took up residence

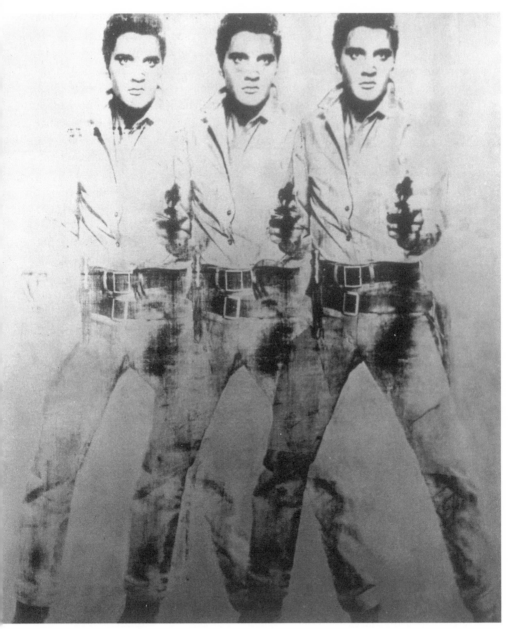

59. Andy Warhol, *Large Triple Elvis*, 1963. Synthetic polymer paint and silk-screen ink on canvas, 6 ft. 10 in. × 6 ft. 10 in.

without permission. Warhol gave his approval by not objecting. Linich was useful. He swept up. He decorated the premises, sparsely, with furniture left on midtown streets for removal by the Sanitation Department. With aluminum foil and Mylar and silver paint, he gave the Factory's surfaces a seedy shimmer. Linich's tireless devotion to labor-intensive tasks was a bonus of an amphetamine habit. His previous hangout had been the San Remo Coffee Shop in the West Village, headquarters for the local "A-men"—homosexual speed addicts who struck the pose of outlaws surviving on sheer energy. Dropping by now and then, Warhol had gotten to know Linich and the other regulars—Ondine, Rotten Rita, Silver George, the Duchess. Linich's San Remo moniker was Billy Name. After Billy settled at the Factory, A-men would appear and ask for him. Wordlessly, Warhol waved them toward the back of the loft.

"They were always discreet about what they did back there," Warhol wrote. "No one so much as took a pill in front of me, and I definitely never saw anyone shoot up. I never had to spell anything out, either; there was sort of a silent understanding that I didn't want to know about anything like that, and Billy was always able to keep everything cool." Of course it was Warhol who kept things cool, with the undeclared authority of the one on whom the scene depended. Quietly but absolutely, he was in charge. Warhol's Factory was a public thoroughfare: Main Street for the city's most stylish derelicts.

The studio had a louche allure for young, well-connected figures like Marguerite Lamkin and Baby Jane Holzer, who called herself a Park Avenue housewife. With her mane of very blond hair and assortment of very short miniskirts, the leggy Holzer spent the early sixties hopping between Mick Jagger's London and the New York of Diana Vreeland, *Vogue* magazine's editor in chief. It was her habit to pop in at the Factory, trailing a gaggle of Upper East Side friends. These visits continued until the Factory began to feel, in her words, "too faggy and sick and druggy." Until then, she found it just faggy and sick and druggy enough—a convenient tableau of the fun and the forbidden, never the same from one visit to the next and always enhanced by a sound track.

On a stereo set Billy Name had retrieved from the sidewalk, Ondine played opera at high volume. In another zone of the Factory, a radio would be blasting out rock and roll—"Louie Louie" or "Sugar Shack." When Warhol wasn't painting, he

> would sit in a corner for hours, watching people come and go and stay, not moving myself, trying to get a complete idea, but everything stayed fragmentary; I never knew what was really happening. I'd sit there and listen to every sound: the freight elevator moving in the shaft . . . the steady traffic down on 47th Street . . . a magazine page turning . . . the

high school typists hitting a key every couple of seconds . . . the water running over the prints in Billy's darkroom . . . men having sex in the back room, girls closing compacts and makeup cases.

By now, Warhol had established his trademark outfit: black leather jacket, dark glasses, motorcycle boots. Visitors new to the Factory could spot him in an instant, no matter how quietly he sat and looked and listened. Sometimes, though, he'd dress anonymously, and then the uninitiated couldn't tell that he was there.

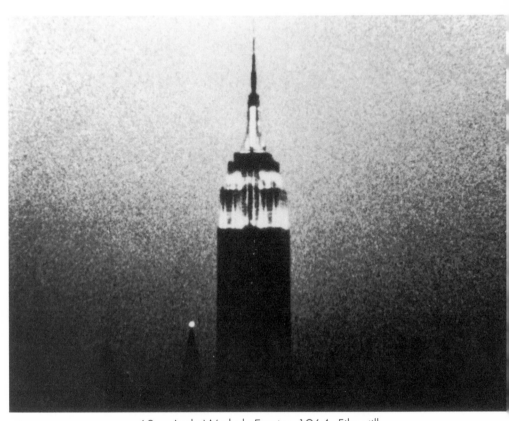

60. Andy Warhol, *Empire*, 1964. Film still

27

After divorcing Leo Castelli in 1960, Ileana Castelli married a dealer named Michael Sonnabend. They settled in Paris and, two years later, opened a gallery. Warhol showed his Disaster paintings there in January 1964. To the press he announced that painting bored him. "My real interest right now is movies," he said. "I make a movie every day." That was almost literally true. After some arch experiments with a 16-mm Bolex, Warhol settled on his cinematic technique: mount the camera on a tripod, point it, let it run. His subjects included the shoulder of the dancer Lucinda Childs, Emile de Antonio drinking a bottle of whiskey, and the face of a young man getting a blow job. In *Couch* (1964), the camera stares at the Factory couch, where Malanga, a woman, and another man demonstrate sex acts. Lighting is harsh, film quality is poor, there is no sound.

Empire (1964) shows the Empire State Building during a night in July 1964. Shot from the forty-first floor of a skyscraper on West Fiftieth Street, the film begins and the sun sets; the sky darkens, floodlights illuminate the skyscraper's upper stories. Stars come out. Seven hours later, the floodlights go dark; the movie continues for another hour. With its grainy stillness, *Empire* is less a motion picture than a cinematic equivalent to Warhol's paintings of Marilyn, Elvis, and Elizabeth Taylor. "The Empire State Building is a star!" he said. Seen through his eyes, so is a can of Campbell's soup or a box of Brillo soap pads.

Though he billed himself as a "retired" painter devoted to film, Warhol was turning out canvases in a style that had become impossible to mistake for Roy Lichtenstein's. Leo Castelli decided that it would make sense, after all, to represent Warhol, who was as eager as ever to show his work in the gallery of Jasper Johns and Robert Rauschenberg. Half a year after closing his last show at the Stable Gallery, Warhol opened at Castelli's with *Flowers*

(1964), pictures of four hibiscus blossoms filched from a snapshot he found by leafing through an issue of *Modern Photography*.

Silk-screened onto square canvases, they had no up or down, no right or left. One could hang them any way one liked. Blank and lovely, these paintings were astonishingly popular. In the month before his debut at Castelli, Warhol turned out as many as eighty a day, in all sizes; eventually, he sold over nine hundred Flowers. The last of the Pop painters to be launched, Warhol was now the hottest, yet he still insisted that he had become a moviemaker.

Warhol's first talkie was *Harlot* (1964), starring a transvestite named Mario Montez. In white gown, platinum wig, and pearls, Mario lolls on a couch and assumes the airs of Jean Harlow and other vamps of the thirties. After much nostalgic posturing, Mario extracts bananas from his purse and consumes them as if they were erect penises. Throughout the shooting, he is interrogated from off-screen by Billy Name and others. Among these hecklers is Ronald Tavel, Warhol's screenwriter, who prods Mario into admitting that he is a man.

Tavel remembered Warhol telling him to get rid of plot. "Of course," the playwright added, "Samuel Beckett had done that in the fifties, but he had retained his characters. So I thought what I could introduce was to get rid of character." *Kitchen*, shot in 1965, ends with a motiveless murder after a trio of unprepared actors have spent seventy minutes reading their lines from pages of Tavel's script. The murder that brings *Kitchen* to a close is not merely unmotivated. It is hardly noticeable. To write a Factory script, said Tavel, was "to work for no meaning."

Toward the end of 1965, Malanga brought Warhol to the Café Bizarre on West Third Street, where a band called the Velvet Underground was churning out an elemental rock sound and decorating it with amplifier feedback. The lead singer was a poet and guitarist named Lou Reed. Though the Velvets could pass for a run-of-the-mill club act, they cultivated a degree of peculiarity. John Cale overlaid the electronic screech of the amplifiers with the embellishments of his electric viola. Nico, a German actress with a voice of deep, catatonic sweetness, played the role of chanteuse. The Velvets were aloof yet aggressive. Feeling an affinity, Warhol invited them to rehearse at the Factory.

After a few months' immersion in the studio's lack of routine, the Velvet Underground found that songs were alternating with monologues by Factory regulars. As these wore on, Gerard Malanga in leather would perform an S&M pantomime with a bullwhip. On a screen behind the band, Warhol's films played continuously. A multimedia troupe had evolved: the Exploding

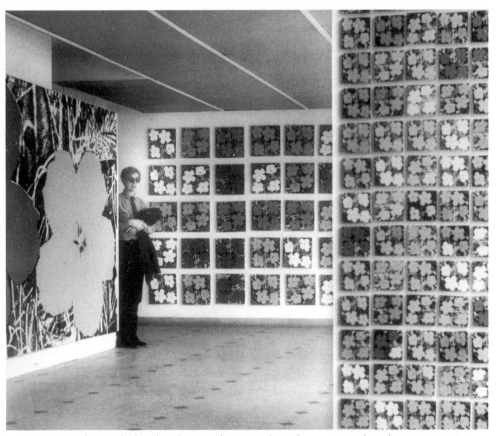

61. Andy Warhol at the Flowers show; Galerie Ileana Sonnabend, Paris, 1965.
Photograph by Harry Shunk

Plastic Inevitable. On tour, the company's overload of music, strobe lights, film, and live action was a hit from Ann Arbor to Boston.

Returning to New York, the EPI took up residence in the dance hall of the Polish National Home—the Polski Dom Narodowy—on St. Mark's Place. In its first week at the Dom, the Exploding Plastic Inevitable took in eighteen thousand dollars. Warhol was now a show-business impresario. "I wanted to do everything," he said. For him, "the ladder of success was always much more sideways than vertical." To paraphrase the title of the first magazine piece Warhol illustrated, in 1949: Success is spreading yourself thin in New York.

A ragged unity got the Warhol family through its Factory days. Each night posed the same question: Where is Andy going and who will go with him? This question became a bit easier to answer in 1966, when a restaurant called

Max's Kansas City opened at Seventeenth Street and Park Avenue South. Max's became the Factory hangout, a place where regulars could spend a long evening and feel connected to Warhol even if he happened to be absent that night.

Danny Fields, an occasional performer with the Exploding Plastic Inevitable, has said that in the back room at Max's "the point was to be fabulous and especially when Warhol was there. He was like *I Am a Camera*. You sort of played to him." Training his lens on the routines of the moment's favorites, Warhol churned out *The Chelsea Girls* (1966). Running for three and a half hours on a split screen, the film overflows with information about the early Factory—its drugs, its wardrobes, its topics of conversation, which, besides drugs and wardrobes, were few.

Announcing himself as "Pope," Ondine is called a phony by the woman sharing his scene. Erupting, he slaps her. There are other bursts of energy besides Ondine's, yet nothing can lessen for long the tedium of this film— not the abundance of documentary fact, the split screen, the shifts from black-and-white to color, the strobe cuts. Near the end of his life, Warhol said that he would not attend the Whitney's retrospective of his films. "They're better talked about than seen," he explained.

In April 1966, Warhol and his entourage were on hand for the Los Angeles opening of *The Chelsea Girls*. Hollywood hardly noticed. Back on the East Coast, Warhol followed the Velvet Underground to Philip Johnson's Glass House, in New Canaan, Connecticut. The band had been hired to play at a benefit for the Merce Cunningham Dance Company, an event sponsored by the Menil Foundation, of Houston. Fred Hughes, a young friend of the de Menil family, served as liaison between the foundation and the Velvets. The day of the benefit, he impressed Warhol with his Saville Row suit. Warhol had impressed him with his movies, and with his paintings even more. Hughes became a Factory fixture. Sweeping floors for a start, he quickly ascended to the status of confidant.

Persistently and not always subtly, Hughes tried to persuade Warhol to concentrate on painting. Preferring to stay scattered and mobile, Warhol kept drawing new people into his gravitational field. Through Debbie Dropout, an occasional visitor to the Factory, he met a car thief named Jimmy Smith who liked to pick fistfights with Ondine. Other figures flashed by more quickly. A young man calling himself Julian Burroughs appeared, claimed he was the son of William Burroughs, then vanished. A woman named Valerie Solanis dropped off a script entitled "Up Your Ass." "It was so dirty," Warhol later wrote, "I suddenly thought she might be working for the police department and this might be some sort of entrapment."

When Solanis called the Factory, she was told that her script had been misplaced. Claiming that her bill at the Chelsea Hotel was overdue, she de-

manded money. Rebuffed, she called again and again, until Warhol, who was
filming *I, a Man* (1967–68), asked her to "come over and be in the movie
and *earn* twenty-five dollars instead of asking for a handout. She came right
over and we filmed her in a short sequence on the staircase and she was
actually quite funny and that was that." Warhol had executed another brush-
off.

Brush-offs were a Warhol speciality, though it could be difficult to know
precisely when he had delivered one. His blank stare and drifting, tentative
voice put him at a distance too great, it seemed, for the delivery of a snub.
But Warhol had no need to take decisive action. He could reject—and
wound—a Factory regular with the subtlest adjustment of his attention.
Henry Geldzahler remembered the Factory as "a sort of glamorous clubhouse
with everyone trying to attract Andy's attention. Andy's very royal. It was
like Louis XV getting up in the morning. The big question was whom Andy
would notice."

Toward the end of 1967, Warhol received notice that the Factory building
was scheduled for demolition. A panicky search led to a large sixth-floor loft
overlooking the trees and statuary of Union Square. Squabbles arose over the
decoration of the new Factory. "The Silver period was definitely over," as
Warhol said, but no one could define the next period. By default, 33 Union
Square West assumed the look of a prosperous New York gallery: white
walls, hardwood floors beneath gleaming polyurethane, ranks of filing cabi-
nets. Desks greeted visitors disembarking from the elevators, and even if no
functionaries sat at them, these businesslike pieces of furniture announced a
new tone. The old swirl of Factory madness had been stilled.

One Monday toward the beginning of June 1968, Warhol arrived late for
work. It was about a quarter past four. Emerging from his cab, he arrived
at the entrance of the new Factory building with Valerie Solanis and Jed
Johnson, a new addition to the Warhol crew. All three took the elevator to
the sixth floor, where they found Paul Morrissey and Fred Hughes at their
desks. Mario Amaya, the editor of *Art and Artists*, was standing nearby, fidg-
eting; he wanted to discuss with Warhol an idea for an exhibition. There was
a call from Viva, the most recently canonized superstar. Wearying of Viva's
gossip, Warhol handed the telephone to Hughes and heard a sharp, explosive
sound.

Turning, he saw Valerie Solanis pointing a pistol at him. She fired again.
Warhol fell, not knowing if he'd been hit. He tried to crawl under a desk.
Solanis moved closer, still shooting. Two slugs struck him, tearing into his
stomach, liver, spleen, both his lungs, and his esophagus. Solanis then shot
Mario Amaya in the hip; still able to move, he ran for a back room. Solanis
followed but couldn't push open the doors.

She tried to force her way into Warhol's office; Jed Johnson held the door shut. When she pointed her gun at Fred Hughes, he said, "*Please!* Don't shoot me! Just *leave!*" Solanis went to the elevator, pressed the down button, then returned to aim the gun at Hughes. The elevator arrived and the doors opened. Hughes said, "Just *take* it!," which she did. Three hours later, Solanis surrendered herself to the police, explaining that she shot Warhol because "he had too much control over my life."

Slowly, Warhol's wounds healed, and in September he resumed his Factory routine. Obviously weak, easily exhausted, he would tremble whenever the elevator arrived at the Factory. He hated to descend alone from the sixth floor to the street. Fearing for his life, he also feared for his art. It had been necessary to shut down the old Factory circus, yet Warhol fretted that "without the crazy, druggy people around jabbering away and doing their insane things, I would lose my creativity. After all, they had been my total inspiration since '64, and I didn't know if I could make it without them."

Spick-and-span and off-limits to the freakish, Warhol's new Factory left Gerard Malanga with so little to do that he invented a project: *inter/VIEW*, a magazine printed tabloid-style on rough newsprint and subtitled *A Monthly Film Journal*. Launched in 1969, it tried to map the common ground between Warhol's Factory films and other varieties of avant-garde cinema. From this mapping emerged a theory: Hollywood movies are great but passé; as the major studios falter, their power will slip into the hands of experimenters impatient with convention, outlaws unafraid to exploit the imagery of sex and violence. In the pages of *inter/VIEW*, there were raves for Federico Fellini's *Satyricon* and for porno hits like *Deep Throat*. Malanga considered it obvious that underground impulses could no longer be denied the light of day; the outrageous would now be the norm. This was the old Factory attitude on parade in a new venue.

By 1971 *inter/VIEW* had become *Interview* and Malanga had drifted away. The magazine's presiding spirit was now Bob Colacello, a graduate of Georgetown University's School of Foreign Service whose talents for diplomacy were mixed with a love of the movies. A teenager in the sixties, Colacello had seen reproductions of Warhol's Pop pictures in *Time* and *Life* and concluded that they were simply, unquestionably great. "If this is art," he told himself, "then I like art." He liked *The Chelsea Girls* enough to sit through it three times. Enrolled in graduate film courses at Columbia University, Colacello already knew the subject well enough to write movie reviews in *New Times*, a short-lived rival of *The Village Voice*. An editor at *Interview* noticed one of his pieces and asked him if he would like to contribute to Andy Warhol's magazine. Colacello's answer was an automatic yes. Beginning as a reviewer, he quickly made himself indispensable. His title

changed at Warhol's whim, but *Interview*'s need for him was constant. So was Warhol's.

With the irascible cooperation of Fred Hughes, Colacello guided Warhol beyond the social margin where the artist had nearly died, onto the high road where Jackie Onassis's sister, Lee Radziwill, jostled the fashion photographer Francesco Scavullo as he ran into Yves St. Laurent. Chats with stars were the magazine's staple. Most were from Hollywood—Ryan O'Neal and his daughter Tatum one month, Bette Davis or Lauren Bacall another. Occasionally, Princess Christina of Sweden or some other royal presence would submit to the new Factory's version of star treatment, which mixed awe with the interviewer's far from negligible sense of his or her importance in the scheme of fashionable life. An issue's lead interview was usually conducted by Warhol himself. The magazine put him in contact with celebrities who might commission portraits. Also, it made him visible to those who lacked the glitter for the *Interview* treatment but not the $25,000 that a Warhol portrait cost. Copies, with variant colors, could be had for an extra $5,000 each.

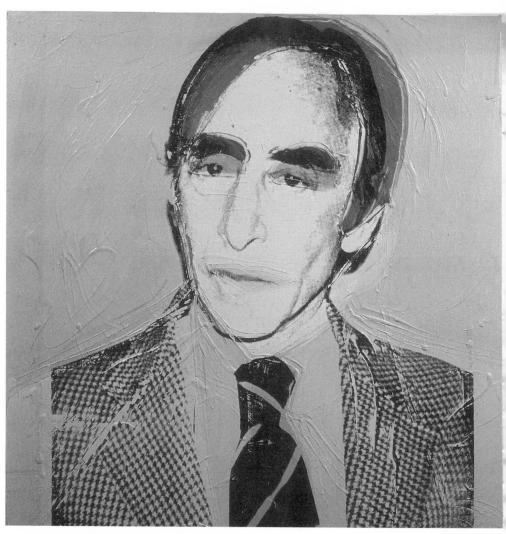

62. Andy Warhol, *Leo Castelli*, 1975. Silk-screen ink on synthetic polymer paint on canvas, 40 × 40 in.

28

During the seventies, portrait commissions became Warhol's chief source of income. At every reception or dinner party, every premiere or visit to a club, he looked for a chance to "pop the question," as he put it. Usually he was too edgy and awkward to get to that point. Popping the question became the delicate task of Fred Hughes, who was at ease with such dazzling and useful people as the de Menil children, Jack Nicholson, Angelica Huston, and the fashion designer Halston.

Colacello calculated that, over the years, Warhol made more than a thousand portraits on commission. By 1980, he was doing one a week. Most are perfunctory. From a Polaroid snapshot of the subject he would make a photo-silk-screen, then transfer this enlarged image to canvas. At an intermediate step, he usually snipped away all signs of the client's age. In the realm of images, Warhol had the powers of a plastic surgeon. Clients hired him to supply a new and sleeker look, just as art directors had hired him to spruce up the image of I. Miller shoes and Chanel No. 5.

A commercial artist in the fifties, Warhol returned to commercial art in the seventies. Claiming that he never left it, his most vehement detractors refuse to see any value even in his iconic images of the sixties. There are defenders of American art who despise Warhol, perhaps because he never rejected the devices of commercial glamour. Instead, he questioned them. He made glamour an object of aesthetic contemplation.

A Warhol Marilyn stops the eye at the surface, where the star's face competes for attention with brute pictorial facts. Colors are harsh, the veneer of photographic detail is grainy, and there is only a nonchalant fit between the layers of the image. Long after the old Factory shut down, Gerard Malanga told an interviewer that

when you're working with silk screen, you don't get everything worked out *totally* in advance. . . . So, everything is going to come out chancy. I mean, sometimes we'd make a mistake. . . . It wouldn't be a seamless thing. And that was an accident! . . . Andy took all those accidents into account, as being part of the art.

It's impossible to love Warhol's *Gold Marilyn Monroe* unless you like to focus on paint and canvas and the errors that insist on the obvious: this image is, after all, an image. Snagging the attention with its glitches, it is not easily consumable. It can't easily be had. Warhol's Marilyns and Lizzes and Jackies are as unyielding in their way as de Kooning's Women.

Adamantly flat, *Gold Marilyn Monroe* is about glamour, but it isn't glamorous in any of the usual ways. Ordinarily, glamour guides us to a zone where gratification is reliable and the present never becomes the future, only a restyled version of itself. Thus glamour distracts us from the passage of time and the approach of death. Exposing the mechanisms of the image to a morbid appreciation, an aesthete's autopsy, Warhol induced glamour to confess its entanglement with death, the inevitability it denies—and imitates. Turning bodies into corpses, death makes people equal to objects. Glamour enforces the same equality. After she had been run through the Hollywood machine, Marilyn Monroe was equivalent to everything rendered glamorous by the routines of tourism and shopping—the Empire State Building, for example, or a Campbell's soup can, that enduring celebrity of the supermarket shelf.

Born from the fear of dying, glamour crawls with this and every other apprehension that drives the demand for distraction and reassurance. To provide these goods is glamour's purpose, and that is why all glamorous images are compatible, especially after Warhol's art has exposed their deathliness. His smiling Marilyn is at ease in the company of his weeping Jackie; his Campbell's Soup Can is at home with his Electric Chair, his Elvises with his Skulls, his Lizzes with his Suicides and Disasters and Atom Bombs.

In the seventeenth century, the *vanitas* painters of Flanders and the Netherlands crowded still lifes with reminders that death is certain. Beside a jeweled crown or a bulging purse—emblems of worldly wealth and power —they might place an hourglass or a just-snuffed candle. Flowers on the verge of wilting suggest that, however long our days may seem, the end is not far off. All is vanity, in the old sense of emptiness and futility. This argument was stated in its bluntest form by an image of a human skull. Because Warhol used this motif, too, it is tempting to suppose that he shared the moral concerns of the *vanitas* painters.

In fact, he didn't. These earlier artists made a theological argument: life on earth is transient and ultimately worthless; therefore, we should turn away from the things of this world to the prospect of eternal life after death.

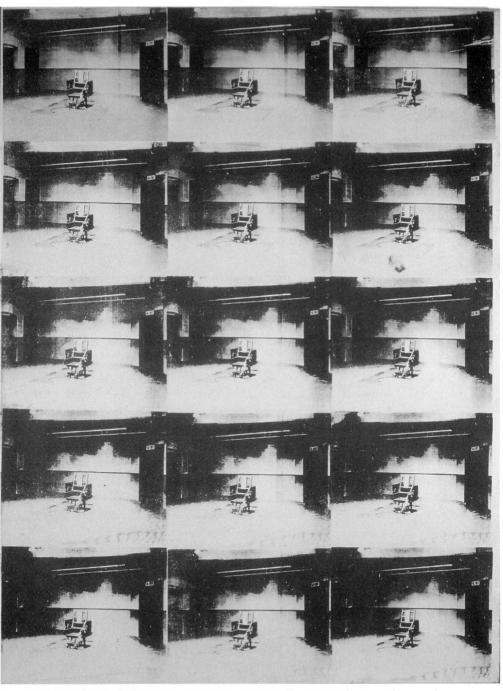

63. Andy Warhol, *Orange Disaster*, 1963. Silk-screen ink on synthetic polymer paint on canvas, 8 ft. 10 in. × 6 ft. 10 in.

Making no argument, Warhol's deathly images propose an unnerving and thoroughly secular variety of aesthetic delight: a savoring of our fears, of our wish to be distracted and numbed by glamour. Not even his remakes of Leonardo's *Last Supper* count as religious pictures, though they may signal a faint, bitter nostalgia for a time when faith could go unquestioned. Warhol's Last Suppers (1986) celebrate the conversion of a holy image to a domestic cliché. Nearly forty feet wide, the largest of these canvases pays homage not only to a banality but to the grandeur it has acquired.

The better to savor the banal, Warhol would become it. In 1981 Christopher Makos photographed him in blond wig and mascara, heavy pancake makeup and heavier lipstick. Sucking in his cheeks to make his cheekbones higher, Warhol looked like a second-string Marilyn impersonator. Able to bear himself only by denying himself, Warhol obsessively scanned the moment for a new image to infiltrate and turn into a disguised self-portrait. The flow of imagery was the medium of his being, and so his feeling of oneness with Marilyn was strongest when he imposed his will on her picture.

He did it first in 1962, soon after she committed suicide. A few years later, Warhol said, "The Monroe picture was part of a death series I was doing, of people who had died by different ways. There was no profound reason for doing a death series, no 'victims of our time'; there was no reason for doing it at all, just a surface reason."

That was the only sort of reason Warhol could give, for surfaces were all he would acknowledge, even in himself. During the same interview, he said, "If you want to know all about Andy Warhol, just look at the surface of my paintings and films and me, and there I am. There's nothing behind it." In 1969 Warhol displayed his scarred abdomen to the camera of Richard Avedon. He never uncovered the inward scars that led him to say, years later, "I think it's horrible to live."

Of course the Warholian surface concealed much, including religious feelings that became widely known only when recalled by eulogists at his funeral. The disparity between the public and the private Warhol is immense. It would be fascinating to know what secrets lurked behind his unflappable facade—fascinating though not germane. Warhol is important for what he displayed, not for what he hid. His works pose no biographical riddles, nor did he present himself as a puzzle to be deciphered. He appeared in public as a person with no life except as a personage, the figurehead of a career, a logo of himself.

For a few months in 1967, a Factory regular named Allan Midgette impersonated Warhol on the college lecture circuit. Exposed, the fraud ended, though it wasn't fraudulent in the usual way. Wearing a silver wig and a leather jacket, Midgette had substituted not one person for another but one image for another. Warhol never claimed to be anything more substantial. In

public, he floated beyond reach, pale and whispery, suspended between his need for glamour and his fear of all that glamour's dazzle is intended to blot out.

Warhol wanted to feel at one with every star he drew into his art, even the soon-to-be crucified Christ of Leonardo's *Last Supper*. He may have seen himself in the apostles, too—Judas, certainly, and maybe Peter, on whom everyone relied. It's difficult to imagine that he wanted to see himself in his Skulls, though they have star quality. They are the presences presiding silently, as Warhol presided, over the ritual of offering up for delectation the dead emptiness of glamour. This bitter aestheticism was the best that Warhol could wring from our society.

One day Warhol appeared at the Factory with a shopping bag full of plastic "space toys." Here, he announced, was the beginning of a "new collection." Fred Hughes was appalled. "Why don't you start a pins collection?" he screamed. "A needles collection? A scissors collection? A paper-bag collection?" In the archives of the Warhol Museum sit more than six hundred "time capsules," cardboard cartons that Warhol filled with Factory mail— letters from friends and fans, death threats, announcements, invitations, magazines, gifts. No principle of selection was at work apparently. Nor did any standard of taste emerge from the accumulations of furniture, artworks, *objets de vertu*, watches, crockery, cookie jars, and jewelry that filled his East Sixty-sixth Street town house and took ten days to auction, at Sotheby's, a year after his death.

The need to accumulate experience—or social contacts—drove him to parties and receptions nearly every night. Until the mid-seventies, his tape recorder ran nonstop; until the end, his camera was snapping. Warhol wanted to "get it all down," wrote Bob Colacello. "He wanted to see everything and record everything, know everyone, and paint, photograph, and interview everyone." Yet he never aimed his microphone at those he considered nobodies. When ordinary people appeared in his snapshots, he left their names out of the captions. Under his discriminatory gaze, the anonymous didn't exist. He was interested, he said, in "people at the top, or around the top." It was not a profound thrill to meet every one of them.

After reporting that Barbra Streisand introduced him to Paul Newman, Warhol complained that he wanted Clint Eastwood. He preferred John Lennon to Paul McCartney, Dick Cavett to Johnny Carson, the bitchy Truman Capote to the surly Norman Mailer. The sum of these preferences suggests that Warhol disliked solemnity. Earnestness, perkiness, and sincerity also set his gaze adrift. Warhol focused on celebrities too blithe, too naughty, too jaded, too resolutely narcissistic to deny the falseness of their facades. He liked dazzle to be deliberate, with no self-justification. Never merely indulg-

ing these tastes, he enforced them rigorously. Through the exercise of his aesthetic will, Warhol surrounded himself with people who seemed, in the flesh, as knowingly artificial as the best of his paintings.

"Everybody has their own America," he said in 1985, "and you live in your dream America that you've custom-made from art and schmaltz and emotions just as much as you live in your real one." In this imaginary nation, Warhol is everywhere and nowhere: the star of the show, the domineering arbiter with life-or-death authority over each glitch or refinement, and the adoring fan merged with the flow of imagery. The grain of his silk-screens is the grain of his sensibility, as it spreads through his images, never feeling any need for measure or moderation, never seeking to establish a boundary. Warhol's grids and series could go on, in principle, forever. His dream America is infinitely large, and he pervades it as thoroughly as Johns and Pollock pervade theirs.

Though Warhol visited Aspen, Colorado, several times during the eighties, the immensities of American space seem not to have impressed him, then or ever. His "dream America" isn't the work of an artist who would say, in chorus with Jackson Pollock, "I am nature." And Warhol was too enchanted by glamour, too impatient with art-world proprieties, to embody high culture in the manner of Jasper Johns. Warhol said, "I am society," meaning the consumerist society of postwar America. He played the part of consumerism alive to itself, able to take conscious delight in its own glitzy mechanisms. Unbeknownst to itself, glamour promises to rescue us from time and from death. Treating that promise as if it were his own bad faith, Warhol made it the salient theme of his art. His pictures invite us to see their artificiality in and for itself, as a quality deserving the sort of attention we might pay to color as color or line as pure arabesque. He subjected glamour's trance to the cruelties of aesthetic scrutiny. At least, that is what he did in his best works, the ones that show us an image of American society as grand and as terrifying, in its own fashion, as Pollock's image of New World nature.

THE QUEST FOR PURITY

64. Helen Frankenthaler, *Mountains and Sea*, 1952. Oil on canvas, 7 ft.
2⅝ in. × 9 ft. 9¼ in.

29

Like his art, Pollock's influence sprawled, blurring genealogical connections. Possibly Agnes Martin's grids are variants on Pollock's looping tangles of paint, though it's just as possible that her grids evolved from the geometries of Barnett Newman. Robert Ryman's all-white paintings calm the furor in Pollock's fields of light; also, they reverse the darkness rippling through the paintings of Clyfford Still. Who, then, are Ryman's aesthetic predecessors? Who are Martin's? Amid uncertainties like these, one line of descent is clear and fully documented. It leads from Pollock the father to Helen Frankenthaler the daughter, and on to a small band of painters who counted for a time as her younger brothers.

Born and raised in Manhattan, Frankenthaler graduated from Bennington College in 1949. A last semester spent in the Fourteenth Street studio of a painter named Wallace Harrison left her poised at the border of the art world. She made her entry the following year, as the curator of a show of recent work by Bennington graduates. Clement Greenberg attended the opening, at the Seligmann Gallery, and let it be known that he particularly disliked Frankenthaler's contribution, *Woman on a Horse* (1950), a picture filled with Cubist lessons well learned from Paul Feeley, her college teacher.

Nonetheless, she and Greenberg became friends. He introduced her to David Smith and Franz Kline, to the de Koonings, to the Pollock-Krasner ménage. More to the aesthetic point, he guided her through the museums and galleries of New York. With Greenberg at her elbow, Frankenthaler learned to see a liberating force in the light of Miró, in the color of Matisse. Kandinsky's early abstractions impressed her with their flat and open calligraphy. She liked the dissolving flow of Arshile Gorky's later forms and the wobble that Willem de Kooning worked into the rigid, nailed-down structures of Parisian Cubism.

Grace Hartigan, Alfred Leslie, Michael Goldberg, and others of her gen-

eration had seen an opening to the future in de Kooning's recent pictures. Frankenthaler saw that opening in Pollock's poured imagery, which so many had dismissed as a high road to a dead end. "You could become a de Kooning disciple or satellite or mirror," she later said, "but you could *depart* from Pollock." The dead end was in de Kooning's art, Frankenthaler came to believe, but only after she proved herself his remarkably accomplished disciple. Steered to her studio by Greenberg, John Bernard Myers picked two canvases for a group show that opened in May 1951 at the Tibor de Nagy Gallery. Among the styles that drift through these pictures, de Kooning's grandly agitated Cubism is the presiding force.

Toward the end of 1951, Myers gave Frankenthaler her first solo exhibition. In a time crowded with notable debuts, this one stood out. The involuted, quasi-abstract anatomies of *The Jugglers* (1951) sent Frankenthaler to the front ranks of the moment's young de Kooningites. And the textures sweeping across the eight-foot width of *Painted on 21st Street* (1950) show how hard she had looked at Pollock's *Autumn Rhythm* and *One* when they appeared at the Betty Parsons Gallery in 1950. Frankenthaler had seen how his gesture opens the image, but she wasn't yet ready to plunge into that openness. In *Painted on 21st Street*, every surge is contained by a flourish of de Kooningesque calligraphy.

Soon after Tibor de Nagy closed its Frankenthaler show, Parsons unveiled Pollock's new works in black and white—expanses of unprimed canvas filled with streaks and pools of enamel laid on with an oven baster. Frankenthaler saw two of these canvases for a second time the following spring, at the Museum of Modern Art's Fifteen Americans. That summer she traveled to Nova Scotia with Greenberg. When she returned to New York, the memory of that northern landscape mingled with her astonished response to Pollock, and she painted an icon of postwar American art—a big canvas, nearly ten feet wide, called *Mountains and Sea* (1952).

On its unprimed surface, a few charcoal lines make lush, wandering curves. Guided by these lines and then ignoring them, translucent greens, blues, and orangy reds spread into an evocation of crisp summer air, crystalline summer light. Details of a landscape emerge. A blue edge suggests a shoreline; green is mountain foliage far away; red is the glare of the sun or the glow of nearby blossoms. One can't be sure, because the picture is, after all, an abstraction —a calm, confident argument advanced by the logic of color. Memory animates but does not constrain it. *Mountains and Sea* sails away from its occasion.

In 1952 Frankenthaler was sharing a West Twenty-third Street studio with a colleague named Friedel Dzubas. The afternoon she finished *Mountains and Sea*, Dzubas told Greenberg by phone that something odd and brilliant had emerged. Arriving at the studio that evening, Greenberg agreed at first glance. Later, the critic arranged for two painters living in Washington, D.C.,

65. Morris Louis, *Point of Tranquility*, 1958. Acrylic on canvas, 8 ft. 5⅜ in. × 11 ft. 3 in.

to have a look at the picture in Frankenthaler's studio. One of them, Morris Louis, said that the picture formed "a bridge between Pollock and what was possible."

At first, Louis and Kenneth Noland, the other visitor from Washington, were simply dazzled by *Mountains and Sea*. In its self-sufficiency, it didn't seem to lead anywhere. Even Frankenthaler felt a bit baffled. As de Kooning flourished, his young followers became more fashionable by the season. Persisting with the technique she had borrowed from Pollock, Frankenthaler worked against the fear that she had joined him in his quandary. Not until the fifties had nearly ended did she take more than a few tentative steps forward. By then, Louis and Noland were crowding close behind. Dzubas took the same path, as did Jules Olitski, Walter Darby Bannard, and a second generation of color-field painters, as these artists came to be known.

During the late fifties and early sixties, Frankenthaler composed with blasts of undiluted primary color—writhing, splashy blobs of red against yellow, blue against red. To keep these clashes from settling into simple standoffs,

she would introduce a secondary color, a green or an orange nearly identical to a dominant red. Spreading veil after veil of watery pigment over the canvas, Louis produced shifting floods of unidentifiable color—reds turning orange or brownish purple, greens turning red. Next, with paints poured in parallel stripes, he attained astonishing clarities of hue. Noland's pouring produced concentric circles, then nested chevrons. Toward the end of the sixties, he sent horizontal bands of color across long, narrow canvases. The allusion to mattress ticking was unintended. For the color-field painters, the point lay not in the image but in the chromatic relationships the image made possible.

Soaked with pigment by Frankenthaler and her aesthetic siblings, the canvas "becomes paint in itself, color in itself," said Greenberg. Moreover, the canvas's "threadedness and wovenness are in the color," making it look "somehow disembodied, and therefore more purely optical." One might wonder how color can be disembodied if it displays the "threadedness and wovenness" of heavy cotton duck. Also, the color-field painters—especially Frankenthaler—habitually generated light-dark contrasts of the kind disallowed by Greenberg's theory. Only in a few of Olitski's big spray-gunned canvases of the mid-sixties does color ascend to a uniformly high key. And there are other disparities between theory and practice. In fact, there are many. These are not as important as the excitement stirred up by Greenberg's doctrine and the painting it supported.

In 1971 color-field enthusiasts in Houston revamped the Deluxe, an old movie theater, and put on a show. There were paintings by Olitski, Bannard, Larry Poons, and others, including Noland, who helped with the hanging. Greenberg appeared and cast an approving eye on the results. The curator of the Deluxe show, a second-generation color-fielder named Peter Bradley, said that he favored artists who are "constantly taking a risk." The need is to move forward. "Pollock-type art" established the starting point. That sort of painting "looked good" but it was "cloudy" and "didn't strike you as being 'clean.'" Now "art is becoming clean and neat," said Bradley. "Clarity moves me. Maybe it's a message, a prophecy."

Greenberg had been calling for "purely optical" painting since the late forties, when Pollock, the patriarch, was sweeping away the remnants of Cubist architecture. His currents of color provided a glimpse of the ideal. Nonetheless, his contrasts of light and dark stir at least the memory of figure and ground. Because this effect suggests objects in space, said Greenberg, it is "sculptural." It has no place in a painting, which ought to be "a strictly visual entity." Even the best of Pollock's canvases are not quite "visual" enough. They evoke the infinite and the energy of his arm. They draw us in bodily and send us careening through imaginary depths. A proper color-field painting does none of that.

With its colors keyed up to high incandescence, a color-field painting pre-

vents sharp tonal contrasts. With no play of light against dark, there can be no oppositions of figure to ground, no suggestions of objects in space. Untainted by these "sculptural" effects, the painting addresses itself solely to matters inherent in the medium. According to Greenberg's doctrine, Frankenthaler and the small band she had inspired were on the verge of revealing "the irreducible essence of pictorial art." Here was momentous news. Out of the seeming dead end of Pollock's great achievement had come an achievement even greater than his.

A Greenbergian critic named Michael Fried declared in 1965 that true progress in art models itself on the revolutionary dialectic proposed by Marxist theory. Marxist practice failed, as Fried noted; radical politics has been a disaster in the twentieth century. Even so, he said, the revolution is succeeding on the plane of art. At the hands of artists favored by the Greenbergian critics, painting had advanced to the point where further progress was difficult to conceive. Praise of Louis, Noland, and Olitski developed a tone of millennial fervor. Perfections had been achieved, for if their imagery did address itself solely to vision, then it would give the viewer the experience of being removed from space, even the space of the body. Perceiving a purely visual image, one would become all eye, pure vision. This was the purity Pollock had prophesied. The color-field painters had attained it. Nonsense, said Donald Judd. Pollock had prophesied a different and a truer purity, which he, Judd, would attain.

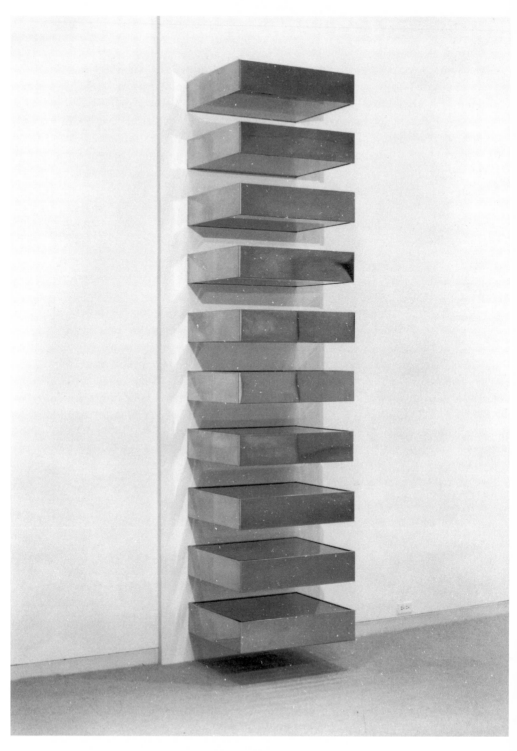

66. Donald Judd, *Untitled*, 1969. Brass and colored Plexiglas on steel brackets; ten units, each 6⅛ × 24 × 27 in.; overall dimensions: 116½ × 24 × 27 in.

30

In all paintings but Pollock's, Donald Judd saw a disturbing effect: parts form wholes, small motifs merge into the larger composition, and the eye loses track of specifics. With his drip method, Pollock prevented this blending, this blurring of the particular. Each strand and pool of pigment maintains its integrity. The canvas, too, preserves the plain truth of its size and rectangular shape. To Judd's eye, a drip painting is an array of uncompromised facts, not a field of "optical" ethereality or an opening onto an infinite. Pollock's great works had prophesied a total candor of the art object. Judd's task was to realize this prophecy.

For seven years, from 1955 to 1962, Judd struggled to exclude from painting everything but the facts of paint on canvas. He flattened forms to patches of color. He textured the surface of his canvas. Exchanging canvas for Masonite, he roughened his textures. He reduced his forms to straight lines parallel to the edges of the surface. Despite all he could do, effects of depth continued to appear. Judd concluded that painting is by nature "spatially illusionistic." It occupies one place and refers to another. The medium should be abandoned, like an obsolete vehicle.

The new vehicle, the one that would bear art into the proper future, was a three-dimensional object of familiar shape. On its uniform surfaces, paint would be smooth. Rescued from its perfidious habit of collaborating with line to generate illusions, color would be one of several self-evident facts that define the work of art as nothing more nor less than a tangible object in ordinary space. By 1963 the facts of Judd's art were those of boxes painted in bright colors—chartreuse or cadmium red—and inflected by eccentric details.

His slim, horizontal wall pieces played solids against voids in symmetrical patterns. With vertical arrays of boxes, identical in size and color, he imposed a regular pattern on the wall itself. Though Judd occasionally permitted a curved edge to appear, he usually confined himself to straight edges, right angles, and scrupulously flat planes. From this small repertory, he generated

a remarkable variety of objects large and small, shiny and matte, bright and drab. Judd's works from the sixties have an air of substantiality, even when they are manifestly hollow, for they are the product of his calm belief that he knew precisely what to do with Pollock's legacy.

The virtue of a drip painting lies in the integrity of its elements. Taking this assumption as axiomatic, Judd argued that virtues can be improved. Integrity can be made more secure. In his first major position paper, an essay called "Specific Objects" (1965), he announced that progress had been made. The most advanced New York artists, wrote Judd—who included but did not name himself—had produced works in which "shape, image, color, and surface are single and not partial and scattered. There aren't any neutral or moderate areas or parts, any connections or transitional areas." All the elements of a piece are equal, hence equally able to assert the simple, incontrovertible facts of their physical being.

Much of the art Judd endorsed was the work of artists who had abandoned the traditional forms of painting and sculpture. A new name was needed. "Minimalism" emerged and gravitated toward Judd and other makers of stark objects. For a time, critics applied the label to any work of art that dispensed with the bravura messiness of de Kooningesque painting. In a season or two, the Minimalists had been identified as Judd, Sol LeWitt, Carl Andre, Robert Morris, and a few others—artists who favored blank surfaces and simple, regular outlines. These, said Morris, are the traits of a good "gestalt"—a shape so clear that the mind apprehends it with speed and unassailable certainty.

Before he became a Minimalist, Morris choreographed and appeared in a series of performances at the Judson Dance Theater. With these works, Morris pledged a temporary allegiance to Robert Rauschenberg and the Judson aesthetic of ordinary movement. Recycling motifs from Jasper Johns and Marcel Duchamp in small leaden sculptures, Morris linked himself to these artists. In 1963 the Green Gallery showed his first nonderivative works: two thin, squared-away slabs, one hovering just off the floor, the other suspended from the ceiling; a large pair of wheels, joined by an axle; a square frame, thick enough to stand on the floor, free of the wall; and *Barrier*, four beams arranged in the ticktacktoe pattern. All these objects were made of plywood painted gray.

The next season, Morris leaned a slab against a wall. He stretched a large square beam along the floor and angled an inverted L shape from wall to floor. He presented smallish cubes in sets of four. There were cubes with mirrored surfaces and former cubes, which is to say cubes with vertical planes slanting slightly inward. Devoted to the ideal of the good gestalt, Morris was testing the limits of goodness. How far can a form deviate from absolute simplicity and still be immediately graspable?

Paraphrasing Judd, Morris wrote in 1967 that a painting is a retrograde object because it cannot help referring to objects other than itself. It produces

a "duality of thing and allusion." The same year, he stated that a successful artwork generates no "divisiveness of experience." It doesn't try to fool the eye or plague it with ambiguities. This general agreement with Judd led to a dispute over a particular. Judd was an exuberant colorist who liked to juxtapose the luster of polished metal with the gleam of industrial paint— brass against smoldering orange, galvanized iron against bright blue. Morris dismissed color as "additive." What matters, he argued, are "scale, proportion, shape"—qualities to be made unambiguously available to the viewer "by the adjustment of an obdurate, literal mass."

On the need for clarity, all the Minimalists agreed. "My arrangements," Andre once said, "are essentially the simplest I can arrive at, given a material and a place." His characteristic work is a set of twelve-by-twelve-inch plates of steel arranged in twelve rows of twelve. Occasionally, he disposes bricks or uniform pieces of wood in orderly patterns. Simplicity is good, Andre believes, because it defeats the temptation to "impose properties on materials." It is better to "reveal" their properties. A material should obviously be what it is and a form should just as obviously be whatever it might be—or become.

Andre does not feel protective toward his floor pieces. "As people walk on them, as the steel rusts, as the brick crumbles, as the materials weather, the work becomes its own record of everything that's happened to it," he stated in 1969. Andre accepts whatever accidents befall his works. Morris does not. He repairs damaged pieces, or refabricates them, as he has done with many of his early plywood pieces. LeWitt, too, keeps his lattices and permuted cubes in good repair. The contingencies he is willing to accept occur in the making of an object.

According to LeWitt's "Sentences on Conceptual Art" (1968), a work emerges from a process launched by an idea. The dictates of the idea must be followed "blindly" in all their particulars. "If the artist changes his mind midway through the execution of the piece he compromises the result," LeWitt wrote, for "the process is mechanical and should not be tampered with. It should run its course." The results may be surprising because "the artist cannot imagine his art, and cannot perceive it until it is complete." Surprises should be welcomed, especially if they offer "ideas for new works."

LeWitt's "Sentences" pointed to a Minimalist ideal: the form that establishes a perfect fit between idea and object. To celebrate this perfection, Minimalists would run a form through a set of permutations. In 1967 LeWitt built cubes of three kinds: closed on all six sides, open on one side, and open on two sides. Then he stacked them, three high, in forty-six different combinations. His lattices simply repeat the form of the cube dozens, sometimes hundreds, of times. Repetitions like these could, in principle, go on forever, and so a work of Minimal art has a resemblance to a drip painting by Pollock: it implies the infinite.

Invoking unbounded space and light, Pollock's gesture sends his presence

sailing through the immensities of his image. No Minimalist ever makes that sort of entry into his work. He stands outside it, an allegorical figure of the idea that dictates its physical attributes. With unrelenting precision, an Andre "carpet" of twelve-by-twelve-inch plates reiterates its premise, which is the twelve-by-twelve pattern itself. The precision of the reiteration and its relentlessness are far more to the Minimalist point than the infinite that the carpet suggests. From formal clarity comes an effect of conceptual control.

Metaphorical play is not encouraged, and in his "Notes on Sculpture," Morris disallowed it. He had no interest in the air, space, light, and bodily presence in the drip paintings of Pollock, who remained for him and the other Minimalists an artist of the literal and the concrete. Here is the true, the believable Pollock, they said. From his example the best artists will advance to forms clear and obvious enough to defeat the untruths of traditional art.

When three-dimensional form is clarified, said Morris, complexity leaves the work and becomes "a function of space, light, and the viewer's field of vision." Drawn into that field, one becomes aware of "kinesthetic demands placed on the body." To be in a gallery filled with Minimalist objects is to be given an acute sense of the room's shape, size, and degree of brightness. Minimalism heightens our awareness of what is. In 1969 the advertisement for Andre's yearly exhibition at the Dwan Gallery reproduced the periodic table of the elements, from hydrogen to lawrencium, as if to say: Good art is like science. It presents us with the real; it makes us more physically real to ourselves. Color-field painters and their Greenbergian critics disagreed. Art, they said, should lift us out of our physical state. In an essay called "Art and Objecthood" (1967), Michael Fried explained how this transcendence of the body occurs.

Art of the right sort, wrote Fried, manifests an abiding essence—the "pure opticality" of a Noland stripe painting, for a crucial example. To perceive this purity is to touch, with vision alone, an absolute that resides nowhere in the three dimensions of ordinary space. Proper art teaches us how to become all vision and thus as intangible, in imagination, as the color effects we are contemplating. No, said the Minimalists, good art reminds us of our tangibility. It renders our bodies vivid to us.

Both parties invoked the authority of Pollock; each defined him to its own best advantage. According to the color-fielders, Pollock was devoted exclusively to vision. His allover canvases make it possible to imagine, to strive for, paintings so purely "optical" that only the eye can enter them. The Pollock of the color-field painters is an artist of the ethereal. For the Minimalists, Pollock was an artist who grappled with matter in viscous, primordial form. Their Pollock points the way to forms so frankly physical that vision cannot grasp them firmly unless the entire body is engaged. These two Pollocks, the literalist and the "optical," had nothing in common, nor could there be any reconciliation between Minimalism and color-field painting. Unnerved by the

hostility of the stalemate, Fried described it as an episode in a perennial "war" between true and false art.

Art turns false, said Fried, when it addresses us by some dubious "theatrical" means. He abominated all these devices—the shock of novelty, the charm of mimicry, the coy invitation to dream. The tactic he feared most was the Minimalists' overbearing presentation of literal fact in ordinary space and time. Fried warned in "Art and Objecthood" that the art war had entered a desperate phase. True art would not survive if the moment's best artists could not "defeat theater" in its latest, most insidious form. This war was unwinnable because each side occupied a battlefield of its own.

As the sixties ended, the continuum of New York art fell into fragments, most of which drifted to the peripheries or vanished entirely. Of the decade's new styles, only Pop, Minimalism, and color-field painting survived with any vigor. Attrition had been ruthless. Surveying its aftermath, Henry Geldzahler saw an opportunity to define a canon. Now the Metropolitan Museum's curator of contemporary arts, he was charged with organizing a spectacle impressive enough to inaugurate the Met's centennial celebration. His response was New York Painting and Sculpture: 1940–1970, an exhibition that filled thirty-five galleries with 408 works of art. The Geldzahler canon was capacious but suitably cautious.

In the beginning were pictures by Pollock and sculptures by David Smith. Then the exhibition reached back to the thirties for a trio of predecessors: Stuart Davis, Edward Hopper, and Milton Avery. Next came works by de Kooning, Newman, Still, Rothko, Kline, Guston, and a few others of that generation. Johns and Rauschenberg had galleries to themselves, as did five of the color-field painters: Frankenthaler, Louis, Noland, Olitski, and Larry Poons. Among the luminaries of this all-star show, these were the brightest —or, at least, the ones most favored by Geldzahler's installation. Of the Minimalists, he recognized only Judd, Morris, and Dan Flavin, whose fluorescent-tube wall pieces had one gallery to themselves and spilled into another.

Geldzahler designed his exhibition to mark the stages of an American advance across a wide front. Here was history on the march, as New York art moved from obscurity in the forties to international recognition in the sixties. And in the spaces occupied by brand-new work, the present seemed to be edging impatiently into the future. "Henry's show," as it came to be known, offered a confident, convincing account of a major triumph. Only Frank Stella presented a problem. His importance was undisputed. The difficulty was in knowing precisely where he belonged in the struggle between Minimalism and color-field painting—between devotion to sheer physical fact and the redemption from fact that Michael Fried called "grace."

67. Frank Stella, *Avicenna*, 1960. Aluminum oil paint on canvas, 6 ft. 2½ in. x 6 ft.

31

In 1956, when he was still an undergraduate student at Princeton University, Frank Stella had never seen the work of Jasper Johns. In some way, though, he knew of it. Johns's art was "a kind of palpable reality of some sort that was in the air," he later said. The young painter found it "interesting to hear about something strongly reputed to be good, and then actually see it be good." From Johns, Stella took cues to a career so successful that, in the sixties, he eclipsed everyone but Andy Warhol.

After a long look at Johns's first exhibition, Stella filled several square canvases with horizontal stripes. Somewhere, usually near the center of the pattern, he would place a block of solid color. Though they contained no stars, these pictures had a conspicuous resemblance to the Flags. Stella's instructor at Princeton was Stephen Greene, an Abstract Expressionist with no sympathy for Johns. On one of his student's new works he scrawled "God Bless America." Outraged at first, Stella forgave this flip assault as a sign of the desperation felt in a rearguard position. From Greene and the writers of *Artnews*, Stella had heard too much Abstract Expressionist talk of the painter who risks all in the struggle to stay alive to his experience. Already a self-confident skeptic, he wanted to find "a way that wasn't so wrapped up in the hullabaloo." Johns showed him the way with the stripes of his Flags, the calm of his monochrome, the restraint of his brush.

In the spring of 1958, Stella left Princeton with his bachelor of arts degree, and set up a studio in a storefront on the Lower East Side of Manhattan. Three or four days a week he painted apartment interiors for a contractor who specialized in rush jobs for landlords under court order to refurbish their properties. His expenses met, Stella spent his days off covering canvases with stripes of black enamel. This was paint sold in gallon cans, not five-ounce tubes. His early paintings have the bleak, sooty look of commercial neighborhoods on the peripheries of Manhattan.

68. Frank Stella, *Flin Flon III*, 1969. Polymer and fluorescent polymer paint on canvas, 8 × 8 ft.

Tomlinson Court Park (1959) is a horizontal canvas just over nine feet wide. Its outermost stripe makes an unbroken circuit of the edge, like a thin black frame. The next stripe makes the same circuit, just inside the first; the rest do the same, stripe within stripe, until the canvas is occupied. An insistent eye could see this pattern as a bird's-eye view of a stepped pyramid. Yet the pyramid keeps collapsing. The image is as flat as the surface it covers, and if the eye balks at this obvious fact, the stripes overcome its reluctance with their unswerving reiterations.

In April 1959 a group show at Tibor de Nagy included a black-stripe painting called *Club Onyx* (1959). Making the gallery rounds, Dorothy Miller looked in and was astonished by this young painter's resistance to the authority of Willem de Kooning. Quickly, she arranged for a visit to Stella's studio with Leo Castelli, who had just added him to his roster. Feeling her first reaction confirmed—and reconfirmed—by the insistence of Stella's patterns, Miller declared her intention of including him in a group show at the

Museum of Modern Art. Castelli suggested that the painter, then twenty-three years old, might be hurt by this early exposure. Turning insistent herself, Miller refused to consider the possibility. When her Sixteen Americans opened in December, it included four of the black paintings.

Years later, Stella speculated at length about form in art. In 1959 he left the commentator's job to Carl Andre, who wrote in the catalog of Sixteen Americans that "symbols are counters passed among people. Frank Stella's painting is not symbolic. His stripes are the paths of brush on canvas. These paths lead only into painting." True, said the Greenbergian Michael Fried, but what sort of paintings does Stella give us? Surely his canvases are not satisfied to be objects, mere physical things immersed in ordinary space. A

69. Frank Stella, *Nasielsk II*, 1972. Painted canvas, felt, Kachina board on wood, 9 ft. 2 in. × 7 ft. 5½ in. × 6 in.

painter of Stella's high ambition must want to do more with paint and canvas than "reveal the properties of the material," as Andre put it. Two decades later, Fried said that he had spent the mid-sixties struggling with Andre for the "soul" of Frank Stella.

Greenberg wasn't convinced that the struggle was worth the prize. He and most of his followers dismissed Stella as one of the Minimalist enemy, a literalist like Donald Judd, who saw Stella's striped canvases as objects— "slabs" to be hung on walls in place of paintings. As if happy to be taken for a literalist, Stella had said that, in his art, "what you see is what you see." The question, Fried argued, is how an artist's works compel us to see them. The viewer has no choice but to see a Minimalist's box-shaped object as an object shaped like a box. But, he said, the shape of a Stella canvas doesn't work that way. Because it reflects the internal pattern of the image, that

70. Frank Stella, *Nogaro*, 1981. Mixed media on aluminum and fiberglass, 9 ft. 7 in. × 10 ft. × 24 in.

71. Frank Stella, *Lo sciocco senza paura (#1, 4X)*, 1984.
Mixed media on etched magnesium, aluminum, and fiberglass,
10 ft. 10¼ in. × 10 ft. 6¼ in. × 24½ in.

shape is pictorial; it is visual, not just the literal edge of an object. No, the Minimalists replied. Stella's stripes map palpable realities. He is one of us.

Fried would not give up. From 1963 to 1967, nearly all his many reviews, articles, and catalog essays argued at length or in passing that Stella's images, no less than Olitski's, generated a kind of "space accessible to eyesight alone." Thus Stella's ancestor was the good, "optical" Pollock of the Greenbergians, not the bad, literalizing Pollock of the Minimalists. As Fried and the Minimalists struggled for his soul, Stella favored neither side. He was absorbed in the effort, more successful every season, to heighten the inexplicable clarity of his art.

In a letter of recommendation written to the Fulbright grant committee in 1960, Alfred Barr spoke of being "deeply impressed" by Stella's black paintings. "I found my eye, as it were, spellbound, held by a mystery," he wrote. "To me the paintings express a stubborn, disciplined, even heroic rejection of worldly values." Having seen something unnamable—something transcendent—in the very simplicity of Stella's patterns, Barr proposed to the trustees of the Modern that they acquire a black painting called *The Marriage of Reason and Squalor* (1959). The trustees resisted. Castelli had given the painting a price of twelve hundred dollars. If it were five hundred dollars

less, Barr told him, *The Marriage of Reason and Squalor* could enter the Modern's collection without the trustees' approval. Castelli asked the director where he would get the money to make the purchase. From his own pocket, said Barr. Castelli lowered the price to seven hundred dollars, and the painting was acquired.

Early in 1960, Stella switched from black to aluminum enamel. In the black paintings, stripes multiply in patterns that fit neatly onto the four-cornered surface of the canvas. The aluminum stripes were not so accommodating. Each had a "jog," a right-angled break in its ruler-straight form. As they spread, these stripes left small patches of canvas uncovered. Stella cut them away. Adjusting canvas to stripes instead of stripes to canvas, he had made his first shaped paintings. A show of these works opened at Castelli's in September 1960, just two and a half years after Johns's debut.

In Stella's next series—the copper paintings—entire regions of the surface vanished, leaving a series of right-angled L, T, and U shapes. Sometimes they stand alone, sometimes they multiply. Four L's form a Greek cross; a pair of U's back-to-back turn into a bulky H. Stella began with stark deprivations and carried on by relieving them, one after another. Monochrome gave way to polychrome; canvases developed extravagantly irregular outlines. Then, suddenly, Stella set aside his ruler and took up a protractor. Once-straight lines now curved. Begun in 1967, the Protractor paintings appeared the following year in Washington, D.C.; Bennington, Vermont; Los Angeles; Toronto; and London. Turning out canvases at a prodigious rate, Stella fell behind the demand. Not until 1969 did Castelli have a chance to show a set of the new paintings.

After a decade of acceleration, Stella's rate of innovation turned manic. With paper, felt, and painted canvas pasted to stretched canvas, he recapitulated the geometries of the visionary modernists—Antoine Pevsner, Naum Gabo, the hard-edged Wassily Kandinsky. Stella exchanged canvas for wood; for paper and felt he substituted more building materials—Masonite and Homasote. His collages were turning into low-relief sculptures. By 1975 Stella was assembling his works from flat shapes made of another new material: honeycomb aluminum. Streaking, scumbling, and sometimes simply smearing these metal forms with steamy color, he recalled the brushy New York manner he had resisted with his black stripes of 1959. The forms themselves took a ready-made extravagance from the French curves of the draftsman's kit.

As Stella loaded more elements into his constructions, low relief expanded to high relief and lost all resemblance to collage. He was a sculptor now, expert in a variety of fabrication processes. Yet he insisted that he had never ceased to address the fundamental issues of pictorial art. In 1984 he launched a series featuring cones and pillars. Bearing stripes of graduated width, these forms make arch reference to academic exercises in perspective.

They allude as well to the evolution of the column in Western architecture, and to Cézanne's remarks on the importance of the cylinder, the sphere, and the cone. Also, Stella's latter-day stripes recall those of his early years, when Fried was trying to rescue him from the orbit of Andre and Judd.

Cantilevered deep into space, the pillars and cones of Stella's maturity offered nothing of interest to Fried, who once led the fight for purely "optical" painting. Nor could Judd or Andre, those guardians of clarity and rigor, feel much affinity for the baroque artist Stella had turned out to be. The struggle for his soul, long abandoned, had been pointless from the start. Stella did not enter the sixties poised between the Minimalist sculptors and the color-field painters; he never would have joined either team. In the moment of forming his first vague notion of ambitious painting, Stella became an "Isolato" as independent as Johns or Pollock.

Though Stella's striped patterns are locked to the surface of the canvas, they are only arbitrarily contained by its edges. One thinks of Pollock's infinite, and the thought recurs whenever Stella clutters a work ingeniously enough to bewilder the eye. Like Pollock, Stella made allover images, but never with Pollock's muscular urgency. At first, he restrained his arm. The black paintings are the work of an ascetic, inventive but unrelentingly strict. Later, he permitted himself to make sensuous art, but only on the condition that he work at a remove from his impulses. Since the early seventies, Stella has been displacing the energies of hand and arm into the mastery of one advanced manufacturing technique after another.

Focusing as narrowly as he can on matters of form, he still insists that "what you see is what you see." Stella's aesthetic is militantly specialized, in principle. In practice, his idea of art is as boundless as Pollock's idea of nature. And the extravagance of his inventions has for years been suggesting nature's plenitude, as his forms and colors, combining and recombining, evolve and mutate according to rules that also come under evolutionary pressure, one season after the next. What you see is what you see, but what you sense is the force of a blind vitality.

32

As Robert Morris saw them, Jackson Pollock's drip paintings were almost perfectly inert. They did not swirl with air or light or muscular energy, or if they did, the effect was residual. Morris approved. Nearly overcoming the "duality of thing and allusion," the drip paintings hover at the verge of being no more nor less than the objects they literally are. With his slabs and columns and boxes, Morris led art across the literalist verge. To a world built from ambiguities and outright deceptions, a gray Morris box offers the utterly reliable truth of its boxiness. By the very candor of its presence, it illuminates the room—the larger box—containing it.

Having made his boxes and a case for their virtue, Morris felt that he had settled his relationship to Pollock. What the painter had promised, Morris had delivered. Then, in 1968, he rethought the lesson of Pollock. It wasn't about things, it was about their substance. With this revision, Morris directed a reproach at his boxes: they had attained unity at the price of a further "duality": a split between form and material; a cube "has no inherent relation" to the wood or metal that makes it palpable, for these materials are not by nature cubical. Always seeking the essence—or the look of it—Morris announced that materials should not be forced into geometric shapes. They need to seek shapes of their own; they must be free to become themselves, like the paints encrusting a Pollock canvas. Form must become "anti-form."

Having theorized this development, Morris wanted to administer it. He persuaded his dealer, Leo Castelli, to let nine young artists do what they liked with neon and canvas and wire in the Castelli Warehouse, a scruffy building on West 108th Street. Pollock had splashed paint and inspired critics to talk of risk. Richard Serra literalized that risk by heating lead to the boiling point and splashing it along the line where wall met floor. Elsewhere in the Castelli Warehouse, he spread metal filings into a low-lying heap. Tagged scatter pieces, anti-forms like these were a favorite alternative to Minimalist objects.

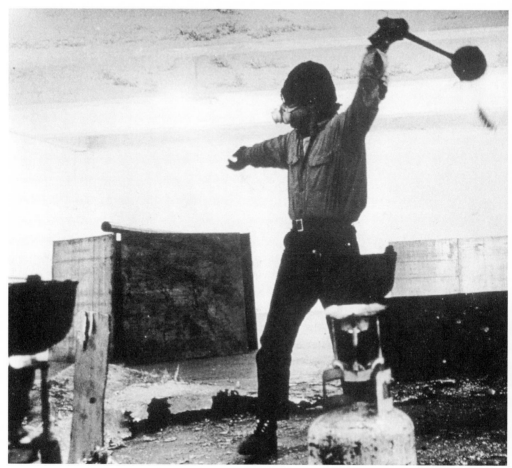

72. Richard Serra throwing molten lead, 1972. Photograph by Gianfranco Gorgoni

In 1966 Carl Andre had strewn a floor with small plastic blocks. At the museum of Cornell University, Morris made his own scatter piece: *Thread-waste* (1968), a floorful of garment-shop leavings.

Whatever its material—tangled thread or earth or scraps of felt—a scatter piece was to be seen as a drip painting relieved of its residual impulse to be a picture. From his doubts about the Minimalist object, Morris had arrived at a certainty: a random scattering of materials made a historically necessary advance on Pollock's slung paints. Other doubts about the object produced other assertions about necessity. Say that it is of the essence of the Minimalist box to be compact. If the box is dubious, its compactness is in question. It may be of the essence for an artwork not merely to spread like a scatter piece but to extend itself aggressively through space. At the Castelli Warehouse,

Bill Bollinger ran a length of chain-link fence from one wall to another; halfway across the room, a single twist in this new art material produced a graceful curve.

Another possibility arose from Morris's revisions. He had argued that it is of the essence for the art object to be not only compact but simply shaped, a strong gestalt. If goodness of this sort is in doubt, it follows that the artwork should be airy and complex—not a good gestalt, easily perceived, but an object that eludes the eye. Alan Saret demonstrated this logic with clouds of crumpled chicken wire. These springy, light-catching sculptures looked like Pollock's drip paintings in three dimensions. From the premise that any object of whatever shape is questionable, Robert Huot arrived at the refurbished room as a work of art. To make a piece called *Two Blue Walls* (*Pratt and Lambert #5020 Alkyd*), *Sanded Floor Coated with Polyurethane* (1969), he spruced up a corner of the Paula Cooper Gallery, then offered it as an exhibition in itself.

Vito Acconci had no quarrel with objects. Still, he doubted that the Minimalist box was the exemplary object, the possessor of absolute thingness. Against that claim, he asserted the thingness of his body. Lurking in his gallery, the Sonnabend, he would wait until a viewer had taken up a position before a work of art. Then, standing uncomfortably close to this unsuspecting person, he would impersonate an inanimate object. In *Following Piece* (1969), the body-object became ambulatory.

Every day for twenty-three days, Acconci stood on a New York street corner and chose someone to follow. Making no contact, he'd tag along until the person entered a private space. Once the exercise lasted for nine hours; another time, it was over in two minutes. We are to see nothing dramatic, nothing adventurous, in this conduct, only rules being followed with impersonal precision. Acconci later described the state he entered to execute *Following Piece*: "I am almost not an 'I' anymore. I put myself in the service of a scheme."

One night at Max's Kansas City in 1970, Acconci spent an hour rubbing his arm. Acconci the artist was handling Acconci the art object. During his next performance, he pressed the sharp edges of a bottle cap into his arm, leaving a series of deep indentations. The artist had inscribed his art object with a pattern. Another time he sat naked in a gallery—art objects do not wear clothes—and marked various parts of his body with his teeth. Artists leave personal imprints on their materials.

Carl Andre said that in planning a sculpture, "I think in terms of a physical reality, a direct physical hefting of matter." Suspending his sense of self, Acconci became the physical matter he hefted, relocated, marked. No one denied that he dehumanized himself. Yet those who were most in sympathy with Acconci's art felt no need to sympathize with him; rather, they felt the

need not to sympathize, for Acconci did not intend his behavior to be expressive. During all his performances, his face remained deader than deadpan. Presenting himself as an object with a certain form, he offered his boredom and pain as phenomena with forms of their own. In a piece called *Claim* (1971), physical pain modulated to anxiety. At the foot of a flight of basement stairs, Acconci sat blindfolded, brandishing lead pipes and threatening to stop anyone who tried to gain entry to the basement. A video monitor brought his voice and his image to viewers at the head of the stairway. With melodramatic flair, Acconci enacted the idea that we all guard with unrelenting vigilance our buffers of personal space.

He has said that, upon arriving in the art world from the world of the New York poets, he found himself in "a field that (as far as I and other members of my generation saw it) had no life of its own, no prescriptions of its own, no inherent characteristics of its own, a field that existed only as it imported from other fields in the world." Acconci's earliest works displaced Minimalist traits from objects to his body. Works like *Claim* brought the concepts of behavioral psychology from the clinic to the world of art.

With *Space Completion Ideas* (1969), a whimsical variation on an intelligence test, Donald Burgy cast himself as a cognitive psychologist and the viewer as his subject. The graph-paper chart Agnes Denes drew up in 1970—*Dialectic Triangulation: A Visual Philosophy into Symbolic Logic*—claims a place for her among the philosophical descendants of Alfred North Whitehead and Bertrand Russell. Other artists imported bits of linguistic philosophy or math. They mimicked scientists and technicians, sociologists and demographers.

In 1969 an artist named Hans Haacke presented visitors to the Milwaukee Art Center with a questionnaire which ranged from family matters—"What is your marital status?"—to politics—"Assuming that you were Indochinese, would you sympathize with the Saigon regime?" Responses were tabulated from time to time and posted in the art center's galleries. At the Museum of Modern Art's Information show, Haacke posed another question: "Would the fact that Governor Rockefeller has not denounced President Nixon's Indochina policy be a reason for you not to vote for him in December?" Again, poll results were periodically posted, though no record of them remains.

One January day in 1970, Peter Hutchinson threw 450 pounds of bread into the Paricutín volcano, south of Guadalajara. He hoped the bread would grow a forest of mold and thus "juxtapose a microorganism against a macrocosmic landscape." It did. This contrast of very small and very large was answered by the contrast between the very old landscape of the Mexican plateau and the very new—molten—landscape still bubbling in the pit of Paricutín. Hutchinson's volcano piece cast him as an antic combination of geographer and historian.

The previous year, Robert Barry had impersonated a science teacher, the kind that likes to show his students the principles of physics in action. Releasing a vial of argon at the ocean front in Santa Monica, he let the gas go "from measured volume to indefinite expansion," as he said, in the language of textbooks. The argon was invisible in its vial, so its dispersion had to be taken on faith. "It continues to expand forever, constantly changing," said Barry, "and it does all of this without anybody being able to see it." In this notional infinite is a memory of Pollock's dripped imagery, which is, in principle, unbounded.

Another link joins Pollock to Barry and to all the artists who spent the late sixties and early seventies inventing alternatives to the Minimalist box. To advance beyond this totemic object, each adapted for idiosyncratic use a corollary of Morris's anti-form theory, which defines Pollock as a painter only slightly interested in painting. His larger interest, said Morris, was in an "investigation of means: tools, methods of making, nature of material." To advance was to position oneself as a successor to Pollock the empiricist. It became common to talk of art as an "investigative activity." The Minimalists had presented the simple facts of simple forms. The successors presented complex facts of whatever sort seemed interesting. The art world became a stage where artists played parts ranging from Burgy's psychologist to Acconci's psychopath waving a lead pipe in a downtown basement.

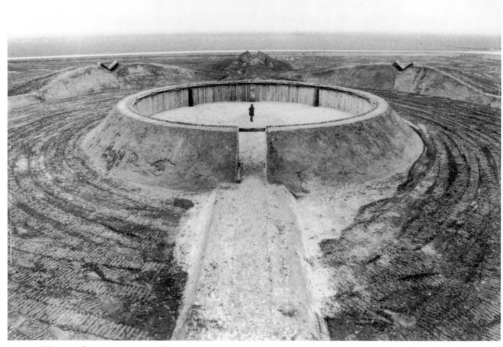

73. Robert Morris, *Observatory*, 1971–77. Earth, wood, granite, steel, and water, 298 ft. 7 in. diameter.

33

Early in April 1970, Robert Morris installed an immense jumble of timbers and concrete blocks on the third floor of the Whitney Museum. At the end of the month, President Nixon announced in a nationwide broadcast that the United States had invaded Cambodia; moreover, he said, resistance to the American presence in Vietnam required him to draft an additional 150,000 soldiers into the armed forces. College students launched protests on campuses across the country. When protesters set fire to the ROTC building at Kent State University in Ohio, the National Guard was called in. On May 4, a detachment of guardsmen fired on a crowd, killing four and wounding nine. Like many others, Morris saw in this murderous incident an allegory of the nation's quickening decline.

His first response was to insist that the Whitney close his exhibition three weeks early. The press learned of this demand when the museum did. Next, Morris informed the trustees of the Whitney that the three suddenly empty weeks in the museum's schedule must be filled by war protests. Also, the trustees were to join with their counterparts at other institutions in seeking to make their programs and policies less oppressive to artists and their audiences. If these instructions were not followed, Morris warned, the world would learn that the Whitney trustees condoned repression in all its forms, including militarism. Though the museum closed Morris's show as directed, his other demands were dismissed.

On May 18, 1970, a day after the Morris exhibition ended, fifteen hundred members of the art world met at the Loeb Student Center of New York University to plan demonstrations against the war. Morris, Carl Andre, and others addressed the crowd. Nominations for chairperson were made. The vote went to Morris and a young artist named Poppy Johnson. Under their guidance, it was resolved that ten percent of all monies paid for works of art would go into a fund for promoting peace; artists occupying galleries and

museums would "politicize" visitors; and on the coming Friday, May 22, artists opposed to the war would go on strike, demanding that museums and galleries close for the day. Klauss Kertess, of the Bykert Gallery, announced that he and other dealers would allow information about the peace movement to be distributed on their premises.

That Friday, the Whitney and the Jewish Museum kept their doors closed. The Guggenheim and the Modern waived their admission fees. Only the Metropolitan tried to ignore the artists' strike, and so it was to the Met that Morris led a contingent of demonstrators. A line of policemen blocked their entry. As a standoff developed, a crowd of would-be visitors formed. The artists distributed broadsides listing their demands. The Metropolitan's administrators issued a counterbroadside stating that, despite their sympathy with the protesters' wish for peace, they thought it best to let art be seen and "work its salutary effect on the minds and spirits of all of us." A few members of the museum's staff joined in the protest. By midafternoon, some of the original protesters had wandered away. The rest split into incompatible factions. Thoroughly inconclusive, the artists' strike against art museums was never repeated, and Morris's career as a political leader was over.

In 1971 he reappeared on the coastal flats of Holland as the boss of a crew at work on a large outdoor structure called *Observatory*. Its high wall of timber, earth, and stone curved into a circle two hundred thirty-three feet in diameter. Slots in the wall established sightlines to sunrise at the two solstices, summer and winter, and to sunrise and sunset at the equinoxes. *Observatory* was a Minimalist sculpture enlarged and aligned to the solar system. A year later, Morris was back in New York making graphite-on-paper rubbings of surfaces in his studio—sections of woodwork, a patch of wall, and the like.

Rubbing is a kind of "automation," he had written in 1970. Find the right method, and "the work makes itself" because "the artist has stepped aside for more of the world to enter into the art." That, said Morris, is what Pollock had done when he flung his paints; letting their viscosity and gravity determine the image, he, too, automated the process of making art. Morris's Pollock is not a hero of willfulness who disperses himself throughout an infinite of his own devising. Instead, he abases his will before the will of his material, and this abasement is what makes him heroic. As Morris rubbed his paper, he could watch the image appear without having to shape it. He made his next set of works—the *Blind Time Drawings* (1973)—by closing his eyes and smearing powdered graphite onto paper with his fingers. Usually, drawing is a collaboration between vision and touch. Here, touch did all the work. And in the blind turns of the labyrinth Morris built in 1974, the viewer had the opportunity to put touch in vision's place.

For that year's show at the Castelli Gallery, Morris installed a work named *Voice*. From behind four blank screens, eight loudspeakers broadcast an array

of speaking voices to listeners seated on boxes covered with white felt. Sculpture had become furniture, and the artist's prose was now wave after overlapping wave of only occasionally intelligible sound. The poster for this show pictures Morris from the waist up, naked and bearded. He wears dark aviator glasses and a Nazi helmet. His muscles are flexed and glistening; manacles bind his wrists; chains fall from the manacles. It is a portrait of the artist as an S&M pinup. With this image, Morris confessed to a previously unacknowledged impulse in Minimalist art.

Seeking a perfect fit between idea and object, a Minimalist tries to exert control in two realms, the conceptual and the physical. The more nearly absolute his control, the better his work. Innocently, we might assume that a Minimalist's absolutism affects only him and his art. Morris's portrait of himself in Nazi headgear suggests that we widen our view. A Minimalist wants to bring the audience under control as well by presenting it with objects that permit only one legitimate response. To be a proper member of Minimalism's audience, one must submit one's perceptions, one's bodily sense, one's idea of aesthetic legitimacy to the dictates of the artist. Giving in utterly, one becomes a gallery-going equivalent to a masochist in the hands of a sadist. With his manacles, Morris argued that the sadist, too, is imprisoned by domination's rituals.

The poster for Robert Morris's *Voice* appeared in April 1974. In November, *Artforum* published a color photograph of the sculptor Lynda Benglis in the nude. Her skin looks well tanned and liberally oiled. Slim yet decidedly feminine, she has assumed a hip-slung pose with back arched—a sexy contrapposto. Her hair is short and slicked back. On her lips a pout is becoming a sneer, and there is a hint of Lolita in the white-rimmed sunglasses that hide her eyes. From Benglis's crotch extends a long and meticulously detailed dildo, held in place with her right hand.

This picture appeared in the front of the issue, as an advertisement for the artist's show at the Paula Cooper Gallery. Farther along was an essay on Benglis by Robert Pincus-Witten, then an associate editor of *Artforum*. The following month, the other associate editors—Lawrence Alloway, Max Kozloff, Rosalind Krauss, Joseph Masheck, Annette Michelson—published a letter to the editor in chief, John Coplans, to let the art world know how deeply they had been offended by the "extreme vulgarity" of Benglis's picture.

It "made a shabby mockery" of "the movement for women's liberation," they said. They called it an effort of "self-promotion . . . in the most debased sense of the term," thus an "exploitation" of the art-world audience and larger public. Noting that one must always be on guard against "complicity" with the marketplace, the editors declared that vigilance would have done no good in this instance. Behind their backs, others at *Artforum* had made a shameful

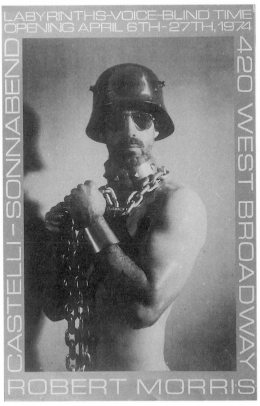

74. Robert Morris, *Untitled*, 1974.
Poster for an exhibition entitled Voice.
Offset lithograph on paper, 36¾ ×
23⅞ in.

deal to publish a completely unacceptable photograph. Though the error was
not their fault, the editors felt obliged to renounce it and to assure their
readers that in future they would bring "critical analysis" to bear on the
conditions that allowed this outrage to occur.

Benglis's picture would unsettle anyone not fixated on precisely this mix
of sexual attributes: gorgeously female body, boyish haircut, super-masculine
phallus. The editors' displeasure arrived on schedule, as expected. Still, it was
a mild shock to see how determined they were to feel nothing but displeasure,
disgust, indignation. A few months later, Robert Rosenblum wrote to *Art-
forum* with a proposal: "Let's give three dildos and a Pandora's Box to Ms.
Lynda Benglis, who finally brought out of the closet the Sons and Daughters
of the Founding Fathers of the Artforum Committee on Public Decency and
Ladies' Etiquette. Too bad they weren't around to protest when Dada and
Surrealism let those arty people run amok and do all those unspeakably
vulgar things."

Many besides Rosenblum believed that the *Artforum* editors had taken a
run at Benglis, theoretical lances at the ready, and completely—hilariously—
missed her. Their aim might have been better if they had listened to the bits

75. Lynda Benglis, advertisement in *Artforum*, November 1974.

of the artist's conversation that pop up in Pincus-Witten's article. Art in New York, says Benglis, is "all about territory," so there is only one pertinent question: "How big?" How big is the zone you capture and occupy with your painting, your floor sculpture, your video piece, your public persona? How powerful is the image that establishes your presence?

To the perennial question How big?, Benglis's dildo gave a literal response: This big. Ironic in her literalism, she mocked the bigness she flaunted. Eyes bulging with horror, *Artforum*'s editors saw the bigness but missed the mockery. Eyes averted, they gave a censorious recital of proper thoughts about feminism, the market, and the standards of decorum that are supposed to keep self-promotion under control.

The charges against Benglis did no damage to her already successful career. The advertisement in *Artforum* was self-promotional, yes, and crass, of course. It was shamelessly vulgar. Nonetheless, it was not merely crass, not merely vulgar. But no one could say exactly why not. The dazzle and the bizarre innocence of her picture teased earnest thought into doubts about its prowess. Benglis flourished in a shimmer of misconceptions. Seen now, her self-portrait with dildo gives her the look of an idol, the limber kind that joins contraries into happy unions. She is male and female, grotesque and comely, enraged and seductive, an aesthete and a political agitator. The art world couldn't make much sense of an image that reached across so many categories, and certain details were too obscure to be grasped.

76. Lynda Benglis, *Totem*, 1971. Pigmented polyurethane foam, overall dimensions: 15 × 50 × 25 ft.

Only recently did Benglis explain what she meant by the sunglasses with cat's-eye frames that she wears in the *Artforum* photograph. "They were supposed to refer to Martha Mitchell," she says, referring to the wife of Richard Nixon's attorney general, John Mitchell. "In 1974 everything about Watergate was coming out, and Martha was doing a lot of the talking. They couldn't shut her up, so she became sort of a role model for me." Benglis wanted to uncover awkward truths.

As she saw it, American art in the seventies was still a "heroic, macho, sexist game." Was Benglis willing to play? Her gargantuan dildo answered that question and others too. How much respect did she feel for the New York art world's ideal of calm gray decorum? Not much. Was she fully committed to abstract form? It seemed not. Mainly, her dildo gave a measure of her ambition. If American art was a "macho, sexist game," she would play it aggressively. Spreading latex on the floor in uncontained pools, she impersonated the pissing, ejaculating Jackson Pollock of legend. Thickening her

material, dying it with Day-Glo colors, she made big layered sculptures that looked like heaps of shiny dung left on gallery floors by cartoon creatures. She was messing about with sticky stuff, as children do in the first years of their lives, before gender is fully settled. Macho games became infantile fun.

Next she built armatures out from the gallery wall and covered them with massive slatherings of polyurethane foam. Solidifying as it slid toward the floor, the foam assumed shapes that whispered of bat wings, Spanish moss dripping from branches, and slithery reptilian creatures. These sculptures gave Benglis the feeling that "they were looking back at me." And they reached into the room wildly, as if the artist's flung color had evolved the power to fling itself at her, and at us. The wall pieces were like predators frozen in midleap and waiting, still alive, to complete their trajectories.

Gesturing, Benglis had conjured up responses to her own gestures. A circle had been closed and she saw no point in retracing it. She needed to "find a new form," she says. "I didn't know how to go about it. When I experimented in the studio, I had no idea of what I was doing." She pinned bunting to a wall in various patterns. She painted it. No satisfactory results appeared. Nearby stood a cluster of African sculptures. Tall and thin, they suggested that she roll her wide strips of bunting into long tubes. She did, giving the tubes skeletal support with rolls of window screening. After knotting the tubes, she dusted the knots with sparkles, painted them with brushes, sprayed them with metallic pigments. These sculptures are like torsos elongated until they have the flexibility of arms and legs.

Benglis rolled, pleated, and knotted cotton fabric, chicken wire, and sheet metal. Encrusted in plaster or cast in bronze, her sculptures resemble pieces of clothing shed in a hurry. The curviest ones evoke corsets, though they look less like devices for shaping the body than images of the body shaped by the artist's desires—and her sense of her desirability. Intricately wrought, glistening with luxurious patinas, Benglis's bronzes are hyperresponsive to the light. They seem watchful and ravenously receptive, or somnolent, as if lost in their own voluptuous involutions. The sober objects of the Minimalists deny their own appeal, and this denial is what makes them appealing to a certain taste. Casual about proprieties, Benglis shapes objects that grab our attention and hold it caressingly. This frankness about the wish to seduce is what makes it difficult for the art world to be entirely at ease with her. Benglis's reputation has been erratic, yet over the seasons she has become a fixture in standard accounts of her generation.

Mocking male aggression, cavorting at the borders of taste, denouncing the boom of the eighties as empty manipulation, Benglis is audacious. Always, though, her audacity is well considered. She would never have published her self-portrait with dildo if a precedent for it had not been set by Morris's portrait of himself in helmet and chains, master of the gamut running from

dominance to submission. Soon after that image appeared, he executed a series of twelve drawings that diagram in crisp black and white *The Realm of the Carceral* (1978), a zone where forms themselves enforce absolute control over perception and behavior.

The coercive architecture of Morris's "Realm" evolved from the paintings of Morris's Pollock, a literalist whose art permits only one correct reading. Benglis's Pollock is playful, a supplier of liberating precedents, and her self-portrait defined her as a generous being of extravagantly versatile sexuality —ready for anything, even a confrontation with the rigid, territorial male implied by so much New York art. Benglis never dismissed her opposition. Instead, she gave its premises new birth. What had been hopelessly macho was now female—shamelessly, and unashamedly, too.

34

Benglis had asked, How big? This question nagged all the artists struggling to insert themselves in the tradition that began with the immensities of Pollock, Newman, and Still. The usual answer was: The bigger the better. When Robert Barry liberated a vial of argon on the shore of the Pacific Ocean, he invited the imagination to follow its dispersion through the world's atmosphere. This work was as big as all outdoors, literally. In 1969 Robert Morris proposed that heaters and air conditioners, the largest available, be buried here and there in a square mile of undeveloped land. "One could wander around," he said, "and come upon these local changes in temperature—a cold wind blowing out of an otherwise still tree or stones radiating heat." Had the project been funded, weather stirred up in a rural neighborhood would have flowed into regional currents and onward, to join continental and eventually global patterns. And Morris had meshed the structure of his *Observatory* with the motions of the solar system.

The example of Pollock and his generation dictated grandiosity. The moment recommended modesty. With America laying waste to Vietnam, the artist of good conscience would of course be reluctant to send metal monuments soaring into the air. Carl Andre was the first to gauge the moral credit that would accrue to a male sculptor who deployed horizontal form. For a show called Primary Structures at the Jewish Museum, Andre stretched a line of 137 bricks across the floor. Quizzed by David Bourdon, the artist explained that he was "putting Brancusi's *Endless Column* on the ground instead of in the sky. Most sculpture is priapic with the male organ in the air. In my work, Priapus is down on the floor. The engaged position is to run along the earth." In 1968 Andre placed 183 bales of hay end to end on the campus of Windham College in Vermont; for him, sculpture must crouch and scamper, or burrow into the ground.

Dennis Oppenheim said that, as the sixties ended, "I found myself trying

to get below ground level. Because I wasn't very excited about objects which protrude from the ground. I felt this implied an embellishment of external space . . . an unnecessary addition to what could be a sufficient space in itself. My transition to earth materials took place in Oakland a few summers ago, when I cut a wedge from the side of a mountain. I was more concerned with the negative process of excavating that shape from the mountainside than with making an earthwork as such." Oppenheim had induced the art object to vanish, leaving only a place—an art place.

Consulting a map of North America, he noticed that a long stretch of the Saint John River has two chores: to separate Maine from Quebec and to mark the international date line. In the winter of 1968, he incised three miles of this double boundary in the frozen surface of the river. During the warm months of the late sixties and early seventies, he planted grain in furrows that followed the topographical contours drawn by map makers. Moving over the earth, the work of art measures it off; and the work claims what it measures, adding it to the realm of the aesthetic.

In Nevada, Michael Heizer scarred the desert floor with a motorcycle. His tracks were drawings, he said. The desert had become an outsize sheet of heavily textured paper. With earth-moving equipment, he made drawings of another sort—shallow trenches over a hundred feet long. Shoveling heaps of dirt from the back of a moving truck, he produced scatter pieces. "The museums and collections are stuffed," he said in 1969. "The floors are sagging, but the real space exists." According to Heizer, Pollock's example required artists to reject the art world. The drip paintings are "environmental," Heizer says. "They imply a continuum. The only way to work with that implication was to get outside the centralized, rigidified structures of art."

Heizer's *Double Negative* (1969–70) is a pair of notches cut into the edge of a plateau that curves through the southern tip of Nevada. Each notch is fifty feet deep and thirty feet wide, and they face each other, in precise alignment, across an immense gap. Imagine a beam more than fifteen hundred feet long, fifty by thirty feet in cross section. This object would fit snugly into the notches of *Double Negative*. Even if it could be fabricated, it would not, of course, fit inside a gallery. It could never become a commodity. In the desert, Heizer found an America untouched by commerce. That innocence made it seem real.

Among Heizer's relatives are geologists who passed along to him their understanding of the bureaucracies that grant leases to uninhabited land in the western states. In 1968 he helped Walter De Maria find a site in the Mojave Desert for an outdoor piece: two lines of chalk running parallel for a mile. A year later, De Maria directed a bulldozer to scrape four half-mile-long lines in the floor of a valley in Nevada. The lines formed a square oriented to the points of the compass.

For most sculptors, the foot is the basic unit of measurement. Oppenheim, Heizer, and De Maria liked to think in miles. Because they are all New York artists quick to claim descent from Pollock and his generation, their works cannot be described merely as large. These artists took Pollock's expansive impulse as their premise and exaggerated it past the point where any scale of measurement applies. Oppenheim's outdoor works melted away in the spring or washed away in the late summer rains. Some of De Maria's and Heizer's were more permanent, like scars left by wounds. Yet those scars are nearly invisible now, a quarter of a century after they were made. Earthworks tend to dissolve into the earth. Often, the only remnant of the earthworker's effort is the idea that drove him over the ground in what Andre called "the engaged position."

Since 1972 Heizer has lived in the Nevada desert, three hours north of Las Vegas, on the site of a four-part work in progress called *City*. The first part, *Complex One*, was finished in 1976. Built of earth, rock, and metal beams, it is one hundred forty feet long and nearly twenty-four feet high. Though he describes its trapezoidal shape as an echo of ancient monuments in the Old World and the New, he does not object vehemently if it is compared to a Minimalist sculpture. On site, says the artist,

> You realize that the work is a place that has been made out of a place, an extremely large one. Size is the issue. In European art, which is basically decorative, there is scale. American art is always working beyond scale to size. In *Complex One* there is none of the relationship, the ratio of object to setting, that produces scale. It is the size it is. This is what makes it real, makes it modern, makes it pure.

Complex Two, an immense wedge of earth and rock, is still under construction. When the other two parts of *City* are finished, the work will occupy sixteen acres. Occasionally, Heizer scales his work down to the space of a gallery. With his New York exhibitions, he confronts the art world with new sculptures—craggy demonstrations showing that even if art must accommodate itself to an urban interior now and then, it is under no obligation to feel comfortable there.

De Maria's presence in the city has been steadier and ghostlier. Though one hardly ever sees him, his *Broken Kilometer* (1979) has been on view since 1979 at 393 West Broadway, one of several premises the Dia Center for the Arts maintains in New York for the display of major works in its collection. Within, an even flow of light reveals immaculately chromed metal rods lying on the polyurethaned floor in five long rows. Laid end to end, these rods would measure off a kilometer. In the depths of this space, which viewers are not permitted to enter, the kilometer's fragments blur and become un-

countable. The idea of a kilometer, of measurement itself, becomes vague. De Maria's one-mile lines of chalk could have gone on for many more miles. Broken, his kilometer at least alludes to the infinite, and the allusion gains strength from the shrinelike calm of 393 West Broadway.

Like Heizer, De Maria has an occasional gallery exhibition in New York. His metal objects are shiny and slim, and even the most blandly Minimalist ones look faintly sinister to those who remember his show at the Dwan Gallery in 1969. To enter this exhibition, one had to sign a form releasing Dwan from all liability for personal injury. Inside lay five slabs of stainless steel, each about six and a half feet long by three and a half feet wide—a good size for an ascetic's bed. From the first slab rose three ten-inch spikes, needle-sharp and evenly spaced. Fifteen spikes rose from the second slab, increasingly more from the third and the fourth, and the fifth bristled with spikes, like a geometric and extremely angry hedgehog. Richard Serra's splashed lead had made literal the notion that radical art puts the artist at risk. With his *Beds of Spikes* (1968–69), De Maria literalized the corollary: radical art poses a risk to the viewer as well.

77. Walter De Maria, *The Broken Kilometer*, 1979. 500 brass rods, each 6 ft. 6 in. in length; overall dimensions: 125 × 45 ft.

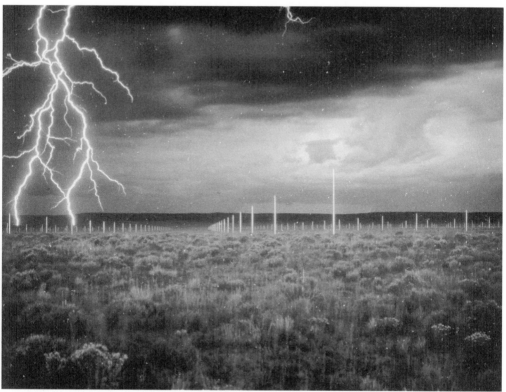

78. Walter De Maria, *The Lightning Field*, 1977. 400 stainless-steel poles, average height: 20 ft. 7½ in.; overall dimensions: 5,280 × 3,300 ft.

In 1974 De Maria began the project of enlarging the fifth *Bed of Spikes* to an outdoor piece. The spikes were to become poles tall enough to draw lightning from the sky. First he planted thirty-five of them in the desert near Flagstaff, Arizona. Three years later, four hundred poles spread in a gridded pattern across a stretch of western New Mexico, not far from the Arizona line. They stand in a valley that looks flat from a distance but isn't. To bring their tips into an even plane, the poles vary in height from fifteen to twenty-six feet. The work is called *The Lightning Field* (1974–77).

Stabbed into the ground, the four hundred gigantic spikes also stab the sky. Here, one might say, are four hundred phallic forms in rigid formation. Yet the entire pattern, a mile long by a kilometer wide and only about twenty feet high, lies as low in the desert as an Andre piece on a gallery floor. The gigantic spikes are puny against the afternoon sky. Photographs usually show the work at night, with a lightning bolt and its tributaries, a riverine flow of white fire, reaching down from the zenith to the pattern of poles. These

images bring Pollock's drip paintings to mind: what the painter did with his arm, the earth artist does with massive systems of violent weather.

In his notes, De Maria points out that "the observed ratio of lightning storms which pass over the sculpture has been approximately 3 per 30 days during the lightning season," which lasts from May to September. Fireworks are rare. "Light," says De Maria, "is as important as lightning." He expects visitors to stay for at least twenty-four hours, to watch the poles catch the angled light of dawn, disappear in the glare of day, then reappear at sunset. Each pole stands two hundred twenty feet from the next. To walk into *The Lightning Field* is to see it vanish. Aggrandized by De Maria, Minimalism lost its command of literal fact. His notes remark on the reality of the invisible.

Heizer talked of the "peaceful, religious space" of the West. Robert Smithson, the other pioneer earthworker, had his own brand of spirituality—melodramatic, morbid, and always mindful of art-world precedent. He built *Spiral Jetty* (1970) on the shore of the Great Salt Lake in Utah. In an essay on the labor of making a film about the piece, Smithson wrote that his "sight was saturated by the color of red algae circulating in the heart of the lake, pumping into ruby currents, no, they were veins and arteries sucking up the obscure sediments. My eyes became combustion chambers, churning orbs of blood blazing by the light of the sun. All was enveloped in a flaming chromosphere; I thought of Jackson Pollock's *Eyes in the Heat*."

35

Robert Smithson was born in Passaic, New Jersey, in 1938. During his first ten years, he lived in Rutherford, then moved with his family to Clifton. These are suburban towns in a bleak, shapeless zone which left Smithson with the conviction that traditional sentiments about the American land are "rinky-dink . . . Mickey Mouse. . . . People of my generation have grown up in the industrial blight, and it's not like rustic woodland that we remember." There were, nonetheless, picturesque vistas and sublime panoramas to visit.

When Smithson was still in grade school, he would plot the family's vacation trips. One took them west on the Pennsylvania turnpike, up to the Black Hills and Badlands of the Dakotas, on to Yellowstone National Park, across to the redwood forests of northern California, down the Pacific coast, and back to the Grand Canyon. As Smithson said much later, "It made a big impression on me. I used to give these little post card shows. . . . I'd set up a little booth and cut a hole in it and . . . show all the kids all these post cards."

After the family moved to Clifton, Robert's father built him an array of shelves and cages in the basement of their new house. Smithson called it his museum. A snapshot shows a cowboy boot and a miniature tepee standing side by side. On the wall nearby, he tacked a school pennant. His museum's main attractions were fossils, shells, and live reptiles. In high school, he decided to become a naturalist. Manhattan first attracted him with its American Museum of Natural History on Central Park West. He admired the museum's paintings of the earth in the days of the dinosaurs, and it occurred to him also that he might make a living as an illustrator. Smithson was good at drawing.

In 1955 he applied for and won a scholarship to the Art Students League. He was by now a junior at Clifton High School, bored with classwork and at odds with his art teacher. The principal at Clifton arranged for Smithson

to spend afternoons at the League. His subjects included cartooning, life drawing, and painting. Through classmates, he got to know students at the High School of Music and Art. He met Richard Bellamy, the director of the Hansa Gallery, and others with links to the New York art world. Soon Smithson had conceived a grand ambition: he would be an artist, not an illustrator, and he would not limit himself to visual images. Many avant-garde painters had been serious writers, he discovered. He, too, would write.

In the late fifties, Smithson moved to New York and learned the art-world rounds. Like Leo Castelli and Thomas B. Hess, he saw Jasper Johns's *Green Target* at the Jewish Museum in 1957. He knew of Rauschenberg's combines and Allan Kaprow's Happenings. Not fully settled in the city, he often went with a friend on long hitchhiking trips through the Southwest. A jaunt to Mexico led to a few days in jail for vagrancy. To support himself in Manhattan, he worked in a bookstore; he taught art at the Police Athletic League. Moving from apartment to loft to apartment, Smithson produced art at high volume.

Certain of his early paintings look like glib illustrations of themes that had obsessed him since his first visits to the American Museum of Natural History: time, death, sexuality, damnation, the state of being monstrous. In Smithson's iconography, the museum's dinosaurs stood for all that and more. As a teenager in art class, Smithson had displayed a graceful touch with a pencil. Now he was bearing down on the canvas with an awkward, over-loaded brush. Big topics collided with homages to major figures in the history of New York art. *Purgatory* (1959) shows creatures reminiscent of Pollock's *She-Wolf* entangled with vertical stripes that Smithson later said he borrowed from Barnett Newman. Unable to get a good fit between style and his ponderous, interlocked subjects, Smithson wandered through widely separated realms of reading matter. He would leap from Ad Reinhardt's satires on the art world, which he saw in *Artnews*, to books on dinosaurs to the *nouveau roman* of Michel Butor.

The art critic Bill Berkson remembers Smithson at the Cedar bar in the early sixties. "He had the look of a brooder," says Berkson. "Always alone, never talking to anyone." Smithson was in his early twenties then, not yet firmly connected to the art scene. He became a talker at Max's Kansas City, where he had the stature of a star, though not a brightly shimmering one. Smithson was tall and somewhat gangling, with large features in a face that seemed at once wide and compressed from above, narrowing his forehead and forcing his eyebrows into a scowl. When he wasn't talking, his lips were set in a tense line. The grain of his being was morose.

Setting aside his brushes, he took up a fine-tipped pen to draw floating, muscular figures with two sets of ancestors: the superheroes of action comic books and the gods of William Blake's invented theology. Smithson had no

reluctance to put low commercial art on a par with the illuminated poems of Blake. After all, his other favorite poet, T. S. Eliot, had mixed any number of modes and manners in *The Waste Land* (1922). Smithson liked clashes of style, disparities of tone, any mismatch that interrupts the smooth flow of imagery and leaves doubt in its wake. He was arriving at the suspicion that there were no truths, only fictions lively enough to feel compelling. He found these everywhere, in high art and lowly genres of the novel, in major poetry and in the Hollywood movies he watched in the second-run theaters of Forty-second Street with an artist named Nancy Holt.

In 1963 Smithson and Holt married and moved into an apartment on Greenwich Avenue in the West Village. By Smithson's reckoning, the next year marks the start of his career as a mature artist. He had found a way to induce a work of art to inspire doubt instead of trust. *The Eliminator* (1964) suspends four zigzag tubes of red neon between two sheets of mirrored glass. The reflections of the neon are as vivid as the neon itself; or the neon looks as insubstantial as its reflection. This is a sculpture engaged in a kind of picturing. Or is it a picture dependent on a sculptural element? It is not clear what is what or why, and as *The Eliminator* flashes on and off at irregular intervals, you feel a slight chronometric disruption. As Smithson said, "*The Eliminator* is a clock that doesn't keep time, but loses it."

In his next sculptures, mirrors mirror mirrors, and the eye is of course confounded. Though the dazzle of these objects gives them the slightly seedy air of a magician's sleight of hand, their designs originated in sober facts about the structure of crystals—bits of science Smithson gathered from his reading. The growth of a crystal follows no familiar, organic rhythms. Its form is geometric but not haunted by Euclid or the canons of correct proportion. Ruminating on crystals, Smithson felt himself breaking free of history—art history, in particular—yet his freedom did not alienate him from the art world. He found that his preoccupation with angular form gave him affinities with the Minimalists.

In 1965 he met them all: Donald Judd, Sol LeWitt, Carl Andre, Robert Morris, Dan Flavin. Before the year had ended, they were his friends. But he was not one of them. The Minimalists offered their objects as unimpeachable embodiments of a clear idea: box, grid, pillar. Smithson was too skeptical to believe in a perfect fit between a name and the thing it names. Yet the Minimalists' friendship had tactical value. He needed to find a way of praising their art. Also, he had to condemn it, for he was always true to his doubts. Smithson's solution to this dilemma was wonderfully duplicitous and brave, for he presented it openly in an essay called "Entropy and the New Monuments" (1966).

The Minimalists, he explained, were devotees of "mistakes and dead-ends" who fully intended the "vapidity and dullness" of their art. Repetitive without

purpose, these artists have affinities with the forces that produced "slurbs, urban sprawl, and the infinite number of housing developments of the post-war boom." Minimalist objects "are not built for the ages, but rather against the ages," he wrote. "Instead of causing us to remember the past like the old monuments, the new monuments seem to cause us to forget the future." Thus they come to rest, inertly, in Smithson's grim present. He had commandeered Minimalism as decor for his mood. And he borrowed Minimalist geometry to make *Plunge*, the ten-part metal sculpture he showed at the Dwan Gallery in 1966.

The ten units stand in an orderly row. Angular, stepped, and identical in shape, they range in height from fourteen and a half to nineteen inches. This work disconcerts by playing a double game, at once supporting and undermining the habits of the eye. From each of the sculpture's ten parts one takes a firm sense of its volume and proportion. The eye is reassured. Uneasiness sets in with a scan of the series, for simplicity does not govern the relations between the sculpture's parts. Their sizes vary at the bidding of equations using squared factors, with results that run counter to the eye's expectations. From one angle, the elements of *Plunge* seem to zoom into the distance too quickly—thus the title of the piece. Reverse the viewpoint and *Plunge* no longer plunges. It appears to back up against space, as if the usual effects of perspective have been stalled.

With *Plunge* and the three *Alogon* pieces he made in 1966, Smithson argued that Minimalist form need not establish a clear and untroubled relation between objects and ideas. Encouraging geometry's secret aptitude for obscurity, his art takes the audience to zones where systems fail to make the sense they promise, and eventually fail even to make promises. Smithson gloated over those failures.

His 1969 show at the Dwan Gallery featured *Nonsites*, bins filled with material collected in the places mapped by the documents he mounted on the gallery walls. The thirty-one steel compartments of *A Nonsite, Pine Barrens, New Jersey* (1968) contained sand from the wide patch of terrain represented by the six-sided map accompanying the piece. As the artist noted in a wall label, "Tours between the *Nonsite* and the *site* are possible." Though few made these treks, the *Nonsites* made their point: the walls of a gallery may enclose the body of an artwork, but its mind wanders at large.

On a trip to Sanibel, an island off the west coast of Florida, Smithson placed a row of eleven mirrors at water's edge. Facing out to sea, addressing themselves to immensities of water and light, they formed no link with the enclosed spaces of the art world. The artist's name for works like these was "mirror displacements." As memory can charge the present with the past, so a sheet of reflective glass can capture fragments of sky and landscape and disrupt the even flow of space. From disruptions like these come ambiguities

of vision and thought, puzzles of the kind that the Minimalists tried to prevent. If audiences were to be persuaded for even a few seasons that the Minimalist object had attained clarity, it had to stay safely indoors, enclosed by an interior that seconded its geometries. Impatient with the yearning for order, Smithson had taken art outdoors, to landscapes as disorderly as he could find.

In September 1969, *Artforum* published "Incidents of Mirror-Travel in the Yucatán," his account of a trip to that jungly region of Mexico. At nine sites discovered in his wanderings through the Yucatán peninsula, he placed a set of mirrors on the ground or amid the branches of a tree. At Palenque he notes that "writing about mirrors brings one into a groundless jungle where words buzz incessantly instead of insects." In the terrain traversed by "mirror-travel," language and world collude, yielding details that are both linguistic and not, and every hybrid nuance of the scene is afflicted by entropy, the decay of the particular that inclines all things toward sameness.

To execute *Asphalt Rundown* (1969), his first earthwork, Smithson had a truckload of asphalt dumped over an eroded cliff in an old gravel quarry near Rome, Italy. On the campus of Kent State University he directed a backhoe operator to pile earth on an abandoned shed until its roof beam cracked. In 1970 he built his best-known work, *Spiral Jetty*, a ramp of mud and rocks that reaches fifteen hundred feet along the surface of the Great Salt Lake, turning in on itself as it goes. This massive form disappeared beneath the rising waters of the lake in 1972. Distressed, Smithson devised plans to build the jetty higher in case the lake did not recede. It didn't. In 1973 he was killed in the crash of a small plane he had hired for an aerial inspection of the scrubland staked out for his fifth earthwork, *Amarillo Ramp*. The crash also killed the pilot and a photographer. Smithson was thirty-five years old.

Spiral Jetty is still submerged. Smithson intended it to vanish slowly, not in a season or two, for it was to celebrate entropy, not be its easy victim. Though he mocked the hope of monumental permanence, the solidity of his earthworks and his attempts to preserve them suggest that he felt this hope as strongly as other artists do. An earthwork is an emblem of the earthworker's will, and the will does not seek its own demise. Proud of his place on the New York scene, Smithson intended his art to make him an equal of the father figures he had recruited from among the mythical leaders of the American avant-garde.

Spiral Jetty is a grand implication of Pollock's gesture. *Amarillo Ramp*, completed to his specifications after his death, can be understood as a variant, on dry land, of *Spiral Jetty*. *Broken Circle/Spiral Hill*, an earthwork constructed in the Netherlands in 1971, looks like a gargantuan reprise of the quasi-

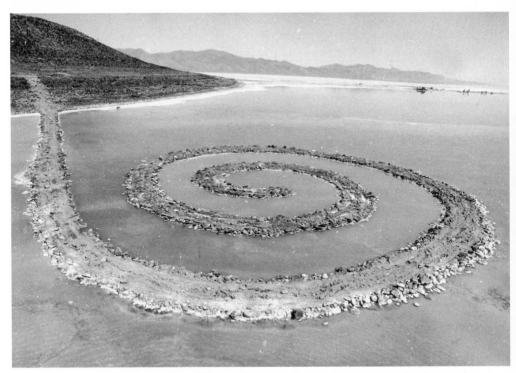

79. Robert Smithson, *Spiral Jetty*, 1970. Rocks, mud, precipitated salt crystals, 1,500 ft. long and 15 ft. wide.

Minimalist sculptures he built in 1966. The lumbering splendor of these earthworks and the avant-garde logic of their development make it easy to overlook Smithson's dedication to the entropic forces that ruin everything splendid and dismantle all the structures of logic.

In an essay, "The Spiral Jetty" (1972), Smithson argues that the purpose of art is to render its audience "conscious of the actualities of perception." Attending to minutiae, one sees through the reassurances of history and ideology, aesthetic and political. One notices entropic pressures at work everywhere, and especially in places ignored by optimism and good taste. Smithson contemplated debased imagery and ramshackle landscapes much as Saint Jerome contemplated the human skull he kept beside him in the wilderness. Any reminder of the entropic end delighted him, for it sharpened his sense of the mortality we share with everything, even dust.

Entropy is the inexorable implication of the Second Law of Thermodynamics, which Smithson never bothered to master. It wasn't a truth for him so much as an image, his master fiction, the one that generated meanings more compelling to him than any truth. To be conscious of entropy was to

construe consciousness as entropic, to feel decay in the processes of seeing, thinking, remembering. "The brain," he wrote, "resembles an eroded rock from which ideas and ideals leak."

The surge and fizzle of thought electrified Smithson, prompting him to fabricate sculptures, make jaunts between sites and nonsites, perform arduous mirror displacements, supervise the building of earthworks, write long essays, give involuted interviews—in sum, to produce the oeuvre that equates his doubts, uncertainties, indifference, fatigue, and forgetfulness with the power that is reducing all things to a null state in which there is no difference between life and death, between then and now, between anything and anything else.

Smithson's point, irritably, interminably reiterated, is that we have something to gain by facing our situation in the art world, in contemporary culture, in a universe that is running down as surely as a badly made watch. It illuminates us to wander through derelict sites, like Percy Bysshe Shelley in the Roman Colosseum, musing on the idea of ruin and feeling the fact of it in one's bones and breathing. As Shelley wandered, he felt the consolations of high art. His dread gave way a bit as he called up the vague and luminous ideal of "intellectual beauty," the redemptive "mystery." Smithson understood ideals and essences as demeaning temptations, buzzing errors to be swatted away like flies.

Nothing but the promise of universal death was entirely alive for Smithson. When a landscape meshed with his feelings, he felt that he possessed it. He felt alone there, like Pollock in his infinite. When Pollock said, "I am nature," he claimed the full force of all creative energy. At his most grandiose, Smithson claimed to be one with nature's destructiveness. He celebrated the force that from the beginning of time has worked against order, intelligibility, meaning, the force that tirelessly bears the universe back to its origins and further, to primordial chaos. Inverted heir of Romanticism, artist of the entropic sublime, Smithson was the anti-Pollock, devoted to a dream of apocalypse in reverse—not the ultimate revelation but the ultimate darkness, the state of absolute unknowability.

FROM DOLDRUMS TO BOOM

80. Miriam Schapiro, *Black Bolero*, 1981. Acrylic and fabric on canvas, 6 × 12 ft.

36

Smithson's *Amarillo Ramp*, De Maria's *Lightning Field*, Heizer's *Complex One*—all were funded by private patrons, and none was ever offered for sale. If commerce leaves a taint, as many suspect it does, then these earthworks attained a kind of purity. Their liberation from commerce seemed a natural benefit of the western habitat. The frontier, we like to believe, is freedom's homeland, though the idea of eluding the market originated in the art world's urban precincts. In 1961 Allan Kaprow pointed out that "a Happening is not a commodity." Vanishing as it appears, its only residue is "a state of mind." A scarcity of goods discourages markets. In 1965 the critic Barbara Rose argued that objects, too, can resist commercial exploitation if they display a properly off-putting attitude.

The best Minimalist sculptures, she wrote, are intentionally "difficult, hostile, awkward and oversize." Flaunting their "refusal to participate, either as entertainment or as whimsical, ingratiating commodity," they "blatantly assert their unsalability and functionlessness." Yet Minimalist objects sold well. In fact, they created a market for artworks unwilling to exert the usual kinds of allure. It was as if seduction by a cold presence were no seduction at all but a refined communion between admirer and admired. Further refinement was suggested by Sol LeWitt, maker of chilly white grids.

His "Sentences on Conceptual Art" (1968) pointed to a future unencumbered by objects, even the least ingratiating. Section ten of his manifesto states: "Ideas alone can be works of art; they are in a chain of development that may eventually find some form. All ideas need not be made physical." LeWitt continued to convert some of his ideas into three-dimensional objects. Some took ephemeral form as wall drawings, and others remained unrealized. Still other ideas, conceived by a generation of younger artists, formed the intangible substance of their oeuvres.

Among the heirs of Minimalism, dismissals of the object became routine,

then insistent, as if an addiction were being overcome. For many years, a conceptualist named Lawrence Weiner accompanied his proposals for artworks with this statement: "1. The artist may construct the piece. 2. The piece may be fabricated. 3. The piece may not be built." A work of art is a mental event; art objects are knickknacks, not always reprehensible but never entirely necessary. Douglas Huebler was stricter. "The world is full of objects, more or less interesting," he said in 1970. "I do not wish to add any more. I prefer, simply, to state the existence of things in terms of time and/or space." Huebler's *Duration Piece* #7 (1969), a sequence of photographs made at one-minute intervals, focused on a patch of sidewalk in Central Park frequented by eleven ducks and occasionally a pigeon. Other *Duration Pieces* showed people sitting in chairs or behind the wheels of their cars.

In an office on upper Madison Avenue, Seth Siegelaub became a dealer for artists with no objects to offer, only careers to pursue. The walls of his gallery were incidental. What mattered was the telephone, which linked him to artists and the printers who gave his artists' work its tangible—rather, its legible—form. "When art does not any longer depend upon its physical presence," said Siegelaub, "it is not distorted and altered by its representation in books and catalogs. . . . When information is primary, the catalog can become the exhibition." Moving at the speed of thought, the new art would not—could not—be snagged and corrupted by market mechanisms. Siegelaub's was the only gallery of its kind, and it survived for just a few seasons.

In his last expansive mood before the boom of the eighties, Leo Castelli found places on his roster for Huebler, Weiner, and a conceptualist named Joseph Kosuth. Other established galleries did not follow Castelli's lead, and artists disinclined to make objects received only token encouragement from museums, which exist, after all, to preserve the art object—indeed, to exalt it. Aesthetic progress, it seemed, was being stymied. Out of this frustration came a new institution: the alternative space.

In 1969 Holly Solomon—once a collector of Pop Art, soon to establish a commercial gallery—put a loft on Greene Street at the disposal of performance artists, dancers, and poets. A year later, the sculptor Jeffery Lew launched the 112 Greene Street Workshop; its first group show repeated, with variations, the anti-form exhibition of the Castelli Warehouse. Later shows displayed the progeny of anti-form, that sprawling family of new mediums which includes video art at one extreme and the texts of hardcore conceptualism at the other. The Kitchen, on Broome Street, specialized at first in video then added performance to its schedule. Artists Space was founded with a mandate to give young artists their first solo shows.

Alanna Heiss, a nonprofit entrepreneur, persuaded the city's bureaucracy that artists could make good use of abandoned municipal buildings. The cavernous space at 10 Bleecker Street became the site of sculpture exhibitions

and workshops from 1972 to 1975. Next, Heiss arranged for three seasons of performance and installation works at 22 Reade Street. P.S. 1, a derelict public school in Queens, and the Clocktower, on lower Broadway, were Heiss's next projects and her most successful. During the seventies, these spaces overflowed with art of high ambition and low commercial appeal. The Clocktower tilted from installation art, its center of gravity, toward conceptualism. Acknowledging everything from paint on canvas to typescript on onionskin, P.S. 1 found a place among the major institutions of the New York art world.

Those who supported conceptualism and kindred developments tended to think of art on the model of technology: new forms rendered the old obsolete; paintings were no longer necessary. Late in the sixties, though, dozens of young painters appeared in New York and unfurled immense canvases filled with what came to be known as Lyrical Abstraction. This wasn't a style, it was a look: big, bright, and atmospheric.

The Lyrical Abstractionists had gazed long and admiringly at the balmy pinks and oranges of painters like Kenneth Noland and Jules Olitski. Charmed by the pleasant weather of the color-field image, they felt a blithe disregard for the notion that paint should meet canvas only under the strict supervision of Greenbergian dogma. Lyrical Abstractionists were not purists. "Opticality" meant nothing to them. The deeper a painting's space, the more dramatic its surges of light, the better. The Lyrical Abstractionists had looked especially hard at the drip paintings of Jackson Pollock. He was their favorite model and chief progenitor. Each wanted to find a creditable variant on his reverberating image.

To stand out in the rush for gallery representation, a painting needed a lively surface, so the Lyrical Abstractionists tinkered extensively with technique. They poured, scraped, dabbed, stenciled, sprayed, rolled, and smeared their paints onto the canvas. Some built their images in layers, applying each with a different method. Always, the Lyrical Abstractionists tried to keep their colors unmuddled. These young painters wanted to show the bright side of Pollock's heroism. They wanted to return to 1950 and chase the tragic darkness from his art.

The Lyrical Abstractionists were well educated. Revisionists usually are. Their grip on the past was confident but not always firm. For them, history was a set of heavily annotated and often-slippery options. The happy dazzle of their colors could look as pedantic as a third-generation work of performance art. Nonetheless, some Lyrical Abstractionists were lively decorators. A few tagged with this label—John Torreano, Victor Kord, Phillip Wofford, John Seery—turned out to be good painters. Their work was noticed, but only in passing. During the early seventies, New Yorkers found it difficult to focus on art objects that lacked a detachable frame of ideas. Painting

needed an intellectual complement, which some painters found in a new brand of politics.

At the opening of the 1970 Whitney Annual, a band of female artists dashed through the galleries blowing whistles, loudly and often. Calling themselves Woman Artists in Revolution, they pointed to a scandal: this and every other Annual included only a minuscule number of women artists, and in most shows, most collections, most histories, women were shockingly underrepresented. Asked why, some in the art world gave a quick response: the best work gets the most exposure; art is art, quality is quality, and it has nothing to do with gender. Confronted with this view in 1971, Lee Krasner said that "any woman artist who says that there is no discrimination against women should have her face slapped."

There had never been a season when Pollock's paintings did not eclipse Krasner's, and she could not help knowing that her neglect owed much to the male assumption that females are by definition negligible. Men like Pollock and de Kooning, Greenberg and Rosenberg competed with one another, not with women. That Grace Hartigan and Joan Mitchell and Helen Frankenthaler were taken seriously by male artists was mentioned now and then to suggest the absence of any real problems. But the problems are real, the problems are crushing, insisted the art world's feminists.

Women should be represented equally in museum collections, they argued, not only in temporary exhibitions. Galleries ought to represent as many women as men, and critics must apply the same standards to all artists. On this last demand, there was disagreement. Certain feminists suggested that women ought to be judged by female standards, just as male standards are applied to men. Talk of female standards turned some eyes to the decorative, domestic imagery that high art excludes. Why can't this be the stuff of serious art? And why can't men make use of it too?

From these elaborations of feminist argument came the blossoming, twining imagery of P&D—pattern and decoration painting. Brushy, repetitive motifs—mostly floral—spread over the canvas, sweeping aside the memory of traditional composition. Here was a new kind of allover painting, a fresh variant on Pollock. P&D was inclusive. It was egalitarian and prompted its practitioners to reach past the boundaries that confine their medium to a narrow strip of high-art terrain. Joyce Kozloff and Miriam Schapiro stitched wall hangings from strips of brightly patterned cloth. Kim MacConnell made fabric pieces that could pass for crazy quilts—that would be quilts, neither more nor less, if they had not borne the "art" label. Robert Kushner designed splashy, flowing costumes for performance pieces—mock fashion shows. Once he mixed food with his fabrics, in a spectacle called *Robert Kushner and His Friends Eat Their Clothes* (1972). From aluminum foil and colored cello-

phane, Thomas Lanigan Schmidt built witty, glittering altars and ex votos.

John Perreault, who wrote about art for *The Village Voice*, was among the few critics who approved of pattern and decoration's success in domesticating Pollock's legacy. P&D, he said, would rescue the New York art world from the forces that made it so dull in the seventies: specialization, professionalism, and the theorizing that sustains them both. Though he seemed to have set himself up as a prophet, Perrault was expressing a wish, and it surprised him least of all when pattern and decoration failed to move beyond the garden where it had first sprung up. High style in New York is public. Major collectors tend not to import art into cozily personal settings; they design their apartments to look like galleries at the Modern. The unapologetic domesticity of pattern and decoration did not comport well with the formality of a Marden monochrome or the chic of Stella's stripes. P&D survived—it even flourished—but only in its lush, out-of-the-way corner.

37

The art world had become a place of corners and niches, some more central, more elevated than others. In the alternative spaces, the new mediums busily evolved. Minimalism was seen chiefly at the John Weber Gallery, color-field painting at Lawrence Rubin and André Emmerich. Lyrical Abstraction obtained a foothold at Emmerich and Max Hutchinson before drifting from sight toward the end of the seventies. Though Holly Solomon specialized in pattern and decoration, she had room on her roster for Nicholas Africano, a New Image painter. Others bearing that label showed at Willard.

Despite the lackluster market of the seventies, well-positioned dealers survived and some quietly flourished. By mid-decade, the institutions of the art world, modest or grand, had settled into a stable pattern. Degrees of renown had been assigned, careers were moving forward along well-charted paths. For those who belonged, the art world had become a place of reassuring certainties. Jasper Johns was, beyond question, New York's most-respected painter, and Leo Castelli its leading dealer. When Castelli opened the SoHo branch of his gallery in 1971, the art world's newest neighborhood acquired instant legitimacy.

For several years, artists had been colonizing SoHo, the district south of Houston Street and north of Canal. The sizable lofts in its cast-iron buildings had become affordable now that manufacturers were abandoning them for more up-to-date premises. Some artists lived and worked in what was known as raw space. Others renovated their spaces, producing a latter-day version of the "luxury loft" that Willem de Kooning had designed for himself in the early sixties.

Shared by lofts and galleries, SoHo's idea of luxury was severe: white walls uncluttered by woodwork, hardwood floors gleaming with polyurethane, furniture minimal in amount and style. After a few seasons of hesitation, municipal authorities chose not to enforce the law that barred permanent

residents from this commercial neighborhood. Artists and their dealers were reviving an area that had threatened to burden the city with a new zone of blight. Bars appeared, then restaurants, boutiques, and home-furnishing shops. Slowly, SoHo evolved into a community. A certain pride mixed with the cautious professionalism of the seventies.

When a young artist named David Salle came to town in 1975, he felt only the "dismalness" of the scene. It oppressed him. It filled him with contempt. By what right was the New York art world dismal? Salle had abandoned Wichita, Kansas, for the California Institute of the Arts in 1969. He earned his bachelor of fine arts there, then his master of fine arts, then abandoned California for New York. An artist can do good work anywhere, as Salle knew. He also knew that the capital city is the amplifier of success. Once he had arrived in New York and settled into a dreary sublet apartment at the corner of Broome and Varick Streets, nothing would persuade him to retreat. Here, if anywhere, his ambition would not seem absurdly outsize. This was where he belonged, yet nothing could induce him to pretend that, in 1975, New York was a happy or even an especially interesting place.

"The art world seemed incredibly insular and protectionist," he says now. "One felt that a tremendous effort was being expended to promote and pro-tect a very few reputations. History was being preserved in the form of a myth—the Castelli touch, and so on. But Leo seemed a bit like the Wizard of Oz. Look behind the curtain, and you'd find this little man who had learned to project an amazingly large image of himself." The illusion had its reality. Castelli did in fact dominate the system, which provided little room for newcomers. "The scene was dead in 1975," says Salle. Its tedium was mitigated by the presence of other Cal Arts graduates—Eric Fishl, Matt Mullican, Troy Brauntuch, and Jack Goldstein. A network of connections formed.

In Buffalo, art students at the local campus of the State University of New York had founded an alternative space called Hallwalls. After giving a lecture there, Goldstein became a point of contact between his friends from Cal Arts and members of the Buffalo group—Charles Clough, Michael Zwack, Cindy Sherman, Robert Longo. Up in Buffalo, bored by his courses, Longo read *Artforum* and built in his head an imaginary art world—a spacious hive of bright white spaces filled with major work. "Hallwalls," he says,

> was supposed to be our part of that world. It was just the corridor between my studio and Charlie Clough's, in this old ice factory where we were working at the time. We turned it into a gallery space and invited people like Vito Acconci and Sol LeWitt to visit and install work or do a performance or whatever. Lucy Lippard came up. Dan Graham. Jonathan Borofsky. They were like proof that the art world existed, and

we felt that Hallwalls was connected to it—an extension of those spaces in Manhattan.

In 1976 Longo was invited to stage a performance piece at Artists Space in Manhattan. At Hallwalls, he organized a group show of works by the Cal Arts crew. "Artists Space and Hallwalls were connected by a kind of exchange program," says Salle. "They became sister organizations. It was so primitive and naive, very sweet and very much of that moment."

Salle presented an installation at the Kitchen in 1979; three years earlier, Artists Space had shown his paintings on paper. "It wasn't as though I was literally nonexistent during those years," he says. "There was some exposure of my work. The main difficulty was knowing what my work ought to be." Salle paid his rent by teaching part-time in a New Jersey college. He worked as a studio assistant for Vito Acconci and others. At Mickey Ruskin's Lower Manhattan Ocean Club on Chambers Street, he got a job as an assistant chef. The head chef was a painter named Julian Schnabel. They didn't talk much about art, Salle remembers. Their conversations were "more about living situations, not having a place to paint, being treated like a dog." He adds, not entirely convincingly, "There was also a good bit of humor about it all." Bitterness lurked beneath the humor; beneath the bitterness was a feeling that anything could be done but only because nothing was required. A young artist's freedom rested on a vast indifference.

Before he learned to cook, Schnabel drove a cab. Discovering, one evening, that his passenger was an art dealer, he took the opportunity to convey a grievance. No one—no dealer, no critic, no curator—would look at his work, said Schnabel. It was worse than unfair, it was cruel, and stupid, too, because he was doing extremely good work. He deserved studio visits. He deserved a gallery. He was a great artist in the making. The dealer, Julian Weissman, still remembers the ferocity of Schnabel's anger. Schnabel doesn't recall the incident. There were many like it, for he was constantly angry in those days.

In the late fifties, Allan Kaprow had argued that old distinctions were fading. To enter the room labeled painting was not to close the door on sculpture. To chose film was not to reject dance. One could simply be an artist and work in whatever medium fit one's intention. Living in Kaprow's future, young artists felt lost. Much later, Salle looked back on his early seasons in New York and said,

Everybody was simply trying to find a way to say to the world that he was an artist. That's what was really going on. And the question of what kind of artist, an artist to what end, why an artist—those questions simply couldn't be answered at that time, because all of the energy went into simply trying to say that one *was* an artist.

Salle tried to say it with performance art and video pieces, with paintings and drawings. He didn't convince himself, nor did he know where to look for models of aesthetic conviction. He had learned that many painters with recognizable names were producing nothing. They had no compelling reason to work. Yet artists of no reputation, absolute beginners, continued to settle in Manhattan. It was ambition's hometown.

Longo left Buffalo in 1977 for an apartment on Fulton Street. Making the art-world rounds, he was baffled. The galleries felt empty, even with art on the walls. "There was no energy," he says.

The art world was vanishing. Just about gone. I started going to the Bleecker Street Cinema a lot. Jean-Luc Godard is a genius, I decided. So is Rainer Fassbinder. After the movies, I'd go to the downtown clubs. I began to think of the art world as the day, with its white spaces. The lighting, the quiet. The club scene was noisy and dark. That was the night, and a lot more was going on in the night than in the day.

Longo has the short, stocky physique of a high-school linebacker. He began to wear black. An elaborate wave piled his curly black hair up on his head. Styling himself as a downtown musician, he got to know Sid Vicious, Joey Ramone, Debby Harry. David Byrne, of Talking Heads, became a friend. Longo played guitar with the Rhys Chatham Band. He organized a band of his own called Menthol Wars. Punk was a bitter parody of rock. Though

81. Robert Longo, *Men Trapped in Ice*, 1980. Charcoal and graphite on paper; three panels, each 60 × 40 in.

Longo let the punk attitude soak through him, he wasn't convinced by the music. Its rage felt too shallow, too much like adolescent whining, or too deep, like helpless fear. Playing or listening, he preferred the New Wave displays of dark, edgy, amplified force.

At the Kitchen in 1979 Longo showed aluminum relief sculptures—vignettes of violence, with their combatants smoothed into anonymity. *Swing* (1978), an image of a punch-out, began as a still from a film noir. The source of *The Wrestlers* (1978) is a statuette by the fifteenth-century Florentine Antonio del Pollaiuolo. Longo constructed tall slabs of metal that would have counted as pieces of Minimalist sculpture if it were not for the human forms that plunge through their surfaces into the room. Longo lent a triptych of large drawings, *Men Trapped in Ice* (1979), to a group show at the Max Protetch Gallery. In the central panel, a figure from Fassbinder's *The American Soldier* appeared, arching his back, touching the place where a bullet has just entered. Nothing sold from the Protetch show. To survive, just barely, Longo worked as Vito Acconci's studio assistant. He and Michael Zwack painted lofts. As the seventies ended, he was driving a taxi to support a nearly anonymous career.

82. Julian Schnabel, *Portrait of Mary Boone*, 1983. Oil paint, plates, and Bondo on wood, 24 × 24 in.

38

Julian Schnabel's paintings of the seventies employed the New Image format: on a monochrome field, a schematic image or two. Often, the image is of a torso in rough outline—whether flesh or statuary, it is impossible to tell. Nearly always, the waxy, perfected surface of the painting shows at least one deep gouge. In 1979 these canvases made a respectable appearance at the Mary Boone Gallery, which had recently opened at 420 Broadway. Castelli's SoHo was two flights up. Later that year, Boone showed Schnabel's *The Death of Fashion* (1978), an immense painting encrusted with shards of crockery. Over this field of broken plates and cups he painted a scrawny scimitar and a headless, armless torso.

René Ricard, an alumnus of the first Warhol Factory, announced in the pages of *Art in America* that Schnabel's plate paintings

> are really quite horrible. But not in any pejorative sense. I've seen the two existing plate paintings in their homes. The first one "hangs" in Anina Nosei-Weber's foyer and it makes you just want to get out of there fast, it is so big and awful.

Of *The Death of Fashion*, Ricard reported that it

> is already owned by Bob Feldman. I saw it in his dining area. It made a complete mockery of the usual niceties of sitting at table. It made the very idea of hanging it in the home grotesque. In front of a thing like this there is simply no room for personal taste.

This painting, says Ricard, is "a pet gorilla," a "bull . . . in the china shoppe, and we are figurines in the stampede." Fear and courage alike require one to give in to this plate painting utterly.

In a little over two years, prices for Schnabel's paintings rose feverishly, from $2,500 to $4,500 to $15,000 to twice and three times that amount. There was talk of giddy collectors offering $60,000, $75,000 for a plate painting. The boom of the eighties was under way, stirring activity even in regions of the art world that lacked a market. As the Whitney Museum of American Art raised money for the purchase of *Three Flags*, a publicly funded organization called Collaborative Projects—Colab, for short—opened its Times Square Show in a former massage parlor at Forty-first Street and Seventh Avenue.

Colab had persuaded more than a hundred young artists to offer new work for next to nothing. Paintings, sculptures, collages, posters, installation pieces, video, and film spread from makeshift galleries into halls and stairwells. The spectacle received wide press coverage, which usually began with the observation that the Times Square Show was as raucous and seedy as Times Square itself. This was nearly true. Christy Rupp showed a tableau of marauding rats. More of these plaster sculptures were on sale at the souvenir shop for fifteen dollars each.

The Times Square Show announced that art ought to be at least as much fun as the movies and television. And if it wasn't fun, it ought to be pertinent. It ought to reflect the tone of the city as accurately as subway graffiti or *The Daily News*. Colab had gathered a milling crowd of artists whose ambitions were as shapeless as the crowd itself. Many resented the established galleries of SoHo and Fifty-seventh Street without wishing, truly, to fit comfortably onto the rosters of those establishments. Needing an art world of their own, the alumni of the Times Square Show invented one in the East Village, the neighborhood where many of them lived. Its first gallery was run by Patti Astor, an underground film actress in the Colab orbit.

When Astor felt the urge to show art, she might have extracted funds from the nonprofit system for an alternative space. Instead, she opened a storefront emporium on East Tenth Street, between Avenues A and B, as the 1981 season began. To explain her entrepreneurial impulse, Astor said, "I didn't want to bother with filling out giant forms." Bureaucracy is tedious. Marketeering is amusing. Named the Fun Gallery, her shop offered graffiti on canvas by "writers" who had been spraying their tags on the subways for years—Fab Five Freddy, Futura 2000, Lee Quinones. Keith Haring, an art-school graduate with a subway career, got his professional start at the Fun Gallery. Break dancers and rap artists performed at Astor's openings, and her artists showed their work in one-night shows at the downtown music clubs—Danceteria, Club 57, the Mudd Club.

Early in 1982, a painter calling herself Gracie Mansion, after the New York mayoral residence, put on The Famous Show in a storefront on St. Mark's Place. A year later, she set up shop on Tenth Street. There were now nearly three dozen East Village galleries, and more kept opening. In 1984 Astor and

her director, Bill Stelling, took to wearing sweatshirts that read: "The Original and Still the Best." Talk of quality was ironic, though of course everyone had preferences. Cliques coalesced and trends appeared. Besides graffiti, there was cartooning, warmed-over Surrealism, mock–children's book illustration, picture-postcard sentimentality, and much, much more.

Some fads lasted from one season to the next; others vanished almost before they were noticed, like quick shifts of climate. East Village styles were old styles recycled, and the irony that drove the recycling was itself recycled from the early days of Pop Art. A few of the new galleries—International with Monument, Pat Hearn—showed sober work of the kind one would expect to see in SoHo. Not even seriousness felt completely out of place at the East Village party.

Traditionally, New York galleries are closed on Sunday and Monday. By staying open on Sundays, East Village dealers added an art day to the week. If the weather was pleasant when that day came around, East Tenth Street would be mobbed, as collectors descended from limousines to galleries that had once been candy stores and shoe-repair shops. Prices were low. Stars were emerging. The East Village attracted the better-informed European tourist, for here was America at its most delightful—raffish, innocent, and picturesque. As galleries proliferated, landlords raised rents, and there was bitter talk of gentrification. Yet the East Village remained a place of burnt-out buildings, crack dens, and Hell's Angels, their bikes lining the curb in gleaming array.

A leading East Village style was art-school Expressionism, with its crudely twisted forms and scrabbling lines, its screeching purples and bleeding crimsons. In SoHo, Anina Nosei, Mary Boone, and a few other dealers imported canvases by the stylistic offspring of the Germans who had invented Expressionism in the early decades of this century. This was a sophisticated product. The young neo-Expressionist Helmut Mittendorf, for instance, had obviously looked hard at the example set by the patriarch, Emil Nolde. Mittendorf's jagged, splashy forms had the old fervor and finesse. Denying any debts to the German Expressionism of earlier generations, Georg Baselitz tried to give the style the autonomy of abstract art. Impressed by big postwar American painting, Anselm Kiefer inflated his Expressionist heritage to the scale of panoramic spectacle.

After the bombast of the Germans came the refinements of the young Italian painters. Blending French Surrealism with its Italian variant, Metaphysical Art, Enzo Cucchi's pictures echoed with lessons New Yorkers had learned in the galleries of the Modern. Francesco Clemente offered a delicate mixture of mysteries, some with Surrealist flavor, others redolent of Symbolist eccentrics like Odilon Redon and James Ensor. Playing with Fauvism, Cub-

ism, and other modernist styles, Sandro Chia gave his canvases the look of updated museum pieces. For so long, painting had seemed marginal. Now it suddenly occupied the center of attention. Painting was new again, and of course it was old. It was the medium it had always been. Flooding into New York from Europe, nicely worked canvases administered shocks of recognition—shocks that reassured.

Ever since Dorothy Miller's New American Painting made its triumphal overseas tour in 1958, New Yorkers felt it was safe to ignore European art. Now they talked of a German invasion, an Italian invasion, and dealers cast about for young Americans who could meet these challenges. The best painter turned up by this search was George Condo. Reworking Cubism, throwing in memories of Surrealism and the funny papers, Condo made a quick ascent from the East Village to SoHo. Eventually he joined the Pace Gallery on Fifty-seventh Street. His paint-handling was brilliant, his wit alluringly bizarre. Suddenly the New York art world had something it hadn't asked for in decades and didn't know it wanted: an American virtuoso of the brush.

A permanent fixture at center stage, Julian Schnabel looked like a virtuoso of Americanism—a producer of big, brash, overbearing paintings more adept than Condo's at defending New York's position in what had suddenly become an international art world. As his prices rose, Mary Boone prevailed upon Leo Castelli to join her in presenting Schnabel's new works. When he agreed to a two-gallery show, Boone stepped into the ranks of major dealers and Castelli had a new star, his first in years. The plate paintings, said Castelli, revived the enthusiasm he "had felt about Jasper, Bob, Frank, and Roy when I first saw their work." Schnabel's 1981 show spread from Boone's gallery to Castelli's upstairs.

Having gathered armfuls of praise and damnation for his plate paintings, Schnabel began to paint on velvet. He attached the skeleton of a fir tree to a painting called *The Raft* (1982). His *Exile* (1980) bears three pairs of antlers. Despite Schnabel's boisterous drawing and awkward arrangements of form, his paintings often display an odd delicacy. It might show in his colors, as they drift into subtle regions of beige and gray. Or two dense blotches of rusty-red color might collide with unexpected consideration for each other's unwieldy bulk. Through these refinements flow currents of difficult feeling, the runoff from an overflowing swamp of anxiety. In 1978 Schnabel wrote that he wasn't interested "in society, or culture." He was concerned with "putting a finger on biological fear." To paint, he said, was to make "icons that present life in terms of our death." A panicky sense of mortality drove Schnabel to gestures big and desperate enough to count as signs of life or, at least, theatrical vitality.

At the newly founded Metro Pictures on SoHo's Mercer Street, Jack Goldstein, Troy Brauntuch, and a few others recycled ready-made images in a hard-

83. Julian Schnabel, *Exile*, 1980. Oil and antlers on wood, 7 ft. 6 in. × 10 ft.

edged manner designed to put the audience at a distance. Viewing their works across a gulf of impersonality, one was to reflect on the mechanisms of the image. These Metro artists raised a point the Pop artists had already made: the world comes to us now through the media. And they wanted us to believe what we fear: living through imagery, we become little more than images, even to ourselves. Flesh-and-blood bodies feel increasingly residual.

Another member of the Metro group, Cindy Sherman, specialized in photographs she called *Untitled Film Stills* (1978–80). Each shows her in a role made familiar by the movies: would-be career girl newly arrived in the big city; demure librarian; disenchanted vamp abandoned in the living room of a mountain lodge. There are nearly one hundred of these excerpts from make-believe movies. With costumes, makeup, and a disconcerting ability to shift the tone of her features, Sherman populated a world in which she never appeared, at least not as herself. "These are pictures of emotions personified," she said. "I'm trying to make other people recognize something of themselves, rather than me." Yet Sherman's *Film Stills* and the disguised self-portraits that flowed from them are always recognizably hers. The Metro aesthetic posited a paradoxical ideal: an impersonality traceable, in a flash, to one or another of the gallery's high-profile egos.

84. Cindy Sherman, *Untitled Film Still #21*, 1978. Black-and-white photograph, 8 × 10 in.

Metro's biggest star was Robert Longo. For several seasons, he had been working with Diane Shea, a professional illustrator with a precise touch. He would rough out an image; she would blow it up and transfer it to paper in charcoal and graphite. The final touches would be his. He had become an artist of cold black and slaty gray on white. His first show at Metro Pictures presented six drawings, each nine feet high, of men in dark suits and ties. Like the figure from Fassbinder's *The American Soldier*, they writhe, though it isn't clear why. Some seem to have been shot. Others might be dancing or simply staggering, intoxicated. Their collective title is *Men in the Cities*. Shea was not Longo's only collaborator. Others helped him gather images and materials. Longo listed their names on the gallery wall, the way a film producer credits the members of a production crew.

Exiting briskly, the *Men in the Cities* were replaced by other images from the urban landscape—equestrian statues, expressways, faces in close-up, buildings ruined and whole. Working in a variety of mediums that ranged from pencil on paper to cast aluminum, Longo would flatten his motifs and arrange them in an outsize wall piece. The effect was cinematic, as if a wide, panoramic shot had been invaded, violently, by montage.

Among the founders of Metro Pictures was Janelle Reiring, who had once worked on the staff of the Leo Castelli Gallery. Noting that the boom had rewarded Castelli and Boone's Schnabel show, Reiring suggested to her for-

mer employer that he collaborate with Metro Pictures on a Longo exhibition. Castelli agreed, and early in 1983 three of Longo's new works crowded into Metro's small Mercer Street gallery. The rest appeared in Castelli's space at 142 Greene Street, which put a floor of thirty-five hundred square feet at Longo's disposal. Leaving it nearly empty, he turned this polyurethaned surface into a promenade where viewers could stroll and view, from a distance, the pieces arrayed on the gallery's eighteen-foot walls. *Now Everybody* (1982–83), a four-paneled work, shows Beirut torn apart by war. In front of this panorama, Longo placed a bronze figure of a casually dressed man. Rising up on one foot, he arches his back. The city has reached out with a bullet. The man's pose makes it clear that he is dying, not dancing. One has the melodramatic sense that the man became a monument in the moment of death.

Early in 1984 Metro Pictures moved from Mercer Street to a space on Greene, just up the block from Castelli. Longo opened a show there in April. Deep in the gallery hung a huge work—eighteen feet wide, eleven feet high—called *Tongue to the Heart* (1984). Along the lower edge of the piece runs a horizontal panel filled with choppy water rendered in yellowish acrylics on canvas. The central panel is a low-relief sculpture cast in lead. Oppressive

85. Robert Longo, *Tongue to the Heart*, 1984. Acrylic and oil on wood; cast plaster; hammered lead on wood; Durotran; charcoal, acrylic, and graphite on canvas. Four panels; overall dimensions: 11 ft. 4 in. × 18 ft. × 25 in.

orthogonals inscribe this leaden surface with the image of a large, official-looking hall. By setting its perspective slantwise to the picture plane, Longo suggests a glance from a corner entrance—the point of view of one hesitant to enter. Airless and filled with dull light, this room looks like the retreat of all anonymous, heavy-handed authority.

Toward the lower left corner, a platform bears a sculptor's version of a painter's traditional device: the *repoussoir* figure whose job is to point out some crucial detail of the picture. Longo strands him in the room with us. His head in his arms, he points at nothing. No image attracts him, no formal order absorbs him. Displaced just a bit from his traditional station, this *repoussoir* figure occupies the open terrain between artwork and audience. Though his proportions are monumental, he is much less than life-size, as if condensed by the pressure of the image-barrage that supplies Longo with the bits and pieces of his art.

39

For all his operatic grandiosity, Longo generates a chill. A terror of death haunts Schnabel's exuberance, too. David Salle, who became the other star of the Mary Boone Gallery, placed death at an art-historical remove. Since Duchamp's time, avant-gardists have announced that painting is dead. To put the matter that way made it too public for Salle, too much a question addressed to all artists—painters, would-be painters, enemies of painting. He preferred the issues of painting to be private, like his moods. He wrote in 1979 not that painting is dead but that "the paintings are dead"—meaning his own. "The way this art works," he added, "is to make you want it to disappear so that you can mourn its loss and love it more completely." Further notes suggested that what was at stake was "a kind of premonition of death" stirred up by doubts about who one is or ought to be. Salle evoked these doubts with paintings that looked awkward, embarrassed, obsessively introverted.

Drawing with the help of an opaque projector, he flaunted an exquisitely clumsy hand. His colors were sour pastels and hot, flustered oranges and greens mixed lugubriously with gray. Among his motifs were surly ducks and goofy rabbits. There were bits of imagery borrowed from travelogues, museum postcards, and family photograph albums—but not, it seemed, his own. Salle's imagery had an uprooted, homeless air. Amid free-floating patches of fake-modern abstraction or pictures of once-stylish modern furniture, Salle would place renderings of naked women bending at the waist or lying on their backs in postures that expose their genitalia. Feminists attacked him as a pornographer. Others noted that Salle borrowed his way of layering his images from the German painter Sigmar Polke, who had borrowed it from late works by the Dada veteran Francis Picabia. They would point to his homages to Jasper Johns, his evocations of Cézanne and Giacometti, and suggest that Salle was at best a mordantly elegant pasticheur.

86. David Salle, *Cigarette Lady: Blue and Yellow*, 1979. Acrylic, oil, and pencil on canvas, 51 in. × 6 ft. 8 in.

87. David Salle, *Melancholy*, 1983. Oil, acrylic, and umbrella on canvas, 61 in. × 6 ft. 8½ in.

Turning to Schnabel, detractors called him an overbearing caricature of an Abstract Expressionist. Longo's art was denounced as a bombastic rerun of Pop. Yet their prices—everyone's prices, it seemed—continued to rise.

"I don't subscribe to the idea that a painter has to starve before he becomes successful," Mary Boone would say. Indeed, it seemed mean to insist that artists endure poverty in a decade when $3.6 million was bid at auction for Jasper Johns's *Out the Window* (1962). In October 1987 the stock market crashed, sending large amounts of speculative money in search of new investments. The following May, a bidder paid $4.18 million for another of Johns's paintings, *Diver* (1962). Then, one night in November 1988, his *White Flag* went for seven million dollars at auction, and the next evening, his *False Start* fetched seventeen million. Not long before, the dealer Richard Fiegan had told *Forbes* magazine that "works of art have become quasi-financial instruments"—near-equivalents to bonds or certificates of deposit. Five-figure prices for the works of stylish young painters did not seem absurd in a market that valued Van Gogh's *Irises* at $53.9 million and Picasso's *Pierrette's Wedding* at $51.3 million.

After the success of Schnabel's two-gallery show in 1981, Castelli was eager to collaborate with Boone in 1984, and again in 1986, on an exhibition of Salle's paintings. "David is an absolutely splendid young artist," said Castelli in the pages of *Interview* magazine. The eighties was the decade of shameless, inflationary hype. So said the detractors, whose voices intensified the hubbub of the boom.

We are witnessing "the inflation of minor talents into major ones, of mere promise into claims on art history," wrote Robert Hughes, the art critic of *Time* magazine, in 1985. "The conditions that produce great art—patience, internalization, relentless self-criticism"—have become impossible to sustain, he added. Entranced by the boom, the art world has capitulated to "the tyranny of novelty," said Walter Darby Bannard in *Arts Magazine*. And when Hilton Kramer surveyed the output of this tyranny, he concluded that "what is at stake is the concept of seriousness."

In full agreement with Kramer, Barbara Rose indicted the moment's new stars for displacing the tactics of commercial entertainment to the realm of high art. This was the unforgivable sin, too great to be theirs alone. "We can thank Andy Warhol for introducing the radical concept that art should be easy, not difficult," she wrote in the mid-eighties, when the boom seemed unstoppable. "Easy art, of course, is dumb art, which is also the point," Rose explained. "You no longer need to be intelligent, sensitive, or cultivated to participate in the happy art-world carnival of fun, fun, fun. Looking right and having the cash are sufficient to get you a ticket to the best rides."

When Warhol's retrospective at the Whitney opened in 1970, a television reporter pointed out that some critics do not consider his paintings to be art.

Declining to be provoked, Warhol said, "They're probably right." He was less tentative with friends. The writer Victor Bockris remembers him dismissing certain of his productions with an arrogance worthy of a Warhol-hater. In 1985 he designed stale but recognizably Warholian images of Elizabeth II, Beatrix of the Netherlands, and a few of their royal colleagues. "Andy felt complete contempt for the Queens," says Bockris. "Usually he would work with the printer, getting everything right, but he wouldn't touch these. He told me they were just trash for Europe. He felt the same way about *Kiku* [1983] and *Love* [1983], which were silk-screen prints of flowers and very tame nudes. These were just commercial trash."

In 1982 Warhol had a fling with television, producing celebrity interviews for cable stations. As art stars proliferated, he collaborated with two of the most stylish—Francesco Clemente and Jean-Michel Basquiat. Sometimes all three would work on a canvas, sometimes only Warhol and Basquiat. In their joint productions, there is no meshing, no interchange, only a display of trademark styles. Each seems to be making a guest appearance in another painter's oeuvre.

At mid-decade, stylish dance clubs commissioned Basquiat, Clemente, Keith Haring, Kenny Scharf, and other artists of the boom to convert their trademarks into decor. Warhol declined this sort of work. He didn't need the exposure, a point he made with Warholian wit in 1985. In a corner of a club called Area, he stood on a pedestal for a short time, then departed, leaving the pedestal behind. This was his "invisible sculpture," a reminder that he had been the first to lead high art from the studio to the dance floor.

Area, the Palladium, the Mudd Club—all the art-smitten night spots of the eighties were latter-day variations of the Dom, the club Warhol had opened on St. Mark's Place in 1966. It became routine to say that the eighties themselves, with their frank devotion to glamour, had been prophesied by Warhol's art and attitudes. Visible or not, he was the decade's tutelary spirit. His pervasive presence was what seemed to matter, not the art he continued to turn out.

In 1981 he ran off a series of canvases called Myths, which includes Howdy Doody and Dracula, Santa Claus and Uncle Sam, Mickey Mouse and others. Remarkably flat, these images could pass for the work of a moderately talented Warhol imitator, and the Endangered Species series (1983) is flatter still. Worse yet, it's fussy. Warhol's pictures of tree frogs and pandas "looked as if they had been whipped up with the children's-bedroom market in mind," said Bob Colacello. Always, it seemed, the later Warhol had some market in mind. Properly priced and distributed, a salable set of canvases could bring in a quick $800,000.

That Warhol was a commercial artist—even a mercenary artist—is undeniable, yet he was never merely that. From 1961 until the end of his life,

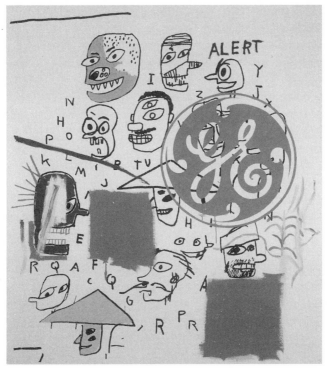

88. Andy Warhol and Jean-Michel Basquiat, *Untitled (Alert, GE),* c. 1984–85. Acrylic, oil, and silk-screen ink on canvas, 7 ft. × 6 ft. 5 in.

he played a double game. Until 1964, three years into his career as the fine artist who produced *Gold Marilyn Monroe*, Warhol still employed Nathan Gluck to assist him with thoroughly commercial projects. In 1976, as the output of empty portraits accelerated, he painted the Skulls, those eloquent addenda to his Death and Disaster pictures—the Car Wrecks, Suicides, and Electric Chairs. At the height of the boom, when many saw Warhol as the devil to whom American art had mortgaged its soul, his Last Suppers subjected the big New York painting to a bitter and brilliant revision. Warhol acknowledged the traditional gulf between difficult art and the glib, ingratiating kind. He defied tradition only with his refusal to stay put on one side of the gulf or the other. A commercial artist capable of fine art, he was a fine artist willing to prettify the look of his best work for the low end of the market.

The stars of the eighties did not play this double game. For them, all imagery appeared on a single continuum, which stretched from the painter's studio to the Hollywood sound stage. Feeling no estrangement from ordinary life, they comported themselves as successful young professionals. Tradition-

ally, artists designed their own lofts; a practitioner of high art wouldn't want to live in a style imported from the ordinary world, no matter how elegant that style might be. But that is precisely what David Salle wanted. His White Street loft was designed by a fashionable young architect, Christian Hubert, in fifties moderne. One specialist in images had employed another specialist in images, and the results were reported in the February 1985 issue of *House and Garden*. A month later, *Vogue* published an article on the loft of Julian Schnabel, who had by then received so much media coverage that the writer made the painter's wife, Jacqueline, the nominal focus of the piece. In July of that year, *House and Garden* ran its feature on Schnabel's loft.

Schnabel lived in a nondescript neighborhood on Manhattan's West Side. Salle, Clemente, and other artists of the boom had their studios in Tribeca, a district to the south of SoHo which artists had colonized during the seventies. Here the bars and restaurants of the eighties opened their doors. The best-known was the Odeon on the lower reaches of West Broadway. Once, it had been a cafeteria like the old Waldorf at Eighth Street and Sixth Avenue, where painters drank coffee in the thirties. Traces of that glum past survived the remodeling, which filled the premises with knowing allusions to Art Deco. Tables and chairs displayed an updated version of tubular moderne. The Odeon's menu invoked Paris and Milan. Its clientele tended toward collectors, dealers, and artists pursuing, or hoping to pursue, upscale careers. This was not a hangout for old-style bohemians and avant-gardists. Prominent or obscure, veterans of other times preserved their pre-boom ways of life in the spacious remains of former art worlds.

Piqued by the lack of contact between the generations, a writer named Kathy Acker assembled a batch of artists, newcomers and veterans, for a session of taped conversation. In a segment of the transcript published by *Artforum*, Richard Serra tells Salle that he and painters of his generation have accepted the history of their medium too easily; their art is the product of style games, the clever mixing and matching of ready-made image-bits. Art shouldn't be that easy, Serra implies. There are large historical truths, and artists must grapple with them.

Thus, Serra says, fashionable painting in the eighties is like a child under pressure from two large, domineering parental figures: Pop Art and Abstract Expressionism. So "there's a contradiction. How do you get your feeling out in terms of contemporary iconography? I mean how do you love Pollock and Warhol and make a connection? . . . You have Warhol and Pollock standing for enormous notions of model figures for young painters to come up to . . . I mean, that's what we're talking about. What do they do about that contradiction?" Salle interrupts: "Are you *asking* me who my mythological figures are or are you imposing them on me?" "I'm not asking you," says Serra. "This thing is an accepted fact." "Not to me," Salle replies.

This is what artists formed in earlier decades could not abide: the effrontery of artists new in the eighties, beginners who believed they could choose at will their ancestors and their purposes. To an artist of Serra's generation, matters like these were determined by the high and hallowed truths of modernism. One became a serious artist by taking history's dictates seriously. It baffled Serra to find, in 1982, that the moment's brightest young artists didn't want to be serious in the familiar modernist way. For Salle, the modernist past was an array of options, not a source of transcendent imperatives.

The right panel of his *Schizophrenia Prism* (1982) is a field of gloomy green inhabited by one of his more demure female nudes. To the left, the painter has slathered on his paints with an abandon that stopped just short of burying all his colors in muddy brown. You might think of Pollock, but not right away, for this expanse of sticky pigment has a mocking resemblance to the paintings of Jean-Paul Riopelle, a Canadian who settled in Paris toward the end of the forties and cultivated dense variations on Pollock's dripped imagery.

Salle finds alloverness no more compelling than traditional composition. Each is a possibility to be selected, or not, from a spectrum that begins with the textures of abstract painting and leads eventually to the rhythms of commercial moviemaking, which Salle employed as the director of a Hollywood film called *Search and Destroy* (1994). Billed as a "screwball tragedy," it had a modest budget and was modestly successful. Without ceasing to be a painter, Salle had become a thoroughly commercial movie director. This was an evolution impossible for an avant-gardist in the tradition that led from Jackson Pollock to Richard Serra, Salle's inquisitor at the *Artforum* session.

Though the primmest members of the postwar avant-garde refused to acknowledge popular culture, Willem de Kooning had an eye for glossy female images in magazine advertisements. He had an ear for songs from the jukebox, yet he believed that his art occupied a plane far higher than that of advertising and popular music. Avant-garde art was different in kind from academic art, commercial art, entertainment—different and superior. De Kooning gazed down at magazine ads from the far side of a gap that he considered uncrossable. Pollock's favorite kind of music, Dixieland jazz, came to him across the same gap, which does not appear on the charts followed by Salle and his generation. The artists of the boom were not egalitarian. They considered some kinds of imagery more prestigious than others. Painting has more cachet than graphic design, obviously. Yet painting, no less than design, is a process of choosing and deploying options from a continuum that sweeps away the old faith in the irreconcilable differences between high and low art.

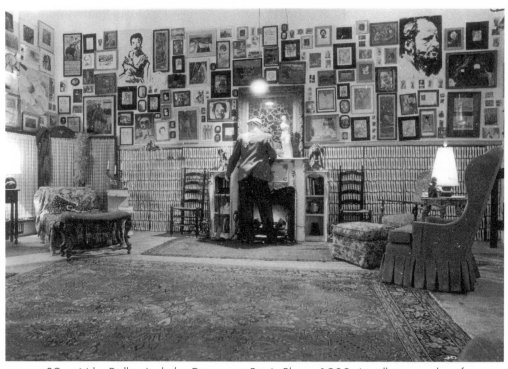

89. Mike Bidlo, *Jack the Dripper at Peg's Place*, 1982. Installation and performance piece

40

Salle's use of Pollock shows oblique finesse. At another stage of sophistication, Mike Bidlo's exercise of the Pollock option made him an art-world equivalent of an Elvis impersonator. In 1982 Bidlo mocked up a fireplace at P.S. 1 and hung make-believe Pollock memorabilia above it. Nearby, he showed his imitations of Pollock's drip paintings. To complete the piece, called *Jack the Dripper at Peg's Place*, he had himself photographed while urinating in the fireplace. Two years later, Bidlo lined a space with aluminum foil in homage to the silver Factory and decorated it with his replicas of Warhol's most famous paintings. Next he copied works by Picasso, Matisse, and Léger, then Lichtenstein, de Chirico, and Magritte. The more slavishly Bidlo tried to embody the historically certified masters of modern art, the further he drifted from modernism's habit of doubt, its knack for experiment. Driven by a fan's uncritical faith, Bidlo could imitate but not elaborate.

Pollock's place among the stars was acknowledged more succinctly by Richard Prince, who simply tacked a photograph of Pollock to his studio wall. An early member of the Metro Pictures group, Prince made his debut with photographs of advertisements for luxury goods. Zooming in on the image, he would reduce it to a fragment—a close-up of a glove or a woman's face, with the surface texture exaggerated to bring out its seductive glow. Liquor advertisements and raunchy photographs from biker magazines appeared in his oeuvre as sumptuous Ektacolor prints. With photo-silk-screen blowups, he transferred *The New Yorker* cartoons from the page to canvas. Sometimes a one-liner from a joke book would float against blankness.

Over the seasons, Prince drew an equation between commercial images and jokes, with their machinery of set-up and punch line. He is a Warholian, so much so that he found a photograph of Pollock, blown up to a poster, irresistible. His image "looked pretty good next to Steve McQueen's, next to

JFK's, next to Vince Edwards's, next to Jimmy Piersal's, and so on," Prince wrote, adding that Pollock is an art star equal to "a TV star, a Hollywood celebrity, a president of a country, a baseball great" and "whatever . . . used to separate their value could now be done away with."

Admiring Pollock as a star on the order of a ballplayer or a politician, Bidlo and Prince ignored his claim to occupy a superior realm, beyond the reach of ordinary life. By the old avant-garde standards of judgment, they treated him badly. But artists like Bidlo and Prince did not apply those standards, nor did other artists of the boom. Their belief in stardom rendered all stars equal, not in magnitude but in kind. Art stars, movie stars, stars of the nightly news—seen through the eyes of the eighties, every star glittered in the same mundane heaven of celebrity.

Gianfranco Gorgoni is a news photographer with an eye for the art of the New York avant-garde. His helicopter shots of Robert Smithson's *Spiral Jetty* gave the art world its memory of that work, and his picture of Serra slinging hot lead has the aura of Hans Namuth's pictures of Pollock slinging paint. One summer day in the mid-eighties, Gorgoni found himself at the beach in the Hamptons. His subject was Julian Schnabel, push broom in hand, smearing color across an enormous canvas. Schnabel was playing Pollock.

A woman strolled by and asked him what he was doing. "Painting," said the painter. "Oh," said the woman, "where could I see some of your work?" "Someday," said Schnabel, "you'll see it in the Museum of Modern Art." Revising Pollock's method, he would receive recognition equal to Pollock's. Since then, Schnabel has compared himself to Picasso. And he, too, has directed a Hollywood movie, a film biography of Jean-Michel Basquiat, who began as Samo the graffiti writer, became an artist of the boom, and died of a drug overdose in 1988. Also, Schnabel produced for commercial distribution an album of himself singing his own pop songs.

Whatever an old-line modernist might think, Schnabel is not splitting himself between irreconcilable worlds. He is realizing ambitions that acknowledge no crucial difference between the art world and Hollywood and the world of popular music. The art world was the site of his early success. It was not, for him, a realm of transcendence reserved for initiates. Schnabel and other artists of the boom see the art world as an upscale sector of the culture we all share. Thus the narrative devices of the film biography appear on a continuum with Pollock's webs of paint, about which Schnabel has been articulate.

In *C.V.J.: Nicknames of Maître d's & Other Excerpts from Life* (1987), Schnabel notes that "in Pollock's work every element is subordinate to every other

element." Or, every element has the power to "disrupt" other elements nearby, and "their cumulative ability to disrupt each other" gives the image its unity. This is a good account of the allover image, a formal option well exercised by Schnabel's plate paintings. Usually, the array of broken plates is the ground for a milling crowd of figures, fragments of a compositional structure at odds with alloverness. When this crowd flashes too wide a variety of styles, alloverness itself falls into fragments and is lost. Exercising the Pollock option, swamping it with other options, Schnabel sometimes gives a painting the look of an overdesigned, overdirected movie.

Robert Longo, too, tends toward cinematic excess. At the center of *All You Zombies: Truth Before God* (1986) he placed a larger-than-life figure on a slowly revolving platform. Cast in bronze from a grotesque assemblage of military hardware, sports equipment, and household clutter, the creature assumes a Quasimodo crouch, with one arm raised in the follow-me gesture of an infantry leader. Wearing a parody of a Viking helmet, his two fanged mouths open in violent grimace, he is an allegorical image of the spirit of war. Behind him curves an immense canvas bearing an image of the loggias at La Scala in Milan. Opera plus war comics plus horror movies plus big New York painting plus the homage to Minimalism offered up by the steel slab where the monster stands—*All You Zombies* puts the entire jumble at the service of an anti-war message.

Longo's *Heads Will Roll* (1984–85) is a wall piece over twenty-six feet wide. On the left, an immense medallion bristles with bladelike forms. To the

90. Robert Longo, *Heads Will Roll*, 1984–85. Lacquer and acrylic on wood, epoxy on fiberglass and aluminum, and Plexiglas, 12 ft. × 26 ft. 1 in. × 46 in.

right hangs a canvas where images of tract houses march in orderly rows. A patch of these geometric forms is hidden by a white silhouette of David Byrne, the lead singer of Talking Heads. He is frozen in a sprinter's tilt: punk rocker flees suburbia. Dissatisfied with the gray of the houses, Longo repainted them. Then he ascended a ladder and, with the canvas flat on the studio floor, flicked "red and white and gold paint across the landscape. I was in a Jackson Pollock mood."

Longo is pleased when viewers recognize his allusion to Pollock, yet he doesn't feel that *Heads Will Roll* is poorly seen if the provenance of his dripped paint is overlooked. Nor does Salle object vigorously if viewers fail to see a reference to Cézanne's middle period in the dish of apples that hovers against the background of the painting called *Black Bra* (1983). Addressing memory with asides, these artists directed the full force of their imagery toward the moment—toward an audience primed for an immediate response, as at the movies, as when flipping through a magazine. This willingness to slight memory, to make it a plaything of moods, showed how thoroughly the young artists of the boom had rejected the modernist ideal of high seriousness. For that ideal is sustained not only by memory but by a solemn, even a fanatic respect for the act of remembering.

At most, commercial artists encourage dim recollections of the past, vague memories in the soft focus of nostalgia. And much commercial imagery tries to lock us into a present filled with the dazzle of glamour. Artists in the modernist tradition consider themselves superior to commercial artists because they offer an escape from that dazzle. They offer to loft us to the far side of a gulf that will protect us, absolutely, from the manipulations of consumerist imagery. Though the artists of the boom recognized no such gulf, they were not apologetic. Their art, they felt, deserved respect for its polish and its power, which were considerable. Working the sophisticated end of a continuum that reaches to the movies and beyond, to soap opera and television advertising, they were well rewarded in the art market and by sympathetic critics. Always, though, they felt the pull of the continuum's most lucrative end, and none felt it more powerfully than Longo.

His earliest works emerged from movie stills, and his most spectacular ones, the wall pieces that made him a star, seemed to yearn for the scale of the movie screen. As his career careened ahead, he kept an eye out for the chance to make a feature film. In 1986 and again the following year, he directed music videos that ran on MTV. In 1987 the New York Film Festival presented his *Arena Brains*, a collection of short episodes in a variety of Hollywood genres, from domestic romance to film noir. Then, in 1989, he bought the screen rights to "Johnny Mnemonic," a story by the science fiction writer William Gibson. Longo's feature-length, studio-produced version of the story

premiered in 1995. Though his *Johnny Mnemonic* did only moderately well, he had entered the ranks of Hollywood directors. Positioned now to make more commercial movies, Longo had traveled so far along the image-continuum that his claim on the artist's role had all but faded. Recollecting his life as a star of the art boom, he expresses more nostalgia than regret.

91. Brice Marden painting, 1990. Photograph by Bill Jacobson

EPILOGUE

For there to be a gulf between high art and low, one must believe in it. During the eighties, the fate of Pollock's gesture fell into the hands of those who did not. Yet aesthetic beliefs are like styles. They fade only with reluctance, and hardly ever vanish entirely. Painters young in the 1950s are still elaborating de Kooning's example. De Kooning himself was reworking his own premises until just a few seasons ago. Lichtenstein continues to refine the clarities of Lichtensteinian Pop. Rauschenberg's flurry of images is unabated, as is the hum of Johns's quietude. All these artists—in fact, most artists—believe that there is a difference in kind between their images and those of advertising and entertainment. They still believe in the gulf between high and low art. Or one could say that they create this uncrossable gulf by believing not only that it does exist but that it should. Some who sustain this faith have recently put the legacy of Pollock to use.

In 1994 Robert Zakanitch exhibited a set of four canvases, each thirty feet wide and filled with motifs borrowed from chinaware, upholstery, and wallpaper. Manufacturers transpose handmade designs into mechanical idioms. Zakanitch transposes them back into the idiom of painterly finesse, distributing them over the canvas with an evenness that settles a lingering question: there is, after all, a resemblance between fabric design and the allover image. Two decades ago, Zakanitch was among the leading proponents of pattern and decoration. Since then, he has slowly raised P&D to the scale of the domestic sublime, which is to say that he has infiltrated the region of the easy chair and the china cabinet with the immensities of Pollock's "nature."

In Pat Steir's latest works, paint drips and splashes over the canvas with a grace that is almost arch. Against dark backgrounds, bright colors unfurl in bursts that recall the fireworks in James McNeill Whistler's Nocturnes of the 1880s. It's as if Steir had given Pollock new birth as a nineteenth-century dandy. In Sean Scully's paintings of the past decade or so, patterns of stripes,

light alternating with dark, make a familiar point: a painter's repetitions could go on forever if they were not halted, arbitrarily, by the canvas's edge. A Scully canvas has many edges, interior borders where one stripe-pattern meets another and another. Often, the play of pattern against pattern generates the stability, the sense of enclosing harmony, that we expect from a properly composed picture of the Old World kind. Scully confronts Pollock with Mondrian, alloverness with composition, and in his best paintings neither of these incompatible possibilities defeats the other.

In its way, a monochrome panel is an allover image—a potentially unbounded field gestured into visibility by a hand intent on obscuring its energy, the more forcefully to insist on a solitary color. For two decades and more, Brice Marden was New York's premier monochromist. No hand was more tactfully retiring than his. One could form simply no idea about his gesture. After a time, he took to abutting two or more panels in a single work. In the early eighties, long, narrow surfaces appeared in post-and-lintel patterns. Marden was now making gestures of placement, like those of an ancient architect. Then, as the eighties ended, his gestures became painterly in the postwar American manner.

Applying his colors with a stick, Marden filled his canvases with an airy tangle of sliding, swerving, curving lines. These webs didn't resemble Pollock's denser ones so much as bring them to mind for comparison. Marden did not become a Pollock imitator. His implement prevented that. Long and limber, his stick puts him at a distance from the canvas, as Pollock's stick had done. Yet Marden's maintains contact with the canvas, as Pollock's did not. Photographs of Pollock at work are filled with the tension of motion suspended. The analogous photographs of Marden are serene, for his stick is an instrument of contemplation. It turns painting into a meditation on the process that leads from impulse to gesture to mark. In his recent paintings, Marden does not confront Pollock with Old World composition. He is not claiming Pollock's "nature" for dandyism or domesticity. With the grayed-out refinement of his colors, the self-conscious hesitations of his line, and the judicious touch that gives each mark the feel of a corrective, he recalls the subtleties of Johns. Marden has found a place for Pollock's gesture in the realm of Johnsian refinement.

Always honored by the New York art world, Pollock was never entirely assimilated. His brilliance had a primordial feel. As Marden said in an interview with Pat Steir, Pollock's strength flowed from a "kind of innocence and total conviction." Sometimes, of course, Pollock fell into utter, abysmal doubt. Yet, as Marden suggests, Pollock remained an innocent. Careening between extremes, he never felt the fastidious compunctions, the hedged convictions, that produce urbanity like Johns's. A quick plunge into Pollock's

92. Brice Marden, *Presentation*, 1990–92. Oil on linen, 7 ft. 10⅜ in. × 59 in.

93. Robert Rahway Zakanitch, *Big Bungalow Suite IV*, 1992–93. Acrylic on canvas, 11 × 30 ft. (artist in foreground)

maelstrom exhilarates us, but for long visits we prefer the infinite of Johns's imaginary studio. This is the realm of culture—of high culture, American-style—and it is Marden's astonishing accomplishment to have taught Pollock's image of unbounded nature to comport itself properly there.

In art, no fate is final. Yet for now the fate of Pollock's gesture in Marden's hands feels decisive. The unassimilable has been assimilated. Culture has not so much triumphed over nature as appreciated it into a state of compatibility with the taste that has guided the appreciation all these years. Instead of triumph there is a reconciliation of a thoroughness, a perfection, that only high art can achieve. If the tone of it is melancholy, in the Johnsian style, that is only a reminder that culture's perfections, even when unbounded, have their limitations.

NOTES

CHAPTER 1

7 "Tom wanted to show": Rudy Burckhardt, interviews with the author, January 15, 1992, and March 1, 1992.

7 "astonishing speed": Elaine de Kooning, "Hans Hofmann Paints a Picture" (1950), *The Spirit of Abstract Expressionism: Selected Writings* (New York: George Braziller, 1994), 67–73.

7 "He told me": Rudy Burckhardt, interviews with the author, January 15, 1992, and March 1, 1992.

8 "Pollock's barn didn't make": Robert Goodnough, interview with the author, January 22, 1992.

8 Pollock's property: Helen A. Harrison, "On the Floor," *The Long Island Historical Journal* 3, no. 2 (Spring 1991): 165 n. 7.

8 a kerosene stove: Barbara Rose, "Jackson Pollock at Work: An Interview with Lee Krasner," *Partisan Review* 47 (Winter 1980): 86.

8 "I have no fears": Jackson Pollock, statement, *Possibilities* 1 (Winter 1947–48): 79. Reprinted in *Abstract Expressionism: Creators and Critics*, ed. Clifford Ross (New York: Harry N. Abrams, 1990), 139–40.

8 "Pollock said he liked": Rudy Burckhardt, interviews with the author, January 15, 1992, and March 1, 1992.

9 she had a homely face: Eleanor Ward, in Jeffrey Potter, *To a Violent Grave: An Oral Biography of Jackson Pollock* (New York: G. P. Putnam's Sons, 1985), 174.

9 "knew all the abstract artists": Francine du Plessix and Cleve Gray, "Who Was Jackson Pollock?," interview with Lee Krasner, *Art in America* 55 (May-June 1967): 49.

9 "To say that I flipped": Lee Krasner, in John Gruen, *The Party's Over Now: Reminiscences of the Fifties—New York's Artists, Writers, Musicians, and Their Friends* (Wainscott, N. Y.: Pushcart Press, 1967), 230.

9 Pollock . . . impressed her: Betsy Zogbaum, in Steven Naifeh and Gregory White Smith, *Jackson Pollock: An American Saga* (New York: Clarkson N. Potter, 1989), 394–95.

10 "I was terribly drawn": Lee Krasner, in Gruen, *The Party's Over Now*, 230.

10 "After dinner": Rudy Burckhardt, interviews with the author, January 15, 1992, and March 1, 1992.

10 "Is He the Greatest?": "Jackson Pollock: Is He the Greatest Living Painter in the United States?" *Life* 27 (August 8, 1949): 42–43, 45.

CHAPTER 2

13 boots and a cowboy hat: Steven Naifeh and Gregory White Smith, *Jackson Pollock: An American Saga* (New York: Clarkson N. Potter, 1989), 186. Pollock didn't know how to ride a horse. See Paul Brach, review of Jeffery Potter's *To a Violent Grave*, in *Art in America* 74 (April 1986): 11.

14 photographs of . . . farmhouses: *Jackson Pollock: A Catalogue Raisonné of Paintings, Draw-*

ings, and Other Works, 4 vols., ed. Francis Valentine O'Connor and Eugene Victor Thaw (New Haven: Yale University Press, 1978), vol. 4, 204, figs. 3 and 4.

14 wanted to study art: Naifeh and Smith, *Jackson Pollock: An American Saga*, 21.

15 "freedom and rhythem": Jackson Pollock, letter to Charles Pollock, January 31, 1930, in O'Connor and Thaw, *Jackson Pollock: A Catalogue Raisonné*, vol. 4, 209.

15 "an Artist of some kind": Jackson Pollock, letter to Charles and Frank Pollock, October 22, 1929, in O'Connor and Thaw, *Jackson Pollock: A Catalogue Raisonné*, vol. 4, 208.

16 "There was a rhythm": George McNeil, in Jeffrey Potter, *To a Violent Grave: An Oral Biography of Jackson Pollock* (New York: G. P. Putnam's Sons, 1985), 36.

16 six feet tall: Potter, *To a Violent Grave*, 18.

16 Benton's slurs: Philip Pavia, in Potter, *To A Violent Grave*, 36.

16 Struggling to draw: Peter Busa, in Naifeh and Smith, *Jackson Pollock: An American Saga*, 164.

16 Historians have argued: See, for example, Stephen Polcari, "Jackson Pollock and Thomas Hart Benton," *Arts Magazine* 53, no. 7 (March 1979): 120–24.

16 "of a most minimal order": Thomas Hart Benton, *An Artist in America*, rev. ed. (Columbia: University of Missouri Press, 1983), 332.

16 "found their essential rhythms": Thomas Hart Benton, letter to Francis V. O'Connor (1962), quoted in Deborah Solomon, *Jackson Pollock: A Biography* (New York: Simon and Schuster, 1987), 53.

16 "it was obvious": Thomas Hart Benton, in Polly Burroughs, *Thomas Hart Benton: A Portrait* (Garden City, N.Y.: Doubleday, 1981), 118.

16 "mother had to know": Frank Pollock, in Potter, *To A Violent Grave*, 27.

17 a speakeasy: Naifeh and Smith, *Jackson Pollock: An American Saga*, 167–68.

CHAPTER 3

19 Museums . . . were sanctuaries: Thomas Hart Benton, *An Artist in America*, rev. ed. (Columbia: University of Missouri Press, 1983), 265.

19 "native painters": Thomas Hart Benton, "Form and the Subject," *Arts Magazine* 5 (June 1924): 303–8.

20 "protesting too much": Steven Naifeh and Gregory White Smith, *Jackson Pollock: An American Saga* (New York: Clarkson N. Potter, 1989), 185.

21 "the country began": Jackson Pollock, letter to Charles Pollock, July 1931, in Francis V. O'Connor, *Jackson Pollock*, exhibition catalog (New York: Museum of Modern Art, 1967), 16.

21 Painting . . . all day: Henry Adams, *Thomas Hart Benton: An American Original* (New York: Alfred A. Knopf, 1989), 200.

22 "Benton is beginning": Jackson Pollock, letter to Roy Pollock, February 3, 1933, in *Jackson Pollock: A Catalogue Raisonné of Paintings, Drawings, and Other Works*, 4 vols., ed. Francis Valentine O'Connor and Eugene Victor Thaw (New Haven: Yale University Press, 1978), vol. 4, 214.

22 *Time* magazine: "U.S. Scene," *Time* 26 (December 24, 1934): 24.

22 "Any fascist or semi-fascist": Stuart Davis, "Rejoinder to Thomas Benton," *Art Digest* 9 (April 1935): 13.

22 a Marxist history: Leo Huberman, *We, the People*, with illustrations by Thomas Hart Benton (New York: Harper and Brothers, 1932). For Benton's Marxism, see Ellen G. Landau, *Jackson Pollock* (New York: Harry N. Abrams, 1989), 25 n. 9.

23 "(Rapp, Owen, Amana)": These are nineteenth-century settlements in Indiana and Iowa; in each of them, property was held in common. See Thomas Hart Benton, statements

(1935), in *A Thomas Hart Benton Miscellany: Selections from His Published Opinions 1916–1960*, ed. Matthew Baigell (Lawrence, Kan.: University of Kansas Press, 1971), 64.

23 the Bentonite ideal: Thomas Hart Benton, statements (1935), in Baigell, *A Thomas Hart Benton Miscellany*, 23, 78.

CHAPTER 4

25 "parties were never as wonderful": David Smith, in Thomas B. Hess, *Willem de Kooning*, exhibition catalog (New York: Museum of Modern Art, 1968), 18.

25 strikers charged by mounted police: Jimmy Ernst, *A Not-So-Still Life: A Memoir* (New York: St. Martin's/Marek, 1984), 194.

25 "You learned to eat practically nothing": Harlan Phillips, "Interview with Burgoyne Diller" (October 2, 1964), typescript, Archives of American Art/Smithsonian Institution, 1, 11–12.

26 earned his meals: Barbara Haskell, *Burgoyne Diller*, exhibition catalog (New York: Whitney Museum of American Art, 1990), 165. See Phillips, "Interview with Burgoyne Diller," 15.

26 a courageous choice: Deborah Solomon, *Jackson Pollock: A Biography* (New York: Simon and Schuster, 1987), 112.

26 Mark Rothko: Diane Waldman, *Mark Rothko, 1903–1970: A Retrospective*, exhibition catalog (New York: Solomon R. Guggenheim Museum, 1978), 266.

26 Some city inspectors: Ernst, *A Not-So-Still Life*, 185.

26 a gallery open to all applicants: Phillips, "Interview with Burgoyne Diller," 11.

26 an out-of-work artist: Harold Rosenberg, "The Profession of Art: W.P.A. Art Project," *Art on the Edge* (Chicago: University of Chicago Press, 1983), 195–97.

26 "We want bread": Hayden Herrera, "John Graham: Modernist Turns Magus," *Arts Magazine* 51 (October 1976): 105.

26 "WE WANT BON-VIVANT JOBS": Thomas B. Hess, *Willem de Kooning*, 18.

26 "can be as ruggedly individualistic": Phillips, "Interview with Burgoyne Diller," 10–11.

27 "encouragement of the fine arts": L. W. Robert, Jr., statement to the press (1933), quoted in Arthur A. Ekirch, Jr., *Ideologies and Utopias: The Impact of the New Deal on American Thought* (Chicago: Quadrangle Books, 1969), 145.

27 "in keeping with our highest democratic ideals": Franklin Roosevelt, letter to Edward Bruce, 1939, quoted in Marlene Park and Gerald E. Markowitz, *New Deal for Art: The Government Art Projects of the 1930s with Examples from New York City and State*, exhibition catalog (Hamilton, N.Y.: Gallery Association of New York State, 1977), 11.

27 "if the salesgirls went out on strike": Joseph Solman, "The Easel Division of the WPA Federal Arts Project," *The New Deal Art Projects: An Anthology of Memoirs*, ed. Francis V. O'Connor (Washington, D.C.: Smithsonian Institution, 1973), 120.

27 artists on the Federal Arts Project: Park and Markowitz, *New Deal for Art*, 16.

27 a standard of seriousness: Willem de Kooning, "Content Is a Glimpse . . . ," interview with David Sylvester (1960), ed. Thomas B. Hess, *Location* 1 (Spring 1963). Reprinted in *Willem de Kooning: Pittsburgh International Series*, exhibition catalog (Pittsburgh: Museum of Art, Carnegie Institute, 1979), 25.

28 "This was around 1936": Rudy Burckhardt, interviews with the author, January 15, 1992, and March 1, 1992.

28 occasionally delayed sum: Ernst, *A Not-So-Still Life*, 191; William Baziotes, William Baziotes Papers, Archives of American Art/Smithsonian Institution, microfilm N70-24.

28 his time on the WPA: Ethel Baziotes, interview with Nancy R. Versaci, May 22, 1984,

quoted in Nancy R. Versaci, "Flying Tigers," *Flying Tigers: Painting and Sculpture in New York 1939–1946*, exhibition catalog (Providence, R.I.: Bell Gallery, Brown University, 1985), 5.

28 a Bogart-like figure: Ernst, *A Not-So-Still Life*, 187.

28 "personal code" of "ascetic discipline": Harold Rosenberg, "The Thirties," *The De-definition of Art* (Chicago: University of Chicago Press, 1972), 186.

28 "when de Kooning was very upset": Rudy Burckhardt, interviews with the author, January 15, 1992, and March 1, 1992.

28 "I often heard him say": Edwin Denby, "On Painting: The Thirties," *Dancers, Buildings and People in the Streets* (New York: Curtis Books, 1965), 202–3.

28 "worn-down cafeteria fork": Edwin Denby, "The Climate," *Collected Poems* (New York: Full Court Press, 1975), 3.

29 "Maybe the talking": Rudy Burckhardt, interviews with the author, January 15, 1992, and March 1, 1992.

29 "the years of hanging around": B. H. Friedman, *Jackson Pollock: Energy Made Visible*, (New York: McGraw-Hill, 1972), 68.

29 "of the people and for the people": Sol Wilson, in Ernst, *A Not-So-Still Life*, 187.

29 avant-gardists in "ivory towers": Phillips, "Interview with Burgoyne Diller," 12.

29 "I, for one,": Lee Krasner, in Barbara Rose, *Lee Krasner: A Retrospective*, exhibition catalog (Houston: Museum of Fine Arts; New York: Museum of Modern Art, 1983), 37.

CHAPTER 5

31 "anticipated Cubist-Constructivist esthetics": Alfred H. Barr, Jr., *Cubism and Abstract Art* (1936), exhibition catalog, reprint (Cambridge, Mass.: Belnap Press of Harvard University Press, 1984), 221.

31 Dorothy Miller: Russell Lynes, *Good Old Modern: An Intimate Portrait of the Museum of Modern Art* (New York: Atheneum, 1973), 137–38.

32 "There was little support": Carter Ratcliff, interview with Lee Krasner, *Art in America* 65 (September/October 1977): 82.

32 Krasner's schooling: See Barbara Rose, *Lee Krasner: A Retrospective* (Houston: Museum of Fine Arts; New York: Museum of Modern Art, 1983), 163; and Cynthia Goodman, *Hans Hofmann*, exhibition catalog (New York: Whitney Museum of American Art, 1990), 187–88.

32 Hofmann in Paris: See William C. Seitz, *Hans Hofmann*, exhibition catalog, with selected writings by the artist (New York: Museum of Modern Art, 1963); and Ellen G. Landau, "The French Sources for Hans Hofmann's Ideas on the Dynamics of Color-Created Space," *Arts Magazine* 51 (October 1976): 76–81.

32 "no explanations": Hans Hofmann, in Dorothy Seckler, "Can Painting Be Taught? 1. Beckman's Answer 2. Hofmann's Answer," *Artnews* 50 (March 1951): 40. See also Seitz, *Hans Hofmann*, exhibition catalog (New York: Museum of Modern Art, 1963), 8.

34 "started hitting people": Peter Busa, in Jeffrey Potter, *To a Violent Grave: An Oral Biography of Jackson Pollock* (New York: G. P. Putnam's Sons, 1985), 50.

34 *The Spirit of Western Civilization*: Steven Nafieh and Gregory White Smith, *Jackson Pollock: An American Saga* (New York: Clarkson N. Potter, 1989), 274–75.

34 "a very hard thing to pin down": Holger Cahill, in Richard D. McKinzie, *The New Deal for Artists* (Princeton, N.J.: Princeton University Press, 1973), 114.

34 "It didn't matter": Harold Rosenberg, in Rose, *Lee Krasner: A Retrospective*, 34.

35 Pollock's classmate: Musa Meyer, *Night Studio: A Memoir of Philip Guston* (New York: Alfred A. Knopf, 1988), 13.

35 Diller agreed to visit Pollock in his studio: Burgoyne Diller, interview with Ruth Gurin, March 21, 1964: 5. Archives of American Art/Smithsonian Institution.

CHAPTER 6

39 "lost its dynamic quality": Henry Adams, *Thomas Hart Benton: An American Original* (New York: Alfred A. Knopf, 1989), 238, 239, 241.

40 Jungian interpretations: Claude Ceruschi, *Jackson Pollock: "Psychoanalytic" Drawings*, exhibition catalog (Durham, N.C.: Duke University Press, 1962), 7–8, 18–20.

40 the artist's helpless drinking: Steven Naifeh and Gregory White Smith, *Jackson Pollock: An American Saga* (New York: Clarkson N. Potter, 1989), 335–36, 359–60.

40 "finds it difficult to form": Naifeh and Smith, *Jackson Pollock: An American Saga*, 363.

40 "twelve, fourteen hours . . .": Francine du Plessix and Cleve Gray, "Who Was Jackson Pollock?," interview with Lee Krasner, *Art in America* 55 (May-June 1967): 50–51.

CHAPTER 7

43 Born Ivan Dombrowsky: John Graham, *System & Dialectics of Art* (1937), ed. Marcia Epstein Allentuck (Baltimore: Johns Hopkins Press, 1971), 4–11.

43 a place in the avant-garde: Irving Sandler, "John D. Graham: The Painter as Esthetician and Connoisseur," *Artforum* 7 (October 1968): 50.

43 "It was said": Thomas B. Hess, "John Graham, 1881–1961," *Artnews* 50 (September 1961): 51.

43 automatic writing: Graham, *System & Dialectics of Art*, 103, 135, 166.

43 talk of spontaneity: See André Breton, "Manifesto of Surrealism" (1924), *Manifestoes of Surrealism*, trans. Richard Seaver and Helen R. Lane (Ann Arbor: University of Michigan Press, 1972), 26.

44 long . . . conversations with Pollock: Graham, *System & Dialectics of Art*, 135, 160, 174.

44 Bentonoid sneers: Deborah Solomon, *Jackson Pollock: A Biography* (New York: Simon and Schuster, 1987), 101–2.

44 Pollock's first critical notice: J[ames] L[ane], "Melange," *Artnews* 40 (January 12–31, 1942): 29.

44 later described as "horror": Barnett Newman, "Surrealism and the War" (1945), *Barnett Newman: Selected Writings and Interviews*, ed. John P. O'Neill (New York: Alfred A. Knopf, 1990), 96.

44 the roster of émigrés: Rona Roob, "Refugee Artists," *MoMA: The Members Quarterly of the Museum of Modern Art* 6 (Winter 1991): 18–19.

44 refused to speak English: Francine du Plessix, "The Artist Speaks: My Father, Max Ernst," interview with Jimmy Ernst, *Art in America* 56 (November-December 1968): 57–58.

45 "subject to the principle of pleasure alone": André Breton, "Surrealism and Painting" (1927), in Patrick Waldberg, *Surrealism* (New York: McGraw-Hill Book Company, 1965), 84.

46 his friend William Baziotes: Sidney Simon, interview with Robert Motherwell (1967), *Abstract Expressionism: A Critical Record*, ed. David Shapiro and Cecile Shapiro (Cambridge: Cambridge University Press, 1990), 35–38.

46 "To my astonishment": Paul Schimmel et al., *The Interpretive Link: Abstract Surrealism into Abstract Expressionism*, exhibition catalog (Newport Beach, Calif.: Newport Harbor Art Museum, 1986), 18, 22, 39, 100, 106.

49 "Jackson yelling": B. H. Friedman, "An Interview with Lee Krasner Pollock," *Jackson*

Pollock: Black and White, exhibition catalog (New York: Marlborough-Gerson Gallery, 1969), 7.

CHAPTER 8

51 a "very poor" Guggenheim: Jacqueline Bograd Weld, *Peggy: The Wayward Guggenheim* (New York: E. P. Dutton, 1988), 31, 38.

51 "with pictures": Peggy Guggenheim, *Out of This Century: Confessions of an Art Addict* (London: Andre Deutsch, 1983), 209–10.

52 "pictures were easier to obtain": John Richardson, "Go Go Guggenheim," *The New York Review of Books* 39 (July 16, 1992): 20.

52 Art of This Century opened late in 1942. See Weld, *Peggy: The Wayward Guggenheim*, 287.

52 "break down the physical": Frederick Kiesler, "Design Correlation," *VVV* 2–3 (March 1943): 76.

52 "was uterine architecture": Rudi Blesh, *Modern Art USA: Men, Rebellion, Conquest 1900–1956* (New York: Alfred A. Knopf, 1956), 219.

53 "Pretty awful, isn't it?": See Jimmy Ernst's two versions of this story, in *A Not-So-Still Life: A Memoir* (New York: St. Martin's/Marek, 1984), 241–42; and in Jeffrey Potter, *To a Violent Grave: An Oral Biography of Jackson Pollock* (New York: G. P. Putnam's Sons, 1985), 71–72.

53 "the greatest painter since Picasso": Guggenheim, *Out of This Century*, 315.

53 Mondrian, Paul Klee, and Jean Arp: Leland Bell, in Potter, *To a Violent Grave*, 72.

53 "until I left America": Guggenheim, *Out of This Century*, 315.

56 "looks pretty big": Jackson Pollock, letter to Charles Pollock, July 29, 1943, in Francis V. O'Connor, *Jackson Pollock*, exhibition catalog (New York: Museum of Modern Art, 1967), 28.

56 This stunt is a matter of public record: Weld, *Peggy: The Wayward Guggenheim*, 325–26.

57 "it was the only way": Guggenheim, *Out of This Century*, 316.

CHAPTER 9

59 "during a northeaster": Barbara Rose, "An American Great: Lee Krasner" (1972), in Hans Namuth, *25 Artists* (Frederick, Md.: University Publications of America, 1982), n. pag.

59 The run-down house: Jeffrey Potter, *To a Violent Grave: An Oral Biography of Jackson Pollock* (New York: G. P. Putnam's Sons, 1985), 85–86.

62 "that we would want to support": Peter Blake, in Potter, *To a Violent Grave*, 96.

62 "Sometimes," said Barr: Alfred H. Barr, Jr., "Gorky, de Kooning, Pollock," *XXV Biennale di Venezia Catalogo* (Venice: Alfieri, 1950), 385. Reprinted in *Artnews* 49, no. 4 (Summer 1950): 60.

62 as Greenberg had been arguing: Clement Greenberg, "Review of Exhibitions of Jean Dubuffet and Jackson Pollock" (1947), *The Collected Essays and Criticism*, 4 vols., ed. John O'Brian (Chicago: University of Chicago Press, 1986), vol. 2, 125; and "The Present Prospects of American Painting and Sculpture" (1947), vol. 2, 166.

63 excreted the major paintings: Steven Naifeh and Gregory White Smith, *Jackson Pollock: An American Saga* (New York: Clarkson N. Potter, 1989), 540–41.

63 "the reason he put his canvas": Patsy Southgate, in Potter, *To A Violent Grave*, 88.

64 "What nonsense!": Grace Glueck, "New Biography, New Debates on Jackson Pollock," *The New York Times* (January 25, 1990): C17.

64 "control the flow of paint": William Wright, "An Interview with Jackson Pollock" (1950),

in Francis V. O'Connor, *Jackson Pollock* exhibition catalog (New York: Museum of Modern Art, 1967), 80.

64 "aerial sphincter": Max Kozloff, "Jackson Pollock" (1964), *Renderings: Critical Essays on a Century of Modern Art* (New York: Simon and Schuster, 1969), 146.

65 "did not know yet": Robert Goodnough, "Pollock Paints a Picture," *Artnews* 50, no. 3 (May 1951): 40–41.

CHAPTER 10

67 "Jackson and I were standing": Lee Krasner, in Barbara Rose, *Lee Krasner: A Retrospective*, exhibition catalog (Houston: Museum of Fine Arts; New York: Museum of Modern Art, 1983), 98.

67 "I'm sort of way out there": Jackson Pollock, in Jeffrey Potter, *To a Violent Grave: An Oral Biography of Jackson Pollock* (New York: G. P. Putnam's Sons, 1985), 203.

67 "a betrayal": Grace Hartigan, interview with the author, January 28, 1992.

67 "he was half-loaded": James T. Valliere, "De Kooning on Pollock: An Interview" (1967), reprinted in *Abstract Expressionism: A Critical Record*, ed. David Shapiro and Cecile Shapiro (Cambridge: Cambridge University Press, 1990), 373, 374.

68 tattered Bentonisms: Ellen G. Landau, *Jackson Pollock* (New York: Harry N. Abrams, 1989), 24, 84.

68 "You could kill a man": Ibid., 259 n. 2.

68 "spiritual projection": Hans Hofmann, in William C. Seitz, *Hans Hofmann* (New York: Museum of Modern Art, 1963), 14.

68 "the problem of civilizing": Hans Hofmann, "Painting and Culture" (1931), *Search for the Real and Other Essays*, ed. Sara T. Weeks and Bartlett H. Hayes, Jr. (Cambridge, Mass.: MIT Press, 1967), 56.

68 "put up or shut up": Carter Ratcliff, interview with Lee Krasner, *Art in America* 65 (September/October 1977): 82.

69 "I am nature": Landau, *Jackson Pollock*, 159. See also Steven Naifeh and Gregory White Smith, *Jackson Pollock: An American Saga* (New York: Clarkson N. Potter, 1989), 869.

69 "ritualistically attended": Harold Rosenberg, "Joan Mitchell: Artist Against Background," *Art on the Edge: Creators and Situations* (Chicago: University of Chicago Press, 1983), 84.

69 essential being: Hofmann, *Search for the Real*, 55, 63, 70. See p. 72 for Hofmann's warning that "spirituality in an artistic sense should not be confused with religious meaning." However, modernist painters, like their Romantic predecessors, often made art a vehicle —and a disguise—for religious impulses.

69 "But if you work from inside": Naifeh and Smith, *Jackson Pollock: An American Saga*, 486.

70 ungraspably large in scale: See Carter Ratcliff, "Big for the Eye," *Jackson Pollock: Drip Paintings on Paper, 1948–1949*, exhibition catalog (New York: C&M Arts, 1993), n. pag.

70 "It all ties together": Jackson Pollock, in Potter, *To a Violent Grave*, 135.

70 a clam without a shell: Grace Hartigan, interview with the author, January 28, 1992.

71 his friend Clyfford Still: Jackson Pollock, in Seldon Rodman, *Conversations with Artists* (New York: Capricorn Books, 1961), 84.

CHAPTER 11

74 "I paint only myself, not nature": Clyfford Still, interview with Benjamin J. Townsend (1961), *Abstract Expressionism: Creators and Critics*, ed. Clifford Ross (New York: Harry N. Abrams, 1990), 196.

74 "total psychic unity": Clyfford Still, interview with Ti-Grace Sharpless (1963), *Clyfford Still*

1904–1980: The Buffalo and San Francisco Collections, exhibition catalog, ed. Thomas Kellein (Munich: Prestel, 1992), 162.

74 "To be stopped by a frame's edge": Ibid.

74 "hopelessly trapped in the grids": Clyfford Still, letter to Mark Rothko, November 10, 1951, reprinted in *Clyfford Still*, exhibition catalog, ed. John P. O'Neill (New York: Metropolitan Museum of Art, 1979), 57.

74 "a melancholy, almost a tragic sense": Peggy Guggenheim, letter to Herbert Read, February 2, 1946, in Jacqueline Bograd Weld, *Peggy: The Wayward Guggenheim* (New York: E. P. Dutton, 1988), 338.

75 "form a theogony": Mark Rothko, introduction, *Clyfford Still*, exhibition catalog (New York: Art of This Century, 1946). Reprinted in Ross, *Abstract Expressionism*, 203.

75 "A strange man," she decided: Peggy Guggenheim, in Weld, *Peggy: The Wayward Guggenheim*, 338.

75 "the high and limitless plain": Clyfford Still, letter to Gordon Smith, January 1, 1959, in O'Neill, *Clyfford Still*, 196.

76 "the people who are looking": Mark Rothko, statement (1954), in Ross, *Abstract Expressionism*, 171.

76 "the states of mind": Mark Rothko, statement (undated), in Ross, *Abstract Expressionism*, 173.

76 "lives by companionship": Mark Rothko, statement (1947), in Ross, *Abstract Expressionism*, 170.

76 "made it clear": Clyfford Still, "An Open Letter to an Art Critic" (1963), in O'Neill, *Clyfford Still*, 47.

76 "To memorialize in the instruments": Clyfford Still, statement (1974) on *1950-A No. 2 (PH-336)* (1950), reprinted in O'Neill, *Clyfford Still*, 190–91.

76 "sterile conclusions of Western European decadence": Clyfford Still, letter to Gordon Smith, January 1, 1959, in O'Neill, *Clyfford Still*, 195.

76 "For the price": Clyfford Still, "An Open Letter to an Art Critic" (1963), in O'Neill, *Clyfford Still*, 47, 54.

77 "When I expose a painting": Clyfford Still, letter to an anonymous friend, May 1951, in Kellein, *Clyfford Still 1904–1980*, 156.

77 "Demands for communication": Clyfford Still, statement, *Fifteen Americans*, exhibition catalog, ed. Dorothy C. Miller (New York: Museum of Modern Art, 1952), 22.

77 embodied for his time: Clyfford Still, letter to Felicia Geffen, September 12, 1972, in O'Neill, *Clyfford Still*, 203–4.

CHAPTER 12

79 "stand all alone": Willem de Kooning, interview with Irving Sandler (1959), in Irving Sandler, *The New York School: The Painters & Sculptors of the Fifties* (New York: Harper & Row, 1978), 9.

79 "out of John Brown's body": Willem de Kooning, in Thomas B. Hess, *Willem de Kooning*, exhibition catalog (New York: Museum of Modern Art, 1968), 16. See also Thomas B. Hess, *Willem de Kooning* (New York: Braziller, 1959), 12.

79 "the most American of us all": Henry D. Thoreau, "A Plea for Captain John Brown" (1859), *Reform Papers*, ed. Wendell Glick (Princeton, N.J.: Princeton University Press, 1973), 125.

79 "basic human emotions": Mark Rothko, in Seldon Rodman, *Conversations with Artists* (New York: Devin-Adair, 1957), 94.

80 "in society signify what is just": Piet Mondrian, "A Dialogue on Neoplasticism" (1919),

reprinted in Hans L. C. Jaffe, *De Stijl* (New York: Harry N. Abrams, 1971), 121, 123.

80 the architecture of utopia: The progress from painting to utopia is a persistent theme in all the writings of Mondrian. For a particularly clear description of this hoped-for development, see Piet Mondrian, "Plastic Art and Pure Plastic Art" (1936), in *The New Art— The New Life: The Collected Writings of Piet Mondrian*, ed. and trans. Harry Holtzman and Martin S. James (Boston: G. K. Hall & Company, 1986), 299–300.

80 "And man?" asked Mondrian: Piet Mondrian, "Home—Street—City" (1926), in Holtzman and James, *The New Art—The New Life*, 209, 211–12.

80 "an empty world of geometric formalisms": Barnett Newman, "The Sublime Is Now" (1948), *Barnett Newman: Selected Writings and Interviews*, ed. John P. O'Neill (New York: Alfred A. Knopf, 1990), 173.

81 "it is precisely this death image": Barnett Newman, statement for the catalog of The New American Painting (1959), in O'Neill, *Barnett Newman: Selected Writings and Interviews*, 179.

81 "busted geometry": Barnett Newman, in Selden Rodman, *The Insiders: Rejection and Rediscovery of Man in the Arts of Our Time* (Baton Rouge: Louisiana State University Press, 1960), 34.

81 "I've licked Mondrian": Barnett Newman, in Thomas B. Hess, *Barnett Newman* (New York: Walker and Company, 1969), 68.

81 most ingenious explicator: See Thomas B. Hess, *Barnett Newman*, exhibition catalog (New York: Museum of Modern Art, 1971).

81 "He came over": Thomas B. Hess, *Barnett Newman* (New York: Walker and Company, 1969), 43.

81 Locke's tabula rasa: In fact, the term *tabula rasa* does not appear in John Locke's writings, though the image of the mind as a blank slate at birth is the starting point of *An Essay Concerning Human Understanding*, which he published in 1690. First used by Aristotle in *De Anima, tabula rasa* reappeared in an early French translation of Locke's image of the newborn mind as a "white paper, void of all characters, without any ideas." The mind generates ideas by reflecting on perceptions, an activity which Locke conceived as a kind of labor. Through reflection and other mental operations, the mind turns "simple sensations" into "complex ideas." Eventually, the mind possesses "a mass of knowledge" (*Essay*, bk. 2, ch. 1). Knowledge is thus a kind of property that individuals develop, through their own effort, from the interplay between the world and the original blankness of their minds. Property in the ordinary sense is gained by an analogous process, according to the second of Locke's *Two Treatises of Government* (1690). The primordial state of nature grants everything to everyone in common. By labor, one transforms things; one removes them from the state of nature, and thus they become one's property (second *Treatise*, ch. 27). Locke's *Essay* and his second *Treatise* have in common the image of the individual emerging, by his or her own labor, from a state of uncivilized blankness. Thus Locke's writing was of great importance to James Madison and others who assigned themselves the task of inventing a government in the New World, and Lockean ideas about the tabula rasa and the self-created individual echo through the comments of American artists who feel acutely the isolation of the United States from the traditions of the Old World. See Carter Ratcliff, "Dramatis Personae, Part IV: Proprietary Selves," *Art in America* 74 (February 1986): 9, 11, 13.

81 "sivilize" him: Mark Twain, *Mississippi Writings: Adventures of Huckleberry Finn*, ed. Guy Cardwell (New York: Library of America, 1982), 912.

82 "almost fifteen years ago": Dorothy Gees Seckler, "Frontiers of Space," interview with Barnett Newman (1962), in O'Neill, *Barnett Newman: Selected Writings and Interviews*, 251.

82 "all the members": Barnett Newman, "On the Need for Political Action by Men of Culture" (1933) and "Our Cultural Program" (1933), in O'Neill, *Barnett Newman: Selected Writings and Interviews*, 5, 6, 7.

82 "The aesthetic act": Barnett Newman, "The First Man Was an Artist" (1947), in O'Neill, *Barnett Newman: Selected Writings and Interviews*, 158.

82 "outside society": Barnett Newman, "A Conversation: Barnett Newman and Thomas B. Hess" (1966), in O'Neill, *Barnett Newman: Selected Writings and Interviews*, 275; and "Interview with Emile de Antonio" (1970), ibid., 304.

84 "An artist paints": Barnett Newman, statement in *Tiger's Eye* (1947), in O'Neill, *Barnett Newman: Selected Writings and Interviews*, 160.

84 "the terror of the Self": Barnett Newman, note in the catalog of the 8th São Paulo Biennial (1965), in O'Neill, *Barnett Newman: Selected Writings and Interviews*, 187.

84 Newman's and Pollock's birthdays: Thomas B. Hess, *Barnett Newman* (New York: Walker and Company, 1969), 57.

84 admiration for Pollock's art: Annalee Newman, interview with the author, March 3, 1992.

84 "had meaning only in relation": Barnett Newman, in Yves-Alain Bois, *Painting as Model* (Cambridge, Mass.: MIT Press, 1990), 254.

CHAPTER 13

87 "a flat, war-shattered city": Henry McBride, "Jackson Pollock" (1949), *The Flow of Art: Essays and Criticisms of Henry McBride*, ed. Daniel Catton Rich (New York: Atheneum, 1975), 425.

87 "painting is self-discovery": Jackson Pollock, in Selden Rodman, *Conversations with Artists* (New York: Devin-Adair, 1957), 85.

87 "the modern artist is working": William Wright, interview with Jackson Pollock, summer 1950, in Francis V. O'Connor, *Jackson Pollock*, exhibition catalog (New York: Museum of Modern Art, 1967), 80. This interview was never broadcast.

87 "Painting is no problem": Jackson Pollock, in Francine du Plessix and Cleve Gray, "Who Was Jackson Pollock?," interview with Lee Krasner, *Art in America* 55 (May-June 1967): 51.

88 Cubism, in particular: Steven Naifeh and Gregory White Smith, *Jackson Pollock: An American Saga* (New York: Clarkson N. Potter, 1989), 591.

88 lessons learned from Hans Hofmann: For Greenberg's acknowledgement of his debt to Hofmann's theories, see Clement Greenberg, "Review of an Exhibition of Hans Hofmann and a Reconsideration of Mondrian's Theories" (1945), *Clement Greenberg: Collected Essays and Writings*, 4 vols. (Chicago: University of Chicago Press, 1988), vol. 2, 18–19.

88 "modern art didn't drop out": Wright, interview with Pollock, in O'Connor, *Jackson Pollock*, 80.

88–89 "a god-damned European": Grace Hartigan, interview with the author, January 28, 1992.

89 "Paul, this is exotic music": Paul Falkenberg, "Notes on the Genesis of an Art Film," in Hans Namuth, *Pollock Painting* (New York: Agrinde Publications, 1980), n. pag.

89 the last day of filming: Namuth, "Photographing Pollock," *Pollock Painting*. See also Jeffrey Potter, *To a Violent Grave: An Oral Biography of Jackson Pollock* (New York: G. P. Putnam's Sons, 1985), 130–33; Lee Krasner, in John Gruen, *The Party's Over Now: Reminiscences of the Fifties—New York's Artists, Writers, Musicians, and Their Friends* (1967; Wainscott, N.Y.: Pushcart Press, 1989), 231; du Plessix and Gray, "Who Was Jackson Pollock?," 49; and Lee Krasner, in B. H. Friedman, *Jackson Pollock: Energy Made Visible* (New York: McGraw-Hill, 1972), 165.

90 "something a little odd": Rudy Burckhardt, interviews with the author, January 15, 1992, and March 1, 1992.

91 taffeta, silk, and ostrich feathers: "American Fashion: The New Soft Look," *Vogue* 17 (March 1, 1951): 156–59.

91 "There was a feeling": Rudy Burckhardt, interviews with the author, January 15, 1992, and March 1, 1992. Later, Krasner said that Pollock, too, felt that he had made enough drip paintings. "He couldn't have gone further doing the same thing," she said, in B. H. Friedman, "An Interview with Lee Krasner," *Jackson Pollock: Black and White*, exhibition catalog (New York: Marlborough-Gerson Gallery, 1969), 7.

94 "I'm not working much anymore": Friedman, *Jackson Pollock: Energy Made Visible*, xvi.

94 "In the forties": Elaine de Kooning, in Gruen, *The Party's Over Now*, 213, 218.

94 Pollock's appearances at the Cedar: Franz Kline, in Naifeh and Smith, *Jackson Pollock: An American Saga*, 758.

96 "What?" said Pollock: Gruen, *The Party's Over Now*, 228–29.

96 an "ugh artist": John Ferren, in Harry F. Gaugh, *Willem de Kooning* (New York: Abbeville Press, 1983), 8.

CHAPTER 14

97 "That's what fascinates me": Harold Rosenberg, "Interview with Willem de Kooning" (1972), *Willem de Kooning*, exhibition catalog (Pittsburgh: Museum of Art, Carnegie Institute, 1979), 148.

100 "The vegetation here": Willem de Kooning, letter to Joseph and Olga Hirshhorn, May 13, 1965, in Judith Zilczer, *Willem de Kooning* (Washington, D.C.: Hirshhorn Museum and Sculpture Garden, 1993), 159.

100 "were not interested in painting *per se*": Willem de Kooning, "Content Is a Glimpse . . . ," interview with David Sylvester (1960), ed. Thomas B. Hess, *Location* 1 (Spring 1963). Reprinted in *Willem de Kooning: Pittsburgh International Series*, exhibition catalog (Pittsburgh: Museum of Art, Carnegie Institute, 1979), 24.

101 "What the hell": Willem de Kooning, interview with Bert Schierbeek (1969), *Willem de Kooning: Collected Writings*, ed. George Scrivani (Madras and New York: Hanuman Books, 1988), 160–61.

101 "and his pointing out to me": Edwin Denby, "On Painting: The Thirties," *Dancers, Buildings and People in the Streets* (New York: Curtis Books, 1965), 202.

104 "I never made a Cubistic painting": Rosenberg, "Interview with Willem de Kooning," 151.

CHAPTER 15

107 he denounced communist dogma: Neil Jumonville, *Critical Crossings: New York Intellectuals in Postwar America* (Berkeley: University of California Press, 1991), 134.

107 one must wear a mask: Harold Rosenberg, "From Play Acting to Self," *Act and the Actor* (Chicago: University of Chicago Press, 1970), 126–32.

107–8 vulgarity of Western society: Harold Rosenberg, "Action Painting: Crisis and Distortion," *The Anxious Object* (Chicago: University of Chicago Press, 1982), 39.

108 "a grand crisis": Harold Rosenberg, "The American Action Painters," *The Tradition of the New* (Chicago: University of Chicago Press, 1982), 25.

108 "it was decided to paint": Ibid., 30.

108 "gesticulated upon the canvas": Ibid., 31.

108 "He is not a young painter": Ibid., 29–30.

108 "the act-painting is of the same": Ibid., 28.

109 de Kooning's willingness to doubt: Harold Rosenberg, "De Kooning: 'Painting Is a Way,'" *The Anxious Object*, 109, 111, 113.

109 Sartre on Giacometti: Jean-Paul Sartre, "The Quest for the Absolute" (1948), trans. Wade Baskin, in *Essays in Existentialism*, ed. Baskin (New York: Citadel Press, 1990), 392, 395, 399.

109 "reading Harold's action-painting piece": Michael Goldberg, interview with the author, May 16, 1993.

109 "we weren't influenced directly": Willem de Kooning, interview with Irving Sandler (1959), in Irving Sandler, *The Triumph of American Painting: A History of Abstract Expressionism* (New York: Harper & Row, 1970), 98.

109–11 "It was a mood, all right": Alex Katz, interview with the author, June 15, 1994.

111 billowing clouds of pretense: Rosenberg, "The American Action Painters," 32–35.

111 Pollock at Rosenberg's house: Jumonville, *Critical Crossings*, 140.

111 "Don't tell me": Harold Rosenberg, in Jeffrey Potter, *To a Violent Grave: An Oral Biography* (New York: G. P. Putnam's Sons, 1985), 181.

111 the best interests of pure painting: Clement Greenberg, "'American-Type' Painting" (1955), *The Collected Essays and Criticism*, 4 vols., ed. John O'Brian (Chicago: University of Chicago Press, 1993), vol. 3, 233–34.

112 "Rosenberg's piece on me": Jackson Pollock, in B. H. Friedman, *Jackson Pollock: Energy Made Visible* (New York: McGraw-Hill, 1972), 197.

112 "Painting for de Kooning": Rosenberg, "De Kooning: On the Borders of the Act," *The Anxious Object*, 124.

CHAPTER 16

113 "lyrical and calm": T[homas] B. H[ess], "Is Today's Artist with or Against the Past?," interview with Willem de Kooning, *Artnews* 57 (Summer 1958): 27, 56.

113 "I took the attitude": Willem de Kooning, "Content Is a Glimpse . . . ," interview with David Sylvester (1960), ed. Thomas B. Hess, *Location* 1 (Spring 1963), in *Willem de Kooning: Pittsburgh International Series*, exhibition catalog (Pittsburgh: Museum of Art, Carnegie Institute, 1979), 27–28.

113 "always in the picture somewhere": Willem de Kooning, in *Artists' Sessions at Studio 35* (1950), in Ann Eden Gibson, *Issues in Abstract Expressionism: The Artist-Run Periodicals* (Ann Arbor: UMI Research Press, 1990), 321–22.

114 To paint like Soutine and Ingres: Rudy Burckhardt, in Burckhardt and Simon Pettet, *Talking Pictures: The Photography of Rudy Burckhardt* (Cambridge, Mass.: Zoland Books, 1984), 150; Burckhardt, "Long Ago with Willem de Kooning," *Art Journal* 48 (Fall 1989): 223.

114 "never seems to make me peaceful or pure": Willem de Kooning, "What Abstract Art Means to Me" (1951), in Thomas B. Hess, *Willem de Kooning*, exhibition catalog (New York: Museum of Modern Art, 1968), 145.

114 "painter and painting are one": Harold Rosenberg, "De Kooning: 'Painting Is a Way,'" *The Anxious Object* (Chicago: University of Chicago Press, 1982), 112, 109–20, passim. See also Harold Rosenberg, "De Kooning: On the Borders of the Act," ibid., 123–29, passim.

114 painters become themselves: Rosenberg, "De Kooning: On the Borders of the Act," *The Anxious Object,* 124.

114 more purely "optical": Clement Greenberg, "Review of an Exhibition of Willem de Kooning" (1948), *The Collected Essays and Criticism*, 4 vols., ed. John O'Brian (Chicago: University of Chicago Press, 1993), vol. 2, 229.

116 "It is impossible today": Hess, *Willem de Kooning*, 74.

116 "The landscape is in the Woman": Ibid., 100. In 1955 de Kooning painted a picture called *Woman as Landscape*.

116 "could sustain this thing": Willem de Kooning, in Harold Rosenberg, "Willem de Kooning" (1973), *Art & Other Serious Matters* (Chicago: University of Chicago Press, 1985), 164. The ellipsis is in the original.

116 "You can't always tell": Willem de Kooning, in David L. Shirey, "Don Quixote in Springs," *Newsweek* 70 (November 20, 1967): 80.

116 "are always original": "Art: Willem the Walloper," *Time* 57 (April 30, 1951): 63.

116 sales were negligible: Thomas B. Hess, *Willem de Kooning* (New York: George Braziller, 1959), 116.

116 "Janis wants me": See Thomas B. Hess, *Willem de Kooning*, exhibition catalog (New York: Museum of Modern Art, 1968), 74. See also Rosenberg, "De Kooning: 'Painting Is a Way,' " *The Anxious Object*, 119. Rosenberg remembered de Kooning saying, while he was still entangled with the Women, "If I had character, I would paint abstractions."

117 "parkway landscapes": Thomas B. Hess, *Willem de Kooning*, exhibition catalog (New York: Museum of Modern Art, 1968), 26.

117 $2,600 in 1950: Francine du Plessix and Cleve Gray, "Who Was Jackson Pollock?," interview with Tony Smith, *Art in America* 55, no. 3 (May-June 1967): 54.

117 " 'luxury lofts' ": Thomas B. Hess, *De Kooning: Recent Paintings* (New York: Walker and Company, 1967), 10. Even at the end of the fifties, a de Kooning canvas offered for sale in New York fetched less than a work of comparable size by contemporary Parisian abstractionists now considered avant-garde hacks. See Thomas B. Hess, "A Tale of Two Cities" (1964), *The New Art*, ed. Gregory Battcock (New York: E. P. Dutton, 1966), 162 n. 1.

117 a studio built—and endlessly rebuilt: Thomas B. Hess, *Willem de Kooning*, exhibition catalog (New York: Museum of Modern Art, 1968), 101–2, 122.

117 "Enormously!" said de Kooning: Harold Rosenberg, "Interview with Willem de Kooning" (1972). Reprinted in *Willem de Kooning: Pittsburgh International Series*, 157.

119 "the center of things": Thomas B. Hess, *Willem de Kooning*, exhibition catalog (New York: Museum of Modern Art, 1968), 101.

CHAPTER 17

121 According to a memoir: Ruth Kligman, *Love Affair* (New York: Morrow, 1974), 30–45.

121 Other accounts: B. H. Friedman, *Jackson Pollock: Energy Made Visible* (New York: McGraw-Hill, 1972), 232.

121 As summer started: Jeffrey Potter, *To a Violent Grave: An Oral Biography of Jackson Pollock* (New York: G. P. Putnam's Sons, 1985), 230.

122 a dozen roses: Steven Naifeh and Gregory White Smith, *Jackson Pollock: An American Saga* (New York: Clarkson N. Potter, 1989), 783–84.

124 "a strange sensation": Mercedes Molleda, review of The New American Painting (1958), in Clifford Ross, *Abstract Expressionism: Creators and Critics* (New York: Harry N. Abrams, 1990), 281. My translation.

124 "Why do they think they are painters?": Claude Roger Marx, review of The New American Painting (1959), in Ross, *Abstract Expressionism: Creators and Critics*, 287.

124 "the roots of this art": André Chastel, review of The New American Painting (1959), in Ross, *Abstract Expressionism: Creators and Critics*, 288.

125 "an extraordinary occasion": Irving Blum, interview with the author, May 9, 1994.

126 They had formed a new academy: Irving Sandler, "Introduction," *Defining Modern Art:*

Selected Writings of Alfred H. Barr, Jr., ed. Irving Sandler and Amy Newman (New York: Harry N. Abrams, 1986), 41.

126 "I don't know how I responded": Grace Hartigan, interview with the author, November 11, 1994.

127 "an eloquent guy": Michael Goldberg, interview with the author, April 27, 1994.

127 "We liked our father figures": Alex Katz, interview with the author, January 21, 1992.

127 "Of course": Elaine de Kooning, "Is There a New Academy?" *Artnews* 56 (June 1959): 36.

127 "unless they are singing": Elaine de Kooning, "Subject: What, How, or Who?" (1955), *The Spirit of Abstract Expressionism: Selected Writings* (New York: George Braziller, 1994), 145.

CHAPTER 18

129 "Beware the body": Jasper Johns, "Sketchbook Notes," *Art and Literature* 4 (Spring 1965), in *Pop Art Redefined*, ed. John Russell and Suzi Gablik (New York: Praeger, 1969), 84.

132 the painting appeared on the magazine's cover: *Artnews* 56 (January 1958).

132 "I thought Alfred Barr was God": Susan Cheever, "Johns & Castelli, Inc.," *Harper's Bazaar* 3373 (January 1993): 78.

132 "a strange and very interesting city": Leo Castelli, interview with the author, May 5, 1992.

132 Trieste, where he was born: Laura de Coppet and Alan Jones, "Leo Castelli," *The Art Dealers: The Powers Behind the Scene Talk about the Business of Art* (New York: Clarkson N. Potter, 1984), 81–83.

134 Mighty Mouse: Willem de Kooning quoted by Ruth Kligman, interview with the author, December 22, 1993; Calvin Tomkins, "Leo Castelli: A Good Eye and a Good Ear," *The New Yorker* 56 (May 26, 1980): 52, 59.

134 Dora and Ernest Rauschenberg: Mary Lynn Kotz, *Rauschenberg/Art and Life* (New York: Harry N. Abrams, 1990), 47–48.

134 *Pinkie* and *Blue Boy*: Barbara Rose, *Robert Rauschenberg* (New York: Vintage Books, 1987), 7.

136 veteran of the Bauhaus: Josef Albers: Kotz, *Rauschenberg/Art and Life*, 60–61.

136 The Stable Gallery: Rose, *Robert Rauschenberg*, 32, 36–37.

137 "I always paid": Ibid., 28.

CHAPTER 19

139 a drawing to erase: Mary Lynn Kotz, *Rauschenberg/Art and Life* (New York: Harry N. Abrams, 1990), 82.

139 "he wasn't going to make it easy": Barbara Rose, *Robert Rauschenberg* (New York: Vintage Books, 1987), 36.

139 "just fooling around": Willem de Kooning, statement (1962), in Kotz, *Rauschenberg/Art and Life*, 79.

140 "think of *Bed*": Robert Rauschenberg, in Calvin Tomkins, *Off the Wall: Robert Rauschenberg and the Art World of Our Times* (New York: Penguin Books, 1980), 137.

140 In some tellings of the story: These versions of Leo Castelli's first meeting with Jasper Johns are from the author's conversation with Castelli, May 5, 1992; Louis A. Zona, "Johns/Castelli: Some Thoughts on a Friendship," *Jasper Johns: Drawings and Prints from the Collection of Leo Castelli*, exhibition catalog (Youngstown, Ohio: Butler Institute of American Art, 1989), 4; Laura de Coppet and Alan Jones, "Leo Castelli," *The Art Dealers: The Powers Behind the Scene Talk about the Business of Art* (New York: Clarkson N. Potter, 1984), 88; "Leo Castelli," an interview, *Art & Auction* 5, no. 6 (February 1983), 63; Tomkins,

Off the Wall, 140; Michael Crichton, *Jasper Johns*, exhibition catalog, rev. ed. (New York: Harry N. Abrams, 1994), 36; Emile de Antonio and Mitch Tuchman, *Painters Painting: A Candid History of the Modern Art Scene, 1940–1970* (New York: Abbeville Press, 1984), 95–96.

140 "I'd never made a print": Vivien Raynor, "Jasper Johns: 'I Haven't Attempted to Develop My Thinking in Such a Way That the Work I've Done Is Not Me,' " *Artnews* 72 (March 1973): 21.

142 "separate and equal": Ruth Fine and Nan Rosenthal, "Interview with Jasper Johns" (1989), *The Drawings of Jasper Johns*, exhibition catalog (Washington, D.C.: National Gallery of Art, 1990), 71.

142 "I knew him so well": Tatyana Grosman, in Crichton, *Jasper Johns*, 19.

142 "Jasper, you must be": John Cage, "Jasper Johns: Stories and Ideas" (1964), *The New Art*, ed. Gregory Battcock (New York: E. P. Dutton, 1966), 212.

142 Allendale, South Carolina: Johns was born in Augusta, Georgia, which was the city nearest to Allendale that had a hospital. Jasper Johns, letter to the author, December 9, 1994.

142 He remembers drawing: D. R. Rickborn, "Art's Fair-Haired Boy: Allendale's Jasper Johns Wins Fame with Flags," *The State*, Columbia, South Carolina (January 15, 1961), in *35 Years: Jasper Johns, Leo Castelli*, exhibition catalog, ed. Susan Brundage (New York: Leo Castelli Gallery, 1993), n. pag.

142 At the age of five: Grace Glueck, " 'Once Established,' Says Jasper Johns, 'Ideas Can Be Discarded,' " *The New York Times* (October 16, 1977): sec. 2, 31.

142 "swans on a stream": Jasper Johns, letter to the author, December 9, 1994.

144 "It didn't occur to me": Fine and Rosenthal, "Interview with Jasper Johns" (1989), 71.

144 "It wasn't especially cheerful": Peter Fuller, "Jasper Johns Interviewed Part II," *Art Monthly* 19 (September 1978): 7.

144 Silas Green's dance troupe: Richard Francis, *Jasper Johns* (New York: Abbeville Press, 1984), 16. Jasper Johns, letter to the author, December 9, 1994.

144 "were not highly accomplished": Jasper Johns, interview with the author, March 11, 1991.

144 refuses to give the school's name: Jasper Johns, letter to the author, December 9, 1994.

144 "made posters that advertised movies": David Bourdon, "Jasper Johns: 'I Never Sensed Myself as Being Static,' " *The Village Voice* (October 31, 1977): 75.

145 "It seemed to me": Glueck, " 'Once Established,' Says Jasper Johns, 'Ideas Can Be Discarded,' " sec. 2, 31.

145 liebfraumilch: Rose, *Robert Rauschenberg*, 33.

145 Johns and Suzi Gablik: Jasper Johns, letter to the author, December 9, 1994.

CHAPTER 20

147 "I have photos of him": Calvin Tomkins, *Off the Wall: Robert Rauschenberg and the Art World of Our Times* (New York: Penguin Books, 1980), 109–10.

147 "the first person": Michael Crichton, *Jasper Johns*, exhibition catalog, rev. ed. (New York: Harry N. Abrams, 1994), 34.

147 turned to each other: Tomkins, *Off the Wall*, 112–13, 118.

147 "It was sort of new": Paul Taylor, interview with Robert Rauschenberg, *Interview* 20 (December 1990): 147.

148 "there wasn't any resistance": Barbara Rose, *Robert Rauschenberg* (New York: Vintage Books, 1987), 36.

148 "Basically," Johns remembered: Tomkins, *Off the Wall*, 134.

148 Rauschenberg meeting Cage: Rose, *Robert Rauschenberg*, 23; Mary Lynn Kotz, *Rauschenberg/Art and Life* (New York: Harry N. Abrams, 1990), 71.

148 "had a really incredible view": Rose, *Robert Rauschenberg*, 33.

149 "an affirmation of life": John Cage, *Silence: Lectures and Writings* (1961), in Tomkins, *Off the Wall*, 69.

149 Seeking freedom: "In the Form of a Thistle: A Conversation Between John Cage and Thomas McEvilley," *Artforum* 31 (October 1992): 100.

149 "If I put a frame": Robin White, "John Cage," *View* 1 (April 1978), in Richard Kostelanetz, *Conversing with Cage* (New York: Limelight Editions, 1991), 211.

149 to impose fixity on flux: "In the Form of a Thistle," 99.

149 "I would want art": Robin White, "John Cage," *View* 1 (April 1978), in Kostelanetz, *Conversing with Cage*, 211–12.

149 "Painting relates": Robert Rauschenberg, statement, *Sixteen Americans*, exhibition catalog, ed. Dorothy C. Miller (New York: Museum of Modern Art, 1959), 58.

149 "I have a peculiar kind": Tomkins, *Off the Wall*, 8.

149 Rauschenberg painted a stripe: Ibid., 118–19.

150 "I don't see the necessity": James Klosty, interview with Jasper Johns, *Merce Cunningham* (New York: Limelight Editions, 1986), 85.

150 Johns corrected Rauschenberg's grammar: Tomkins, *Off the Wall*, 119.

CHAPTER 21

151 "a social attitude": Gene Swenson, "What Is Pop Art," interview with Jasper Johns (1964), in *Pop Art: The Critical Dialogue*, ed. Carol Anne Mahsun (Ann Arbor: UMI Research Press, 1989), 135.

151 "I liked the attention": Michael Crichton, *Jasper Johns*, exhibition catalog, rev. ed. (New York: Harry N. Abrams, 1994), 38.

152 "sympathy" for the Dada spirit: Marcel Duchamp, interview with Dorothy Norman (1953), *Art in America* 57 (July-August 1969): 38.

152 They liked each other: Crichton, *Jasper Johns*, 39–40.

152 recently published book on Duchamp: Robert Lebel, *Marcel Duchamp* (1959), with chapters by Marcel Duchamp, André Breton, and H.-P. Roche (New York: Grove Press, 1959).

152 "when my work was first compared": Roberta J. M. Olson, "Jasper Johns: Getting Rid of Ideas" (1977), in Riva Castleman, *Jasper Johns: A Print Retrospective*, exhibition catalog (New York: Museum of Modern Art, 1986), 11.

152 "My interest in his work": Peter Fuller, "Jasper Johns Interviewed I," *Art Monthly* 19 (July-August 1978): 10.

152 "it may be a great work": Jasper Johns, "Thoughts on Duchamp," *Art in America* 57 (July/August 1969): 31.

153 "the shadows change": John Coplans, "Fragments According to Johns: An Interview with Jasper Johns," *Print Collector's Newsletter* 3 (May-June 1971): 31.

153 "I don't think": April Bernard and Mimi Thompson, interview with Jasper Johns, *Vanity Fair* 47 (February 1984): 65.

156 a champagne picnic: Roberta Bernstein, *Jasper Johns' Paintings and Sculptures 1954–1974: The Changing Focus of the Eye* (Ann Arbor: UMI Research Press, 1975), 122–23.

158 Leonardo: Ibid., 60. In an early statement, Johns extracts from Leonardo's comments on drawing a thoroughly Johnsian ambiguity—the notion that, in Johns's words, "the boundary of a body is neither part of the body nor a part of the surrounding atmosphere." See

Jasper Johns, statement, *Sixteen Americans*, exhibition catalog, ed. Dorothy C. Miller (New York: Museum of Modern Art, 1959), 22.

158 *Moby Dick*: Mark Rosenthal, *Jasper Johns: Work since 1974*, exhibition catalog (Philadelphia: Philadelphia Museum of Art, 1990), 75.

158 faucets and laundry hamper: Ibid., 65, 70.

Chapter 22

161 "Any fool can see that it's a broom!": Alan R. Solomon, "Jasper Johns," *Jasper Johns*, exhibition catalog (New York: Jewish Museum, 1964), 16.

161 its use, which is to make art: For Johns's discovery, in the writings of Ludwig Wittgenstein, of the theory that meaning follows from use, see Roberta Bernstein, *Jasper Johns' Paintings and Sculptures 1954–1974: The Changing Focus of the Eye* (Ann Arbor: UMI Research Press, 1985), 92–94.

162 "was something that I could do": Michael Crichton, *Jasper Johns*, exhibition catalog, rev. ed. (New York: Harry N. Abrams, 1994), 30.

162 the sale of *Three Flags*: Arnold Glimcher, in Laura de Coppet and Alan Jones, *The Art Dealers: The Powers Behind the Scene Talk about the Business of Art* (New York: Clarkson N. Potter, 1984), 168–69.

162 "Whatever I do seems artificial": Crichton, *Jasper Johns*, 53.

163 "I think art criticizes art": Vivien Raynor, "Jasper Johns: 'I Haven't Attempted to Develop My Thinking in Such a Way That the Work I've Done Is Not Me,'" *Artnews* 72 (March 1973): 21.

163 "They just looked": Grace Glueck, "Art Notes: Art's Artist," *The New York Times* (January 16, 1966), in *35 Years: Jasper Johns, Leo Castelli*, exhibition catalog, ed. Susan Brundage (New York: Leo Castelli Gallery, 1993), n. pag.

164 "No. The title *Scent*": David Bourdon, "Jasper Johns: 'I Never Sensed Myself as Being Static,'" *The Village Voice* 22 (October 31, 1977): 75.

164 "I don't put any value": Gene Swenson, "What Is Pop Art," interview with Jasper Johns (1964), in *Pop Art: The Critical Dialogue*, ed. Carol Anne Mahsun (Ann Arbor: UMI Research Press, 1989), 135.

165 "If you have one thing": Ibid., 136.

Chapter 23

167 "One thing is not another thing": Walter Hopps, "An Interview with Jasper Johns" (1965), *Looking Critically: 21 Years of Artforum Magazine*, ed. Amy Baker Sandback (Ann Arbor: UMI Research Press, 1984), 27.

167 "it's not too important": John Coplans, "Fragments According to Johns: An Interview with Jasper Johns," *Print Collector's Newsletter* 3 (May-June 1972): 32.

167 the focus of your eye: Jasper Johns, statement, *Sixteen Americans*, exhibition catalog, ed. Dorothy C. Miller (New York: Museum of Modern Art, 1959), 22; Gene Swenson, "What Is Pop Art," interview with Jasper Johns (1964), in *Pop Art: The Critical Dialogue*, ed. Carol Anne Mahsun (Ann Arbor: UMI Research Press, 1989), 132–33.

168 "My immediate impression": Jasper Johns, interview with the author, March 11, 1991.

168 "acknowledging the common continent": Herman Melville, *Moby Dick* (New York: Modern Library, 1950), 119.

169 "Even the simplest thing": Robert Rosenblum, interview with the author, March 17, 1991.

170 proceeded with deliberation: Brice Marden, statement, in Carl Andre, "New in New York: Line Work," *Arts Magazine* 41 (May 1967): 50.

CHAPTER 24

175 "confronted, assaulted, sucked in": Allan Kaprow, "The Legacy of Jackson Pollock" (1958), *Essays on the Blurring of Art and Life*, ed. Jeff Kelley (Berkeley: University of California Press, 1993), 1–7.

175 "Art should not be different": John Cage, quoted by Francine du Plessix Gray, in Martin Duberman, *Black Mountain: An Exploration in Community* (New York: E. P. Dutton, 1972), 349.

176 "wanted his canvas": Harold Rosenberg, "The American Action Painters" (1952), *The Tradition of the New* (Chicago: University of Chicago Press, 1982), 25, 30.

176 "not to more paintings": Allan Kaprow, in Michael Benedikt, *Three Experiments* (New York: Doubleday & Company, 1967), 355.

176 "events that, put simply, happen": Allan Kaprow, "Happening in the New York Scene" (1961), in Kelley, *Essays on the Blurring of Art and Life*, 16–17.

176 "is to be intimate": Allan Kaprow, in Irving Sandler, *The New York School: The Painters and Sculptors of the Fifties* (New York: Harper & Row, 1978), 201–2.

177 "It was becoming so chic": Jim Dine, statement, in *American Artists on Art, from 1940 to 1980*, ed. Ellen H. Johnson (New York: Harper & Row, 1982), 68.

177 John Cage objected: John Cage, in Sandler, *The New York School*, 213 n. 37.

177 Kaprow had acknowledged the obvious: Ibid., 203.

177 "Pop Art, Minimalism": Elizabeth Baker, interview with the author, September 25, 1994.

178 the Supremes themselves performed: Ibid.

179 Henry Geldzahler took Rauschenberg to Warhol's studio: Andy Warhol and Pat Hackett, *POPism: The Warhol '60s* (New York: Harcourt Brace Jovanovich, 1980), 22; Roni Feinstein, *Robert Rauschenberg: The Silkscreen Paintings 1962–64*, exhibition catalog (New York: Whitney Museum of American Art, 1990), 45.

180 "not so likely to get hung up": Robert Rauschenberg, interview with Calvin Tomkins, June 25, 1963, in Feinstein, *Robert Rauschenberg: The Silkscreen Paintings 1962–64*, 42.

182 "seemingly can't be dealt with": G. R. Swenson, "What Is the F-111?," interview with James Rosenquist (1965), in John Russell and Suzi Gablik, *Pop Art Redefined* (New York: Praeger, 1969), 109.

183 "the great scale": Allan Kaprow, "The Legacy of Jackson Pollock" (1958), in Kelley, *Essays on the Blurring of Art and Life*, 2.

CHAPTER 25

185 "We all loved him": Diana Vreeland, statement (1989), in Kynaston McShine, *Andy Warhol: A Retrospective*, exhibition catalog (New York: Museum of Modern Art, 1989), 424.

187 Warhol's birth date: Victor Bockris, *The Life and Death of Andy Warhol* (New York: Bantam Books, 1990), 10; David Bourdon, *Warhol* (New York: Harry N. Abrams, 1989), 14, 25 n. 2.

187 "My father was away": Andy Warhol, *The Philosophy of Andy Warhol (From A to B and Back Again)* (New York: Harcourt Brace Jovanovich, 1975), 21–22.

188 "started on the first day": Ibid., 21.

188 comic books and coloring books: John Warhola, in Bennard B. Perlman, "The Education of Andy Warhol," *The Andy Warhol Museum* (Pittsburgh: Andy Warhol Museum, 1994), 148.

189 "I got something": Warhol, *The Philosophy of Andy Warhol*, 22.

189 "Andy's first idea": Philip Pearlstein, in Jean Stein, *Edie: An American Biography* (New York: Alfred A. Knopf, 1982), 187.

189 "Success Is a Career at Home" and so on: "What Is Success?" with illustrations by Andy Warhol, *Glamour* 22 (September 1949): 147–53.

189 the last *a* was dropped from Warhola: Perlman, "The Education of Andy Warhol," 149.

189 They were "electrifying": Tina S. Fredericks, "Remembering Andy," in Jesse Kornbluth, *Pre-Pop Warhol* (New York: Panache Press at Random House, 1988), 11.

189 When Andy fell ill as a child: Bob Colacello, *Holy Terror: Andy Warhol Close Up* (New York: HarperCollins, 1990), 16–17.

191 Warhol's imagery "made an enormous difference": Geraldine Stutz, in Patrick S. Smith, *Warhol: Conversations about the Artist* (Ann Arbor: UMI Research Press, 1988), 101, 103–6.

192 "almost nonexistent": Tina S. Fredericks, interview (1978), in Smith, *Warhol: Conversations about the Artist*, 101.

192 a cockroach crawls out: Colacello, *Holy Terror*, 21.

192 *1000 Names and Where to Drop Them*: Bourdon, *Warhol*, 61.

193 "a piece of shit": Andy Warhol and Pat Hackett, *POPism: The Warhol '60s* (New York: Harcourt Brace Jovanovich, 1980), 6.

193 "I'm doing work just like that myself": The source of this version of the story is Ivan Karp, in Stein, *Edie: An American Biography*, 195. For other versions, see Ivan Karp, in Smith, *Warhol: Conversations about the Artist*, 211; Ted Carey, in Smith, *Warhol: Conversations about the Artist*, 88–89; and Warhol and Hackett, *POPism: The Warhol '60s*, 7.

CHAPTER 26

195 Lexington Avenue Studio: Ivan Karp, in Jean Stein, *Edie: An American Biography* (New York: Alfred A. Knopf, 1982), 195; Walter Hopps, in Stein, *Edie*, 192.

196 "to be the eyes of the Met": Ingrid Sischy, "An Interview with Henry Geldzahler," in Henry Geldzahler, *Making It New* (New York: Turtle Point Press, 1994), 2.

196 "I think they're really wonderful": Ted Carey, in Patrick S. Smith, *Warhol: Conversations about the Artist* (Ann Arbor: UMI Research Press, 1988), 90.

196 "They were stacked away": Eleanor Ward, in Smith, *Warhol: Conversations about the Artist*, 202.

196 too much like Lichtenstein's: David Bourdon, *Warhol* (New York: Harry N. Abrams, 1989), 109.

197 a show at the Ferus Gallery: Irving Blum, in Smith, *Warhol: Conversations about the Artist*, 195.

197 "Look what the cat dragged in": Eleanor Ward, in Smith, *Warhol: Conversations about the Artist*, 200–1, 204.

197 Philip Johnson: Victor Bockris, *The Life and Death of Andy Warhol* (New York: Bantam Books, 1990), 116.

197 his first Pop images: Bourdon, *Warhol*, 106–8. During the fifties, Warhol had used balsa wood and eraser stamps to produce commercial images. See Jesse Kornbluth, *Pre-Pop Warhol* (New York: Panache Press at Random House, 1988), 122.

197 rows of Coca-Cola bottles: Marjorie Frankel Nathenson, "Chronology," in Kynaston McShine, *Andy Warhol: A Retrospective*, exhibition catalog (New York: Museum of Modern Art, 1989), 407.

198 "assembly-line effect": Andy Warhol and Pat Hackett, *POPism: The Warhol '60s* (New York: Harcourt Brace Jovanovich, 1980), 22.

198 an empty fire station: Bourdon, *Warhol*, 142.

198 a building on East Forty-seventh Street: Warhol and Hackett, *POPism: The Warhol '60s*, 61.

200 "They were always discreet": Ibid., 54–55, 61–65.

200 a Park Avenue housewife: Ibid., 59.

200 "too faggy and sick and druggy": Jane Holzer, in Stein, *Edie: An American Biography*, 228.

200 "Sugar Shack": Warhol and Hackett, *POPism: The Warhol '60s*, 64, 83–84.

201 his trademark outfit: Ibid., 172.

CHAPTER 27

203 a dealer named Michael Sonnabend: Calvin Tomkins, "Profile: Leo Castelli," *The New Yorker* 56 (May 26, 1980): 62.

203 a skyscraper on West Fiftieth Street: This is the Time-Life Building, at West Fiftieth Street and Sixth Avenue. See Callie Angell, *The Films of Andy Warhol: Part II* (New York: Whitney Museum of American Art, 1994), 15.

203 "The Empire State Building is a star!": Andy Warhol, statement, *Andy Warhol*, exhibition catalog (Stockholm: Moderna Museet, 1968), n. pag.

203 a "retired" painter devoted to film: Andy Warhol and Pat Hackett, *POPism: The Warhol '60s* (New York: Harcourt Brace Jovanovich, 1980), 113, 115.

203 *Flowers*: David Bourdon, *Warhol* (New York: Harry N. Abrams, 1989), 191, 193.

204 to get rid of plot: Ronald Tavel, in Jean Stein, *Edie: An American Biography* (New York: Alfred A. Knopf, 1982), 232, 234.

205 "I wanted to do everything": Warhol and Hackett, *POPism: The Warhol '60s*, 263.

206 "the point was to be fabulous": Danny Fields, in Patrick S. Smith, *Warhol: Conversations about the Artist* (Ann Arbor: UMI Research Press, 1988), 290.

206 "They're better talked about than seen": Paul Taylor, "Andy Warhol: The Last Interview," *Flash Art* 133 (April 1987): 41–44.

206 to concentrate on painting: See Bob Colacello, *Holy Terror: Andy Warhol Close Up* (New York: HarperCollins, 1990), 90ff.

206 Debbie Dropout: Warhol and Hackett, *POPism: The Warhol '60s*, 255–57, 259.

206 "It was so dirty": Ibid., 271.

207 "a sort of glamorous clubhouse": Henry Geldzahler, in Stein, *Edie: An American Biography*, 201.

208 "he had too much control over my life": Bourdon, *Warhol*, 284; Stein, *Edie: An American Biography*, 288–94; Warhol and Hackett, *POPism: The Warhol '60s*, 271–74, 277; Paul Alexander, *Death and Disaster: The Rise of the Warhol Empire and the Race for Andy's Millions* (New York: Villard Books, 1994), 64–71.

208 "without the crazy, druggy people": Warhol and Hackett, *POPism: The Warhol '60s*, 285.

208 "If this is art": Colacello, *Holy Terror*, 4–5.

CHAPTER 28

211 portraits on commission: Bob Colacello, *Holy Terror: Andy Warhol Close Up* (New York: HarperCollins, 1990), 89, 94–95, 446. The price of copies had risen to $20,212 by the end of Warhol's life.

212 "when you're working with silk screen": Gerard Malanga, in Patrick S. Smith, *Warhol: Conversations about the Artist* (Ann Arbor: UMI Research Press, 1988), 170.

214 "The Monroe picture": Gretchen Berg, "Nothing to Lose: An Interview with Andy Warhol" (1967), *Andy Warhol: Film Factory*, ed. Michael O'Pray (London: BFI Publishing, 1989), 54, 56.

214 "If you want to know": Ibid., 56.

214 "I think it's horrible to live": Andy Warhol, unpublished interview with Scott Cohen, October 1980, in Colacello, *Holy Terror*, 438.

214 religious feelings recalled by eulogists: See, for example, John Richardson, "Eulogy for Andy Warhol" (1987), in Kynaston McShine, *Andy Warhol: A Retrospective*, exhibition catalog (New York: Museum of Modern Art, 1989), 454.

215 "Why don't you start": Colacello, *Holy Terror*, 373.

215 "get it all down": Colacello, *Holy Terror*, 373–74.

215 "people at the top, or around the top": Andy Warhol, with Bob Colacello, *Andy Warhol's Exposures* (New York: Andy Warhol Books/Grosset & Dunlap, 1979), 19.

215 he wanted Clint Eastwood: Ibid., 188.

215 The sum of these preferences: Carter Ratcliff, "Starlust: Andy's Photos," *Art in America* 68 (May 1980): 120–22.

216 "Everybody has their own America": Andy Warhol, *America* (New York: Harper & Row, 1985), 8.

CHAPTER 29

220 "You could become a de Kooning disciple": John Elderfield, *Frankenthaler* (New York: Harry N. Abrams, 1989), 39.

221 "a bridge between Pollock and what was possible": John Elderfield, *Morris Louis*, exhibition catalog (New York: Museum of Modern Art, 1986), 13.

221 had joined him in his quandary: Helen Frankenthaler, interview with the author, March 3, 1989.

222 "becomes paint in itself": Clement Greenberg, "Louis and Noland" (1960), *The Collected Essays and Criticism*, 4 vols., ed. John O'Brian (Chicago: University of Chicago Press, 1993), vol. 4, 95–97. See also Greenberg, "Introduction to Jules Olitski at the Venice Biennale" (1966), *The Collected Essays and Criticism*, vol. 4, 228–30.

222 disparities between theory and practice: Carter Ratcliff, "Art Criticism: Other Eyes, Other Minds (Part V), On Clement Greenberg," *Art International* 18 (December 1974): 53–57.

222 "constantly taking a risk": Simone Swan, "A Conversation with Peter Bradley," *The Deluxe Show*, exhibition catalog (Houston: Menil Foundation, 1971), 67.

223 "the irreducible essence of pictorial art": Greenberg, "After Abstract Expressionism" (1962), *The Collected Essays and Criticism*, vol. 4, 131–34. For evidence that Frankenthaler did not entirely accept the Greenbergian theory of flatness and pure "opticality," see Cindy Nemser, "Interview with Helen Frankenthaler" (1971), *American Artists on Art from 1940 to 1980*, ed. Ellen H. Johnson (New York: Harper & Row, 1982), 55.

223 true progress in art: Michael Fried, "Three American Painters," *Three American Painters: Kenneth Noland, Jules Olitski, Frank Stella*, exhibition catalog (Cambridge, Mass.: Harvard University, Fogg Art Museum, 1965), 8.

223 a tone of millennial fervor: See, for example, Walter Darby Bannard, "Color, Paint, and Present-Day Painting," *Artforum* 4 (April 1966): 35–37; Michael Fried, "The Achievement of Morris Louis," *Artforum* 6 (February 1967): 34–30; Jane Harrison Cone, "Kenneth Noland's New Paintings," *Artforum* 6 (November 1967): 36–41; and Kermit S. Champa, "Olitski: Nothing but Color," *Artnews* 66 (May 1967): 36–38, 74–76.

CHAPTER 30

225 an array of uncompromised facts: Donald Judd, "Jackson Pollock" (1967), *Complete Writings 1959–1975* (Halifax, Nova Scotia: Nova Scotia College of Art and Design Press, 1975), 151.

225 "spatially illusionistic": Donald Judd, interview (1971), in Jeanne Siegel, *Artwords: Discourse*

on the 60s and 70s (Ann Arbor: UMI Research Press, 1985), 48. See also Bruce Glaser, "Questions to Stella and Judd," in *Minimal Art: A Critical Anthology*, ed. Gregory Battcock (New York: E. P. Dutton, 1968), 155.

226 "shape, image, color": Donald Judd, "Specific Objects" (1965), in *Art and Theory, 1900–1990: An Anthology of Changing Ideas*, ed. Charles Harrison and Paul Wood (Oxford: Blackwell, 1992), 813.

226 the traits of a good "gestalt": Robert Morris, "Notes on Sculpture, Part 1" (1966), *Continuous Project Altered Daily: The Writings of Robert Morris* (Cambridge, Mass.: MIT Press, 1993), 6–8.

227 "duality of thing and allusion": Robert Morris, "Notes on Sculpture, Part 3: Notes and Non Sequiturs" (1967), *Continuous Project Altered Daily*, 26.

227 no "divisiveness of experience": Ibid., 25.

227 "scale, proportion, shape": Morris, "Notes on Sculpture, Part 1," 4.

227 "My arrangements": Carl Andre, statement (1978), in *Minimalism*, exhibition catalog (Liverpool, Eng.: Tate Gallery Liverpool, 1989), 12.

227 "As people walk on them": Carl Andre, statement (1969), *Art in Process IV*, exhibition catalog, ed. Elaine H. Varian (New York: Finch College Museum of Art/Contemporary Wing, 1969), n. pag.

227 idea must be followed "blindly": Sol LeWitt, "Sentences on Conceptual Art" (1968), *Conceptual Art*, ed. Ursula Meyer (New York: E. P. Dutton, 1972), 174–75.

228 Metaphorical play is not encouraged: Robert Morris, "Notes on Sculpture, Part 2" (1966), *Continuous Project Altered Daily*, 11–16.

228 the periodic table of the elements: Advertisement for an exhibition of Carl Andre's work at the Dwan Gallery, New York, May 1969. See *Arts Magazine* 43 (May 1969): 22.

228 "pure opticality": Michael Fried, "Art and Objecthood" (1967), in Battcock, *Minimal Art*, 116–47.

CHAPTER 31

231 "a kind of palpable reality": Frank Stella, in William S. Rubin, *Frank Stella*, exhibition catalog (New York: Museum of Modern Art, 1970), 12.

231 to find "a way": Ibid., 13.

232 Miller declared her intention: Leo Castelli, interview, in Laura de Coppet and Alan Jones, *The Art Dealers: The Powers Behind the Scene Talk about the Business of Art* (New York: Clarkson N. Potter, 1984), 92–93.

233 "symbols are counters": Carl Andre, "Frank Stella," *Sixteen Americans*, exhibition catalog, ed. Dorothy C. Miller (New York: Museum of Modern Art, 1959), 76.

234 the "soul" of Frank Stella: Michael Fried, "Theories of Art after Minimalism and Pop: Discussion," *Discussion in Contemporary Culture, Number 1*, ed. Hal Foster (Seattle: Bay Press, 1987), 79.

234 Stella's paintings as "slabs": Donald Judd, in Bruce Glaser, "Questions to Stella and Judd" (1966), *Minimal Art: A Critical Anthology*, ed. Gregory Battcock (New York: E. P. Dutton, 1968), 162.

234 "what you see is what you see": Frank Stella, in Bruce Glaser, "Questions to Stella and Judd," 158.

234 The question, Fried argued: Michael Fried, "Art and Objecthood" (1967), in Battcock, *Minimal Art*, 120.

235 He is one of us: Donald Judd, in Bruce Glaser, "Questions to Stella and Judd," 162.

235 "space accessible to eyesight alone": Michael Fried, "Shape as Form: Frank Stella's New

Paintings," *Frank Stella: An Exhibition of Recent Paintings*, exhibition catalog (Pasadena: Pasadena Art Museum, 1966), 7.

235 "deeply impressed": Alfred H. Barr, Jr., letter to Fulbright grant committee, October 28, 1960, Stella file, Museum of Modern Art library, New York. See Rubin, *Frank Stella*, 153 n. 57.

235 Barr proposed to the trustees: Leo Castelli, interview, in de Coppet and Jones, *The Art Dealers*, 92–93.

CHAPTER 32

239 "duality of thing and allusion": Robert Morris, "Notes on Sculpture, Part 3: Notes and Non Sequiturs" (1967), *Continuous Project Altered Daily: The Writings of Robert Morris* (Cambridge, Mass.: MIT Press, 1993), 25.

239 "has no inherent relation": Robert Morris, "Anti Form" (1968), *Continuous Project Altered Daily*, 41.

241 simply shaped, a strong gestalt: Robert Morris, "Notes on Sculpture, Part 1" (1966), *Continuous Project Altered Daily*, 6–8.

241 "I am almost not an 'I' ": Vito Acconci, in Kate Linker, *Vito Acconci* (New York: Rizzoli, 1994), 20.

241 "I think in terms": Jeanne Siegel, "Carl Andre: Artworker," interview (1970), *Artwords: Discourse on the 60s and 70s* (Ann Arbor: UMI Research Press, 1985), 135.

242 he found himself in "a field": Vito Acconci, "Notes on My Photographs, 1969–1970" (1988), *Vito Acconci: Photographic Works 1969–1970*, exhibition catalog (Chicago: Rhona Hoffman Gallery, 1988), n. pag.

242 At the Museum of Modern Art's Information show: Haacke provided ballots. Of the 37,129 visitors who voted, slightly more than two-thirds said that Rockefeller's silence on Vietnam had turned them against him. See Francis Frascina, "The Politics of Representation," *Modernism in Dispute: Art since the Forties* (New Haven: Yale University Press, 1993), 120–21.

242 "juxtapose a microorganism": Lucy R. Lippard, *Six Years: The Dematerialization of the Art Object from 1966 to 1972* (New York: Praeger, 1973), 95, 145.

243 "from measured volume": Ibid., 95. See also Robert Barry, statement (1969), in *Conceptual Art*, ed. Ursula Meyer (New York: E. P. Dutton, 1972), 38–39.

243 "investigation of means": Morris, "Anti Form," 44–45.

243 art as an "investigative activity": Ian Wallace and Russell Keziere, "Bruce Nauman Interviewed," *Vanguard* 8 (February 1979): 16.

CHAPTER 33

246 "work its salutary effect": Maurice Berger, *Labyrinths: Robert Morris, Minimalism, and the 1960s* (New York: Harper & Row, 1989), 107–12.

246 *Observatory: Observatory* was destroyed later in 1971. A larger version, 298 feet in diameter, was built in 1977, in Oostelijk, Flevoland, the Netherlands. See *Robert Morris: The Mind/ Body Problem*, exhibition catalog (New York: Solomon R. Guggenheim Museum, 1994), 238–39.

246 a kind of "automation": Robert Morris, "Some Notes on the Phenomenology of Making: The Search for the Motivated" (1970), *Continuous Project Altered Daily: The Writings of Robert Morris* (Cambridge, Mass.: MIT Press, 1993), 77–78, 87.

247 a color photograph: Arthur Gordon, *Artforum* 13 (November 1974): 7.

247 "extreme vulgarity": Lawrence Alloway, Max Kozloff, Rosalind Krauss, Joseph Masheck, Annette Michelson, letter to the editor, *Artforum* 13 (December 1974): 9.

248 "Let's give three dildos": Robert Rosenblum, letter to the editor, *Artforum* 13 (March 1975):
 8–9.

249 "all about territory": Lynda Benglis, in Robert Pincus-Witten, "Lynda Benglis" (1974),
 The New Sculpture 1965–1975: Between Geometry and Gesture, ed. Richard Armstrong and
 Richard Marshall (New York: Whitney Museum of American Art, 1990), 312.

250 "They were supposed to refer": Lynda Benglis, interview with the author, September 27,
 1994.

250 "heroic, macho, sexist game": Lynda Benglis, in Pincus-Witten, "Lynda Benglis," 312.

251 "they were looking back at me": Lynda Benglis, interview with the author, Septem-
 ber 27, 1994.

251 "find a new form": Lynda Benglis, interview with the author, June 24, 1987.

CHAPTER 34

253 "One could wander around": Robert Morris, statement on his *Los Angeles Project II* (1969),
 in Thomas Krens, *The Drawings of Robert Morris*, exhibition catalog (Williamstown, Mass.:
 Williams College Museum of Art, 1982), n. pag.

253 "putting Brancusi's *Endless Column*": Carl Andre, in David Bourdon, "Carl Andre's Razed
 Sites" (1966), *Minimal Art: A Critical Anthology*, ed. Gregory Battcock (New York: E. P.
 Dutton, 1968), 104.

253 "I found myself": Lisa Bear and Willoughby Sharp, interview with Dennis Oppenheim
 (1970), in Lucy R. Lippard, *Six Years: The Dematerialization of the Art Object from 1966 to
 1972* (New York: Praeger, 1973), 183–84.

254 "The museums and collections": Michael Heizer, "The Art of Michael Heizer," *Artforum*
 8 (December 1969): 34.

254 The drip paintings are "environmental": Michael Heizer, interview with the author, Feb-
 ruary 13, 1991.

254 That innocence made it seem real: Heizer, "The Art of Michael Heizer," 34.

255 its trapezoidal shape: Elizabeth C. Baker, "Artworks on the Land," *Art in America* 64
 (January-February 1976): 94.

255 "You realize": Michael Heizer, interview with the author, February 13, 1991.

255 *Complex Two*: Virginia Rutledge, "Monuments to Making," *Art in America* 83 (July 1995):
 70–71.

258 "the observed ratio": Walter De Maria, "The Lightning Field," *Artforum* 18 (April
 1980): 58.

258 To walk into *The Lightning Field*: Baker, "Artworks on the Land," 95.

258 the "peaceful, religious space" of the West: Michael Heizer, in Howard Junker, "The
 New Sculpture: Getting Down to the Nitty Gritty," *Saturday Evening Post* 241 (Novem-
 ber 2, 1968): 43.

258 "sight was saturated": Robert Smithson, *The Spiral Jetty* (1972), *The Writings of Robert
 Smithson*, ed. Nancy Holt (New York: New York University Press, 1979), 113.

CHAPTER 35

259 "rinky-dink . . . Mickey Mouse": Robert Smithson, conversation with Dennis Wheeler
 (1970), in Eugenie Tsai, *Robert Smithson Unearthed: Drawings, Collages, Writings* (New
 York: Columbia University Press, 1991), 123.

259 "It made a big impression": Paul Cummings, interview with Robert Smithson (1972), *The
 Writings of Robert Smithson*, ed. Nancy Holt (New York: New York University Press,
 1979), 142–43.

260 He would leap from Ad Reinhardt's satires: Robert Smithson, "A Museum of Language in the Vicinity of Art" (1968), *The Writings of Robert Smithson*, 73, 76.

260 "He had the look of a brooder": Bill Berkson, interview with the author, January 26, 1995.

261 *"The Eliminator* is a clock": Robert Smithson, *"The Eliminator"* (1964), *The Writings of Robert Smithson*, 207.

261 "mistakes and dead-ends": Robert Smithson, "Entropy and the New Monuments" (1966), *The Writings of Robert Smithson*, 10–13.

262 "Tours between the *Nonsite* and the *site* are possible": Robert Hobbs, *Robert Smithson: Sculpture*, exhibition catalog (Ithaca: Cornell University Press, 1981), 104.

263 "writing about mirrors": Robert Smithson, "Incidents of Mirror-Travel in the Yucatan" (1969), *The Writings of Robert Smithson*, 97.

264 "conscious of the actualities": Robert Smithson, "The Spiral Jetty" (1972), *The Writings of Robert Smithson*, 90.

265 ideal of "intellectual beauty": See Percy Bysshe Shelley, "Hymn to Intellectual Beauty" (1816); Percy Bysshe Shelley, "The Colosseum" (1818), *Shelley's Prose: The Trumpet of Prophecy*, ed. David Lee Clark (Albuquerque: University of New Mexico Press, 1954), 224–28.

CHAPTER 36

269 "a Happening is not a commodity": Allan Kaprow, "Happenings in the New York Scene" (1961), *Essays on the Blurring of Art and Life*, ed. Jeff Kelley (Berkeley: University of California Press, 1993), 25–26.

269 "difficult, hostile, awkward and oversize": Barbara Rose, "A B C Art" (1965), *AutoCritique: Essays on Art and Anti-Art, 1963–1987* (New York: Weidenfeld and Nicolson, 1988), 69–70, 72.

269 "Ideas alone can be works of art": Sol LeWitt, "Sentences on Conceptual Art" (1968), *Conceptual Art*, ed. Ursula Meyer (New York: E. P. Dutton, 1972), 174.

270 "1. The artist may construct the piece": Lawrence Weiner, statement (1969), in Lucy R. Lippard, *Six Years: The Dematerialization of the Art Object from 1966 to 1972* (New York: Praeger, 1973), 73.

270 "The world is full of objects": Douglas Huebler, statement (1970), in Lippard, *Six Years*, 74.

270 "When art does not any longer depend": Seth Siegelaub, interview with Ursula Meyer (1969), in Lippard, *Six Years*, 125.

272 a quick response: Marcia Tucker, "Women Artists Today," *Making Their Mark: Women Artists Move into the Mainstream, 1970–1985*, ed. Randy Rosen and Catherine C. Brawer (New York: Abbeville Press, 1989), 198–99.

272 "any woman artist who says": Lee Krasner, in Cindy Nemser, "Forum: Women in Art," *Arts Magazine* 45 (February 1971): 18.

273 P&D, he said: John Perreault, "Issues in Pattern Painting," *Artforum* 16 (September 1977): 32–36.

CHAPTER 37

276 the "dismalness" of the scene: Peter Schjeldahl, *David Salle* (New York: Random House, 1987), 14.

276 "The art world seemed": David Salle, interview with the author, September 7, 1994.

276 Hallwalls: Robert Longo, interview with the author, September 25, 1994.

277 "Artists Space and Hallwalls": David Salle, interview with the author, September 7, 1994.

277 "It wasn't as though": Ibid.

277 "more about living situations": Schjeldahl, *David Salle*, 12.

277 Schnabel doesn't recall the incident: Julian Weissman, interview with the author, September 25, 1994; Julian Schnabel, interview with the author, October 31, 1994.

277 "Everybody was simply trying": Schjeldahl, *David Salle*, 9.

278 "There was no energy": Robert Longo, interview with the author, September 25, 1994.

CHAPTER 38

281 "are really quite horrible": René Ricard, "Julian Schnabel's Plate Painting at Mary Boone," *Art in America* 67 (November 1979): 125–26.

282 prices for Schnabel's paintings: Anthony Haden-Guest, "The New Queen of the Art Scene," *New York* 15 (April 19, 1982): 28; Susan K. Reed, "The Meteoric Rise of Mary Boone," *Saturday Review* (May 1982): 38.

282 "I didn't want to bother": Walter Robinson and Carlo McCormick, "Report from the East Village: Slouching Toward Avenue D," *Art in America* 72 (Summer 1984): 138.

283 "The Original and Still the Best": Nicolas A. Moufarrage, "The Year After," *Flash Art* 118 (Summer 1984): 51.

284 "had felt about Jasper": Laura de Coppet and Alan Jones, "Leo Castelli," *The Art Dealers: The Powers Behind the Scene Talk about the Business of Art* (New York: Clarkson N. Potter, 1984), 107.

284 "in society, or culture": Julian Schnabel, notebook (1978), in Julian Schnabel, *C.V.J.: Nicknames of Maître d's & Other Excerpts from Life* (New York: Random House, 1987), 146.

285 the mechanisms of the image: Jack Goldstein, statement (1978), *Jack Goldstein*, exhibition catalog (Erlangen, Germany: Städtische Galerie Erlangen, 1985), n. pag.

285 "These are pictures of emotions": *Cindy Sherman*, with an introduction by Peter Schjeldahl and an afterword by I. Michael Danoff (New York: Pantheon Books, 1984), 198.

CHAPTER 39

289 "the paintings are dead": David Salle, "The Paintings Are Dead" (1979), *Blasted Allegories: An Anthology of Writings by Contemporary Artists*, ed. Brian Wallace (New York: New Museum of Contemporary Art, 1987), 325–27.

291 "I don't subscribe to the idea": Mary Boone, interview with the author, January 21, 1984.

291 $3.6 million for *Out the Window*: Peter Watson, *From Manet to Manhattan: The Rise of the Modern Art Market* (New York: Random House, 1992), 416–18.

291 "works of art have become quasi-financial instruments": Susan Lee, "Greed Is Not Just for Profit," *Forbes* 141 (April 18, 1988): 64–66.

291 "David is an absolutely splendid young artist": Laura de Coppet, "Leo Castelli," *Interview* 12 (February 1982): 60–62.

291 the hubbub of the boom: Carter Ratcliff, "Dramatis Personae, Part I: Dim Views, Dire Warnings, Art-World Cassandras," *Art in America* 73 (September 1985): 9, 11, 13, 15.

291 "the inflation of minor talents": Robert Hughes, "Careerism and Hype Amidst the Image Haze," *Time* 125 (June 17, 1985): 83.

291 "the tyranny of novelty": Walter Darby Bannard, "The Emperor's Old Clothes," *Arts Magazine* 57 (September 1982): 83.

291 "what is at stake": Hilton Kramer, "Postmodern: Art and Culture in the 1980s," *The New Criterion* 1 (September 1982): 40.

291 "We can thank Andy Warhol": Barbara Rose, "Art in Discoland," *AutoCritique: Essays on Art and Anti-Art, 1963–1987* (New York: Weidenfeld and Nicolson, 1988), 291.

292 "Andy felt complete contempt": Victor Bockris, interview with the author, May 25, 1993.

292 Warhol's art and attitudes: For indictments of Andy Warhol, see Robert Hughes, "On Art and Money," *The New York Review of Books* 31 (December 6, 1984): 27; Robert Hughes, "The Rise of Andy Warhol," *Art after Modernism: Rethinking Representation*, ed. Brian Wallis (New York: New Museum of Contemporary Art, 1984), 45–57; Kramer, "Postmodern: Art and Culture in the 1980s," 40; and especially Suzi Gablik, *Has Modernism Failed?* (New York: Thames and Hudson, 1984), 56–62.

292 "looked as if they had been whipped up": Bob Colacello, *Holy Terror: Andy Warhol Up Close* (New York: HarperCollins, 1990), 473.

292 bring in a quick $800,000: Ibid., 446.

294 a fashionable young architect, Christian Hubert: Martin Filler, "Tribeca Textures," *House and Garden* 157 (February 1985): 128–35.

294 Schnabel's loft: Andre Leon Talley, "Portrait of the Artist's Wife: Jacqueline Schnabel," *Vogue* 175 (March 1985): 510–15, 560; Doris Saatchi, "Julian Schnabel: An Artist's Life," *House and Garden* 157 (July 1985): 108–15, 182.

294 "there's a contradiction": Richard Serra and David Salle, in "Portraits," *Artforum* 20 (May 1982): 59, 61–62.

295 *Schizophrenia Prism*: See "Expressionism Today: An Artists' Symposium," *Art in America* 70 (December 1982): 58–59.

CHAPTER 40

297 "looked pretty good": Richard Prince, *Why I Go to the Movies Alone* (1983), in Lisa Phillips, *Richard Prince*, exhibition catalog (New York: Whitney Museum of American Art, 1992), 48.

298 an eye for the art of the New York avant-garde: Grégoire Müller, *The New Avant-Garde*, with photographs by Gianfranco Gorgoni (New York: Praeger, 1972), 82–92, 96–97.

298 "Painting," said the painter: Gianfranco Gorgoni, interview with the author, May 7, 1992.

298 compared himself to Picasso: Michael Stone, "Off the Canvas: The Art of Julian Schnabel Survives the Wreckage of the Eighties," *New York* 25 (May 18, 1992): 31.

298 "in Pollock's work every element": Julian Schnabel, *C.V.J.: Nicknames of Maître d's & Other Excerpts from Life* (New York: Random House, 1987), 41.

300 "red and white and gold paint": Robert Longo, statement in Paul Gardner, "When Is a Painting Finished?" *Artnews* 84 (November 1985): 91.

EPILOGUE

304 "kind of innocence and total conviction": Pat Steir, "Brice Marden: An Interview," *Brice Marden: Recent Drawings and Etchings*, exhibition catalog (New York: Matthew Marks Gallery, 1991), n. pag.

ILLUSTRATION CREDITS

10. Jackson Pollock, *Stenographic Figure*, 1942. Museum of Modern Art, New York. Mr. and Mrs. Walter Bareiss Fund. Photograph © 1996 Museum of Modern Art. © 1996 The Pollock-Krasner Foundation / Artists Rights Society (ARS), New York

11. Jackson Pollock, *The She-Wolf*, 1943. Museum of Modern Art, New York. Photograph © 1996 Museum of Modern Art. © 1996 The Pollock-Krasner Foundation / Artists Rights Society (ARS), New York

12. Jackson Pollock, *Mural*, 1943. University of Iowa Museum of Art, Iowa City. Gift of Peggy Guggenheim, 1959. © 1996 The Pollock-Krasner Foundation / Artists Rights Society (ARS), New York

13. Jackson Pollock, *Eyes in the Heat*, 1946. The Peggy Guggenheim Collection, Venice; the Solomon R. Guggenheim Foundation, New York. Photo credit: David Heald © 1996 The Solomon R. Guggenheim Foundation. © 1996 The Pollock-Krasner Foundation / Artists Rights Society (ARS), New York

14. Jackson Pollock, *One, Number 31 (1950)*, 1950. Museum of Modern Art, New York. Sidney and Harriet Janis Collection Fund. Photograph © 1996 Museum of Modern Art. © 1996 The Pollock-Krasner Foundation / Artists Rights Society (ARS), New York

15. Clyfford Still, 1958. © 1996 Estate of Hans Namuth

16. Clyfford Still, *1954*, 1954. Albright-Knox Art Gallery, Buffalo, New York. Gift of Seymour H. Knox, 1957

17. Barnett Newman, 1951. © 1996 Estate of Hans Namuth

18. Barnett Newman, *Onement I*, 1948. Courtesy PaceWildenstein Gallery, New York. © 1996 Estate of Barnett Newman

19. Pollock painting *Autumn Rhythm*, 1950. © 1996 Estate of Hans Namuth

20. Jackson Pollock, *The Water Bull*, c. 1946. Stedelijk Museum, Amsterdam. © 1996 The Pollock-Krasner Foundation / Artists Rights Society (ARS), New York

21. Jackson Pollock, *Number 14, 1951*, 1951. Tate Gallery, London. © 1996 The Pollock-Krasner Foundation / Artists Rights Society (ARS), New York

22. Jackson Pollock, *Easter and the Totem*, 1953. Museum of Modern Art, New York. Gift of Lee Krasner in memory of Jackson Pollock. Photograph © 1996 Museum of Modern Art. © 1996 The Pollock-Krasner Foundation / Artists Rights Society (ARS), New York

23. Jackson Pollock, *Male and Female*, 1942. Philadelphia Museum of Art. Gift of Mr. and Mrs. H. Gates Lloyd. © 1996 The Pollock-Krasner Foundation / Artists Rights Society (ARS), New York

24. Jackson Pollock, *The Deep*, 1953. Musée National d'Art Moderne, Centre Georges Pompidou, Paris. © 1996 The Pollock-Krasner Foundation / Artists Rights Society (ARS), New York

25. Willem de Kooning, New York, 1950. © 1996 Rudy Burckhardt

26. Willem de Kooning, *Elaine de Kooning*, c. 1940–41. © 1996 Willem de Kooning Revocable Trust / Artists Rights Society (ARS), New York

27. Willem de Kooning, *Queen of Hearts*, c. 1943. Hirshhorn Museum and Sculpture Garden, Smithsonian Institution, Washington D.C. © 1996 Willem de Kooning Revocable Trust / Artists Rights Society (ARS), New York

28. Willem de Kooning, *Painting*, 1948. Museum of Modern Art, New York. Photograph © 1996 Museum of Modern Art. © 1996 Willem de Kooning Revocable Trust / Artists Rights Society (ARS), New York

29. Hans Hofmann, *Fantasia*, c. 1944. University Art Museum, University of California, Berkeley. Gift of the artist

30. Willem de Kooning, *Woman I*, 1950–52. Museum of Modern Art, New York. Photograph © 1996 Museum of Modern Art. © 1996 Willem de Kooning Revocable Trust / Artists Rights Society (ARS), New York

31. Willem de Kooning, *Suburb in Havana*, 1958. Collection Mr. and Mrs. Lee V. Eastman, New York. © 1996 Willem de Kooning Revocable Trust / Artists Rights Society (ARS), New York

32. Franz Kline, *Mahoning*, 1956. Whitney Museum of American Art, New York

33. Grace Hartigan, *New England, October*, 1957. Albright-Knox Gallery, Buffalo, New York. Gift of Seymour H. Knox, 1957

34. Alfred Leslie, *Soldier's Medal*, 1959. Albright-Knox Gallery, Buffalo, New York. Gift of Seymour H. Knox, 1957

35. Joan Mitchell, *Untitled*, 1958. © 1996 Estate of Joan Mitchell, courtesy Robert Miller Gallery, New York

36. Jasper Johns, *Target with Plaster Casts*, 1955. Collection Leo Castelli, New York. © 1996 Jasper Johns / Licensed by VAGA, New York, NY

37. Jasper Johns in his New York studio with *Flag,* 1955. © 1996 Robert Rauschenberg / Licensed by VAGA, New York, NY

38. Robert Rauschenberg, *Bed*, 1955. Museum of Modern Art, New York. Gift of Leo Castelli in honor of Alfred H. Barr, Jr. © 1996 Museum of Modern Art. © 1996 Robert Rauschenberg / Licensed by VAGA, New York, NY

39. Robert Rauschenberg, *Monogram*, 1955–59. Moderna Museet, Stockholm. © 1996 Robert Rauschenberg / Licensed by VAGA, New York, NY

40. Jasper Johns, *False Start II*, 1962. Museum of Modern Art, New York. Gift of the Celeste and Armand Bartos Foundation. Photograph © 1996 Museum of Modern Art. © 1996 Jasper Johns / Licensed by VAGA, New York, NY

41. Jasper Johns, *According to What*, 1964. Collection Mr. and Mrs. S. I. Newhouse, New York. © 1996 Jasper Johns / Licensed by VAGA, New York, NY

42. Jasper Johns, *Scent*, 1973–74. Ludwig Collection, Aachen. © 1996 Jasper Johns / Licensed by VAGA, New York, NY

43. Jasper Johns, *Fool's House*, 1962. Collection Jean Cristophe Castelli. © 1996 Jasper Johns / Licensed by VAGA, New York, NY

44. Jasper Johns, *Flag on Orange Field*, 1957. Museum Ludwig, Cologne. © 1996 Jasper Johns / Licensed by VAGA, New York, NY

45. Susan Rothenberg, *Cabin Fever*, 1976. Modern Art Museum of Fort Worth

46. Donald Judd, *Untitled*, 1964. Collection Joseph Helman, New York. © 1996 Estate of Donald Judd / Licensed by VAGA, New York, NY

47. Andy Warhol, *Brillo Box (Soap Pads)*, 1964. © 1996 The Andy Warhol Foundation for the Visual Arts / Artists Rights Society (ARS), New York

48. Frank Stella, *Conway I*, 1966. Collection Marie Christophe Thurman, New York. © 1996 Frank Stella / Artists Rights Society (ARS), New York

49. George Segal, *Man at Table*, 1961. Stadtisches Museum, Monchengladbach, Germany. © 1996 George Segal / Licensed by VAGA, New York, NY

50. Robert Rauschenberg, *Barge*, 1963. Collection of the artist, on extended loan to the National Gallery of Art, Washington, D.C. © 1996 Robert Rauschenberg / Licensed by VAGA, New York, NY

51. James Rosenquist, *F-111*, 1965. Installation view. © 1996 James Rosenquist / Licensed by VAGA, New York, NY

52. Claes Oldenburg, *Bedroom Ensemble*, 1963, reconstructed in 1996. Collection Claes Oldenburg and Coosje van Bruggen, New York. Photograph courtesy of PaceWildenstein

53. Andy Warhol, *Yarn*, 1983. © 1996 The Andy Warhol Foundation for the Visual Arts / Artists Rights Society (ARS), New York

54. Andy Warhol at the Factory, 1966. © 1996 Billy Name / Photonica

55. Andy Warhol, *Five Boys*, c. 1954. Courtesy Susan Sheehan Gallery, New York. © 1996 The Andy Warhol Foundation for the Visual Arts / Artists Rights Society (ARS), New York

56. Andy Warhol, *Coca-Cola*, 1960. Dia Art Foundation, New York. © 1996 The Andy Warhol Foundation for the Visual Arts / Artists Rights Society (ARS), New York

57. Andy Warhol, *Large Coca-Cola*, 1962. Collection Elizabeth and Michael Rea, New York. © 1996 The Andy Warhol Foundation for the Visual Arts / Artists Rights Society (ARS), New York

58. Andy Warhol, *Marilyn Monroe's Lips*, 1962. Hirshhorn Museum and Sculpture Garden, Smithsonian Institution, Washington, D.C. © 1996 The Andy Warhol Foundation for the Visual Arts / Artists Rights Society (ARS), New York

59. Andy Warhol, *Large Triple Elvis*, 1963. © 1996 The Andy Warhol Foundation for the Visual Arts / Artists Rights Society (ARS), New York

60. Andy Warhol, *Empire*, 1964. Film still. © 1994 The Andy Warhol Foundation for the Visual Arts / Artists Rights Society (ARS), New York

61. Andy Warhol at the Flowers show; Galerie Ileana Sonnabend, Paris, 1965. © 1996 Harry Shunk

62. Andy Warhol, *Leo Castelli*, 1975. Collection Leo Castelli, New York. © 1996 The Andy Warhol Foundation for the Visual Arts / Artists Rights Society (ARS), New York

63. Andy Warhol, *Orange Disaster*, 1963. Solomon R. Guggenheim Museum, New York. © 1996 The Andy Warhol Foundation for the Visual Arts / Artists Rights Society (ARS), New York

64. Helen Frankenthaler, *Mountains and Sea*, 1952. Collection of the artist, on extended loan to the National Gallery of Art, Washington, D.C. © 1996 Helen Frankenthaler

65. Morris Louis, *Point of Tranquility*, 1958. Hirshhorn Museum and Sculpture Garden, Smithsonian Institution, Washington, D.C. Photo credit: Lee Stalsworth. Courtesy Emmerich / Sotheby's

66. Donald Judd, *Untitled*, 1969. Hirshhorn Museum and Sculpture Garden, Smithsonian Institution, Washington, D.C. © 1996 Estate of Donald Judd / Licensed by VAGA, New York, NY

67. Frank Stella, *Avicenna*, 1960. Menil Foundation, Houston. © 1996 Frank Stella / Artists Rights Society (ARS), New York

68. Frank Stella, *Flin Flon III*, 1969. Collection unknown. © 1996 Frank Stella / Artists Rights Society (ARS), New York

69. Frank Stella, *Nasielsk II*, 1972. Courtesy Knoedler & Company, New York. © 1996 Frank Stella / Artists Rights Society (ARS), New York

70. Frank Stella, *Nogaro*, 1981. Collection Sally Ganz. © 1996 Frank Stella / Artists Rights Society (ARS), New York

71. Frank Stella, *Lo sciocco senza paura (#1, 4X)*, 1984. Collection Ann and Robert Freedman, New York. © 1996 Frank Stella / Artists Rights Society (ARS), New York

72. Richard Serra throwing molten lead, 1972. © 1996 Gianfranco Gorgoni

73. Robert Morris, *Observatory*, 1971–77. Oostelijk, Flevoland, The Netherlands. Photo courtesy the artist and the Solomon R. Guggenheim Museum, New York. © 1996 Robert Morris / Artists Rights Society (ARS), New York

74. Robert Morris, *Untitled*, 1974. Collection of the artist. Photo courtesy the artist and the Solomon R. Guggenheim Museum, New York. © 1996 Robert Morris / Artists Rights Society (ARS), New York

75. Lynda Benglis, advertisement in *Artforum*, November 1974. Photograph by Arthur Gordon. © 1996 Lynda Benglis / Licensed by VAGA, New York, NY

76. Lynda Benglis, *Totem*, 1971. Installation at Hayden Gallery, Massachusetts Institute of Technology, Cambridge. © 1996 Lynda Benglis / Licensed by VAGA, New York, NY

77. Walter De Maria, *The Broken Kilometer*, 1979. Photo credit: John Cliett. © 1996 Dia Center for the Arts, New York

78. Walter De Maria, *The Lightning Field*, 1977. Near Quemado, New Mexico. Photo credit: John Cliett. © 1996 Dia Center for the Arts, New York

79. Robert Smithson, *Spiral Jetty*, 1970. Rozel Point, Great Salt Lake, Utah. Photograph © 1972 Gianfranco Gorgoni. Estate of Robert Smithson, courtesy John Weber Gallery, New York

80. Miriam Schapiro, *Black Bolero*, 1981. Art Gallery of New South Wales, courtesy of Steinbaum Krauss Gallery, New York

81. Robert Longo, *Men Trapped in Ice*, 1980. Courtesy Metro Pictures, New York

82. Julian Schnabel, *Portrait of Mary Boone*, 1983. Collection Mary Boone, New York

83. Julian Schnabel, *Exile*, 1980. Collection Barbara Schwartz, New York

84. Cindy Sherman, *Untitled Film Still #21*, 1978. Museum of Modern Art, New York. Courtesy Metro Pictures, New York

85. Robert Longo, *Tongue to the Heart*, 1984. Collection Eli Broad, Los Angeles. Courtesy Metro Pictures, New York

86. David Salle, *Cigarette Lady: Blue and Yellow*, 1979. Collection Larry Gagosian, New York. © 1996 David Salle / Licensed by VAGA, New York, NY

87. David Salle, *Melancholy*, 1983. © 1996 David Salle / Licensed by VAGA, New York, NY

88. Andy Warhol and Jean-Michel Basquiat, *Untitled (Alert, GE)*, c. 1984–85. © 1996 The Andy Warhol Foundation for the Visual Arts / Artists Rights Society (ARS), New York

89. Mike Bidlo, *Jack the Dripper at Peg's Place*, 1982. Installation and performance piece, P.S. 1, New York. Installation view. Courtesy the artist and Gallery Bruno Bischofberger, Zurich

90. Robert Longo, *Heads Will Roll*, 1984–85. Collection Eli Broad, Los Angeles. Courtesy Metro Pictures, New York

91. Brice Marden painting, 1990. © 1990 Bill Jacobson, courtesy Matthew Marks Gallery, New York

92. Brice Marden, *Presentation*, 1990–92. Collection of the artist. © 1996 Brice Marden / Artists Rights Society (ARS), New York

93. Robert Rahway Zakanitch, *Big Bungalow Suite IV*, 1992–93. Collection of the artist

Index

Abstract Expressionism, 148, 177, 195, 231, 294

Acconci, Vito, 241–42, 279

According to What (Johns), 152, 153, 154–55, 163

Acker, Kathy, 294

action painters, 105, 108–9, 111–12, 113, 114, 176

Africano, Nicholas, 170, 275

Albers, Josef, 136

All You Zombies: Truth Before God (Longo), 299

Alogon (Smithson), 262

Amarillo Ramp (Smithson), 263, 269

Amaya, Mario, 207

"American Action Painters, The" (Rosenberg), 108–9, 111, 112

American Artists Congress, 39

America Today (Benton), 15, 20, 22

Andre, Carl, 226, 241, 245, 255, 261; on Stella, 233, 234, 237; works, 182, 227, 228, 240, 253

Anuskiewicz, Richard, 179

Arena Brains (Longo), 300

Armstrong, Tom, 162

Arrive/Depart (Johns), 157

"Art and Objecthood" (Fried), 228, 229

Artforum, 247–50, 263, 294

Art in America, 152, 281

Artists Space, 270, 277

Artists' Union, 26–27, 29

Artnews, 7–9, 10, 11, 44, 105, 108, 113, 127, 175, 231, 260

Art of This Century, 52–53, 68, 74

art-school Expressionism, 283

Arts Magazine, 291

Arts of Life in America, The (Benton), 20

Art Students League, 14, 15–17, 33, 73, 259–60

Asphalt Rundown (Smithson), 263

Astor, Patti, 282–83

automatism, 45–46, 48

Autumn Rhythm (Pollock), 86, 90, 91, 113, 184, 220

avant-garde art, 25–29, 48, 51, 295, 303; *see also* New York artists

Avery, Milton, 229

Avicenna (Stella), 230

Baechler, Donald, 170–71

Baker, Elizabeth, 177, 178

Bannard, Walter Darby, 221, 222, 291

Barge (Rauschenberg), 180–81

Barr, Alfred H., Jr., 31, 46, 52, 123, 132; on New York painters, 125–27, 151; on Pollock, 59, 62–63; on Stella, 235–36

Barrier (Morris), 226

Barry, Robert, 243, 253

Baselitz, Georg, 283

Basquiat, Jean-Michel, 292, 293, 298

Bauer, Rudolf, 51

Baziotes, Ethel, 28

Baziotes, William, 25, 28, 46, 123

Beaton, Cecil, 90–91

Bed (Rauschenberg), 138, 139–40

Bedroom Ensemble (Oldenburg), 183–84

Beds of Spikes (De Maria), 256–57

Bellamy, Richard, 260

Benglis, Lynda, 247–51, 252

Bent "Blue" (Johns), 167

Benton, Maecenas Eason, 21, 22

Benton, Rita, 15, 33

Benton, Thomas Hart, 19–20, 21–23, 39–40; political views, 22–23; relationship with Pollock, 15–16, 21, 33, 34, 37, 38, 39–40; as teacher, 14, 15–16, 33; works, 3, 15, 18, 20, 21, 22, 23

Benton, Thomas Hart (senator), 21–22

Berkson, Bill, 260

Bernstein, Roberta, 156

Betty Parsons Gallery, *see* Parsons, Betty

Bianchini Gallery, 178

Bidlo, Mike, 296, 297, 298

Bierstadt, Albert, 74

Big Bungalow Suite IV (Zakanitch), 306–7

Birth (Pollock), 42, 44

Black Bolero (Schapiro), 268

Black Bra (Salle), 300

Black Mountain College, 136, 145, 148, 175

Blesh, Rudi, 52

Blind Time Drawings (Morris), 246

Blue Poles (Pollock), 117

Bluhm, Norman, 99, 109, 134

Blum, Irving, 125, 196, 197

Bockris, Victor, 292

Bollinger, Bill, 241

Boone, Mary, 281, 283, 284, 289, 291

Borofsky, Jonathan, 276

Bourdon, David, 164, 197, 253

Brach, Paul, 134

Bradley, Peter, 222

Braque, Georges, 104

Brauntuch, Troy, 276, 284–85

Breer, Robert, 177

Breton, André, 44, 45, 46

Brillo Box (Soap Pads) (Warhol), 174

Broken Circle/Spiral Hill (Smithson), 263–64

Broken Kilometer, The (De Maria), 255–56

Brown, James, 171

Brown, John, 79

Burckhardt, Rudy, 6, 7–9, 10, 11, 27–28, 29, 90, 91, 98, 114

Burgy, Donald, 242

Busa, Peter, 34

Bykert Gallery, 170, 246

Cabin Fever (Rothenberg), 171

Cage, John, 148–49, 175, 177

Cahill, Holger, 34

Calder, Alexander, 31

Cale, John, 204

Carey, Ted, 193, 196

Castelli, Ileana, *see* Sonnabend, Ileana

Castelli, Leo, 132–34, 203, 275; de Kooning and, 133; gallery, 131–32, 134, 169, 193, 246, 270, 276; Johns and, 140, 141, 151–52, 153, 156, 158, 162; Pollock and, 133, 134; Rauschenberg and, 139, 140; Schnabel and, 284; SoHo gallery, 281, 286–87, 291;

Stella and, 232, 233, 235–36; Warhol and, 195, 203–4

Castelli Warehouse, 239, 240–41

Cathedral (Pollock), 2

Cedar Street Tavern, 94–96, 111, 121, 136–37, 260

Chamberlain, John, 176, 177

Chastel, André, 124

Chelsea Girls, The (Warhol), 206, 208

Chia, Sandro, 284

Church, Frederick E., 74

Cigarette Lady: Blue and Yellow (Salle), 290

City (Heizer), 255

Claim (Acconci), 242

Clemente, Francesco, 283, 292, 294

Clocktower, 271

Clough, Charles, 276

Club Onyx (Stella), 232

Coca-Cola (Warhol), 190

Colacello, Bob, 208–9, 211, 215, 292

Collaborative Projects (Colab), 282

color-field painting, 177, 178, 221–23, 228–29, 271, 275

Complex One (Heizer), 255, 269

Complex Two (Heizer), 255

conceptualism, 270, 271

Condo, George, 284

Convergence: Number 10, 1952 (Pollock), 93

Conway I (Stella), 174

Cotton Pickers (Pollock), 35, 37

Couch (Warhol), 203

Cubism, 31, 88, 104–5

Cucchi, Enzo, 283

Cunningham, Merce, 148, 150, 179, 206

C.V.J.: Nicknames of Maître d's & Other Excerpts from Life (Schnabel), 298–99

Dada, 151, 152

Dancers on a Plane (Johns), 150

Davis, Stuart, 22, 101, 229

de Antonio, Emile, 192, 193, 197, 203

Death of Fashion, The (Schnabel), 281

Deep, The (Pollock), 94, 95

de Kooning, Elaine, 7, 94, 117, 127, 133, 219

de Kooning, Willem, 27–28, 79, 98, 100, 101, 137, 219; on American painting, 79, 113; on art, 149; Castelli and, 133; economic success, 117, 123; exhibitions, 62, 123, 134, 229; on existentialism, 109, 113; influence,

105, 139, 168, 220; paintings, 4, 53, 99–
100, 101–5, 112, 113–18, 303; Pollock and,
67–68, 79, 88–89, 96, 113; popular culture
and, 295; recognition, 118–19; Rosenberg
on, 109, 112, 114; in Springs, 117; tech-
nique, 99–100; training, 100–1
de Laszlo, Violet, 40, 44
De Maria, Walter, 254–58, 257, 269
Denby, Edwin, 28, 101–2
Denes, Agnes, 242
Depression, 25–29, 33–35
Dia Center for the Arts, 255
Dialectic Triangulation (Denes), 242
Diller, Burgoyne, 26–27, 35, 40
Dine, Jim, 177
di Suvero, Mark, 176, 178
Diver (Johns), 291
Door to the River (de Kooning), 117
Double Negative (Heizer), 254
drip paintings: analogies to bodily fluids,
63–64, 70; critics on, 87, 90, 222; frames
of, 80, 175; infinite implied in, 70, 222,
227–28; influence, 184, 222, 228, 239, 254,
258, 271, 295, 297; Judd's view of, 225,
226; Morris's view of, 239, 246; of No-
land, 222; of Pollock, 7–9, 10, 59, 62, 65,
69–71, 220, 222, 225; Pollock on, 87; Pol-
lock's technique, 59, 64–65, 89, 91–93;
shapes in, 70; theories on, 63–64; tools,
91–93; uniqueness in modern art, 88
Dubuffet, Jean, 134
Duchamp, Marcel, 52, 56, 152–53, 158,
226
Duration Piece #7 (Huebler), 270
Dwan Gallery, 228, 256, 262
Dzubas, Friedel, 134, 220, 221

earthworks, 254–55, 257–58, 263–64,
269
Easter and the Totem (Pollock), 92, 93–94
Echo: Number 25, 1951 (Pollock), 91
Eddingsville (Johns), 156
Egan, Charles, 116
Elaine de Kooning (de Kooning), 102
Eliminator, The (Smithson), 261
Empire (Warhol), 202, 203
"Entropy and the New Monuments"
(Smithson), 261–62
Ernst, Jimmy, 28

Ernst, Max, 52
European art: Cubism, 31, 88, 104–5; émi-
gré artists in New York, 44–46, 51; Ex-
pressionism, 283; in 1980s, 283–84;
Surrealism, 43–48
Excavation (de Kooning), 99–100, 105
Exile (Schnabel), 284, 285
existentialism, 109–11, 113
Exploding Plastic Inevitable (EPI), 204–5
Expressionism, 283
Eyes in the Heat (Pollock), 58, 59, 258

F-111 (Rosenquist), 181–82, 183
Factory, 198–201, 204–9, 215
Falkenberg, Paul, 89
False Start (Johns), 141–42, 291
False Start II (Johns), 143
Fantasia (Hofmann), 110
fashion industry, 90–91, 179, 190–91
Federal Arts Project (FAP), 27, 29, 34–35,
40, 44, 101
Feeley, Paul, 219
Feldman, Morton, 89
feminism, 247–49, 272
Ferren, John, 96
Ferus Gallery, 197
Fiegan, Richard, 291
Fields, Danny, 206
films: by Longo, 300–1; by Salle, 295; by
Schnabel, 298; by Warhol, 203, 204, 206,
207; of Pollock, 89, 111
Finn, Huckleberry, 81–82
Fishl, Eric, 276
Five Boys (Warhol), 188
Flag (Johns), 131, 132, 141, 151, 162
Flag on an Orange Field (Johns), 166, 170
Flame (Pollock), 40, 41
Flavin, Dan, 177, 229, 261
Flin Flon III (Stella), 232
Flowers (Warhol), 203–4
Following Piece (Acconci), 241
Fool's House (Johns), 160, 161, 163
Francis, Sam, 123
Frankenthaler, Helen, 218, 219–22, 223, 229,
272
Fredericks, Tina S., 189, 192
Fried, Michael, 223, 228–29, 233–35, 237
Friedman, B. H., 94
Fun Gallery, 282

Gablik, Suzi, 145
Geldzahler, Henry, 179, 196, 197, 207, 229
Giacometti, Alberto, 109, 134
Gibson, William, 300
Gift (Man Ray), 151
Girl with Ball (Lichtenstein), 193
Glimcher, Arnold, 162
Gluck, Nathan, 197, 293
Going West (Pollock), 36, 37
Goldberg, Michael, 109, 117, 126–27, 219–20
Gold Marilyn Monroe (Warhol), 197, 198, 212
Goldstein, Jack, 276, 284–85
Goodman, Job, 34
Gorgoni, Gianfranco, 240, 298
Gorky, Arshile, 46, 62, 101, 112, 114, 123
Goodnough, Robert, 7, 8, 9, 10, 11, 64
government, *see* Federal Arts Project
Graham, Dan, 276
Graham, John, 9, 26, 43–44, 101
Greenberg, Clement, 32, 62, 63, 64, 114, 116;
 on color-field painting, 222; Frankenthaler
 and, 219, 220–21; Pollock and, 88, 105,
 111–12, 222; on Stella, 234
Green Box (Duchamp), 152
Greene, Stephen, 231
Green Gallery, 196, 226
Green Target (Johns), 131, 132, 260
Grosman, Tatyana, 140, 142
Grünewald, Matthias, 158
Guardians of the Secret, The (Pollock), 48
Guggenheim, Peggy, 51–53, 74, 75; Pollock
 and, 52–53, 56–57, 68
Guggenheim, Solomon, 51, 53
Guggenheim Museum, 53, 246
Guston, Philip, 35, 96, 111, 123, 229

Haacke, Hans, 242
Hallwalls, 276–77
Hansa Gallery, 176
Happenings, 176–77, 269
Hare, David, 56
Haring, Keith, 282, 292
Harlem Light (Johns), 156
Harlot (Warhol), 204
Harper's Bazaar, 179, 192
Hartigan, Grace, 67, 99, 123–24, 126,
 219–20, 272
Heads Will Roll (Longo), 299–300
Heiss, Alanna, 270–71

Heizer, Michael, 254, 255, 258, 269
Held, Al, 99, 117
Heller, Ben, 132
Henderson, Joseph L., 40
Hess, Thomas B., 7, 25, 43, 81, 113, 117,
 127, 131–32
History of Water, The (Benton), 20
Hofmann, Hans, 7, 88, 110, 112, 114; paint-
 ings, 3; Pollock and, 68–69; School of
 Fine Arts, 32–33
Hopper, Edward, 229
House and Garden, 294
Huberman, Leo, 22
Hubert, Christian, 294
Huebler, Douglas, 270
Hughes, Fred, 206, 207, 208, 209, 211
Hughes, Robert, 291
Huot, Robert, 241
Hutchinson, Peter, 242

I, a Man (Warhol), 207
I. Miller, 190–91
"Incidents of Mirror-Travel in the Yucatán"
 (Smithson), 263
Indiana, Robert, 123, 169, 197
Interview, 208–9, 291
In the Studio (Johns), 157–58
Ireland, Patrick, 182
Isenheim Altarpiece (Grünewald), 158

Jackson, Harry, 99
Jack the Dripper at Peg's Place (Bidlo), 296,
 297
Jacobson, Bill, 302
Janis, Sidney, 116, 134
Jewish Museum, 131, 179, 246, 253
Johnny Mnemonic (Longo), 300–1
Johns, Jasper, 127, 135, 142–45, 147, 169,
 275, 303; on de Kooning, 168; drawings,
 193; Duchamp's influence on, 152–53,
 158; exhibitions, 131–32, 141, 151–52, 153,
 156, 163, 164, 229; influence, 169–72, 226,
 231; lithographs, 140–41, 142; paintings,
 130, 131–32, 141–42, 151, 152, 153, 154–
 55, 156–59, 160, 161–65, 167–69; on Pol-
 lock, 168; prices of paintings, 291; prints,
 167; Rauschenberg and, 140, 141, 145,
 147–48, 149, 150; theater work, 150
Johnson, Jed, 207, 208

Johnson, Philip, 132, 197, 206
Johnson, Poppy, 245
Judd, Donald, 223, 234, 237, 261; exhibitions, 229; works, 174, 177, 224, 225–26, 227
Judson Church, 179
Jugglers, The (Frankenthaler), 220

Kandinsky, Wassily, 32–33, 51
Kansas City Art Institute, 39, 136
Kaprow, Allan, 175–76, 177, 183, 269, 277
Karp, Ivan, 193, 195–96, 197
Katz, Alex, 99, 111, 127
Kelly, Ellsworth, 178, 182
Kertess, Klauss, 246
Kiefer, Anselm, 283
Kiesler, Frederick, 52
Kiku (Warhol), 292
Kitchen, 270, 277, 279
Kitchen (Warhol), 204
Klein, Ralph, 94
Kligman, Ruth, 121–22
Kline, Franz, 114, 137, 140, 219; exhibitions, 123, 229; influence, 117; on Pollock, 94–96; works, 119, 123
Kluver, Billy, 179
Kord, Victor, 271
Kosuth, Joseph, 270
Kozloff, Joyce, 272
Kozloff, Max, 64
Kramer, Hilton, 291
Krasner, Lee, 6, 219; career, 9, 26, 32, 33, 44, 67; politics, 29; on Pollock, 11, 40, 56, 84, 87, 90; relationship with Pollock, 9–10, 33, 44, 48–49, 67, 68, 88, 121–22; Rosenberg and, 111–12; in Springs, 7, 8, 9, 10, 56–57, 59; training, 32; on women artists, 272
Krishnamurti, Jedda, 70
Kushner, Robert, 272

Landscape with Rider (Pollock), 37
Lane, Lois, 170
Large Coca-Cola (Warhol), 191
Large Triple Elvis (Warhol), 199
Lebel, Robert, 152
Leo Castelli (Warhol), 210
Leslie, Alfred, 117, 125, 126, 219–20
Lew, Jeffery, 270
LeWitt, Sol, 182, 226, 227, 261, 269

Lichtenstein, Roy, 4, 169, 178, 193, 195, 303
Life, 10, 87
Light Bulb (Johns), 193
Lightning Field, The (De Maria), 257–58, 269
Linich, Billy, *see* Name, Billy
Lippard, Lucy, 276
Locke, John, 81
Long Island, *see* Springs
Longo, Robert, 276–77, 278–79, 286–88, 289, 291, 299–301
Lo sciocco senza paura (#1, 4X) (Stella), 235
Louis, Morris, 221, 222, 229
Love (Warhol), 292
Lye, Len, 177
Lyrical Abstraction, 271, 275

MacConnell, Kim, 272
Macdonald-Wright, Stanton, 19
Magazine of Art, 43
Mahoning (Kline), 119
Makos, Christopher, 214
Malanga, Gerard, 198, 203, 204, 208, 211–12
Male and Female (Pollock), 93–94
Man at Table (Segal), 174
Mangold, Robert, 169–70
Mansion, Gracie, 282
Marden, Brice, 170, 302, 304, 305, 307
Marilyn Monroe's Lips (Warhol), 194, 198
Marisol, 197
Marot, Helen, 40
Marriage of Reason and Squalor, The (Stella), 235–36
Martin, Agnes, 182, 219
Martin, David Stone, 190
Marx, Claude Roger, 124
Masson, André, 44, 45, 46, 48
Matisse, Henri, 32, 93
Matta Echaurren, Roberto, 45, 46
Max Protetch Gallery, 279
Max's Kansas City, 206, 241, 260
McBride, Henry, 87
McMillen Gallery, 44, 68
McNeil, George, 16
Meditation of the Painter (Masson), 45
Melancholy (Salle), 290
Melville, Herman, 168
Men in the Cities (Longo), 286
Men Trapped in Ice (Longo), 278, 279

Merce Cunningham Dance Company, 150, 179, 206
Metro Pictures, 284–85, 286–87, 297
Metropolitan Museum of Art, 90, 113, 196, 229, 246
Metzger, Edith, 122
Midgette, Allan, 214
Miller, Dorothy, 31, 123, 132, 232–33
Minimalism, 177, 178, 226–29, 239–41, 243, 247, 269–70; economic success, 269, 275; influence of Pollock, 229; Smithson on, 261–62
Miró, Joan, 46, 48
Mitchell, Joan, 117, 125, 126, 127, 272
Mittendorf, Helmut, 283
Mogenson, Paul, 169–70
Molleda, Mercedes, 123–24
Mondrian, Piet, 33, 52–53, 74, 80–81, 134
Monogram (Rauschenberg), 140, 141
Monroe, Marilyn, 197, 198, 212
Montauk Highway (de Kooning), 117
Morris, Robert, 226–27, 241, 261; exhibitions, 229; "Notes on Sculpture," 228; political activities, 245; on Pollock, 239, 243, 246; set designs, 150; works, 240, 244, 245, 246–47, 248, 251–52, 253
Morrissey, Paul, 207
Moser, Barry, 158
Moskowitz, Robert, 170
Motherwell, Robert, 44, 46, 123
Mountains and Sea (Frankenthaler), 218, 220–21
Mullican, Matt, 276
Mural (Pollock), 54–55, 56
Museum of Modern Art, 31–32, 246; American art in, 116, 123, 132, 220, 233, 235–36, 242; focus on European art, 31–32; New American Painting show, 123–25; Op Art exhibit, 178; Pollock exhibition, 122–23; Pollock works purchased by, 46, 62
Museum of Non-Objective Painting, *see* Guggenheim Museum
Myers, John Bernard, 220

Naifeh, Steven, 63–64
Name, Billy, 186, 198–201
Namuth, Hans, 72, 76, 78, 86, 89, 111, 149
Nasielsk II (Stella), 233
Nauman, Bruce, 169

neo-Dada, 151–52
neo-Expressionism, 283
Neon Templates of the Left Half of My Body Taken at Ten-Inch Intervals (Nauman), 169
New England, October (Hartigan), 124
New Image painters, 170–71, 275, 281
Newman, Barnett, 44, 78, 80–85, 137; exhibitions, 81, 84, 123, 229; influence, 260; Pollock and, 84; works, 3, 46, 81, 82, 84–85, 158
New School for Social Research, 15, 20, 175
New York: alternative spaces, 270–71, 277, 279; artists' attraction to, 28–29; East Village, 282–83; SoHo, 275–76, 281, 284–85; Tribeca, 294
New York artists: attitude toward Europeans, 44–45, 51; at Cedar Street Tavern, 94–96, 111, 121, 137, 260; in Depression, 25–29, 34; and existentialism, 109–11; Happenings, 176–77; incomes, 117; leftist politics, 25, 26–27, 29, 39, 245–46; lofts, 26, 294; in 1950s, 117, 123–27; in 1960s, 169–70, 177–79, 229; in 1970s, 275–77; in 1980s, 282–83, 284–88, 291, 292, 293–95, 300
New Yorker, The, 65
Nico, 204
1954 (Still), 75
Nogaro (X, 4.75X = 1st version) (Stella), 234
Noland, Kenneth, 221, 222, 229
Nolde, Emil, 283
Nonsites (Smithson), 262
Nosei, Anina, 281, 283
"Notes on Sculpture" (Morris), 228
Novros, David, 169–70
Now Everybody (Longo), 287
Number 1A (Pollock), 62
Number 4, 1950 (Pollock), 64–65
Number 14, 1951 (Pollock), 91
Number 32, 1950 (Pollock), 9

Observatory (Morris), 244, 246, 253
O'Hara, Frank, 109
Ohr, George, 158
Oldenburg, Claes, 123, 169, 177, 183–84, 197
Olitski, Jules, 178, 221, 222, 229, 235
One, Number 31 (1950) (Pollock), 60–61, 62, 90, 117, 184, 220

Onement I (Newman), 83

Op Art, 178

Oppenheim, Dennis, 253–54, 255

Orange Disaster (Warhol), 213

Orestes (de Kooning), 102

Orozco, José Clemente, 39

Out the Window (Johns), 141, 291

Oxidation paintings (Warhol), 184

Ozenfant, Amédée, 32

P&D, *see* pattern and decoration (P&D) painting

Pace Gallery, 284

Painted on 21st Street (Frankenthaler), 220

Painting (de Kooning), 102, 104

Parsons, Betty, 62, 76, 81, 84, 89, 90, 136, 137, 140, 220

pattern and decoration (P&D) painting, 272–73, 275, 303

Paula Cooper Gallery, 241, 247

Pearlstein, Philip, 189, 192

Pearman, Pat, 135

performance art, 270

Perilous Night (Johns), 158, 161

Perreault, John, 273

Phenomena (Tchelitchew), 133

Picabia, Francis, 151

Picasso, Pablo, 43, 48–49, 94, 101, 104, 158

Pincus-Witten, Robert, 247, 249

Plunge (Smithson), 262

Point of Tranquility (Louis), 221

Polke, Sigmar, 289

Pollock, Charles (brother), 14, 15, 39

Pollock, Frank (brother), 16

Pollock, Jackson, 6; on action painting, 112; aims in painting, 40–41, 69, 71, 87; alcoholism, 10, 16–17, 34, 40, 56, 63, 67–68, 84, 89–90, 94–96, 111; *Artnews* interview, 7–9, 11; and art world, 10, 33, 219; Benton and, 15–16, 21, 22, 33, 34, 37, 38, 39–40; Castelli and, 133, 134; childhood, 14; death, 67, 122; in Depression, 33–35, 39–40; dreams, 67; during World War II, 40, 44; evolution as painter, 35, 37–38, 48; exhibitions, 44, 53, 56, 62, 87, 90, 122–23, 134, 220, 229; family, 13–14; in Federal Arts Project, 34–35, 40; in films, 89, 111; income, 117; independence, 88–89;

influence, 3–4, 99, 219; influence on earthworkers, 255, 258; influence on Frankenthaler, 219, 220, 223; influence on Minimalists, 229; influence in 1960s, 182–84, 243; influence in 1980s, 294, 298–99; influence in 1990s, 298–99, 303–4, 307; influence on pattern and decoration painters, 272–73; influence of surrealism, 46–48; Kaprow on, 175; and Kligman, 121–22; Matta and, 46; Mondrian on, 53; music and, 295; mysticism, 70; on nature, 265; Newman and, 84; painting gestures, 7–9; Peggy Guggenheim and, 52–53, 56–57; personality, 16, 41, 96; physical appearance, 16; psychiatrists, 40, 94; public image, 88–90; Rauschenberg and, 137; and recognition, 10–11, 87–88, 297–98; relationship with Krasner, 9–10, 33, 44, 48–49, 67, 68, 88, 121–22; resentment against Europe, 44, 89; resentment against other artists, 96; Schnabel on, 298–99; in Springs, 7, 8, 10, 56–57, 59, 87–88, 89–90; training, 14–17, 33; working habits, 40; works, 36, 38, 41, 42, 47, 54–55, 58, 60–61, 86, 90, 91, 92, 93, 95; *see also* drip paintings

Pollock, Lee Krasner, *see* Krasner, Lee

Pollock, Roy (father), 13–14, 63

Pollock, Sanford (brother), 33–34, 39, 40

Pollock, Stella (mother), 13, 14, 16

Poons, Larry, 182, 222, 229

Pop Art, 4, 169, 177, 178, 197, 229, 294

Portrait of Cézanne (Picabia), 151

Portrait of Mary Boone (Schnabel), 280

Potter, Jeffrey, 16, 63, 67

poured paintings: of color-field painters, 222, 228; *see also* drip paintings

Presentation (Marden), 305

Prince, Richard, 297–98

P.S. 1, 271, 297

Purgatory (Smithson), 260

Queen of Hearts (de Kooning), 103

Race Track, The (Ryder), 37–38

Racing Thoughts (Johns), 158

Raft, The (Schnabel), 284

Rauschenberg, Robert, 134–37, 147, 149; de Kooning and, 139; exhibitions, 123, 136–

Rauschenberg, Robert (*cont.*)
 37, 139, 179, 229; influence, 226; Johns
 and, 140, 141, 145, 147–48, 149, 150; thea-
 ter work, 150, 179; works, 136–37, 138,
 139–40, 141, 176, 179–81, 303
Rauschenberg Overseas Culture Interchange,
 150
Ray, Man, 31, 151
Realm of the Carceral, The (Morris), 252
Reed, Lou, 204
Reinhardt, Ad, 123, 137, 260
Reiring, Janelle, 286–87
Reuben Gallery, 176
Ricard, René, 281
Richardson, John, 52
Riley, Bridget, 178
Riopelle, Jean-Paul, 295
Rivera, Diego, 39
Rivers, Larry, 123, 140
*Robert Kushner and His Friends Eat Their
 Clothes* (Kushner), 272
Rockburne, Dorothea, 169–70
Rodman, Selden, 87
Roosevelt, Franklin D., 27
Rose, Barbara, 29, 67, 269, 291
Rosenberg, Harold, 107–9; on action paint-
 ers, 105, 108–9, 111–12, 113, 114, 176; on
 artists in Depression, 26, 28, 29, 34; de
 Kooning and, 116, 117; on Hofmann, 69;
 Krasner and, 111–12
Rosenblum, Robert, 123, 169, 248
Rosenquist, James, 123, 177, 181–82, 183, 196
Rosenthal, Rachel, 147, 148
Rothenberg, Susan, 170–71
Rothko, Edith Sachar, 26
Rothko, Mark, 26, 44, 137; exhibitions, 123,
 229; paintings, 46, 79–80; Still and, 74,
 75–76
Royal Academy (London), 162
Rubin, William, 63
Rupp, Christy, 282
Russell, Morgan, 19
Ryder, Albert P., 37–38
Ryman, Robert, 182, 219

Salle, David, 276, 277–78, 289, 290, 291, 294,
 295, 300
Sandler, Irving, 109
Saret, Alan, 241

Sartre, Jean-Paul, 109, 111
Scent (Johns), 157, 164
Schapiro, Miriam, 268, 272
Scharf, Kenny, 292
Schizophrenia Prism (Salle), 295
Schmidt, Thomas Lanigan, 273
Schnabel, Julian, 277, 289, 291, 294; exhibi-
 tions, 284; films, 298; on Pollock, 298–99;
 works, 280, 281–82, 284, 285, 299
Schwankovsky, Frederick John de St. Vrain,
 14, 15
Scully, Sean, 303–4
Seasons, The (Johns), 158
Seery, John, 271
Segal, George, 174, 178
Self Portrait in Profile (Duchamp), 152
Self-Portrait with Rita (Benton), 18
Seligmann Gallery, 219
"Sentences on Conceptual Art" (LeWitt),
 227, 269
Serra, Richard, 239, 240, 256, 294, 295, 298
Shea, Diane, 286
Sherman, Cindy, 276, 285, 286
She-Wolf, The (Pollock), 46–48, 56, 59, 260
Shimmering Substance (Pollock), 59
Shunk, Harry, 205
Siegelaub, Seth, 270
Siqueiros, David Alfaro, 3, 39, 64
Smiling Workman, The (Dine), 177
Smith, David, 25, 101, 134, 219, 229
Smith, Gregory White, 63–64
Smith, Tony, 117
Smithson, Robert, 258, 259–65, 269, 298
Snow, Carmel, 192
Social History of Indiana, A (Benton), 20, 21
SoHo (New York), 275–76, 281, 284–85
Solanis, Valerie, 206–8
Soldier's Medal (Leslie), 125
Solman, Joseph, 27
Solomon, Holly, 270, 275
Sonnabend, Ileana, 133, 139, 203
Sonnabend, Michael, 203, 241
Sonnier, Keith, 169
Southgate, Patsy, 63, 94, 109
Space Completion Ideas (Burgy), 242
"Specific Objects" (Judd), 226
Spectrums (Kelly), 182
Spiral Jetty (Smithson), 258, 263, 264, 298
Springs, Long Island: de Kooning in, 117;

Pollock and Krasner in, 7, 8, 10, 56–57, 59, 87–88, 89–90
Stable Gallery, 136, 197
Stankiewicz, Richard, 176
Stanley, Bob, 178
Steir, Pat, 303
Stella, Frank, 192, 229, 231–37; critical reaction to, 233–35; exhibitions, 123; and fashion, 179; set designs, 150; works, 174, 177, 178, 230, 232, 233, 234, 235–37
Stelling, Bill, 283
Stenographic Figure (Pollock), 46, 47
Stevens, Wallace, 158
Still, Clyfford, 72, 73–77, 80, 111; exhibitions, 74–76, 77, 80, 123, 229; Pollock and, 71; works, 3, 71–72, 75, 76
Stone, Allan, 196
Studio (Johns), 153
Studio II (Johns), 156
Stutz, Geraldine, 190
Suburb in Havana (de Kooning), 118
Sultan, Donald, 170
Summertime: Number 9A, 1948 (Pollock), 10
Surrealism, 43–48
Swenson, Gene, 151, 197
Swing (Longo), 279
Synchromists, 19

Tabak, May, 111
Takis, 177
Tanning, Dorothea, 52
Tantric Detail (Johns), 157
Target with Four Faces (Johns), 131–32
Target with Plaster Casts (Johns), 130, 131, 132
Tavel, Ronald, 204
Taylor, Paul, 179
Tchelitchew, Pavel, 44, 133
Thiebaud, Wayne, 196–97
Thoreau, Henry David, 79
Threadwaste (Morris), 240
Three Flags (Johns), 162
Tibor de Nagy Gallery, 220, 232
Tiffany & Co., 148
Tiger's Eye, 84
Time, 22, 116, 136
Tolegian, Michael, 21
Tomkins, Calvin, 147

Tomlin, Bradley Walker, 123
Tomlinson Court Park (Stella), 232
Tongue to the Heart (Longo), 287–88
Torreano, John, 271
Totem (Benglis), 250
Totem Lesson II (Pollock), 91
T.P.'s Boat in Menemsha Pond (Pollock), 38–39
Tremaine, Burton, 132, 162, 196
Tribeca, 294
Twain, Mark, 81–82
Two Blue Walls (Huot), 241
Twombly, Cy, 136

University of South Carolina, 144
Untitled (Johns; 1964–65), 153, 156
Untitled (Johns; 1972), 156–57
Untitled (Judd), 174, 224
Untitled (Mitchell), 126
Untitled (Morris), 248
Untitled (Alert, GE) (Warhol and Basquiat), 293
Untitled Film Stills (Sherman), 285, 286

Velvet Underground, 204–5, 206
Venice Biennale, 62
Ventriloquist (Johns), 158
Vietnam War protests, 245
Vir Heroicus Sublimis (Newman), 81, 84
Viva, 207
Vogue, 90–91, 179, 294
Voice (Morris), 246–47

Ward, Eleanor, 136, 196, 197
Warhol, Andy, 4, 186, 205; Campbell's soup cans, 196–97, 198; celebrities and, 209, 215–16; childhood, 187–88, 189; collections, 215; commercial art, 189, 190–92, 211, 292–93; critics on, 291–92; death, 187; exhibitions, 197, 203–4, 291–92; Factory, 198–201, 204–9, 215; family, 187, 189; films, 203, 204, 206, 207; image, 192, 214–15, 216; influence, 294; influence of Johns, 169; influence of Pollock, 184; Op Art, 178; paintings, 184, 192–93, 195–98, 203, 212; portraits, 209, 211–14, 292, 293; set designs, 150; shooting of, 207–8; silk screens, 179, 197–98, 203–4, 211, 212, 216; studios, 195; supermarket logos, 177;

Warhol, Andy (*cont.*)
 training, 188–89; works, 174, 184, 188,
 190, 191, 194, 199, 202, 210, 213, 293
Warhol Museum, 215
Water Bull (Pollock), 90, 91
Weber, John, 177, 275
Weil, Susan, 136
Weiner, Lawrence, 270
Weissman, Julian, 277
Wesselman, Tom, 169
We, the People (Huberman), 22
White Flag (Johns), 131, 132, 291
White Numbers (Johns), 132
Whitman, Robert, 179
Whitney Museum of American Art, 20, 162,
 180, 245, 246, 272, 291–92

Winters, Terry, 171
Wofford, Philip, 271
Woman Artists in Revolution (WAR),
 272
Woman on a Horse (Frankenthaler), 219
Woman I (de Kooning), 115, 116
women's liberation movement, 247–49, 272
Works Progress Administration (WPA), 27;
 see also Federal Arts Project
Wrestlers, The (Longo), 279

Yarn (Warhol), 184
yarn paintings (Warhol), 184

Zakanitch, Robert, 303, 306–7
Zwack, Michael, 276, 279